D1480646

# THE COMPLETE
# DRAWING
# COURSE

# THE COMPLETE
# DRAWING
# C O U R S E

## IAN SIMPSON

RUNNING PRESS

**PHILADELPHIA, PENNSYLVANIA**

A QUARTO BOOK
Copyright © 1993 Quarto Inc.

All rights reserved under the Pan American and International
Copyright Convention. First published in the United States of
America in 1993 by Running Press Book Publishers.

This book may not be reproduced in whole or in part in any form
or by any means, electronic or mechanical, including photocopying,
recording, or by any information, storage and retrieval system now
known or hereafter invented, without prior permission in writing from
the publisher and copyright holders.
9 8 7 6 5 4 3 2 1

Digit on the right indicates the number of this printing
ISBN 1-56138-349-X

Library of Congress Cataloguing-in-Publication
Number 93-84163

This book was designed and produced by
Quarto Inc.
The Old Brewery
6 Blundell Street
London N79BH

**Senior Editor** Hazel Harrison

**Senior Art Editor** Penny Cobb
**Designer** Clive Hayball

**Picture Research Manager** Rebecca Horsewood
**Picture Researchers** Laura Bangert, Anna Kobryn
**Photographers** Paul Forrester, Ken Grundy, Les Wies,
Jon Wyand

**Art Director** Moira Clinch
**Publishing Director** Janet Slingsby

Typeset in Great Britain by Servis Filmsetting Ltd, Manchester
Printed in Singapore by Saik Wah Press Pte. Ltd
Manufactured in Singapore by Colour Trend

This book may be ordered by mail from the publisher. Please include
$2.50 for postage and handling. *But try your bookstore first!*

Running Press Book Publishers
125 South Twenty-second Street
Philadelphia, Pennsylvania 19103

# Contents

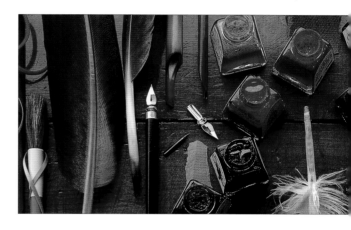

## MEDIA AND METHODS 4

# What is drawing?

· · · · · · · · · · · · · · · · · · ·

**A**ll drawings can be defined as a series of marks made on a surface to produce a picture or diagram, but they are many other things as well. We usually associate drawing with lines drawn with a pencil or pen, but the term drawing today embraces a wide variety of both monochrome and color media which can be used in many different ways.

Drawing can be used purely descriptively or more expressively, to convey moods and emotions. But perhaps most important of all is the directness of drawing. It is the most immediate means by which artists can react to something which has excited their interest. Whether you are responding to something in the external visual world or in the internal world of your imagination, the quickest way to record it is to draw it. This book will enable you to discover what excites your interest, and show you how to communicate it in drawing.

Drawing is mainly learned by doing it. All the teachers and books in the world can only provide you with information; the learning comes through practise. This practise, however, needs to have direction, and for many people a structured course that provides a route to follow can be the most effective means by which to learn to draw. This book provides such a course, and because it is in book form, you can proceed at whatever speed suits you.

## THE AIMS OF THE COURSE

The book starts from the premise that anyone can learn to draw. Drawing is a natural means of communication and expression which all children do well but which they often abandon as they grow older, believing it to be only for those with a special ''gift'' and a particular kind of talent. The Complete Drawing Course, which is in the form of a series of lessons, aims first to teach you to draw by enabling

## INFORMATION FEATURES

### PRACTICAL INFORMATION

The information features dealing with the drawing media list everything you will need to make a start, and encourage you to try out different media. Other information features explain helpful "basics," such as human proportions.

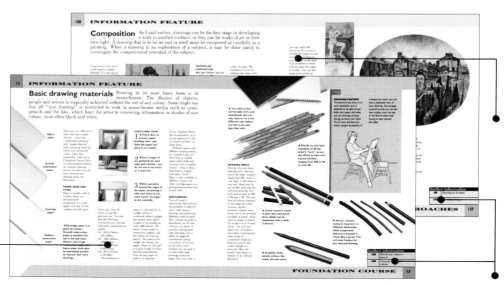

## THEORETICAL INFORMATION

These features, which outline some of the basic tenets of picturemaking, are designed to help you toward developing an individual approach.

## FURTHER INFORMATION

The cross-reference panel found on every right-hand page points you toward further information on the topic under discussion.

## PARTS ONE AND TWO: LESSONS

### THE AIMS OF THE PROJECTS
Each lesson includes an information panel setting out the aims of the projects and telling you how much time you will need to complete them.

### STEP BY STEP
Each project is illustrated with a full demonstration. Some projects have been carried out by two artists so that you can see different approaches and interpretations.

### SELF CRITIQUE
The projects are followed by a number of questions for you to ask yourself. This will help you check your progress and correct faults in your work.

### INTRODUCTIONS
The core of the book is a series of carefully structured lessons and projects. Introductory text explains the general principles and specific purposes of the projects.

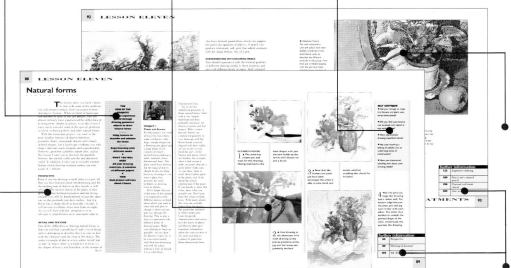

### OTHER EXAMPLES
Finished drawings by other contemporary artists are shown after each project. These are all related to the theme of the lesson, but show a wide variety of styles and media.

### FURTHER INFORMATION
The cross-reference panel found on every right-hand page points you toward further information on the topic under discussion.

---

you to see in the analytical and selective way that an artist sees. Second, it shows you how to explore the visual world in a systematic way, and in doing so to discover your own personal way of drawing the things that interest and excite you most.

### HOW TO USE THIS BOOK
This is not an ordinary book which you read, and then put aside. It is a kind of workbook. Often it gives you instructions and sets specific tasks. Try to imagine the text, as you read it, as your teacher speaking to you. With most chapters you

should first read straight through the text, and then go back to the beginning, following the guidance given step by step. Keep the book open beside you for reference as you work.

### PART ONE
The first part of the book is a Foundation Course in drawing, from which you will learn how to see "with all the senses," and how to translate what you see into drawing. It consists of seven lessons, each covering a major drawing fundamental.

Each of the lessons has projects for you

to carry out, with clearly stated aims and demonstrations so that you know exactly what to do. So that you can check how well you have done, a self-critique is provided in the form of some questions for you to ask yourself about your work. The answers you give yourself will tell you what you have achieved. This is most important, since on any course you need to be made aware of your strengths and weaknesses, and be assured that you are making progress.

At strategic places between the lessons and projects there are Information Features which give technical help and information on, for example, perspective and the proportions of the figure.

**PART TWO**
The second part of the book, Themes and Treatments, is structured in a similar way to the first, with lessons, projects and information features. The difference is that in Part One the projects mainly required you to draw simple still-life subjects, while Part Two extends the range of subjects, and introduces some of the most important problems encountered in drawing.

**PART THREE:
LESSONS**

● **OTHER EXAMPLES**
In addition to the "key" drawing, each lesson includes examples of the work of contemporary artists working in a similar style or subject area.

● **OTHER ARTISTS
TO STUDY**
Each lesson provides brief biographies of artists whose work you may like to study for further ideas and inspiration.

● **SUGGESTED PROJECTS**
Each lesson concludes with suggestions for projects, enabling you to try out the style or approach that forms the basis of the lesson.

● **THE KEY DRAWINGS**
These lessons explore the varied reasons for drawing, and look at different themes and styles. Each lesson features a "key" drawing by an old master or important modern artist.

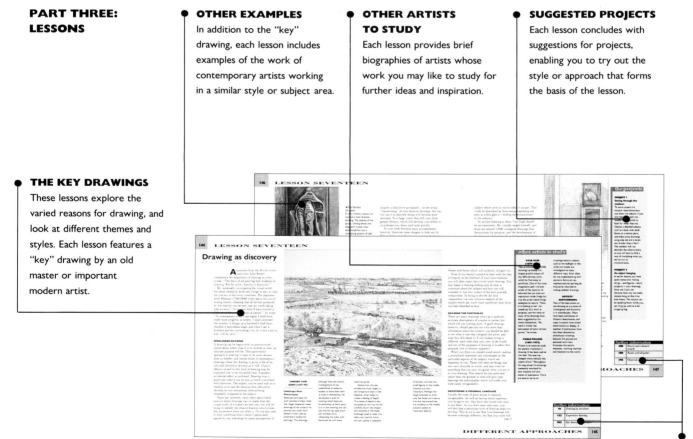

**FURTHER
INFORMATION**
The cross-reference panel found on every right-hand page points you toward further information on the topic under discussion.

**DEMONSTRATIONS**

Step by step demonstrations of techniques which are both useful and exciting to try show some of the options open to you.

**OTHER EXAMPLES**

As in the earlier sections of the book, finished drawings by contemporary artists provide further inspiration.

**THE PROJECT**

A project is set for each of the media, encouraging you to experiment with techniques.

**THE TEXT**

Clearly written text expands the earlier information on the drawing media, thus helping you to get the best out of your chosen medium.

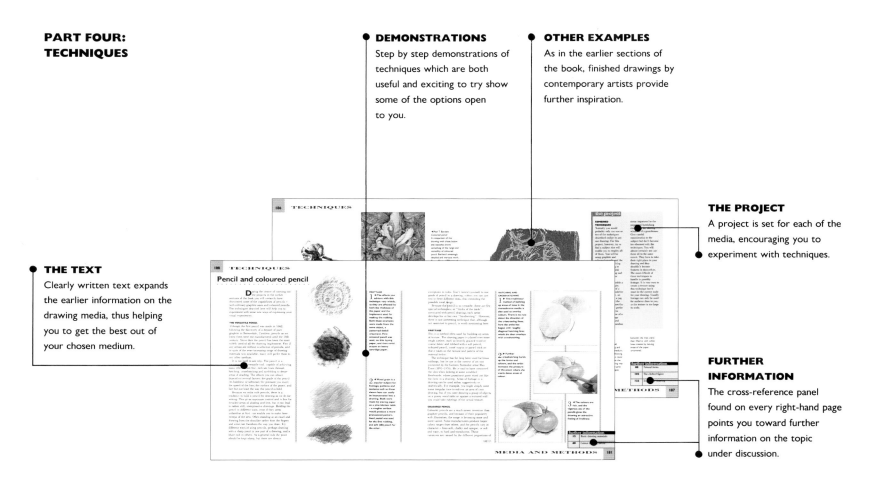

**FURTHER INFORMATION**

The cross-reference panel found on every right-hand page points you toward further information on the topic under discussion.

**PART THREE**

Part Three shows you the main approaches to drawing and how, in addition to the visual world, the memory and the imagination have been sources of inspiration for artists. It discusses the close relationship between drawing and painting, and how abstraction can be achieved through drawing. Looking at the work of distinguished artists is an important part of an art student's education, and in this part of the book each lesson features a "key drawing" by an old or modern master. The lessons incorporate projects for you to carry out as in the earlier parts of the book, though here they are not illustrated.

**PART FOUR**

By the time you reach this point in the course you will have developed considerable technical skill, and in this final section of the book technique is re-examined so that you can explore some new ways of using drawing media. Through these you will discover how to develop your own drawing style, and find new things to say about both old and new subjects.

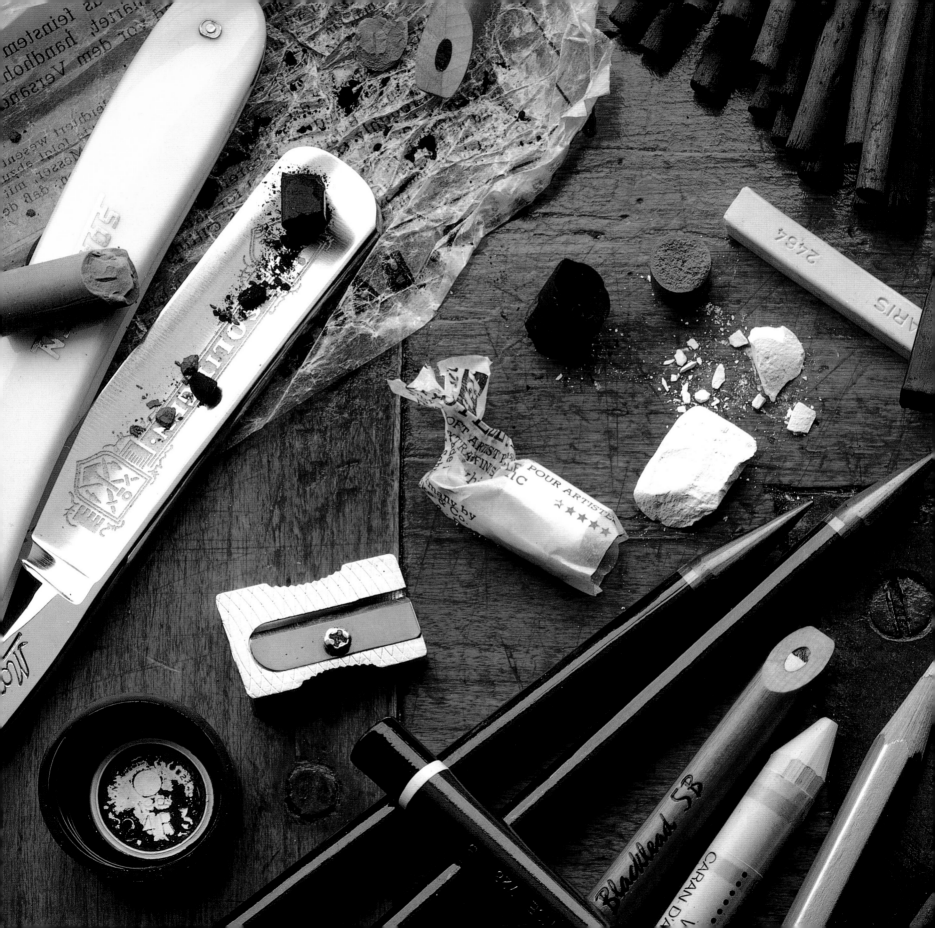

# PART ONE

# Foundation course

. . . . . . . . . . . . . .

Learning to draw isn't primarily concerned with learning special techniques; it is about learning to see in a new way. There are many different ways of seeing the same things. If you walk down a street which you usually drive down, you will notice all kinds of things you didn't see from your automobile. And if you then stand for a moment and look at an object at the side of the street, you will see features that you didn't notice as you walked past it. Drawing could be described as the art of looking carefully; you have to train yourself to see in an active, analytical way. The inability to draw an object is almost always a failure to see it rather than a lack of technical skill, and as you work your way through the projects in the Foundation Course, you will discover that if you can truly see something, then you will be able to draw it.

The projects in the following lessons require the minimum of materials and equipment and no prior knowledge of drawing. The drawing subjects are chosen from your familiar everyday environment. The first drawings you will be asked to make will be of ordinary household objects, then as you gain confidence and move on to the lessons in Part Two, you will go on to drawing landscapes and townscapes, fruit and flowers, and people.

# Basic drawing materials

Drawing in its most basic form is in monochrome. The illusion of objects, people and scenes is magically achieved without the use of any color. Some might say that all "true drawing" is restricted to work in monochrome media such as pens, pencils and the like, which limit the artist to conveying information in shades of one color, most often black and white.

**Charcoal paper**

**Smooth watercolor paper**

**Drawing paper**

**Medium watercolor paper**

However, it is difficult to limit drawing to monochrome – terms like "watercolor drawing" and "pastel drawing," both indicating drawings which will incorporate color, make that impossible. Later on in Foundation Course there is an Information Feature on colored drawing media, but here only the basic monochrome drawing media are discussed.

### PAPER: SIZES AND TYPES

Paper is usually sold in A sizes, which are internationally recognized. A1 is the largest size and A5 the smallest you will need.

◀ **Drawing paper is a good all-rounder. Smooth watercolor paper is excellent for ink or ink and wash. Medium and rough watercolor paper, and charcoal paper both give an interesting texture to charcoal and conté drawings.**

Each size, from A1 down, is half the previous one. You may find the following conversion into metric and imperial measurements useful.
A1:  $33 \times 23\frac{3}{8}$in
   ($840 \times 594$mm)
A2:  $23\frac{3}{8} \times 16\frac{1}{2}$in
   ($594 \times 420$mm)
A3:  $16\frac{1}{2} \times 11\frac{3}{4}$in
   ($420 \times 297$mm)
A4:  $11\frac{3}{4} \times 8\frac{1}{4}$in
   ($297 \times 210$mm)
   The thickness of

### STRETCHING PAPER

**1** ◀ **This is done to prevent paper buckling when wet. Soak the paper and place it on a board.**

**2** ◀ **Cut a length of gummed tape for each edge and moisten – but do not wet it too much or it may tear.**

**3** ◀ **Stick the tape around the edges of the paper, smoothing it with your hand as you work. Leave the paper to dry naturally.**

paper is expressed as weight per ream (480 sheets). Cartridge paper is usually between 72 and 90lbs, while the thicker paper used for watercolor and wash drawings varies from 140 pounds to 300 pounds.

You can buy paper in pads or in separate sheets. Separate sheets are recommended, as it is less expensive to buy A1 sheets, and then cut them down when you

want smaller sizes.

Different papers suit different drawing media, for example, a pen will draw best on smooth paper while chalk and charcoal need a rougher surface – what is often described as a paper with some "tooth." Paper is also available in different colors, but white drawing paper is a good general-purpose one to start with, and this will do for all the work you will be asked to do in this part of the course.

### SKETCHBOOKS

You will need a sketchbook. Sketchbooks are available in different sizes, with various bindings and containing different kinds of paper. Don't choose too small a sketchbook; an A2 size will give you plenty of room for making quite large drawings, but is rather too large for conveniently taking everywhere. If you buy an A3 with a sewn binding, you can open it out, and make large drawings across two pages when you need to. You may prefer to have

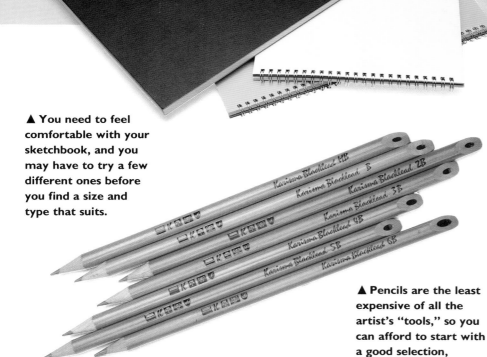

▲ You need to feel comfortable with your sketchbook, and you may have to try a few different ones before you find a size and type that suits.

▲ Pencils are the least expensive of all the artist's "tools," so you can afford to start with a good selection, ranging from HB to 4B or even 6B.

two sketchbooks with drawing paper, one of at least A3 and another smaller one which will go in a pocket or bag.

## DRAWING MEDIA

Pencils, the most basic drawing tools, and also one of the most versatile, range from 6H, which is very hard, to 6B which is very soft. Hard pencils are usually used only for technical drawing. You will need at least an HB, a 2B and a 4B. The only kind of crayons required at this stage are conté crayons, square-sectioned slightly waxy sticks which are normally available in black, white and two shades of brown. Try to get a stick of each color. You will also need a box of medium-sized willow charcoal and some sticks of compressed charcoal. Charcoal

▲ Conté crayon is made in both stick and pencil form. Sticks can be sharpened with a knife if desired.

► Graphite sticks, pencils without the wood, are also useful.

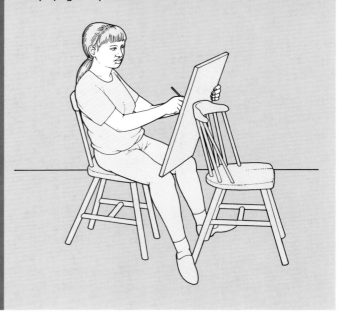

**tip**

**DRAWING POSITION**
The position you draw in is very important, as it is essential to be able to see both your paper and what you are drawing without having to move your head. Try to have the board as nearly upright as possible; if it slopes too much, you will have a distorted view of your drawing. And arrange yourself so that you can see your subject over the top of the board rather than having to peer around the sides.

► Willow charcoal comes in twig form in different thicknesses, while compressed charcoal is encased in wood, like a pencil. You will need spray fixative for any charcoal drawing.

| further information | |
|---|---|
| 180 | Pencil and colored pencil |
| 196 | Charcoal and conté crayon |

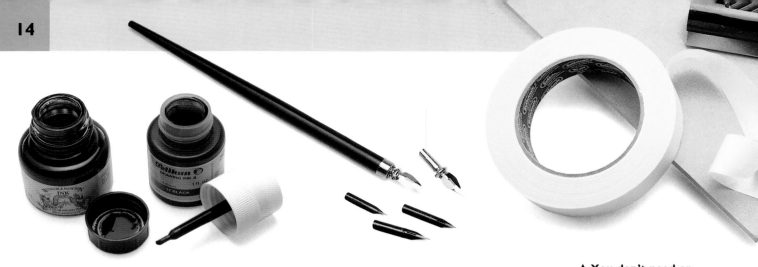

▲ There are many different drawing inks, but the two main categories are waterproof and water-soluble. There are also many different drawing pens, but a dip pen with interchangeable nibs would be a good first buy.

▼ The range of felt- and fiber-tipped pens is bewilderingly large. Try them out before buying, and make sure they are colorfast – some fade badly.

pencils are useful, though not essential. They are usually equivalent in softness to an ordinary 2B pencil.

There are many kinds of drawing pens and drawing inks, but begin with a small bottle of black drawing ink and a drawing pen which can take separate nibs. Drawing ink can usually be diluted with distilled water, so make sure that any ink you buy can be thinned in this way.

A wide range of ballpoint, fiber-tipped and felt-tipped pens is stocked not only by

artist's materials suppliers but also by stationery stores. Many of these pens are suitable for drawing, provided the point isn't too thick. If you find working with a pen suits you, try out as many kinds as possible. Most shops have sample pens for you to experiment with, so you can try them and reject the ones you don't like without having to buy them.

Finally, you will need spray fixative, to protect drawings done with charcoal, charcoal pencil and soft pencils, and prevent them from smudging. This can be bought in aerosol cans (ozone friendly), or in bottles with which you need a spray diffuser.

### BRUSHES
You may think that brushes are for painting rather than drawing, but you will discover that they are very useful drawing tools. You will need at least two round soft brushes; sizes 4 and

▲ You don't need an expensive drawing board; a piece of fiberboard like this is quite adequate. You will also need clips, masking tape or drawing pins for securing your paper.

▲ These brushes are genuine sables, but there is a variety of less expensive substitutes on the market today.

6 would be good to start with. Ideally they should be sable hair brushes, but these are very expensive, even in these small sizes, so you will probably want to begin with a sable substitute.

### DRAWING BOARDS
You will need a flat board to support your paper for drawing, and this needs to be a little larger than the largest paper you are likely to use. Specially made boards can be bought at

artist's materials stores, but a piece of blockboard or plywood of $\frac{3}{4}$-inch thickness is perfectly satisfactory. Chipboard is too rough, and normal masonite usually too thin to stay flat, although there are some thick masonites which can be used.

For fixing the paper to your board use either spring clips, drawing-board clips or masking tape. Drawing pins are not suitable for the recommended boards.

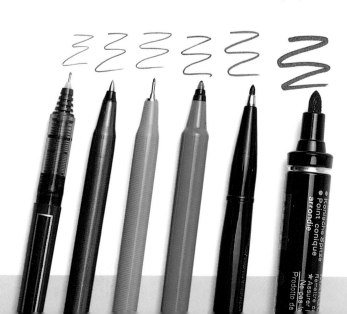

## OTHER USEFUL ITEMS

It isn't necessary to have an easel, but you usually need something to support your board when you are drawing. You can use the back of a chair for this when drawing indoors, but if you already have an easel, you will be able to use it to hold your board in a similar way.

● An eraser – although I shall often discourage you from using it, a plastic general-purpose eraser is useful.

● A sharp knife – either one with replaceable blades such as a craft knife or one with snap-off blades. A knife can be used both for cutting paper and for sharpening pencils. Alternatively, a pencil sharpener can be used for the latter.

● A palette – this could be a special artist's chinaware (or plastic) tinting saucer, but an ordinary saucer will do quite well. The saucer is for thinning ink to make washes for drawing.

● A metal straightedge will be necessary if you are going to cut paper.

● A notebook – not essential but helpful for keeping an account of your problems and progress.

● Water pots and rags or paper towels for wiping brushes and general mopping up.

● Some kind of portfolio for storing your drawings – they need to be kept flat. A simple folder can be made with two sheets of board (eg, mounting board) hinged with masking tape.

▼ ► If you intend to do any ink and wash work, you will need a palette and a water pot. Jelly jars are fine for indoor work, but the non-spill pots with lids are a great help when drawing out of doors.

▼ ► An eraser is useful – but don't rely on it too much. A metal straightedge is not essential.

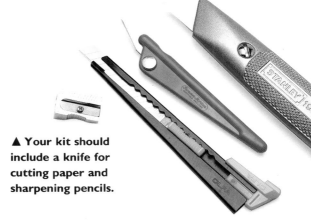

▲ Your kit should include a knife for cutting paper and sharpening pencils.

◄ Once your drawings begin to pile up, you will need a portfolio of some kind.

# Materials and marks

• • • • • • • • • • • • • • • • • • • • •

In the lessons in this part of the course you will be translating what you see using the monochrome drawing media described on page 12. Before you make a start on recording your visual experiences, however, you need to become familiar with the materials you will be using, and gaining familiarity with the marks you can make with them, so in this first lesson I'm not going to ask you to draw from objects at all, or to draw from memory. The projects are concerned only with discovering what your drawing media can do. One of the things you will find, though, is that they will by chance create objects on your paper, with almost no effort on your part.

## DRAWING BY ACCIDENT

Surrealist artists have taught us that the subconscious plays a very important part in art. Most people have doodled idly on a piece of paper and noticed that a few chance strokes can suggest something, such as a bird or a flower. When they draw, artists look for such accidental effects, and try to exploit them.

We usually think of Surrealism as a 20th-century form of art, but in fact it has a long history. Artists such as Hieronymus Bosch (*c.* 1450–1516) in the 15th century and Francisco de Goya (1746–1828) in the 18th and 19th expressed the weird and fantastic. In the 20th century the work of two of Surrealism's leading exponents, René Magritte (1898–1967) and Salvador Dali (1904–89), has become familiar to most people, if not through the actual paintings then from adaptations of them used in advertising.

**THE AIMS OF THE PROJECTS**
Trying out your drawing materials
———
Discovering the range of possible marks you can produce
———
Seeing if you accidentally create recognizable effects
•
**WHAT YOU WILL NEED**
You will need all your drawing materials, your drawing board, at least five sheets of white drawing paper and clips or tape to fix your paper to the board. Distilled water will be required for diluting your drawing ink, and spray fixative for fixing charcoal. You will also need a thin stick about the length of a knitting needle. A fairly straight twig will do
•
**TIME**
The three projects should take you about 2 hours in all. You may, however, need more time so that you can repeat some of them and understand their purpose before continuing to the next

## PROJECT I
### Experiments with drawing media

Lay out your materials on a table or similar surface. You can work with your board flat on the table for this project. Attach one of your A2 sheets to your board and begin by drawing on it with all the media you have in turn. Don't try to draw anything, but instead let yourself become totally involved in the lines, dots and kinds of shading which each medium will produce. Use your imagination and spend at least thirty minutes trying out every way you can think of to make marks with each drawing medium. It is rather like practicing handwriting. Once you are confident about what each medium can do, you will be on the way to using them to describe what you see.

▲ Marks made with a 2B pencil.

▲ Marks made with an HB pencil.

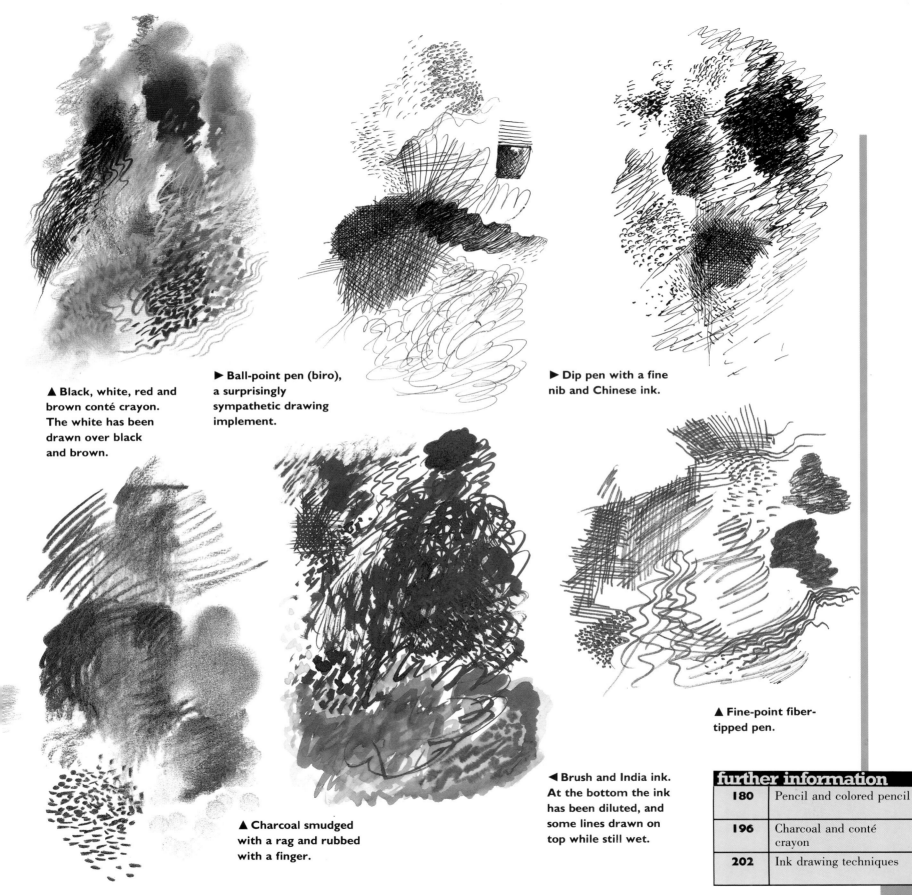

▲ Black, white, red and brown conté crayon. The white has been drawn over black and brown.

► Ball-point pen (biro), a surprisingly sympathetic drawing implement.

► Dip pen with a fine nib and Chinese ink.

▲ Charcoal smudged with a rag and rubbed with a finger.

◄ Brush and India ink. At the bottom the ink has been diluted, and some lines drawn on top while still wet.

▲ Fine-point fiber-tipped pen.

FOUNDATION COURSE

## PROJECT 2
### Automatic drawing

To assist in releasing the subconscious, the Surrealists developed the practice of "automatic drawing." They believed that if you allow your hand and arm to move freely, without conscious control, you will draw what is in your subconscious mind. A degree of automatic mark-making is evident in the work of many artists who make no claim to being Surrealists. Look at reproductions of drawings by Pablo Picasso (1881–1973) or Henri Matisse (1869–1954), for example, and see which you feel contain lines drawn with an automatic sweep of the artist's hand.

Using a new sheet of paper, try making your own automatic drawings. Start by using any or all of your drawing media and make sweeping lines down or across the paper, moving your hand and arm freely. Next think of the foliage of a tree and then try to describe it with freely drawn lines. Don't try to draw a tree. Allow your hand to be guided by impulse, prompted by imaginary kinds of foliage that comes to mind. The result might be something like the drawing here on the right, but it could be completely different.

Then imagine a town seen from a distance and try to draw it. When you are drawing, don't take your drawing instrument off the paper more than is absolutely necessary. As far as possible, draw with one continuous unbroken line. Describe the features of the town as quickly as you can without stopping to see how you are getting on. Then make another drawing of a distant view of your imagined town, but this time keep your eyes shut as you draw.

► The lines have been drawn in charcoal, dip pen and ink and pencil, and the foliage in charcoal. "Doodling" with different media is an excellent way of gaining experience.

▼ Imaginary town drawn in one continuous line with dip pen and ink.

▲ A distant view of the imaginary town drawn in the same way.

▲ This time the town has been drawn with eyes closed. A ball-point pen was used, as a dip pen would not have been practicable.

▼ Blots of India ink dropped from a stick have been developed into a landscape by adding lines drawn with the same stick.

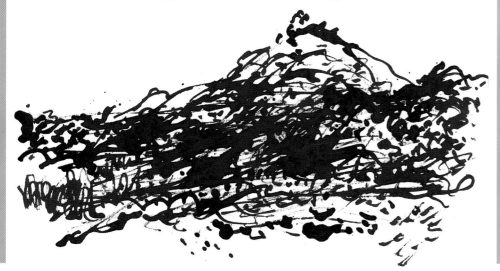

## PROJECT 3
### Blot drawing

It is now accepted that accidental effects can be an important feature of drawing, but this is not a new discovery. More than 200 years ago Alexander Cozens (1717–86), an English painter who was also an eminent drawing master, took an idea from the 15th-century artist Leonardo da Vinci (1452–1519) and developed it into a method for producing landscape drawings. The idea was the simple one of dropping blots of ink onto paper and then developing a landscape from these random marks. Cozens' system was explained in his book *New Method of Assisting the Invention in Drawing Original Compositions of Landscape* published in 1785/6.

On a new sheet of paper, try dropping ink first from a stick, and then from a pen and a brush. Look carefully at groups of blots, and see f if their accidental arrangement suggests something to you. You may see the marks as dark clouds, plants, a face or perhaps figures. Let your imagination wander freely, and once the blots have suggested something to you, try to develop this image using more blots or ink lines made with a pen or a brush so that the imagined subject becomes clearer. Then try the experiment again, but this time first wet the area of the paper on which you are going to drop blots with clean water.

### SELF CRITIQUE

● Have you used all the drawing media and produced all the effects you think are possible?

● Do you now feel fairly confident about using all the drawing media?

● Do you prefer one medium to another?

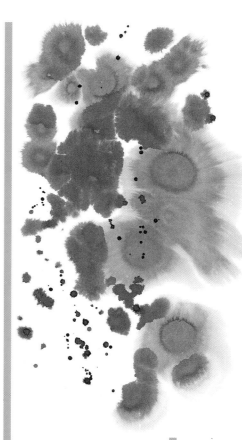

▲ Blots dropped onto wet paper form interesting patterns which may suggest a subject.

▶ John Houser
*Brush with ink*
The ink has been used both at full strength and diluted in this portrait drawing. A dry brush has been used for the dark background which throws the profile into relief. The brush is a very sensitive drawing implement, and here has been used with skill and confidence.

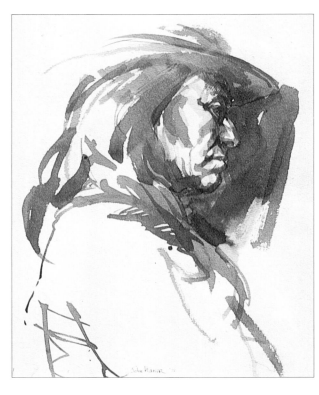

▼ David Carpanini
*Charcoal*
In this dramatic and atmospheric drawing of a mining landscape, **South Winder**, there are almost no lines; the charcoal stick has been used on its side to build up dark areas, and smudged in places to create soft effects. For a drawing like this it is often necessary to use spray fixative at various stages so that the charcoal can be built up thickly.

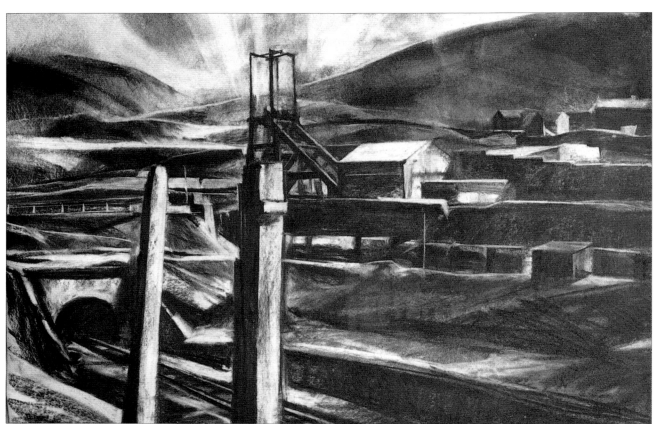

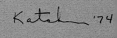

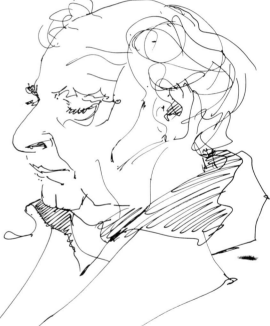

▼ John Elliott
*Pen and ink*
Freely drawn, with loosely scribbled shading, this portrait gives a surprising amount of information about the sitter. An artist may have to discard many drawings before one is created as effortlessly.

▲ Carole Katchen
*Pastel and ink*
This drawing, **The Violinist**, has been made at great speed, the whole composition being created with just a few "slabs" of shading made with the side of the pastel stick plus some touches of pen line.

By seizing on the most significant aspects of the figure and avoiding unnecessary detail, the artist has given a powerful suggestion of the musician in performance.

| further information | |
|---|---|
| **160** | Drawing a likeness |
| **206** | Brush drawing |
| **196** | Charcoal and conté crayon |

# Different ways of looking

This drawing course puts the emphasis on seeing, and so it will be no surprise to find as you read on that the next projects, which involve drawing objects, are concerned mainly with looking and not with techniques. At first sight the three projects may seem to be only for absolute beginners, but this isn't so. They could be returned to time and time again by experienced artists, and lead to a widening of their horizons and an escape from seeing in a preconceived way.

**WAYS OF SEEING**

There are without doubt different ways of seeing the same object. Matisse said that when he looked at a tomato, he saw it in the same way as anyone would, but that when he painted it, he saw it differently. In this lesson you will begin to see what he meant.

The way you decide to draw is one of the factors which determines the way you look at an object. For example, if you say "I am going to make a line drawing," you will be looking at the outline shape of the object very carefully but not be so concerned with how light or dark it is. If, however, you decide to make a drawing without any lines, then the lightness or darkness of the object will be important. The projects that follow all require you to make line drawings, but as you will discover, you won't just be looking at outlines.

**POSITIONING YOURSELF TO DRAW**

Once you start to draw actual objects, your position and that of your drawing board becomes important. Look back at page 12 and you will see an illustration of an artist drawing with a board propped against a chair. Notice that the board is propped on his knee so that it is almost vertical and that he is drawing sitting well back with his drawing arm stretched well out. He is looking past the left side of the board at his subject.

To draw easily and fluently you must be

26 ▷

## THE AIMS OF THE PROJECTS
Looking at objects in different ways
_____
Identifying an object's character
_____
Developing skill in using line
•
## WHAT YOU WILL NEED
Pencils, pens, charcoal, conté crayon.
Several sheets of at least A3 size paper
•
## TIME
You should spend at least 1 hour on each of projects 1 and 2 and at least 2 hours on project 3

**PROJECT 1**
**Contour drawing**

The subject for your first drawing can be anything which is not too large or complicated. I suggest a pair of shoes, a pair of gloves, or a cup and saucer and plate. Place them on a table a convenient distance away from you, and make certain you have yourself and your board in the right position for drawing.

Choose any medium suitable for making a line drawing, then fix your eyes at a particular point on the outline shape of one of the objects and rest the point of your pencil (or other instrument) on your paper. The point on the paper must be the same one that you are looking at in the subject. You are now going to draw without looking at the paper. Very slowly make your eyes feel their way around the contour shapes of the objects – don't look at the paper – and equally slowly and deliberately, in pace with your eyes, make your

hand describe what you see.

If your hand and eye get out of step, relocate your pencil at a particular point on your drawing, fix your eyes at the same point on the contour of your subject and continue. Don't rub out any lines. Keep on until you have drawn the complete contours of your subject and only then look at your drawing.

If you have really followed the contours your drawing will not be just a silhouette because in some places your eyes will have been led inside the outline shapes to describe, for example, the rim of a cup before returning to the silhouette shape again.

It will probably take some time to produce a drawing which looks right. Your first drawing may not look anything like the subject but it doesn't matter. Learning to feel with your eyes is what is important.

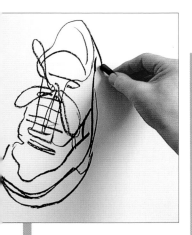

**KAY GALLWEY**

**1** ◄ The artist is feeling her way around the contour of one of the shoes, drawing it as it leads around the object, with the sharp edge of a conté crayon.

**2** ▲ The second shoe is being introduced into the drawing. The line is kept continuous, except when there is a change in direction.

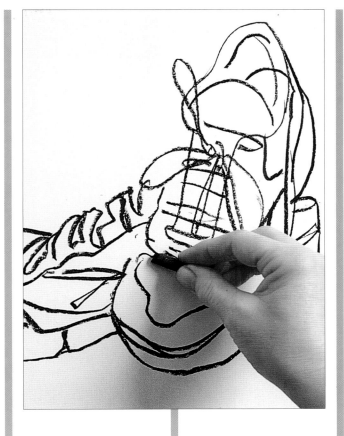

**3** ◄ The drawing continues, with the contour of the second shoe leading back to the first one.

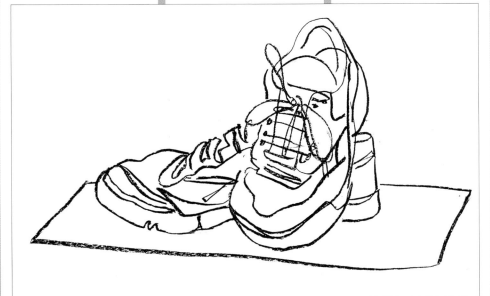

**4** ◄ The complete drawing gives a remarkably good idea of the shoes, although it was done quickly and with no hesitation. The artist has also related them to the surface beneath, by drawing in the outline of the paper on which they rest.

**further information**

| 56 | Two more ways of looking |
|---|---|
| 196 | Charcoal and conté crayon |

## PROJECT 2
### Inner forces

Drawing the contours of an object is only one way of describing it. Another way is to look within the contours to see if you can identify some particular characteristic there. When making drawings of a static figure artists often refer to the "movement," by which they mean that even when someone is perfectly still, a feeling of movement is still identifiable. The figure may be slumped in a chair or standing stretching upwards. You will be examining the movement contained within a figure later in this course, but it is not only figures that have these internal dynamic qualities. They are more obvious in figures than in chairs and tables, vases, bottles and cups and saucers, but they are there nevertheless. A table or a chair has a feeling of its weight pressing it onto the floor, and even a sack dumped in the corner of a barn will bulge to suggest the character of its contents.

Choose an object to draw which looks heavy or has some other kind of internal tension. You might suspend an object from a hook to see how it sags under its weight or choose a bag of carrots, or potatoes which takes on a particular appearance because of its contents. I then want you to make drawings which describe these inner forces. They shouldn't be drawings of the external appearance of the objects but they should show the particular internal characteristics of the subject.

Draw in line only using a different medium from the one used in the last project. Draw quickly, using a continuous line without taking your pencil from the paper, though this time you can look at the paper as you draw. Let your drawing instrument dart about describing how the object seems to twist, thrust or fall. Make the action of your hand describe the movement in the object.

As your line describes its movement, you will sometimes be drawing through the center of the object, and sometimes in your efforts to give your drawing its true dynamic you may end up drawing outside the object altogether. Draw with absolute freedom, and above all don't follow the contours of the object, because this won't describe the inner forces.

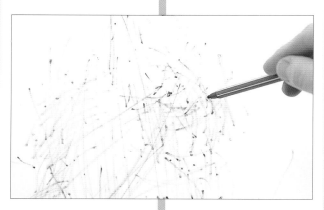

**KAREN RANEY**

**1** ◄ **Fruit in a plastic bag provides an excellent subject and, using fine fiber-tipped pens, the artist is starting to draw the way the objects hang – their weight and their downward forces.**

**2** ◄ **Direction lines, describing the downward thrust of the fruit, are drawn in a series of delicate but decisive lines.**

**3** ► **The finished drawing gives a feeling of suspended weight without following the contours of the fruit or bag. The artist has allowed her hand to follow the implied movement of the objects. This has given the drawing a dynamic quality which describes the inner forces of the subject rather than its outward appearance.**

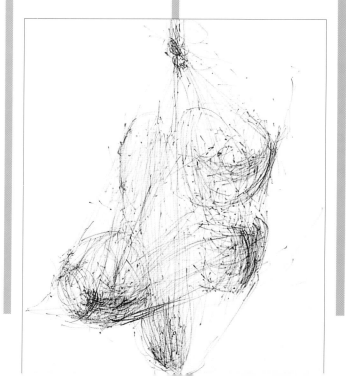

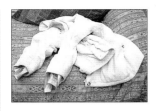

## PROJECT 3
### Outer and inner

When people start learning to draw there is a tendency to concentrate on contours and ignore what happens inside them. In this project I want you to consider not just the "edges" of an object but what happens in between them. You will need a basically cylindrical object which can be placed vertically or horizontally; something like the sleeves of the jacket in the drawing is ideal. The sleeves have had paper stuffed inside them to make them round so that folds and creases in the fabric run round the arms like irregular corrugations.

A similar subject could be made with a pair of pants, but the object doesn't have to be a garment. A vase with a striped pattern, a log of wood or a few cups stacked one inside the other would all be excellent. What is needed is a set of positive lines running in from the edges of a tubular form.

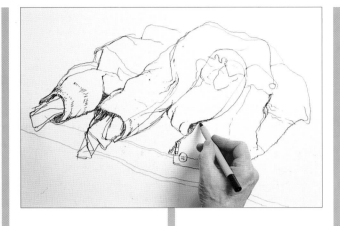

**IAN SIMPSON**

1 ◀ **A fine black fiber-tipped pen is being used to follow the folds and creases in this jacket. The lines describe the cross-section of the garment rather than just its outline shape.**

**SELF CRITIQUE**
● Did the drawings you made in Projects 1 and 2 help you to make a convincing drawing in Project 3?

● Are you beginning to know what to look for when you draw?

● Are you drawing freely and more fluently?

● Have you continued to draw regularly in your sketchbook?

2 ◀ **The undulations of the folds of the jacket have been drawn in much the same way as the hills and hollows of a landscape might be described. It is very important that when you are drawing, you realize that the "middle" of the object matters as much as its edges.**

Draw in line, use a medium which you haven't used so far in this lesson. Make your eyes follow the stripes or folds as they run across the form you are drawing, and use line to describe what you see. If you are drawing a garment, you will see that there isn't a continuous outline around its edge. The line will frequently turn inwards to describe folds, for example, and, as it does, it may provide an accurate cross-section of the object.

Lines that run around forms are very important in making objects appear to be three-dimensional, and often in drawing classes students are told that they must learn to draw across forms, and not merely remain on the edge. The project should compel you to do this.

comfortable and able to move your arm and hand freely. You should be able to take your eyes from the object to the board in the quickest possible time. Your board must be as near vertical as possible, as this allows you to see your drawing as it actually is. If the board were horizontal, you would get a distorted view of your drawing.

All these points may seem obvious, but it is surprising how many students make drawing an almost impossible task by not taking account of them. It is amazing how much you forget about what you have seen even in the split second it takes to transfer your eyes from the object to your board, but it is not unusual to see students trying to draw things which are almost behind them. Many also draw with the board flat on their knee, and are surprised to find that in order to compensate for the foreshortened view of their drawing, they have elongated the objects.

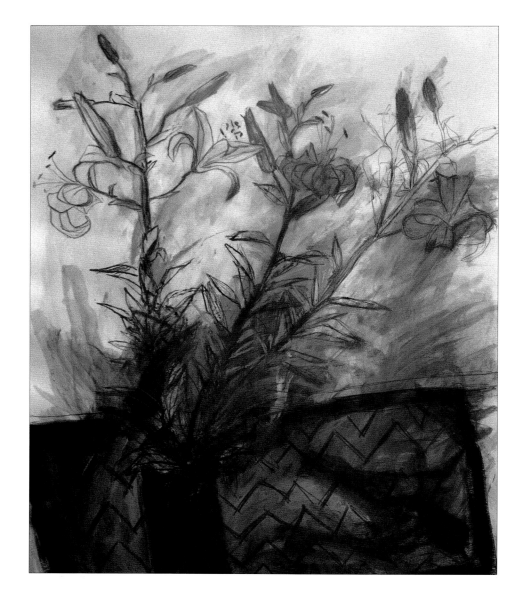

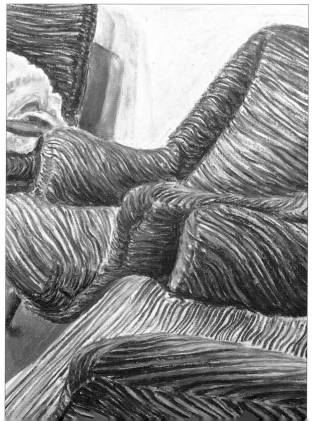

▲ Barbara Walton
*Mixed media*
Whatever your level of experience you can try using more than one medium in a drawing. In **Lilies in a Black Vase** the artist has combined charcoal, pastel and touches of acrylic to produce a well-integrated drawing with a strong feeling of movement.

▶ Paul Bartlett
*Oil pastel*
In **Chairs** a close-up view of upholstered furniture has been drawn by using the distinctive pattern and texture of the upholstery fabric as a series of contour lines to build up the forms.

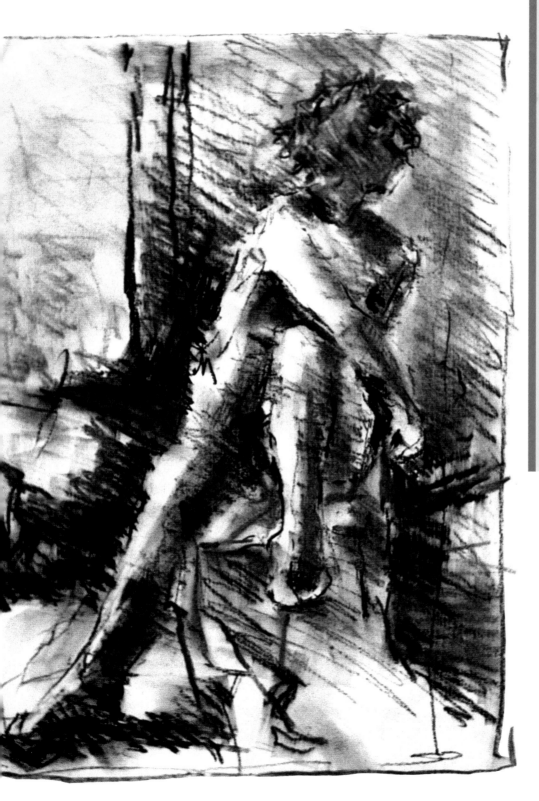

tip

## STARTING A SKETCHBOOK

From now on, aside from the various projects you will be asked to do in the book, there is an important learning process which you should develop on your own initiative. You must now begin to look at everything anew and to draw anything and everything. These drawings should be made in your sketchbooks, and these will become records of your exploration of the visual world as well as showing you your drawings gradually become more assured, fluent and personal.

You should aim to draw every day even if only for three or four minutes. Quick drawings are very important because you have to sum up your subject rapidly and draw what seems important. As you proceed through the course you will discover the significance of such decisions, and the more you practise the more rapidly this skill will develop.

At this stage I don't want you to worry about how you draw in your sketchbook; your drawings will improve as you develop new skills and discover new strategies. What is important is that in addition to carrying out the various course projects you are practicing drawing as much as you can. This book will only be properly understood when you have personally experienced the points it makes. Drawing is ultimately learned by practise, and your sketchbook allows you to try out your own ideas, extend ideas which come from the projects, and draw the things which specially appeal to you.

◀ Joan Elliott Bates
*Charcoal*
Charcoal is the ideal medium for broad effects, and in **Life Drawing II** it has been used very freely to describe both the play of light on the figure and the dynamic qualities of the pose. Shading has been done by scribbling, hatching and smudging, and the vigorous use of the medium gives the drawing life and vitality.

# Drawing two dimensions

When you draw the shape of an object you only have to consider two dimensions, height and width, but it is not always easy to make an accurate outline drawing. In this lesson you will be learning how to relate shapes of an object to a background, first by drawing on a grid of squares and then by using background features as a check for shapes.

If your drawings are not entirely accurate at first, don't be disappointed. To be able to see shapes clearly and draw them well demands concentration and practise. Some people have the idea that they should be able to sit in front of an object with a line pouring out of their pencil and automatically tracing the shape onto their paper, but this is a myth. Some may have greater drawing facility than others, but what counts most is training yourself to see. When you begin to notice discrepancies between the shape of the object and the shape in your drawing, then you are learning to draw.

The projects in this lesson will make you realize how important it is to compare shapes and directions when you draw. Usually people see objects in isolation; for example, landscape is seen as first one tree, then another, and then a background. In learning to see and compare all these features simultaneously you are learning to see in the way that an artist does.

In drawing classes students are often advised to hold a pencil vertically as a drawing aid, or to use a pencil held at arm's length to measure the different sizes of two shapes. In my experience these methods are unreliable, and I recommend that you make comparisons between objects, seeing how they relate to each other and to their background. This drawing habit may take a little time to learn, but once you have acquired it you will be able to draw in this way automatically.

## THE AIMS OF THE PROJECTS
**Relating an object to its background**

---

**Learning to see accurately**
●
## WHAT YOU WILL NEED
Your drawing board, three sheets of drawing paper (or two and one piece of white card), a ruler, a B or 2B pencil and a pen
●
## TIME
About 1½ hours for each project

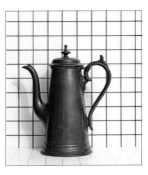

## PROJECT I
### Relating an object to a grid
You will be drawing the silhouette shape of a pitcher, teapot or something similar. Choose an object that has a handle, spout and other projections which give it an interesting shape. Your drawing is to be made on a grid of squares, with another identical grid placed behind the object, so draw up the grids first. Mark points at 1½-in intervals along the sides of each piece of paper, and then use a ruler or straight edge to join them. If you have no convenient wall on which to pin up the grid which is to be placed behind the object, you may have to draw it on card and prop it up. It must be absolutely vertical and not turned at an angle.

Place the object on the table not more than 2in from the grid, positioning it so that you have the best possible view of it, and see the handle or other projections clearly. Draw the shape of the object, in line only, checking constantly to make sure that the pitcher in your drawing relates to the grid on your paper in precisely the same way that it relates to the grid placed behind it.

You can start drawing at any point on the silhouette. Check where this particular point is in relation to its background square, and make sure that you start in exactly the same place in a square on your drawing paper. Continue to plot the shape of the pitcher in relation to the grid. Don't rub out if you get lines in the wrong place; draw and redraw the shape until it is as accurate as possible. Then spend a few minutes comparing your drawing with your view of the actual object.

**JOHN TOWNEND**

**1** ◄ Using a black fiber-tipped pen, the artist carefully draws the shape of the lid, checking it against the squares of the background grid.

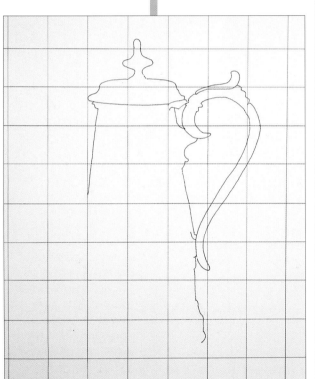

**2** ▲ As he develops the drawing, he continues to check the shapes against the background squares.

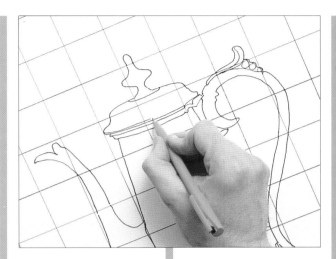

**3** ▲ It is important not to change your viewpoint in any way, as this will alter the relationship of the object to the grid.

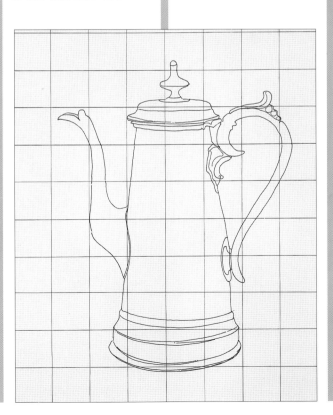

**SELF CRITIQUE**
● Did you find it difficult to decide on the exact position of the object in relation to the squares on your drawing?

● Did you find out anything unexpected about the object? Is its shape precisely symmetrical, for instance?

● How would you rate the accuracy of your drawing on a scale of 1–10?

● Did you find that you concentrated on drawing one object and lost sight of its relationship to everything else?

**4** ◄ Because the artist is an experienced draftsman, he has been able to complete the drawing with no revisions. A student will almost certainly need several attempts to produce an accurate drawing. If you have to make some corrections, don't erase the earlier lines.

| **further information** | |
|---|---|
| **12** | Basic drawing materials |
| **64** | Perspective |
| **70** | Using perspective |

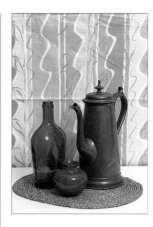

**PROJECT 2**
**Relating objects to their background**
Obviously you can't arrange everything you want to draw so that it has a grid behind it. In practise you have to make the maximum use of the background and relate objects to it in any way possible to see them accurately. Remember that the background is just as important as the objects themselves. In this project I want you to draw two objects with interesting silhouettes – one can be the same as you used in the last project and the other a similar one, perhaps a watering can or vase.

Place the two objects close together on the table, and either change your drawing position or move the table so that you can see something more than just an unpatterned wall behind the objects. If the wall has a definite pattern on it, that will be an excellent background but if it hasn't, try to arrange things so that you have a window frame or the folds of drapes behind your two objects. If this isn't easy to arrange, you can place something flat and simple behind the objects – perhaps a couple of books resting back against the wall. You can stand your objects on a patterned tablecloth if you wish. Or put each on a place mat or a book.

This time, draw with a pencil or charcoal, still in line only. Draw only the silhouette shapes of the objects, but don't draw them in isolation. Relate them to the background as you did in the last project. This time you have to find a substitute for the grid, so before you start to draw, look carefully to see what you can use as references. A window frame, for example, will make vertical lines against which the curves of the pitcher and teapot can be assessed, and a patterned tablecloth provides identifiable shapes with which to compare the bases of the two objects.

Start by drawing something you're confident you can get right. Any horizontals and verticals make a good start as they only involve drawing straight lines parallel to the edges of your paper. They are of great importance in a drawing because they give you instant references against which you can measure angles. Draw and redraw objects and background until you feel that they fit together as accurately in your drawing as you can make them.

**JOHN TOWNEND**
**1** ▲ This time the artist is using charcoal, but as in the previous project he is drawing in line only. As he draws, he checks the shapes against the background pattern. You can see that some correction lines have already been necessary.

**2** ◀ The drawing is gradually developed by the addition of the other objects.

$3$ ◄ Careful attention is paid to the shape of the spout in relation to the pattern on the background fabric.

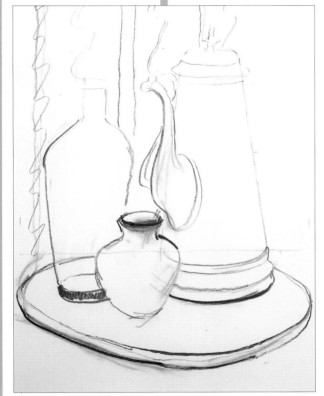

$4$ ▲ All the objects have now been indicated, with the shapes checked against each other as well as against the background.

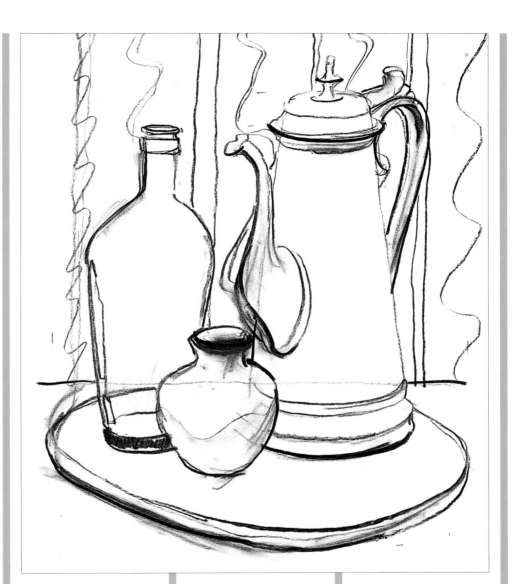

$5$ ▲ When drawing a group of objects, it is helpful to look at the "negative" shapes, that is, the spaces between the objects (see page 56). Here both the negative and positive shapes have been well observed.

**SELF CRITIQUE**
● Is this drawing more accurate than the last one?

● Did you manage to relate the objects to each other as well as to the background?

**further information**

| 56 | Drawing spaces |
| --- | --- |
| 196 | Charcoal and conté crayon |

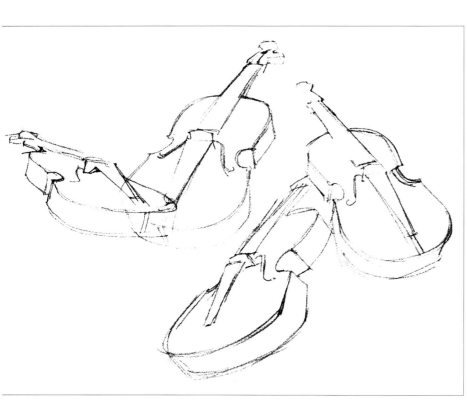

▲ John Houser
*Pencil*
Four different views of a
violin have provided the
artist with an exciting
relationship of subtle
curved shapes. No shading
has been attempted, as this
could have detracted from
the overall effect.

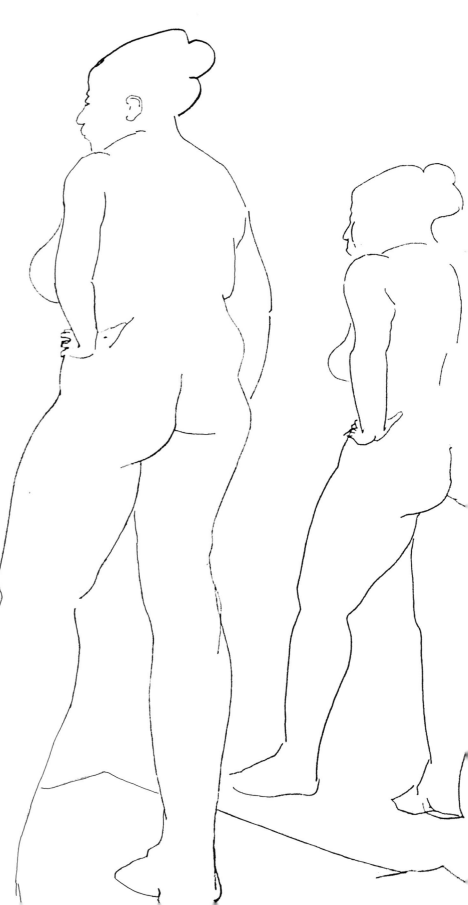

► Olwen Tarrant
*Charcoal pencil*
The artist has used only line
for these drawings, but the
figures still look
convincingly solid because
she has followed the
contours inwards across the
figures. Notice how the
overlapping lines at the
shoulders and down the
back create a sense of
three-dimensional form.

▼ Carole Katchen
*Pen and ink*
As in the drawing of violins, the artist has been primarily interested in the relationship of the shapes, and has arranged them to create an elegant composition. But even so, she has described form by following contours across the figures. Here it is the clothing – the hats, scarves and the hem of a jacket – which provide the visual clues about the three-dimensional forms.

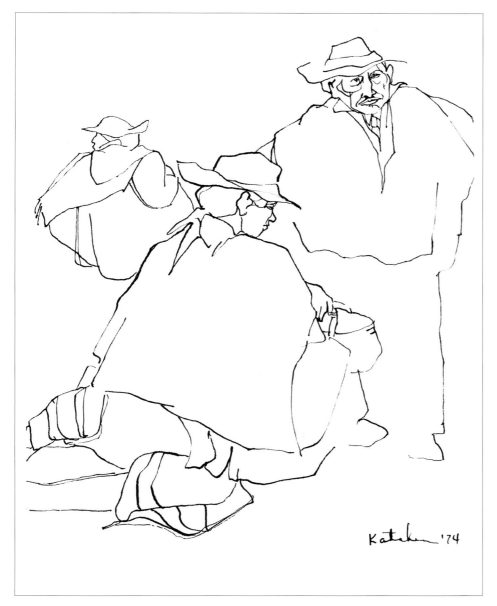

▲ Kay Gallwey
*Pastel*
Here too only line has been used, drawn decisively with the tip of a black pastel stick. It is surprising how much can be conveyed about form by the subtle variations in the weight and direction of the lines used.

# Drawing three dimensions

The drawings you made in the last lesson were concerned only with the outlines of shapes, but the truly magical feature of drawing is its ability to create an illusion of three dimensions – height, width and depth – on the two-dimensional surface of a piece of paper. Here you will be experimenting with shading, one of the basic ways of making objects look solid.

## LIGHT AND FORM

Form is created by the light that falls on an object, so when you want to draw a solid, rounded object like an apple, look first at the way it is illuminated so that you can use shading to describe the light and shade. Look also for any lighting effects which will help you to describe its solidity. For example, if the apple has a stalk and is lit from high on the left, drawing the shadow cast by the stalk will help to describe the dimple on top of the apple. The right side of the apple, which is in shadow, will be darker than the left, but if it is on a light surface you may see a tiny line of light running around this dark edge. This is usually called "reflected light," which bounces back from the table onto the apple. You don't necessarily have to draw reflected light, but it can be useful in describing where the form begins to curve away.

## SHADOWS AND CONTOURS

There may be a dark shadow immediately beneath the apple, but treat this with caution; if you translate it as a very dark mark in your drawing, it will almost certainly destroy the sense of solidity. This is because the mark will emphasize the contour, or the outline of the fruit, which in fact is the furthest part of it from you, where the curvature disappears from sight. To make a rounded form look really solid, you need to put the emphasis on the nearest part of the object. Shadows in drawings do sometimes help to describe the flatness of a table or prevent objects from looking as if they are floating in space, but they are not always helpful, as they often disguise or obscure the objects.

## THE AIMS OF THE PROJECTS
**Describing the forms of objects through light and shade**

---

**Selecting the lighting effects that are most important**

---

**Using different methods of shading**

---

**Drawing rounded shapes and hollows**

●

## WHAT YOU WILL NEED
**Pencils, pens, charcoal and conté crayon. Ink and a brush, palette and water for making washes. Two sheets of A2 paper**

●

## TIME
**Project 1: about 1½ hours. Project 2: 2 hours**

## PROJECT I
### Rounded forms

I want you to make a drawing of a group of fruit, such as two or three apples and one or two pears, or some oranges and lemons. Apples and pears would be best, because you want objects with a fairly smooth surface or you will become distracted by texture, which is not the point of this exercise.

Put the fruit on a table on a plain, light-colored surface such as a piece of white paper. Don't worry about the positions of the fruit as long as you can see them all clearly. The most important thing is the lighting, as it is this that describes the forms. The group needs to be illuminated from one side only, so if you are drawing by daylight, you may have to move your table near a window. If you are working in the evening, you can use a table lamp as your light.

Choose a drawing position that allows you to see the tops of the fruit, and using soft pencil, charcoal or conté crayon, draw them as large as possible, paying careful attention to the way the light falls, and trying to identify the darkest and lightest areas of each of the fruit. Don't draw everything you can see just because it's there; concentrate on drawing only what makes the objects look solid. From time to time look at your drawing critically, and see whether the fruit look three-dimensional. A common mistake is to make the outlines too strong, which destroys the effect of the shading, and another is to make the shadows below the objects too dark.

This is a very important lesson, and you will find it worthwhile to make several drawings of the same objects, changing the direction of the light and experimenting with different media and ways of shading. If you used charcoal in the first drawing, for example, you could try ink wash for another one. Or if you found charcoal too soft and uncontrollable, try pencil, using a hatching and crosshatching method of shading.

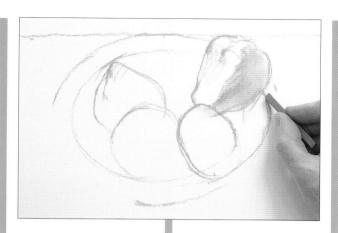

**IAN SIMPSON**

**1 ▲ The shapes of the** fruit and the plate have first been drawn in lightly in line with conté crayon. The artist now starts to use shading to indicate the direction of the light, which is falling from above.

**2 ► The forms of the** fruit are described by identifying the lightest and darkest areas. Note that the artist is developing the whole drawing at the same time, not just concentrating on one object.

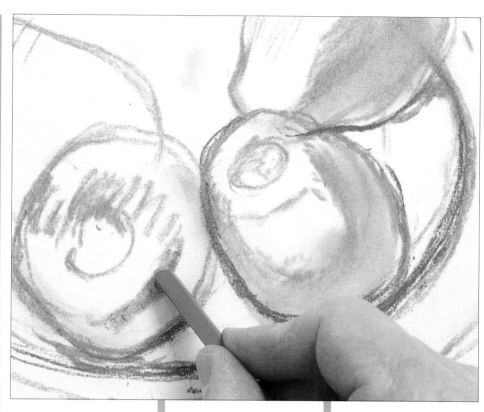

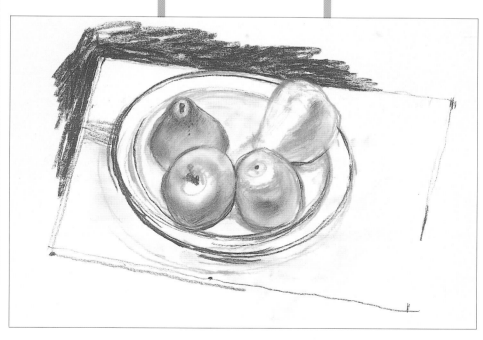

**3 ◄ A darker brown** conté has now been introduced into the background, and to emphasize the nearest parts of the fruit. Although the outlines on the fruit are quite dark, the shading is sufficiently strong to make the objects appear solid. The artist has only drawn what he considered important; shadows cast by the objects, for example, have been ignored.

| **further information** | |
|---|---|
| **12** | Basic drawing materials |
| **196** | Charcoal and conté crayon |
| **180** | Pencil and colored pencil |

**ELIZABETH MOORE**

1 ▶ In this pencil drawing, shadows have been seen from the beginning as important. As well as establishing the shapes of the fruit on the plate, the artist has also related these objects to the near edge and corner of the table and to the cloth under the plate of fruit.

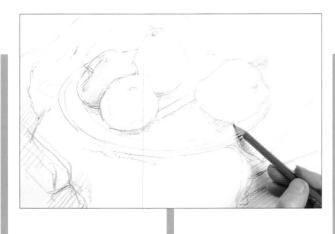

2 ▶ In this drawing the light is coming from the right, and the artist now builds up shading to describe the dark areas of the fruit.

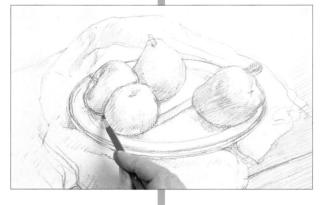

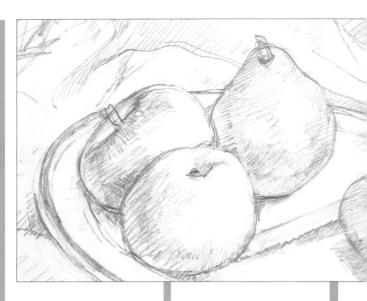

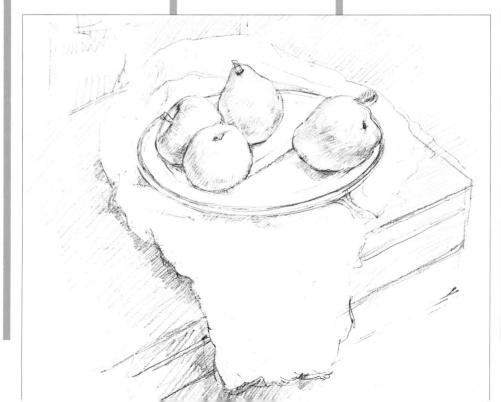

3 ▲ This close-up detail reveals how the artist has carefully described the hollows at the tops of the apples and the subtle undulations on the surface of the pear. The shading is made with freely scribbled lines which give the drawing vitality.

4 ◀ As the artist worked, she became particularly interested in the different kinds of three-dimensional forms in the subject. She has used line and shading to describe the hard, sharp corner of the table, the smooth rounded forms of the fruit and the soft crumpled form of the cloth under the plate.

**SELF CRITIQUE**

● Could the fruit look more solid and three-dimensional?

● Have you concentrated too much on the outline shapes?

● Have you confused matters by drawing in the shadows?

● Would you have been happier using a different drawing medium?

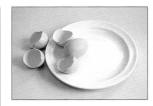

## PROJECT 2
## Convex and concave forms

This project is an extension of the last one, but with a most important extra feature – the problem of drawing hollows. Again you will need a group of smooth-surfaced objects, but they don't have to be fruit. An ideal group of objects could be made from eggs and table-tennis balls. Whatever you choose, at least two of the forms must be convex forms and two concave, so eggs are particularly suitable, as you can break one in half. The two pieces of the shell will provide excellent hollows to draw (and you can cook the contents). Table-tennis balls, similarly, could be cut in half.

If you made several drawings in different media for the previous project, choose the medium you felt happiest with for this one. Place the objects close together so that you can see them all, and put one of the convex forms nearer to you than anything else.

When you start to draw, remember which part of this form is the nearest to you, and be certain that your drawing explains this. Bear in mind anything which went wrong in the last drawing, and do your best to get it right this time. Make frequent stops to check that you are getting the concave and convex forms to emerge appropriately in your drawing.

**ELIZABETH MOORE**

1 ▼ **Pencil has been chosen as a suitable medium for the delicacy of this subject. The contrast between the concave forms on the left and the convex forms on the right is suggested by the shading inside the hollows of the broken eggs.**

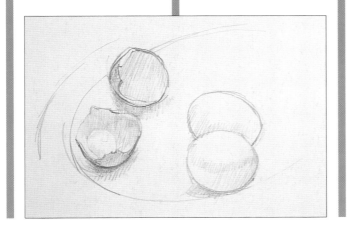

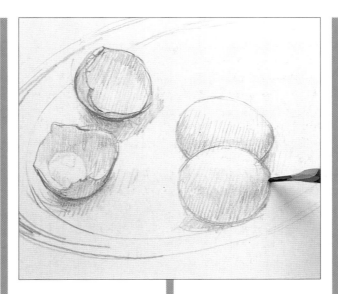

2 ▲ **Notice how the artist has emphasized the jagged edges of the broken shells in order to make them project. She has also used reflected light and the shadows under the broken eggs to enhance the dimensional effect.**

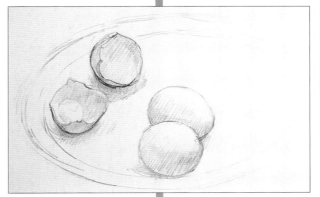

3 ▲ **The light is from the left, but the artist has been less concerned with its direction than with describing the way it illuminates the convex and concave forms.**

**SELF CRITIQUE**
● Compare all the drawings you have made in this lesson.

● Do the objects look more convincing in some than others? Do you know why?

● Have you found cast shadows useful or have they tended to camouflage the objects?

● Have you used wash as well as the other drawing media?

● Have you observed shadows and reflected light well?

▶ Roy Freer
*Charcoal*
In this drawing, **Still Life, Flatford**, charcoal has been used both freely and solidly to give a powerful sense of light and depth. Although the objects in the room are suggested, they are not described in any detail, and have been simplified into almost abstract shapes and forms. The medium has been used in a variety of ways – hatching, free cross-hatching and smudging are all clearly evident, and some of the white shapes have been created by using an eraser as a drawing tool to "lift out" these light areas. (This technique is demonstrated on page 193.) Working on this borderline between description and abstraction is difficult; many people find it impossible to avoid becoming caught up in descriptive detail, which can often dilute the effects of light and pattern that this drawing conveys so well.

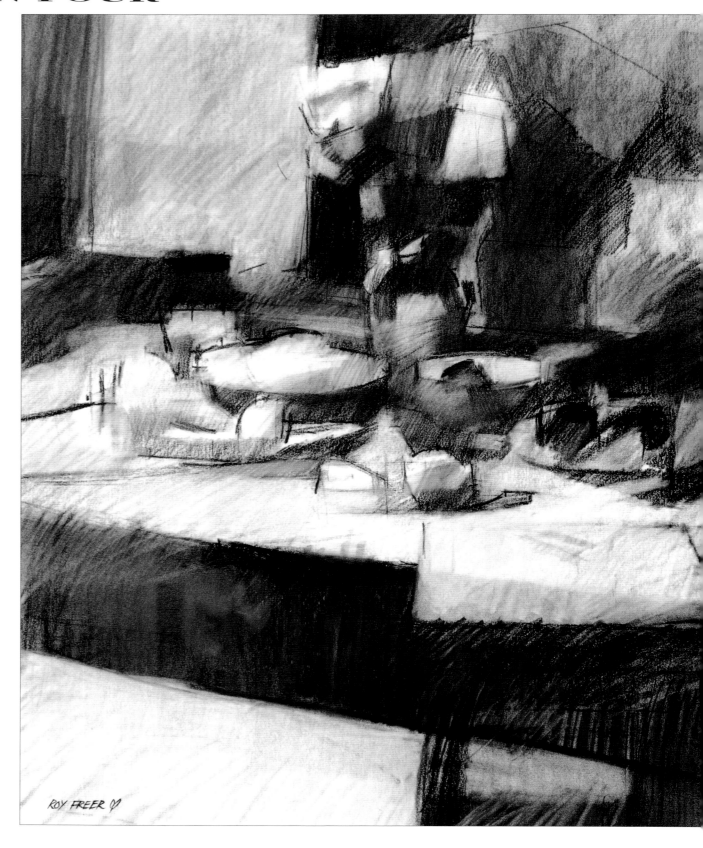

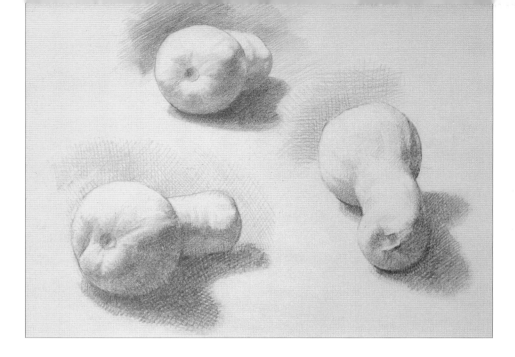

▲ John Houser
*Pencil*
**Squash Studies in Lamplight** was done with an HB pencil, skillfully shaded and blended to describe light, reflected light and shadows.

► Brian Yale
*Charcoal*
In contrast, a very soft pencil has been used here, in a carefully controlled technique of hatching, smudging and blending. The strong pattern of light and dark, and the organization of the subject into simple shapes, makes a powerful drawing, which looks deceptively easy. The impact comes from the way the artist has selected only the important features of the subject; the best way of appreciating the skill needed to make a drawing like this is to try to visualize all the things he has probably left out.

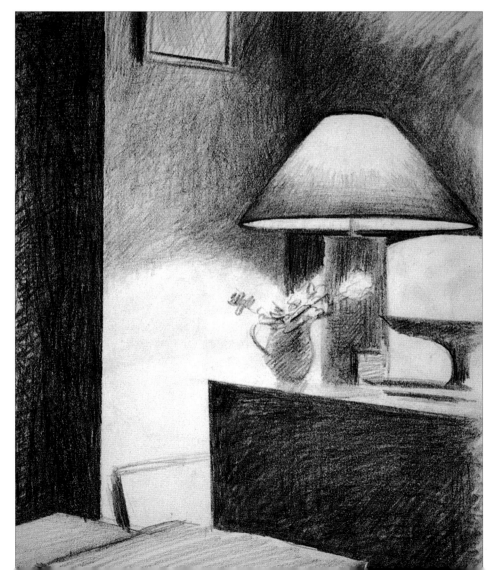

▲ Olwen Tarrant
*Charcoal*
The use of charcoal here is quite different from that in Freer's drawing (opposite page). A certain amount of smudging can be seen, but line predominates, used both as a means of describing the shapes of some of the objects and for hatching and crosshatching to build up areas of tone. This drawing is much more concerned with the character of the individual objects than with lighting effects.

# Color drawing media

It is impossible to mark a clear dividing line between drawing and painting. Traditionally drawing has been seen as a preparatory stage leading to a finished work in another medium, but at least since the late 19th century the distinction between drawing and painting has been blurred. Before then, drawings – generally in monochrome – would be made from life and a painting developed from them.

The Impressionists, however, by painting directly from their subjects, combined drawing and painting in a new and expressive way, and subsequently artists have been free to use color as an integral part of drawing. Drawings are no longer always seen as a means to an end; they can be, of course, but they can also be complete works in themselves.

There are no set rules about which media are exclusively for drawing and which for painting. However, for the purposes of this drawing course, I am not including paints amongst the colored drawing media, which are restricted to pastels, markers, colored inks and colored pencils. You don't need to buy all the drawing media introduced here. It will be a valuable experience to draw with color, but one or two will be sufficient to start with.

## PASTELS

Soft pastels are colored sticks made from powdered pigment (the basis of all paints) held together with the minimum of binding medium. Pastels can produce brilliant color effects and are exciting to use, although practise

▶ **Soft pastels, also known as chalk pastels, are available singly or in boxed sets.**

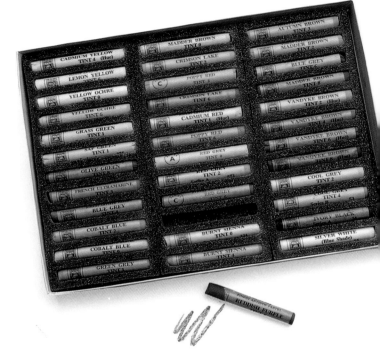

is needed to use them well. Pastels are made with different degrees of hardness, and some are available cased in paper or with a plasticized coating to protect your fingers from the color, which powders and rubs off easily. There are also pastel pencils, which are cleaner to use but lack the versatility of "real" pastels. Pastel sticks can be used on their sides to lay in broad areas of

color, but with pastel pencils you obviously can't do this, and they tend to produce a less sharp line than can be made with the corner of the conventional square-section stick. Pastels have to be fixed in the same way as charcoal.

You can mix pastel colors on the paper by laying one layer of color over another, but they do not mix as thoroughly as paints. Pastel artists usually do the minimum of color mixing, relying on the wide variety of colors prepared by the manufacturers; one manufacturer produces a range of 194 colors. Pastels are available in boxes of assorted colors and also in special subject-related sets, for example 72 colors for landscapes or 72 colors

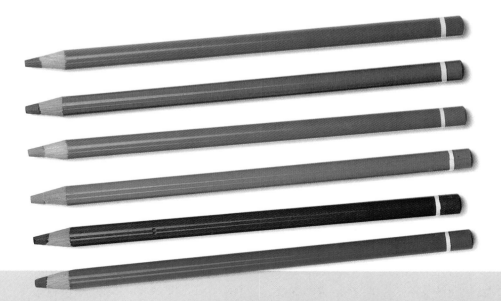

◀ **In terms of softness, pastel pencils come somewhere between soft and hard pastels.**

for portraits. If you wish to experiment with pastels, I recommend that you start with an assorted set of about 24 colors.

▼ Hard pastels can be combined with other media or used on their own.

## MARKERS

Marker pens, under which heading I include felt-tipped pens, are available in a wide variety of colors. They have pointed or wedge-shaped nibs and the colors they contain are either water-based or spirit-based. The spirit-based colors tend to spread – ''bleeding''

beyond the shape drawn by the nib. They also tend to bleed right through the paper, which means they have to be used with care, particularly in sketchbooks, where they can ruin a drawing on the previous page. There are some marker pads made with special paper which largely controls the problems of color bleeding. Another problem with marker colors is that they fade when exposed to light.

Marker ink is transparent, so you can mix colors by laying one color over another. This needs practise, but vigorous, brilliantly colored drawings can be made with markers and felt-tips, and it is well worth trying them. I recommend the water-based markers, and suggest you start with a crimson and a brilliant red, a blue, a yellow, a bright green, and black.

▲ Markers are made with both fine tips (top) and broad, wedge-shaped ones (above). They can be either spirit- or water-based.

| further information | |
|---|---|
| 44 | Drawing with color |
| 50 | Creative uses of color |

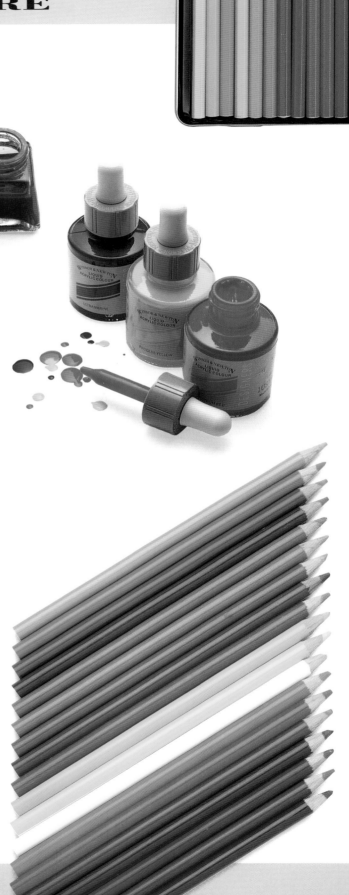

### INKS

Colored inks can be used with pens, brushes or any stick-like instrument. The range of colors is limited, but is sufficient for making colored drawings where a linear approach is required. The best pens to use are dip pens with interchangeable nibs.

Some colored inks (sometimes described as liquid watercolors) are water-soluble, and can be diluted and intermixed or applied as washes if required. Other shellac-based inks (often called drawing inks) can be diluted with distilled water. With waterproof inks, the pens and brushes have to be carefully cleaned after use, or the ink will dry on them and be impossible to remove. Waterproof inks should never be used in any kind of pen which has a reservoir (such as a fountain pen or technical

▲ ▶ Both colored drawing inks (above) and "liquid acrylics" (right) can be mixed with each other and thinned with water.

drawing pen). I suggest you buy shellac-based inks, which have brilliant transparent colors. Two reds (one a crimson) a blue, a yellow, a green, and black would be sufficient to make a start with colored-ink drawings.

### COLORED PENCILS

Colored pencils are probably the color drawing medium with which you will be the

◀ ▶ Colored pencils are made in a very wide color range. They vary in consistency from one make to another.

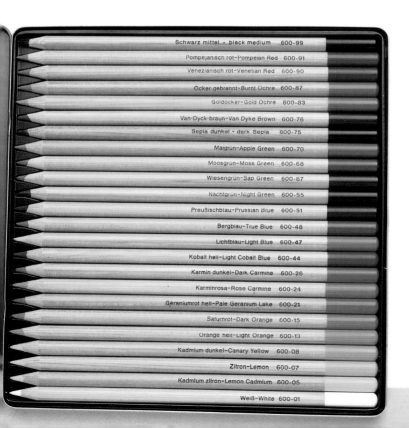

| Schwarz mittel - black medium | 600-99 |
| Pompejanisch rot–Pompeian Red | 600-91 |
| Venezianisch rot–Venetian Red | 600-90 |
| Ocker gebrannt–Burnt Ochre | 600-87 |
| Goldocker–Gold Ochre | 600-83 |
| Van-Dyck-braun–Van Dyke Brown | 600-76 |
| Sepia dunkel - dark Sepia | 600-75 |
| Maigrün–Apple Green | 600-70 |
| Moosgrün–Moss Green | 600-68 |
| Wiesengrün–Sap Green | 600-67 |
| Nachtgrün–Night Green | 600-55 |
| Preußischblau–Prussian Blue | 600-51 |
| Bergblau–True Blue | 600-48 |
| Lichtblau–Light Blue | 600-47 |
| Kobalt hell–Light Cobalt Blue | 600-44 |
| Karmin dunkel–Dark Carmine | 600-26 |
| Karminrosa–Rose Carmine | 600-24 |
| Geraniumrot hell–Pale Geranium Lake | 600-21 |
| Saturnrot–Dark Orange | 600-15 |
| Orange hell–Light Orange | 600-13 |
| Kadmium dunkel–Canary Yellow | 600-08 |
| Zitron–Lemon | 600-07 |
| Kadmium zitron–Lemon Cadmium | 600-05 |
| Weiß–White | 600-01 |

▲ **Water-soluble colored pencils are particularly versatile. They can be used dry or brushed with water to produce washes of color in certain areas of a drawing.**

most familiar. These pencils, which are thin sticks of color encased in wood, vary in softness depending on the type. Some are relatively hard, and can be sharpened so that they will make very incisive lines. Others are softer and more like pastels to use except that they are much more manageable. With colored pencils the colors can be mixed to some extent by laying one over another, but like pastels a wide range of ready-mixed colors is available.

There are also water-soluble colored pencils, sometimes called watercolor pencils, which can be used wet or dry. If you draw on the paper with a dry pencil, you can then wet the area of color with a soft brush dipped in clean water and spread it just like watercolor. You can also dip these colored pencils

in water, and use them directly on the paper if you wish.

If you already have some of the drawing media introduced here, by all means use them, but if you haven't, I suggest that to make a start at drawing in color, you should buy some colored pencils. You will need two reds (one crimson) a blue, a yellow, a green, and black, or you could buy a box of assorted colors.

### OTHER COLOR-DRAWING MEDIA
The media described above are not the only ones which could be used for drawing in color. The other main ones are chalks, which are similar to pastels but

◄ **Oil pastels, like soft pastels and colored pencils, can also be bought in boxes or singly.**

not produced in nearly so wide a range, and oil pastels. Oil pastels are sticks of color similar to soft pastels but bound with oil, and sometimes with the addition of wax, which makes them soft and greasy. Handled well they can produce effects similar to oil paint, and because they do not powder, most people find them easier to control than soft pastels. Compared with "real" pastels, the range of colors available is limited, but their waxy quality makes it easier for colors to be mixed on the paper.

### PAPERS FOR DRAWING IN COLOR
All the media described here can be used on drawing paper. As with all inks, colored drawing inks are best on smooth paper, while pastels and chalks, like charcoal, can exploit the grain of

▲ ► **Colored papers are nearly always used for pastel drawings, and sometimes for colored pencil, but some monochrome drawings can also benefit from a colored background provided it is not too obtrusive.**

rougher papers. There are some papers, such as charcoal and Mi-Teintes paper, made specially for pastel drawing, which have a distinct texture, and are available in a wide range of colors so that paper of a color appropriate to the subject can be chosen. This color can then be incorporated in the drawing, which saves having to cover the whole paper laboriously with pastel shading.

# Drawing with color

**W**ith many subjects the thing that you notice first is the color. You have only to think of a landscape or a seascape, for example, to recognize how important the color is, and it is often this most of all that makes you want to recreate what you see.

From this lesson onward you can use color in the projects if you want to, but if you prefer drawing in monochrome or wish to alternate color and monochrome, by all means do so.

## THE PROPERTIES OF COLOR

Any color has three basic properties – its hue, its tone and its intensity. Hue means the color as identified by its name – red or blue, for example. Tone means the lightness or darkness of a color. You can, for example, have a light blue or a dark blue. In addition to the properties of hue and tone, colors have varying degrees of intensity. Two reds may be identical in tone and yet be clearly different, with one more intense, or brighter, than the other. This difference in intensity is sometimes called color saturation or chroma, but here the phrase "color intensity" will be used.

When you use the word color you are generally referring to these three properties – hue, tone and intensity – simultaneously. However, it is helpful to be able to identify them separately because when you notice that a color is "wrong," you will be better able to pinpoint what is wrong with it – whether it is too light in tone or too intense.

## LOCAL COLOR

The local color of an object is its actual color seen in natural light (or to be absolutely precise, the color it reflects). If you look carefully at any object, however, you will see the local color only in small areas, and sometimes not at all, as it is modified by the light and shadow and by the distance of the object from you. To explain it more simply: any object strongly lit from one side ceases to look as if it is a single color. Although the shadow side and the light side have the same local

48 ▷

48 ▷

---

**THE
AIMS OF THE
PROJECTS
Identifying the tones of
colors**

---

**Trying out your color
drawing media**

---

**Using color to describe
objects**
●
**WHAT YOU WILL
NEED**
For Project 1: sheets of
paper in five different
shades of gray;
scissors, glue.
For Project 2: your
color drawing medium;
colored or white paper
●
**TIME**
Project 1: about
2½ hours.
Project 2: about 2
hours

---

## PROJECT 1
### "Drawing" with colored paper

As an introduction to working in color, I want you to begin by translating color into tone. You won't be drawing in the usual way, though. Instead of building up tones as you work, you will be using dark, gray and white pieces of paper, which are then cut or torn in small pieces, and stuck down on your working surface.

You can either use bought papers, in a range of not more than five colors, or make your own by rubbing tracing paper with a pencil. If you choose the former, try to get one black or very dark gray, one white and two different mid-grays. Work on off-white paper, which will provide the fifth tone.

When you do a "normal" monochrome drawing, the number of tones you can use is wide, extending to possibly ten or more. When you are restricted to a certain number you have to look closely at your subject and work out which tones are the most important.

This method also compels you to concentrate on shapes, and thus has a strong element of design which can teach you much about the process of picturemaking.

### Making the drawing

You can draw any objects you like for this project, but you will need a group that provides you with strong tonal contrasts. A few

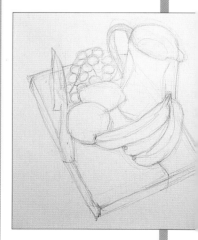

**KAREN RANEY**

**1** ▲ **The main shapes
of the still-life group
have been drawn in
pencil to act as a guide
for the placing of the
pieces of paper.**

fruits such as oranges, lemons and grapes, or vegetables such as bell peppers, onions and carrots will give you interesting shapes as well as splashes of color. Or you could set up two or three bottles and jars in different colors, perhaps using a patterned background. Don't choose anything too elaborate, as drawing with torn paper is a slow process.

Start by making an outline drawing in pencil to act as a guideline for the paper shapes. Then identify the most dominant shape and tone in the group, and match this as closely as you can to one of your papers. If the group includes an eggplant, for example, you could begin by cutting one large piece of black or dark gray paper. Once you have the darkest tone in place, you will have a key for the rest of the drawing. Find the lightest area of tone next, and put some white pieces of paper in place, then start to build up the middle tones gradually until you have described each object.

When you have finished, keep the drawing nearby so that you can refer to it when you work on thẽ next project, and leave the group in place, as you will be drawing it again.

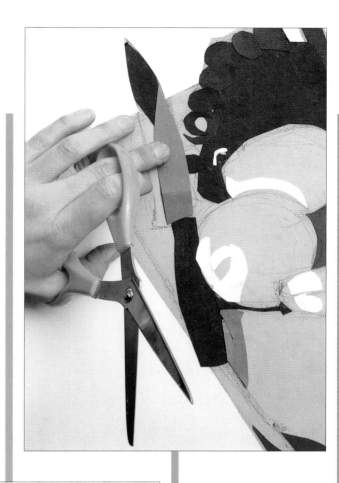

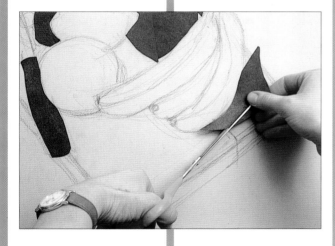

2 ▲ The darkest shapes are being identified and appropriate shapes cut out and stuck down. If any shapes or tones look wrong later on, they can easily be corrected by pasting further pieces on top.

3 ▶ The main pattern of dark tones has now been established, and the "drawing" begins to take shape.

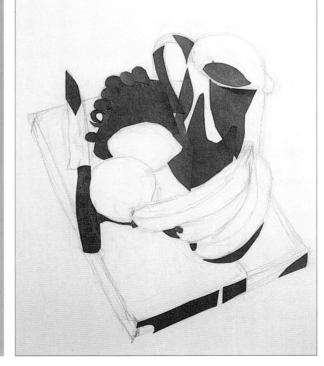

4 ▲ Now the lightest tones, the highlights on the fruit, have been pasted over the mid-gray paper which stands as a middle tone, and the artist adds a dark gray for the knife.  ▷

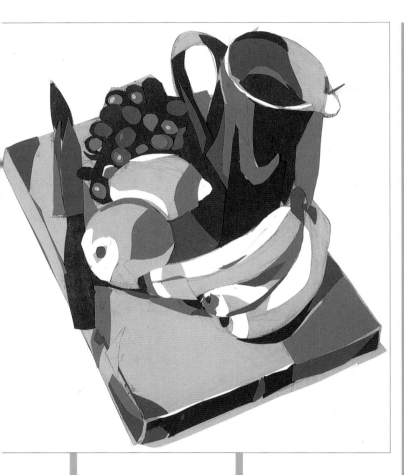

**PROJECT 2**
**Descriptive color**
You can use any color drawing medium you like for this project, but before you start, experiment with your chosen medium on a spare sheet of paper so that you know how to mix colors, and have an idea of the range of colors you have available. If you have only the basic colors listed in the Information Feature on pages 40-43, you will have to simplify the colors you see.

You don't have to draw the same group as you did in the previous project, but you will learn more if you do. It will also be easier, as you will have already spent some time analyzing the colors and tones.

How you begin depends on the medium you are using. For pastel, you can start by making a drawing of the main shapes in charcoal, or you can use one of the pastel sticks for the drawing. If you are working in colored pencils, use a light neutral color for the drawing. For inks or markers, make a light drawing in pencil first, but keep it simple, as the inks are transparent and may not cover the pencil lines.

Now start to use color to describe the objects, bearing in mind what you discovered about tone in the previous project, but this time considering hue and color intensity as well. Keep your drawing simple, without too much detail, and translate the

color as accurately as possible, relying on what you actually see, not on what you think is there. Remember everything has a color if you look for it. Shadows, for instance, are not merely gray or black. As you look for color don't forget to see tone. Keep asking yourself what color it is; how dark it is; how intense it is. Unless there is an area that you want to leave white, cover all the paper with color. If you are using pastels, you may need to fix your drawing between stages as well as at the end.

5 ▲ Having to define and translate tones in this way often produces a clear, powerful drawing, as in this case. Cut-paper drawing, or collage, is exciting to do as well as being a useful preparation for color work. If you have enjoyed this project, you may find you want to experiment further with collage. There is more about the technique on page 214.

**SELF CRITIQUE**
● Have you managed to give an idea of the colors?

● Have you conveyed the light and shade?

● Does the drawing look realistic?

● Did you find charcoal hard to manage?

**KAREN RANEY**
1 ◀ The artist is now drawing the same group in color, using oil pastels, having first established the main shapes with charcoal.

**4** ▶ The colors are built up by laying one layer of pastel over another. Notice how cool greens and grays have been introduced into the bananas, in contrast to the warm, rich colors of the orange.

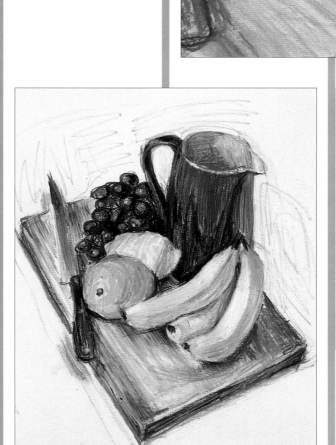

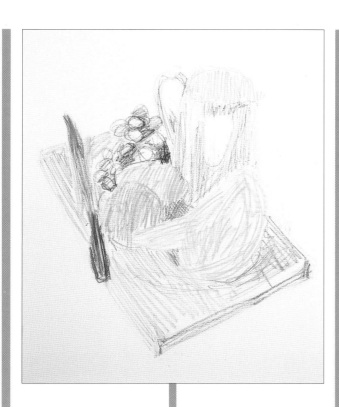

**2** ▲ With this medium the color has to be built up gradually, and as a first step the artist is identifying the main local colors in the subject.

**3** ◀ Careful attention must be paid not just to identifying the color of an object but also its tone. The pitcher is not simply blue, as opposed to the yellows of the foreground fruit; it is also much darker in tone.

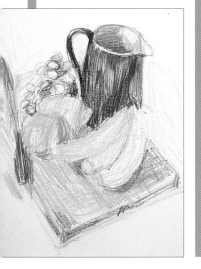

**SELF CRITIQUE**
● Has your drawing managed to translate the color you saw?

● If not, can you identify the faults?

● Could you improve it if you had a wider range of colors?

● Did you find it difficult to mix the colors you could see in the still life?

**5** ▲ The drawing is now complete, with the colors further developed and the tonal contrasts preserved.

**further information**

| 50 | Warm and cool colors |
|---|---|
| 214 | Collage |

color, they look completely different. And if you take two pieces of identically colored paper or fabric, and place one close to you, and the other on the opposite side of the room, you will also find they look different; more distant will be less intense in color.

One of the problems facing you when you begin to deal with color is to make the colors you see consistent with the local color. Most inexperienced artists try to imitate the actual color; they know a lemon, for instance, is yellow, so they ignore the fact that parts of it may be green or brown. Others exaggerate the colors they see, losing sight of the yellowness altogether.

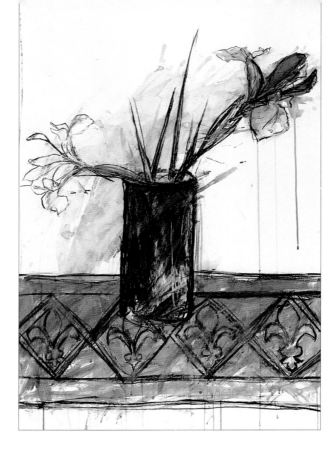

◀ Barbara Walton
*Mixed media*
In **Two Irises on a Red Strip** the artist has used mainly charcoal, pastel and acrylic to produce a lively depiction of the flowers silhouetted against a light background. Color has been used very selectively. The yellow of the iris is only suggested; its color is of less importance than that of the purple iris and the subdued red tablecloth, which give the drawing its two main color areas.

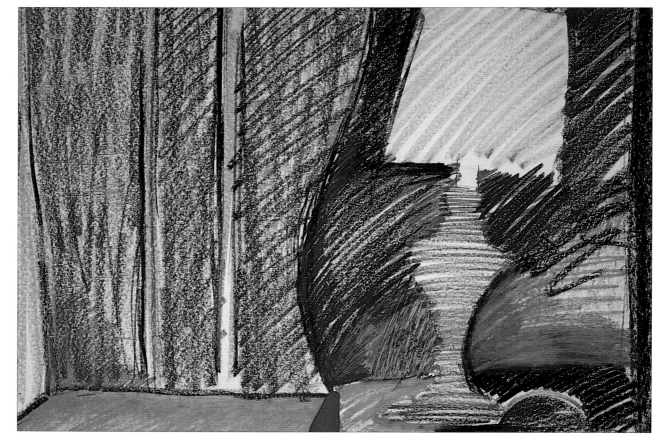

▶ Paul Powis
*Colored pencil*
The still-life group has been translated into basic shapes, and the color applied with vigorous pencil hatching. The bold strokes made in different directions give vitality to a drawing with a very simple structure.

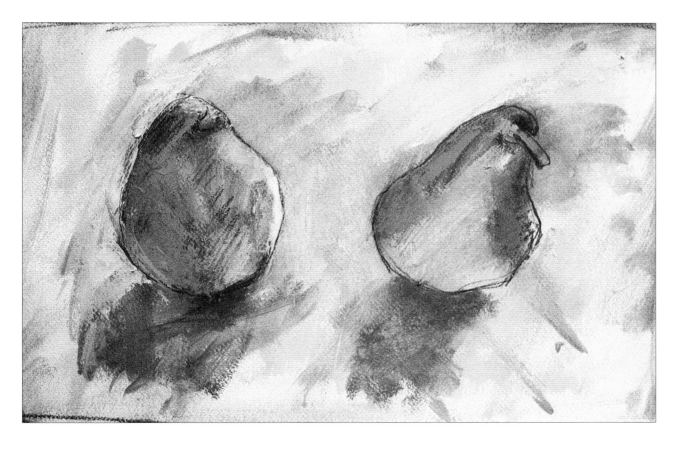

◀ Barbara Walton
*Mixed media*
Drawn mainly in charcoal with acrylic on textured paper, **Two Pears** is a very "painterly" drawing, full of light and a sense of movement created by the bold, free technique.

▶ Brian Yale
*Mixed media*
In this lively and atmospheric drawing of a fisherman's hut, the artist has combined ink, pencil, colored pencil and pen. Tone has been carefully observed, with the hut a dramatic dark shape against the sea and the latter light at the shore but darkening toward the horizon. The tonal contrasts give the drawing both drama and a powerful sense of three-dimensional space.

| further information | | |
|---|---|---|
| **50** | Creative uses of color | |
| **73** | Aerial perspective | |
| **122** | Expressive drawing | |
| **210** | Mixed media techniques | |

# Creative uses of color

In the last lesson you used color to provide your drawing with an additional descriptive element, but color has other uses. You are now going to explore two of these – how color can be used in drawing to enhance the illusion of three-dimensional space and how it can be used to express emotions.

## COLOR CONTRASTS

Different color effects are produced by the way that colors contrast with each other. Colors are often arranged around a circle, called a color wheel, starting with red and proceeding in steps through orange, yellow, green and blue to violet. The greatest contrasts are between colors opposite each other on this circle, for example red and green. These colors, called complementary colors, provide the maximum excitement for each other, and can set up definite discords. Colors which are harmonious are those next to each other on the color circle, for example, yellow and orange, blue and mauve.

## WARM AND COOL COLORS

There is also another very important kind of color contrast, which is of the greatest importance in creating an illusion of three-dimensional space in drawing and painting. This is sometimes referred to as "color temperature." Colors which are reddish in hue are described as "warm," while "cool" colors are those which tend toward blue. Generally, warm colors appear to advance to the foreground of a drawing and cool colors recede into the background. This can't be taken as a firm rule; if you have an intense blue in the foreground and a muted red in the background, for example, the intensity will compensate for the tendency of blue to recede.

## COLOR AND THE EMOTIONS

Color can also be used to convey a mood. The associations that colors have are apparent from our

55 ▷

**THE AIMS OF THE PROJECTS**
**Making color recede**
———
**Contrasting warm and cool colors**
———
**Learning to express yourself through color**
———
**Gaining experience of color media**
•
**WHAT YOU WILL NEED**
**Your chosen color-drawing medium, paper. If you are using pastel, this would be an opportunity to try a colored paper. Choose an unobtrusive mid-tone for your first attempt**
•
**TIME**
**Project 1: about 2 hours. Project 2: 5–8 hours**

**PROJECT 1**
**Creating space**
You can draw the same kinds of objects you have been drawing up till now, but you will need some bright, warm colors such as reds, oranges and yellows. The difference between this project and the previous ones is that you need to have more depth in your drawing, so position your group of objects so that you can see well beyond them across the room, or through an open door.

**Making your drawing**
This time, don't draw in charcoal or pencil; start in color from the very beginning of your drawing. Use an unobtrusive color (pale blue, for example) to draw the main shapes rapidly, but as soon as possible try to establish the main colors in your drawing. The aim in this drawing is to identify warm and cool colors,

and by emphasizing these color qualities create a feeling of depth.

Something you will probably begin to notice is that the colors of shadows tend to be cooler than the light-struck areas of an object, and using blues or greens in the shadows will help you make them look solid. You will also see that the colors in the background are cooler and less intense than those in the foreground, and if necessary you can exaggerate this. The exercise may sound complicated, but experienced artists use warm/cool contrasts automatically, and once you have learned to identify the colors, you won't find it difficult.

**ELIZABETH MOORE**

**1** ◀ The main shapes of the group have been drawn in line, using gray pastel reinforced in places with blue, which the artist has already identified as a color that will be important in the drawing.

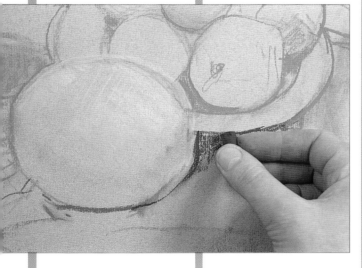

**2** ▲ Patches of yellow have now been introduced to help the artist assess the depth of color needed for the blue cloth. This is now slightly intensified.

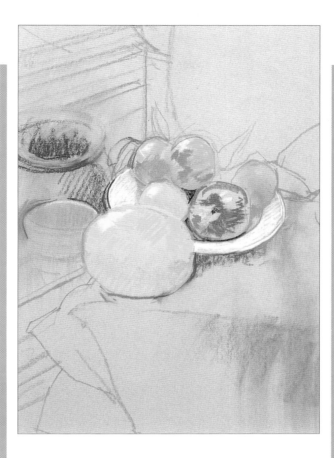

**3** ◀ The drawing of the group is now well established, with all the objects clearly defined and the main colors blocked in. The cool gray of the paper has been left uncovered in the background.

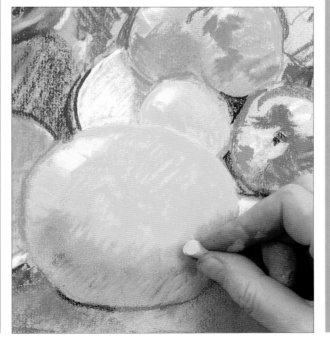

**4** ◀ The artist builds up the color of the grapefruit, the largest foreground object, to give it a greater sense of three-dimensional form. The colors of the other fruit are assessed against the brilliant yellow and blue in the immediate foreground.

**further information**

| 44 | Drawing with color |
|----|--------------------|
| 188 | Pastel and oil pastel |

5 ▼ All the objects are gradually developed into a more complete statement. Here the artist is rubbing pastel with a finger to create an area of soft color.

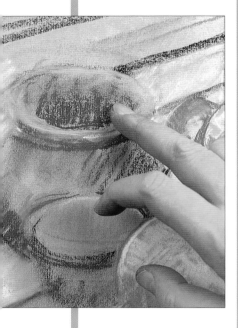

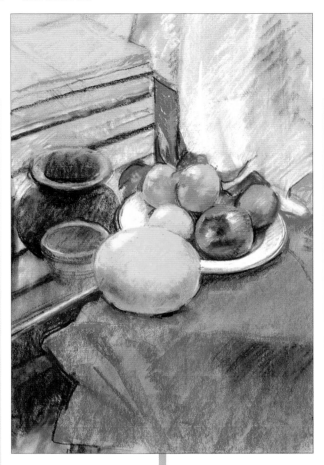

6 ▲ The finished drawing has a good feeling of depth, partly because the objects look convincingly solid and three-dimensional, and partly because the background colors are cooler than those in the foreground. Blue can be a "recessive" color, but in this case its vividness is accentuated by the striking contrast with the yellow.

**SELF CRITIQUE**

● Has your drawing a feeling of depth?

● If so, do you think that this is mainly because of your use of color?

● Or is it because you have drawn the relative sizes of the objects accurately?

● Did you find it easy to assess whether a color was warm or cool?

● Are you finding that more practise with color is improving your ability to match the colors you see?

**PROJECT 2**
**Color and mood**
In this project I want you to make a drawing of a group of objects which have particular associations for you, and to try to use color to create an appropriate mood for your drawing. In the earlier projects, the choice of objects you drew was not very important, but objects in drawings and paintings can have great significance.

Since the mid-17th century, drawings and paintings of objects, usually known as still lifes, have been an important branch of art, and the objects in them have often been selected very carefully. The early still lifes, for example, included such things as hourglasses, skulls, flowers and partly burned candles, intended to express the eventual triumph of death over life. In more modern times, artists often choose objects which have a more personal significance, such as books, possessions, or even the remains of a meal.

**Choosing a group**
I want you to think of objects which have some meaning for you and to assemble a group which has personal significance. It might symbolize your childhood, a particular phase in your life, or that of someone close to you. The objects might be from a place which has powerful memories for you, or they could be things that belonged to someone you were fond of, perhaps parents or grandparents, or a child now grown up.

You don't have to use conventional still-life objects. Your group could include a chair, an article of clothing, some jewelry or a favorite toy. Assemble them in a way which you think will enhance their meaning, and try to arrange the lighting so that it helps the atmosphere you are trying to create. Finally, before you start to draw, look at the overall color. Do you see a single main color or several competing ones?

**Planning the drawing**
Start by making two or three quick small studies of the group in color, each taking about five minutes. Try through your choice of color to find different ways of creating an appropriate mood in your drawing. If you want a happy effect, for example, you won't want to emphasize dark,

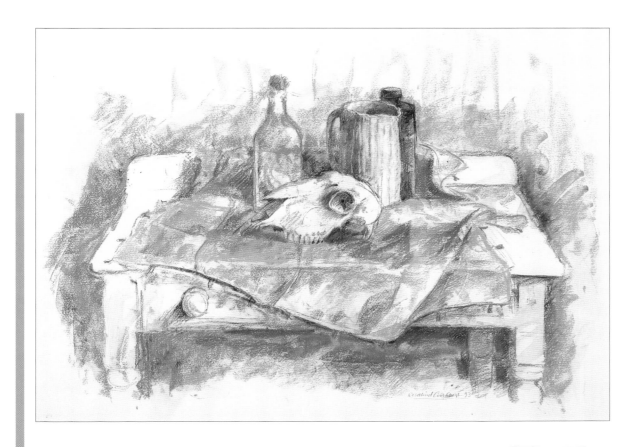

heavy colors. Let the objects and your feelings toward them suggest a color scheme, and when you start the drawing, don't try to reproduce each color in the group exactly as they are. Instead be faithful to your color idea, and translate what you see, thinking always in terms of the drawing itself.

## SELF CRITIQUE

● Did you find expressing feelings rather than dealing with visual fact too intangible?

● Did you find that you had to rethink what you had learned about color earlier?

● Did you think that this is a way of working you would like to try again?

● What do you feel are the main lessons to be learned from this project?

**ROSALIND CUTHBERT**
▲ A skull in a still-life drawing or painting usually denotes that it is of the *vanitas* type, a reminder of the fleeting quality of life. In this pastel drawing the artist has ignored the actual colors of most of the objects and given the drawing a wistful, slightly melancholy color scheme in keeping with the theme.

**JANE STROTHER**
► In contrast, this visual reminiscence of a holiday has a bright, carefree look, due as much to the choice of colors as to the objects.

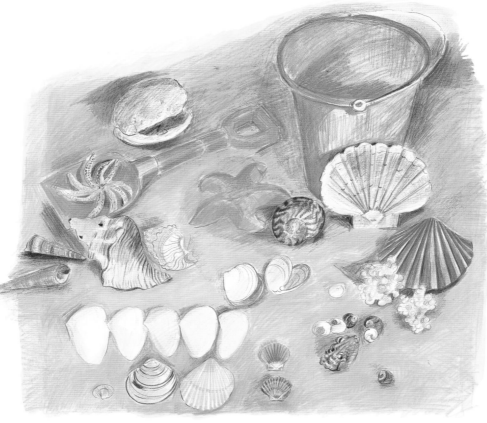

▶ Stephen Crowther
*Charcoal and pastel*
In **Evening in Venice** the mood is set by the setting sun and delicate colors of the sky reflected in the water. The color of the sun is repeated on the facades of some of the buildings, and on the lamps near the bridge. Notice how the touches of bright color on the small figures make the scene look cheerful and busy.

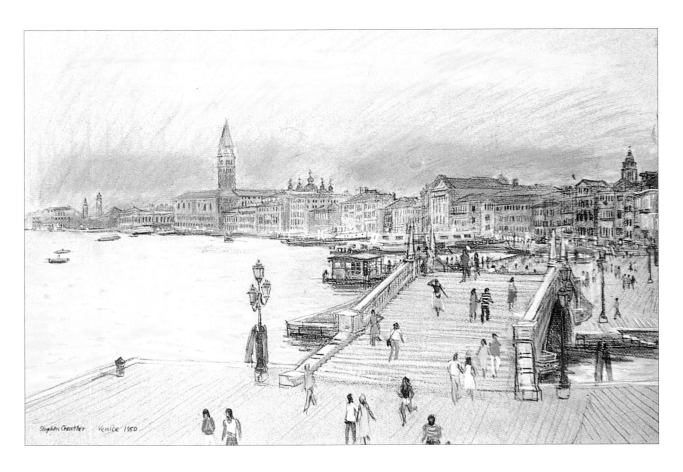

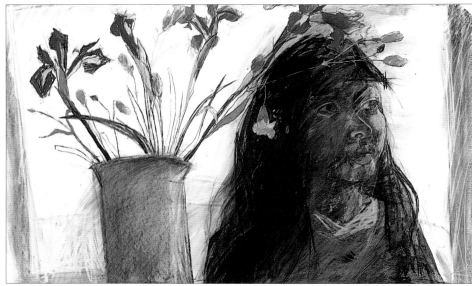

◀ Barbara Walton
*Mixed media*
Mainly charcoal and pastel have been used for this unusual portrait, **Shino with Flowers**. The head has been drawn in monochrome, with the emphasis on the way the light strikes the features. Bright color has been imaginatively saved for the flowers, which provide vivid contrasting accents.

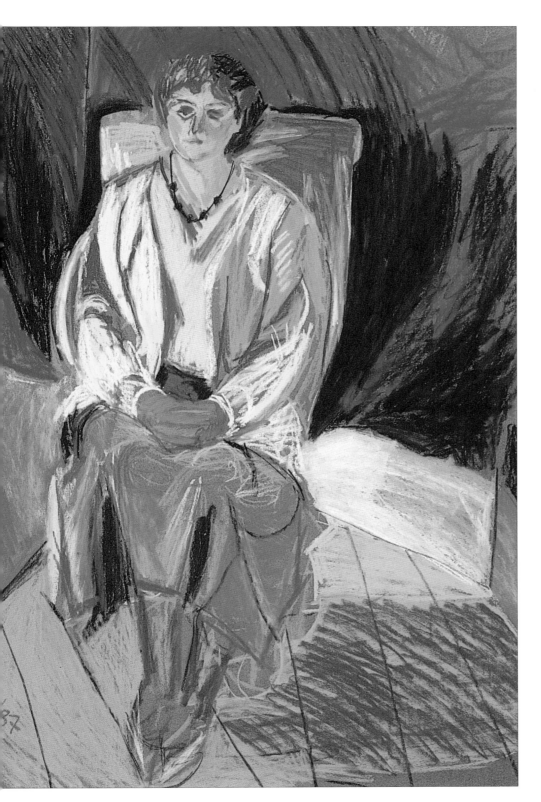

everyday speech – we talk about "seeing red" and "feeling blue." Such phrases are not reliable guides to the emotional properties of colors: red, although certainly an assertive color, is not necessarily an angry one, and blue is now widely believed to have a calming effect rather than a depressing one. However, the way colors are used and juxtaposed in a drawing can be very expressive. Dark, heavy colors create a somber mood, while light, bright ones give a carefree impression, and violently clashing colors can give a feeling of restlessness or unease. In the second project in this lesson you will be exploring the expressive use of color, while the first one is concerned with using warm and cool colors to create space.

◀ David Cuthbert
*Pastel*
In his portrait of **Denise** the artist has used color in a free and non-literal way, with the blue and yellow swirls of the girl's arms echoed by the darker blue and black shapes behind the figure. Clever use has been made of the blue-gray paper, which has been allowed to show through the pastel in places, providing a unifying element. The use of color and the vigorous application of the pastel gives the still, posed figure a feeling of life and energy.

# Further ways of looking

Except in the last lesson, in which you experimented with expressing yourself through color, I have throughout the course asked you to look carefully, compare one thing with another and to draw what you see. This appears to be quite straightforward and not too difficult, but you may by now be feeling that it isn't as easy as it sounds.

### EYE AND BRAIN

The problem is that seeing is much more complicated than it seems. Although our eyes in some ways operate like a camera, receiving small images, they don't translate objects into pictures as a camera does. They work in conjunction with the brain, sending it coded information in the form of tiny electrical impulses. This information is arranged in such a way that to the brain it represents the objects, acting as a substitute just as a word is a substitute for an object.

The brain is extremely adept at decoding the information it receives, and telling us about the visual world, but it is not infallible and can be deluded into coming to the wrong conclusion. Significantly, however, and this is most important from the point of view of drawing, the brain is always trying to make objects from the information it receives from the eyes, and it needs little stimulus to produce them. In drawing you have to make marks on your paper which simulate the effects the visual world has on your eyes. Sometimes a few lines are enough to create an object, and even a single horizontal line across a piece of paper will be seen by most people as the horizon line of a landscape.

### CONDITIONING

Even more important is the fact that your brain sometimes edits what you see. It realizes certain expectations for you and it becomes conditioned to seeing in certain ways. It is this that makes seeing so difficult. Just as a child makes important objects

61 ▷

**THE
AIMS OF THE
PROJECTS**
**Freeing your eyes from
preconceived ideas**

**Looking at spaces**

**Drawing from unusual
viewpoints**
•
**WHAT YOU WILL
NEED**
**Charcoal or conté
crayon, or ink, white
paint and a brush. A2
paper**
•
**TIME**
**Each project will take
about 3 hours**

### PROJECT I
#### Negative shapes
In Lesson Four you were asked to check the shape of an object against the background, but this time you are going to check the shapes and sizes of objects by looking at the spaces between them. Indeed you are not going to draw the objects at all. The reason for this is simple: you may have preconceived ideas of what the objects look like, but you won't have any preconceptions about the spaces between them, so you'll be coming quite fresh to the subject. These spaces between the "positive shapes" of the objects are often called "negative shapes," and I want you to concentrate solely on these and see what results.

#### Arranging a group
As you aren't actually drawing the objects in drawing the objects in this project, in a sense it doesn't matter what they are. It is best, however, to choose things with interesting and complicated silhouette shapes, so you can get away from the boxes and bottles which have featured strongly in the projects so far. Try to have a minimum of six different objects, and if they are mainly flat ones like kitchen utensils and plates, place them below your eye level so that you can see the shapes and spaces clearly. If you choose tall objects, have them higher so that they are silhouetted against a wall. Arrange them so that the negative spaces are all different shapes and sizes.

#### Drawing spaces
It is easiest to check that shapes are correct if you fill them in rather than drawing in line, so start by drawing the negative shapes quickly in line and then, using charcoal or a single color of ink, block them in as areas. When you do this, don't just fill in between the lines you have drawn, but look carefully, and keep checking to see if the shape looks right. Remember to relate one shape to another, and to

use anything in the background to help you to get directions and shapes as accurate as you can. You will almost certainly have to draw and redraw the negative shapes several times before they look right, so if you are drawing with ink and a brush, use white paint to make corrections as you work.

You may find it hard at first to ignore the objects, but, as you draw, they will begin to emerge like ghostly cutouts. Leave them as a single abstract pattern, and resist the temptation to develop them as recognizable objects.

**KAREN RANEY**

**1** ▲ The shapes between and around the objects – the negative shapes – have been drawn in line with charcoal. The artist has successfully ignored the objects themselves.

**2** ▲ The negative shapes are now blocked in, and the shapes checked and where necessary

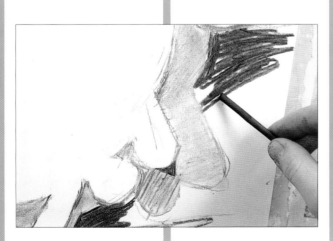

modified. This photograph shows the artist drawing the shapes of the cast shadows.

**3** ► After checking again for accuracy, the negative shapes are shaded darker and drawn more precisely. Although the objects are beginning to assume a definite identity, the drawing concentrates on the abstract pattern made by the positive and negative shapes. The shadows could have been disregarded as well as the objects and an even simpler drawing produced.

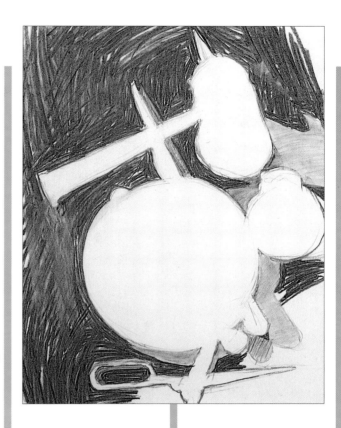

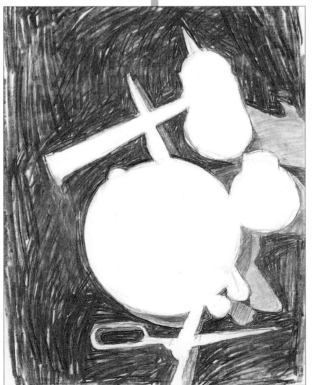

**4** ◄ In the final drawing, the most obviously recognizable object is the pair of scissors. When something has a shape which is both distinctive and familiar, it needs very little information to describe it.

| **further information** | |
|---|---|
| 22 | Different ways of looking |
| 28 | Drawing two dimensions |
| 196 | Charcoal and conté crayon |

**KAY GALLWEY**

1 ▲ The shapes of the objects have been drawn in line in red conté crayon, and a start has been made on shading the negative shapes.

2 ▼ The negative shapes are now developed by rubbing the conté to produce areas of tone.

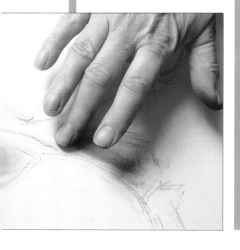

3 ▲ The objects are now beginning to appear in the drawing – as silhouettes. Notice that the artist hasn't managed to ignore the objects completely – in order to get the back curve of the ellipses right the top of the cup and pitcher have been drawn in carefully (see step 1).

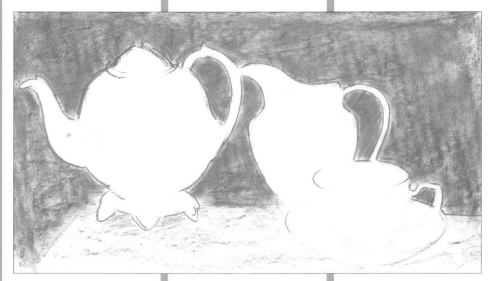

**SELF CRITIQUE**

● Did you manage to stick to drawing only the negative shapes?

● Are the positive shapes (the objects) in your drawing accurate?

● Did you find this method of drawing helpful?

● Did you find it easier than drawing the objects themselves?

4 ▲ As a final touch, the artist decided to introduce a second tone for the table top, but the drawing would have been equally effective if it had been restricted to white with a single dark tone.

**PROJECT 2**
**Objects upside down**
Another way of banishing our preconceived ideas about an object is to place it in an unfamiliar situation. In art schools elaborate groups are sometimes constructed to present familiar objects in unusual ways. This is a very valuable drawing experience, and worth trying for yourself, but you can achieve the same result simply by turning an object upside down. It may surprise you to be told that this makes it easier to see it clearly, but you can prove it to yourself. Take any drawing in this book and spend a few minutes trying to copy it, first the right way up and then upside down. Almost certainly your second drawing will be more accurate, because once the drawing is upside down you forget what the objects in it are, and concentrate on the abstract shapes.

**The drawing**
Choose an object such as a stool, a chair or an ironing board, or something much smaller like a plate rack, and turn it upside down on the floor or on a table. The object needs to be something which is fairly complicated but with a

construction which is easy to identify. Make a drawing in line, color or line and tone as you wish. This time draw the object itself but don't forget the importance of the negative shapes, as they are a very useful drawing aid. As you draw, from time to time turn your drawing upside down (right way up) and see how it looks, but resist the temptation to continue drawing it the correct way up. When you have finished, place the drawing upside down (right way up) for viewing.

**2** ▲ **A darker marker is now used to shade in the background and re-state and strengthen some of the lines describing the chair.**

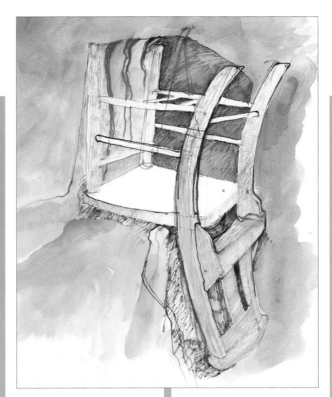

**3** ▼ **The crimson stripes have been reinforced and a wetted brush used to spread the marker ink into a wash for the background area.**

**4** ▲ **It is easier to concentrate on the abstract qualities of an object when it is seen in an unfamiliar context or upside down, as in this case.**

**IAN SIMPSON**
**1** ▲ **The drawing has been begun in line, drawn with a colored water-soluble marker. This particular color was chosen because it will later be used to describe the color of the**

chair. Attention is paid both to the negative shapes and the abstract pattern of the chair.

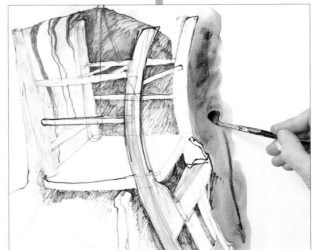

**SELF CRITIQUE**
● Does the object look convincing?

● Did you find it easier to draw the object upside down?
    Or did you find that you had constantly to turn your board?

● Did you find it easier to produce an accurate drawing in this way?

| further information | |
|---|---|
| 41 | Markers |
| 170 | Abstraction through drawing |
| 196 | Charcoal and conté crayon |

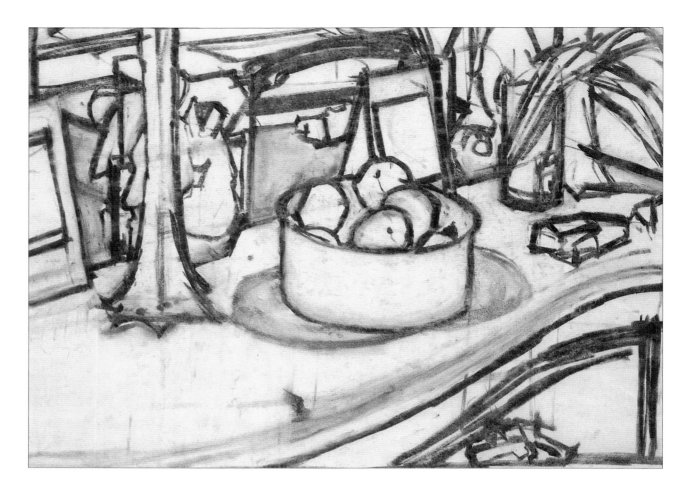

► Christopher
Chamberlain
*Charcoal*
Negative shapes play an
important part in this
drawing, and both these
and the positive shapes of
the objects have been
drawn and re-drawn in line.
There is less concern with
the identity of the objects
than with shape and
pattern, and this has
resulted in a powerful
drawing with strong
abstract qualities.

◄ David Cuthbert
*Colored pencil*
**Stoneware** is a more
descriptive drawing, but the
emphasis is still on the
pattern the objects make.
Color has been used
selectively to describe the
objects, but the total effect
is of an elaborate abstract
design.

▼ John Townend
*Black, brown and white
conté crayon*
In this bold but accurate
drawing, negative shapes
don't play an important
part, but were used as a
check in the early stages of
the work. It is much easier
to draw a complex subject
like this if you look
carefully at the shapes and
relative sizes of the spaces
between chair legs, struts
and so on.

## tip

**A REMINDER ABOUT YOUR SKETCHBOOK**

I have already stressed the importance of keeping a sketchbook, and I hope that you have managed to draw in it frequently. It would be useful to extend the projects in this lesson by, for example, making drawings of negative shapes from a wide variety of subjects in your sketchbook. You can then check how different subjects were revealed by this approach to drawing.

Similarly, you could explore in greater detail how you see things more clearly when they are in unfamiliar surroundings.

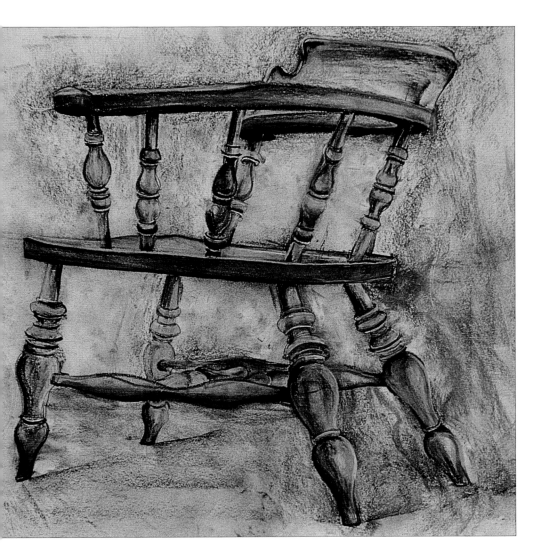

large in its picture, so we are unable to see the relative sizes of objects because we have preconceived ideas about them. If you look at your face in a mirror you cannot fail to recognize the image, and because you know the actual size of your head you read the mirror image as the same size. But this is far from the truth; if you mark the top of your head and your chin on the mirror, you will make the surprising discovery that the mirror image is very much smaller than you are. This gives new meaning to the phrase about being unable to "believe our eyes."

This ability of the brain to jump to conclusions is partly caused by our education, which is primarily verbal. From childhood onward we name things, and learn to see them in terms of words. When you see a chair, your brain in effect says, "That's a chair. You know what chairs are like." So you don't draw what you see, you draw a symbol for the chair, which may come from childhood. How then can you subjugate your brain so that you see an object as it actually is? The two projects in this lesson demonstrate two ways of seeing objects afresh.

| further information | |
|---|---|
| **170** | Abstraction through drawing |
| **180** | Pencil and colored pencil |
| **196** | Charcoal and conté crayon |

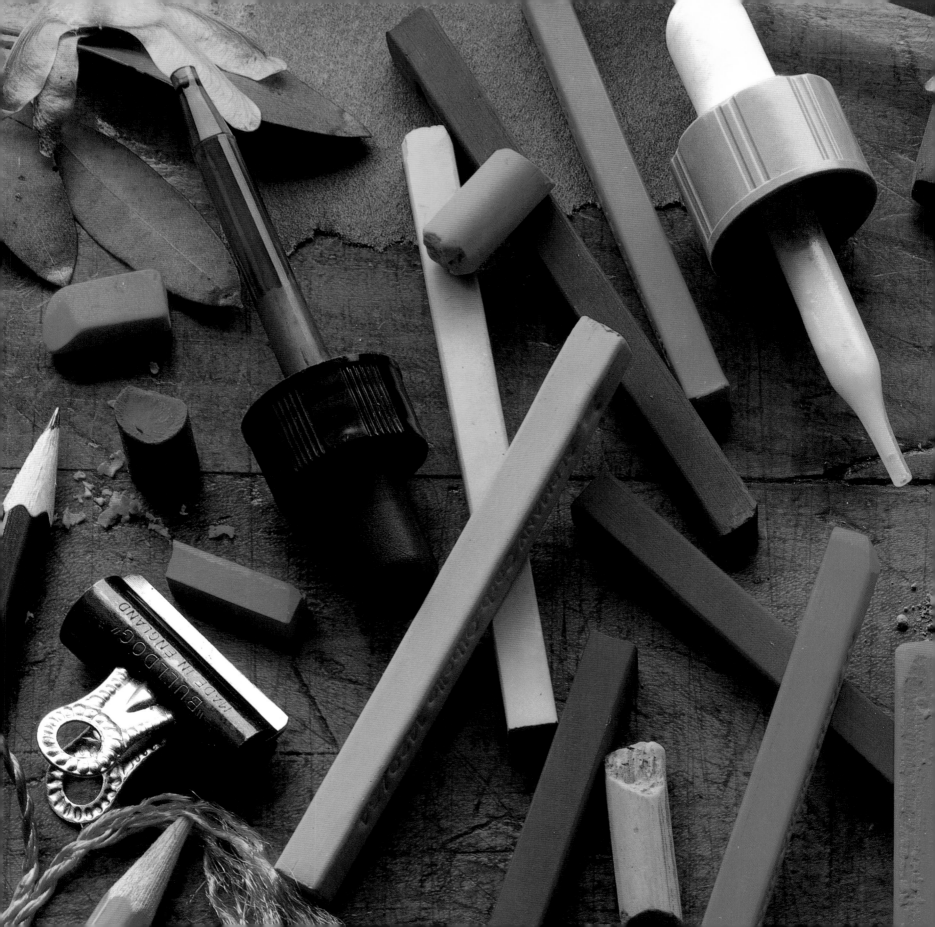

## PART TWO

# Themes and treatments

· · · · · · · · · · · · · · · · · · ·

In Part One of the course you have experimented with the drawing media, and learned ways of seeing and comparing objects which help you to draw them accurately. The subjects so far have been mainly simple still-life objects which have enabled you to draw – and to learn – at your own pace. Part Two of the course is structured in the same way as Part One, with a series of lessons, projects and information features, but you will be drawing a wide range of new subjects, including landscape, townscape and the human figure.

In this section you are also presented with some of the general problems of drawing. For example, you will learn how to draw something larger or smaller than you see it, and how to create three-dimensional space by means of perspective systems. Even more important, you will discover how to develop your own visual "handwriting," and make your drawings more expressive and personal.

# Perspective

. . . . . . . . . . .

If you observe carefully and draw exactly what you see, you can make convincing drawings of objects without knowing anything about perspective, but some knowledge of the rules is helpful. The word perspective is used in relation to life in general. The phrase ''getting things in perspective'' means deciding the relative importance of things, and in art, perspective is a method of depicting objects in the correct scale and relationship to each other.

## THE HISTORY OF PERSPECTIVE

In the long history of art perspective is a comparatively recent discovery. It emerged in Italian art in the 15th century, and soon became the method used by all artists to create three-dimensional effects in drawing and painting. Artists had, however, managed to create three-dimensional effects long before this; there are Greek wallpaintings from as far back as the 1st century AD showing realistic landscapes with shepherds and cattle.

The foreground objects were made large and the background objects small, and the

difference of scale makes the landscape appear convincing. It is only when you attempt to work out exactly how far apart the objects are, that you realize that artists did not then try to depict that kind of information – they simply thought of objects as near or distant. It is important to recognize, though, that although these artists did not use perspective, they created work which was realistic without being primitive or naive.

In the first decade of the 15th century, the Florentine architect Filippo Brunelleschi (1377–1446) was employed on the completion of Florence Cathedral, for which his employers wanted him to span a vast space with a dome so large that it appeared impossible to design. His successful

solution to this problem, which was largely mathematical, made him instantly famous, and it was his interest in mathematics and measurement which led him to discover something which had escaped the Greek landscape painters. He found that there were mathematical laws which governed the way that objects appear to diminish in size as they recede.

This discovery, although greeted with great excitement by his contemporaries, did not lead instantly to pictures which were more realistic than before. We can see the enthusiasm for perspective, as it became known, in the painting by Paolo Uccello (1397–1475), *The Battle of San Romano*. But as you can see, the total

effect is not completely realistic. The figures appear cut out because Uccello had not understood how to use light and shade.

### WHAT PERSPECTIVE CAN DO
In a sense perspective has always been there,

but it was only when artists became intrigued by the accurate measurement of distance that it could be discovered. The simplest way of illustrating what Brunelleschi interpreted in mathematical terms is to look at an ordinary rectangular doorway, first

**CHANGING SHAPES**
▲ It is easy to underestimate the effect of perspective, even when you know the rules. It's the old problem of being unable to discard preconceived ideas; we know that a door is rectangular. You may find it helpful initially to hold up your pencil and tilt it to assess the angle. Also check the negative shapes – the space you can see at the top, bottom and side of the door.

**THE NEW KNOWLEDGE**
◀ ▶ Uccello's painting does not really succeed in describing three-dimensional space. As far as perspective is concerned, the most important part is the foreground. The soldier lying on the ground, although out of scale with the foreground horseman, is a convincing representation of a foreshortened figure.

with the door closed, and then with it open, as shown in the photographs.

Now consider a further visual fact. If you look again at the open door first from a sitting position and then standing, the door will change its shape as you change your position. These simple exercises in observation illustrate the basic principle on which perspective is based. Receding parallel lines (the top and bottom of the open door) would, if they were extended, meet at a certain point. This point is called the vanishing point, or VP for short, and is always at the level of your own eyes, often referred to in books about perspective as the "horizon line" or simply the "horizon."

The reason that the door appeared to change shape when you moved from a seated to a standing position is that your eye level had changed, and with it, the point where the two parallel lines meet.

The shape would change again if you were to move to the right or the left, and you can try this out with another simple exercise. Look out through a high window where there are buildings both nearby and some distance away, and trace the main lines of the view onto the glass. You could use a

wax crayon or paint and a small brush, but you can still get the idea if you simply trace on the glass with a wet finger. You will find it impossible to trace the view accurately unless you close one eye, and as soon as you move your head, the objects you are tracing will move in relation to your tracing on the glass.

To put it simply, perspective relies on a consistent viewpoint, placing your picture in the position of the window, and imagining you as having a single eye and your head fixed in one position. Providing you accept this limitation, knowing the rules of perspective will then enable you to draw, for example, the receding walls of houses, or a path leading into the distance, and relate the height of a person in the foreground

to someone in a garden a hundred yards away.

**DIMINISHING SIZE**
As we have seen, when the door was opened, it ceased to be a rectangle and became an irregular straight-sided shape, with the vertical edge at the back shorter than at the front. As objects become further away from you they become smaller and smaller, until they disappear altogether on the horizon. This optical shrinking gives rise to the phenomenon of foreshortening. As well as getting the receding lines of an object correct in a perspective drawing, you have also to get the right amount of foreshortening. When Uccello drew his foreshortened soldier, he probably worked it out mathematically. Nowadays it is more

usual to judge by eye, but foreshortening involves a fundamental problem. Nearly always, when objects are drawn from direct observation, the extent to which they are foreshortened is underestimated, because you know their real size, and so fail to see how much smaller they become when pushed back in space.

**CONVERGING PARALLELS**
▲ The effect of the parallel lines appearing to meet at a vanishing point is seldom quite as obvious as in this frontal view. Often you will have to cope with bends or irregularities at the edges of a path, or it may be running slightly up or down hill, which affects the level of the vanishing point.

**FIXED VIEWPOINT**
▶ These diagrams show clearly what happens when you move your viewpoint even slightly. If you look at something with one eye closed, and then open that eye and close the other, everything appears to shift to the right or left.

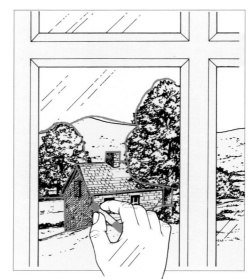
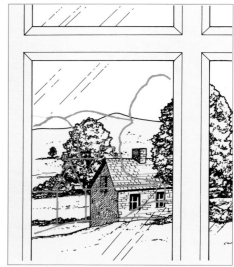

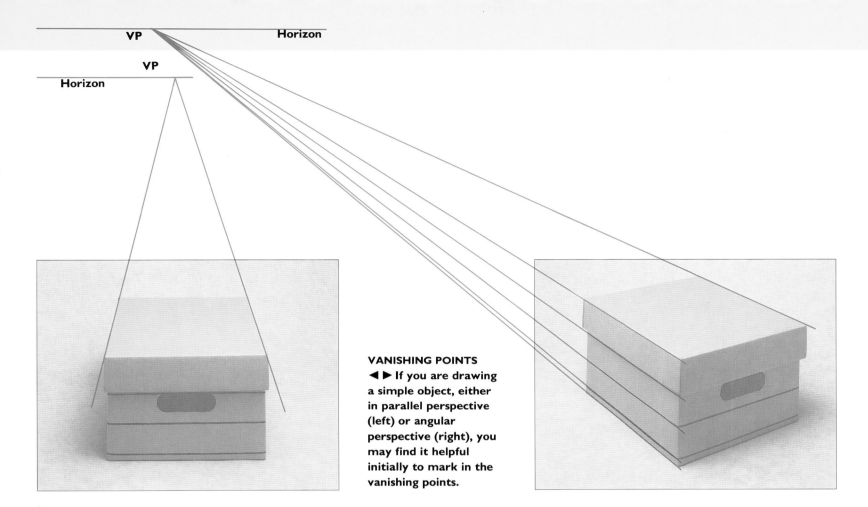

**VANISHING POINTS**
◄ ► If you are drawing a simple object, either in parallel perspective (left) or angular perspective (right), you may find it helpful initially to mark in the vanishing points.

**ANGULAR PERSPECTIVE**

Initially all pictures in perspective were drawn like the first photograph of the box here, with one plane of the main object parallel to the picture plane.

The limitations of parallel perspective made it impossible to depict corner-on views of objects. For views of this kind angular perspective was developed where, for example, two sides of a building which are actually at right angles to each other can be drawn receding to separate vanishing points.

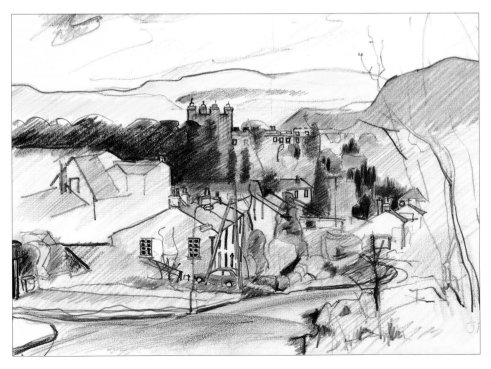

**SLOPING PLANES**
◄ The vanishing point for the road in John Townend's drawing would be below that of the houses. Declined planes (sloping down) and inclined ones (sloping up) have vanishing points below or above your eye level. Houses, however, are built on level foundations, and thus follow the normal rules.

| further information | |
|---|---|
| **70** | Using perspective |
| **80** | Drawing on location |

## CYLINDERS AND ELLIPSES

Students often have difficulty drawing circular and cylindrical objects in perspective.

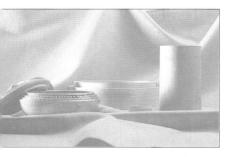

There is a simple rule that can help you here – circles fit into squares, so once you can draw a tabletop or box, you can draw a circle or cylinder. The other important thing to remember is that circles, like the rectangles on page 65, change shape according to your viewpoint. The photographs show how perspective makes the circles appear to be ovals, usually called ellipses, and also how the shapes of the ellipses change according to where they are in relation to your eye level.

### CIRCLES IN PERSPECTIVE

◄ Circles and ellipses are the bugbear of many drawing students – and some professional artists. Remember that they change according to your eye level, so take care to keep a consistent viewpoint as you work. You will also find it much easier if you mark the center first, and measure each side on your drawing to make sure both are equal.

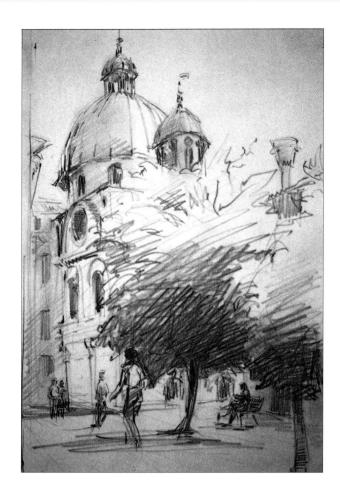

### TRICKY PERSPECTIVE

◄ A dome with a square structure on top seems to present a very complex problem in perspective, but you won't go far wrong if you trust your eyes, and look out for clues. Notice how, in Audrey MacLeod's confident pencil drawing, the sections of the dome become smaller and smaller at the edges, and the curve follows the general direction of the straight parallel lines below.

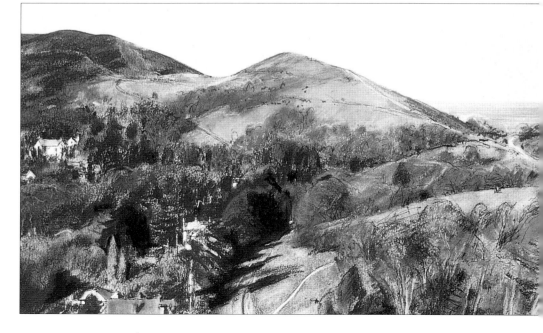

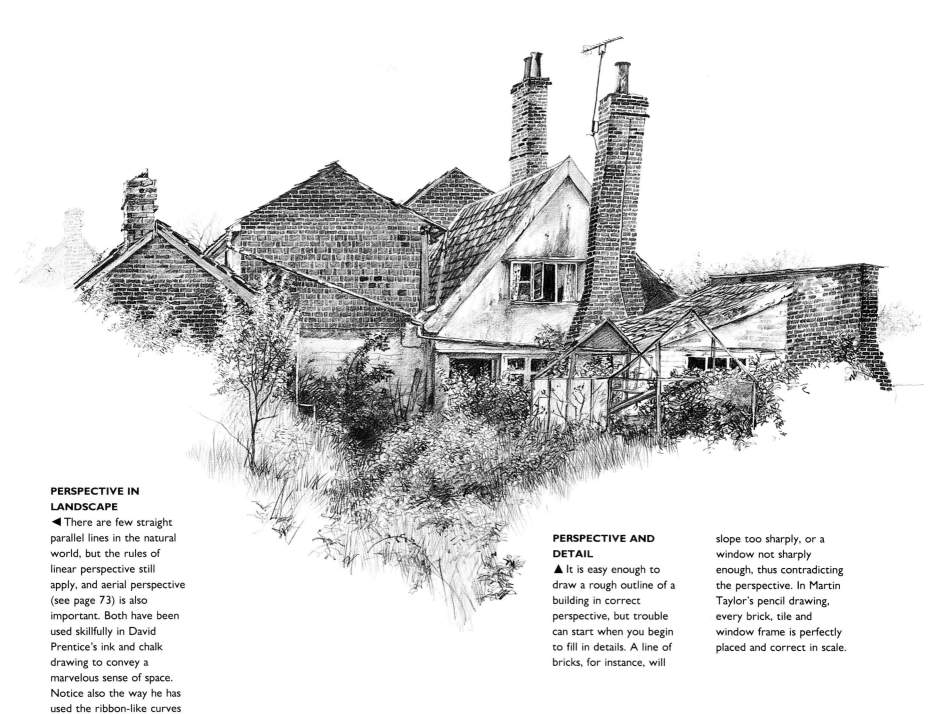

## PERSPECTIVE IN LANDSCAPE

◄ There are few straight parallel lines in the natural world, but the rules of linear perspective still apply, and aerial perspective (see page 73) is also important. Both have been used skillfully in David Prentice's ink and chalk drawing to convey a marvelous sense of space. Notice also the way he has used the ribbon-like curves of paths to help describe the contours of the hills.

## PERSPECTIVE AND DETAIL

▲ It is easy enough to draw a rough outline of a building in correct perspective, but trouble can start when you begin to fill in details. A line of bricks, for instance, will slope too sharply, or a window not sharply enough, thus contradicting the perspective. In Martin Taylor's pencil drawing, every brick, tile and window frame is perfectly placed and correct in scale.

# Using perspective

In this lesson I shall be asking you to put some of the information about perspective on the previous pages into practice. The projects are concerned with drawing from observation but making use of perspective systems; you won't be required to make elaborate perspective or axonometric drawings, though it will do no harm to practice the various drawing systems if you wish to, as they will all add to your knowledge and experience. For four of the projects you will be drawing objects placed on a table, and for the other you will need a view from a window.

### THEORY AND PRACTISE

You may be disappointed with the drawings you produce in this lesson. This is because taking the theory of what you should see, and comparing it with what you actually do see and draw exposes many inaccuracies. Trying to make really accurate drawings can be both challenging and depressing, but checking whether you have the right degree of foreshortening or that receding lines are at the correct angle is important. If you don't get them right, it will reduce the sense of space in your drawings. Once you have carried out a few basic exercises like the ones here, you will find it all becomes much easier.

You will also find that the rules of perspective help your drawing. Although perspective has the severe limitation of demanding a fixed viewpoint and narrow angle of vision, it nevertheless relates to what you see, and is very useful when things go wrong. For example, if two rectangular objects don't appear to be on the same level in your drawing when they are meant to be, you can check that their receding sides really do meet on roughly the same level, and that this eye level is consistent with the view you have of the objects.

**THE AIMS OF THE PROJECTS**
**Drawing objects in parallel perspective**

**Assessing angles and foreshortening**

**Experiencing the relationship between linear perspective and what you actually see**
●
**WHAT YOU WILL NEED**
All your drawing materials, and at least seven sheets of white drawing paper. A long ruler or straightedge (a piece of wood about a yard long is ideal). Gummed strip or something similar for joining pieces of paper in Project 2
●
**TIME**
Project 1: about ½ hour. Project 2: about 1 hour. Project 3 about 2 hours

### PROJECT 1
### Foreshortening by eye

To demonstrate the extent to which receding objects become foreshortened, I want you first to make a drawing of two identical-sized postcards. You are only going to draw their shapes so they can be

plain or have pictures. Place them as shown here, and make a line drawing of the shapes of the cards. The vertical card will be a perfect rectangle of the same proportions as the actual card. The horizontal card will be foreshortened, and the angles of its receding sides and the extent to which it is foreshortened can be judged by comparing it with the standing postcard.

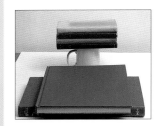

### PROJECT 2
### More foreshortened rectangles

Place two books of the same size flat on a table in front of you, with one about 6in away but directly behind the other. Support another two books, of any size, on anything suitable (drinking glasses would do) so that they are flat but at different heights above the table. These should also be viewed straight on.

Make a drawing of the four books, carefully checking the angles of their receding sides against the horizontal

sides. Draw without using a ruler and redraw the lines until they look correct. Be sure to assess the foreshortening of each book carefully, and see if you can identify a difference in the foreshortening of the two books which are raised up.

When you have drawn the books as accurately as you can, look straight ahead and decide where an imaginary horizontal line projected from your eyes would be in your drawing. This line drawn above the books will be your eye level. Mark this in with a ruler.

Even though the books you have drawn are in different places on the table or at different heights above it, each pair of receding sides is parallel, and the lines formed by these sides, if extended, will meet on your eye level at the same vanishing point. Extend them in your drawing and see if they do.

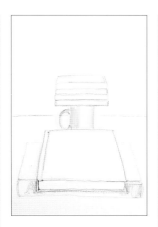

**JOHN TOWNEND**

1 ▲ **Colored pencil has been used to draw the books and the mug on which the top books rest. Although the latter is not part of the exercise, the drawing would have looked odd without it.**

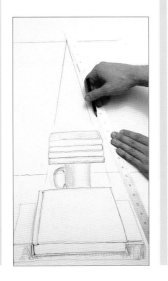

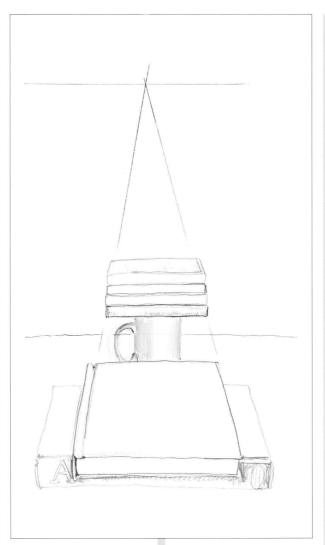

2 ◄ **The artist has drawn in his eye level, and is using a long ruler to extend the sides of the books to check whether they meet at the same point on the eye-level line.**

3 ▲ **You can see in the final drawing that the sides of all the books, if extended, would meet on the eye-level line at the same vanishing point.**

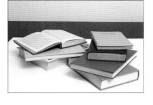

**PROJECT 3**
**Angular perspective**
I have already mentioned that angular perspective had to be developed before angled views could be drawn. To understand how this works, arrange six or more books of any size so that they are all corner-on to you, with some at an angle on top of others. Make a drawing of their shapes from observation. This time the books won't provide any horizontals to help you check angles, but you may be able to use the edge of the table as a reference, or you could stand something on the table near the books to provide a vertical for comparison with the receding sides of the books.          ▷

When you have drawn the books as accurately as you can by eye, draw in your eye level as in the previous project and extend the sides of the books until they meet. If any of the books are actually parallel to each other each pair of parallel sides should meet at the same vanishing point. Otherwise each book will have two vanishing points, but they will all be on the same eye level.

The difficulty in drawing objects at angles is that most of the vanishing points will be off your drawing paper, so you will need to extend your paper on both sides at the eye level so that you can check where the receding lines meet.

**JOHN TOWNEND**

**1** ▶ **With the books placed corner on,** the artist has to assess angles without the help of any horizontals. This is considerably more difficult than drawing objects in parallel perspective.

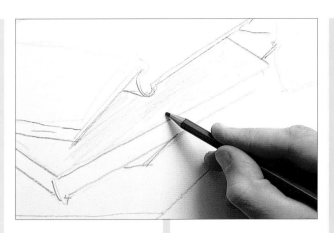

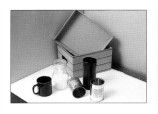

**2** ◀ **Even when you are drawing what** may seem a dull subject, the way you use the medium can make the drawing interesting. Here the artist makes good use of colored pencil.

**3** ◀ **Another sheet of paper has been** added to the drawing so that the eye level can be extended, and the vanishing points for the receding sides of the books checked. A sheet added to the other side of the drawing would enable the other sides of the books to be checked also.

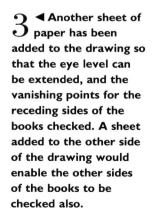

**PROJECT 4**
**Boxes and cylinders**
Assemble a group of at least six different box-shaped and basically cylindrical objects. The boxes could be shoe boxes or smaller ones such as matchboxes. The cylinders might be jelly jars or cans of fruit or vegetables, but some should be made from clear glass, as this will allow you to check easily the difference between the ellipse at the top and bottom of each cylinder. You don't have to position the objects very carefully, but group them close together, with the boxes arranged at different angles, and a couple of the cylinders lying on their side and turned away from you. Don't include your eye level in this drawing; instead try to draw the boxes and the cylinders as accurately as possible from observation, using any media or drawing method you like.

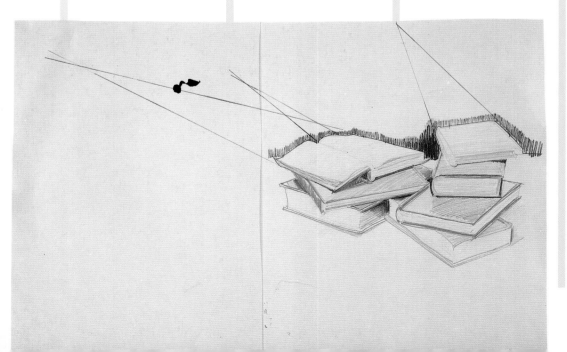

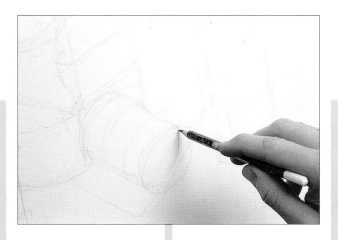

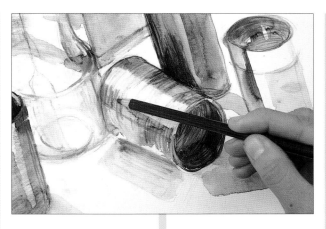

**KAREN RANEY**

1 ▲ The positions of the objects are first indicated in pencil.

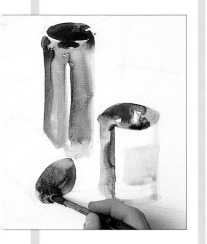

2 ◀ Ink and wash are being used to develop the drawing and re-establish the shapes of the ellipses.

4 ▲ Pencil is now used to give the objects more definition as well as building up an interesting surface in this mixed media drawing.

5 ▼ Pencil and wash have been used to develop the drawing to its final state. Notice the differences between the top, middle and bottom ellipses of the glass jar, which are shallow at the top and become progressively rounder.

**PROJECT 5**
**Aerial perspective**
The effect of the atmosphere on tones and colors can be seen best either toward evening when the light is beginning to fade or on misty days. For this drawing you need a convenient view from a window where you can relate distant and close-up objects. A view from a high window looking down your yard or across rooftops would be an excellent subject. Look at the way that tone contrasts are less and less distinct the further they are away from you. Use line as little as possible (ideally not at all), and translate what you can see into a tonal ▷

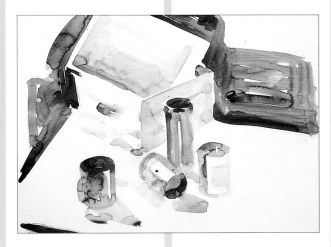

3 ▲ The background boxes have now been added to the drawing, which remains quite free. As she

works, the artist continues to reassess the exact shapes of the objects and their relative positions.

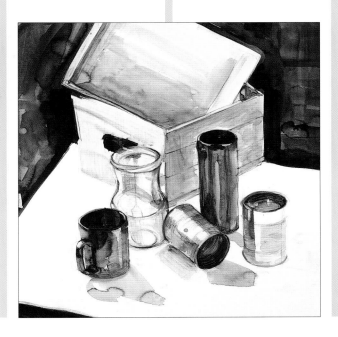

drawing using conté crayon, charcoal or wash. You can include color in your drawing if you wish, which will help to create a feeling of depth through the blueness of distant colors.

**2 ▲ She now strengthens the drawing of the chair, which is the most prominent foreground object.**

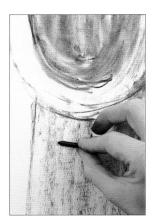

**3 ▲ Shading is done by using the charcoal flat on its side.**

**SELF CRITIQUE**

● Do you feel that the drawings in this lesson have taken you a step forward?

● Or have you found the accuracy required in some of them rather daunting?

● Have you understood the principles underlying the drawing systems?

● Are there some things that you feel you should return to and try again before going on?

● Which drawings from this lesson are the best and why?

● Do you feel that you are acquiring a better command of the drawing media?

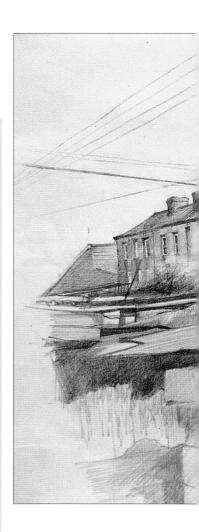

▲ David Carpanini
*Pencil*
In this sketchbook drawing, the foreground wall and buildings with the terrace of houses behind have provided the artist with a fascinating angular perspective problem.

**KAREN RANEY**

**1 ▲ Using charcoal, the artist starts by establishing the positions of the chair and the window behind.**

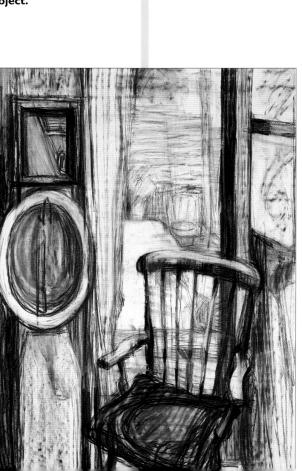

**4 ◄ In the final drawing a sense of depth has been created by the strong tone contrasts in the foreground. As you look out through the door and down the path, the contrasts become less distinct and less clearly defined.**

◄ Christopher
Chamberlain
*Pencil*
The artist chose a view
which gave him an
extremely complex
perspective problem.
Differences of scale, lines
receding in many directions
and the curves of the
arches on the right have all
been brilliantly and
decisively drawn. Notice
the care taken in following
the changes of direction in
the foreground fence and
the sidewalk.

▲ Geoff Masters
*Charcoal and pencil*
Even though the beams in
this old barn are not
perfectly straight, **Lower
Farm Barn** is a drawing
with a single vanishing point
at which all the receding
parallels meet. As well as
being beautifully observed
in terms of perspective, the
drawing conveys a strong
feeling of atmosphere.

# Altering the scale

The size you draw objects can be very important. You may wish to focus on something quite small and make it large and monumental. At the other extreme, you may want to draw a wide panoramic view in a small sketchbook, which will involve scaling everything down. It isn't always easy to do either of these two things because most people draw objects the actual size they see them. If you try to enlarge a small object, you will probably find that, although you can start confidently enough, the drawing will get smaller and smaller as you continue. It is equally difficult to scale down a large foreground object, as you may have already discovered when drawing in your sketchbook. Often the subject runs off the page, and another danger is that, in your efforts to keep it within the boundaries of the page, you may distort the scale and proportions.

**SIGHT SIZE**

Drawing objects the size you see them rather than the size they are is usually described as drawing "sight size." To make a check on the size you draw naturally, use a pencil to make a rapid line drawing of the silhouette of any object you can see in the room you are in, or something you can see through the window. Stay in your drawing position and, holding your pencil at arm's length, close one eye and measure on the pencil with your thumb, the main proportions of the object and compare these measurements with your drawing. You will almost certainly find that, if you do this carefully, the measurements in your drawing are identical.

It is because we naturally draw sight size that drawing teachers often advocate constantly making measurements with a pencil in this way, transferring these measurements directly to your drawing. I personally believe that this advice, though it can be helpful, is hard to follow because it is difficult to be certain that you keep precisely the same position, and hold your arm out to the same extent when each measurement is made.

78 ▷

---

**THE AIMS OF THE PROJECTS**
Drawing objects larger than you actually see them

---

Drawing objects smaller than you see them
●
**WHAT YOU WILL NEED**
You will need a large sheet of paper for Project 1, smaller pieces – or a sketchbook – for Project 2. Color isn't important in this context, so I suggest that you make your drawings in monochrome using line and tone
●
**TIME**
About 3 hours for each project

---

**ELIZABETH MOORE**

1 ▶ You will find it easier to enlarge if you use a medium that makes you draw really boldly. Here conté crayon has been chosen.

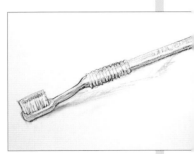

2 ▶ Attention has been paid to the ridged pattern on the handle and the shadow beneath, both of which describe the object's shape and give it solidity.

**PROJECT 1**
**Enlarging**

I want you to make three drawings for this project, spending about an hour on each. For the first I want you to make an enlarged drawing of something small, such as a spring clip, a toothbrush, or an electrical plug. Your drawing is to fill an A4 sheet of paper, so look at your subject carefully, and try to imagine it the size of a building which you can walk around. Start by drawing the silhouette shape quickly, and then proceed to construct a drawing within this shape which is as detailed and accurate as possible. Pay attention to the shapes of the different surfaces, and try to reproduce the shading you can see.

When you have finished the drawing and got the idea of drawing larger than you see, make two further drawings in which you enlarge small objects to monumental size. One could be a kitchen utensil such as a garlic press, a toaster or a food mixer. For your third drawing choose a soft object, perhaps a screwed-up handkerchief which you can visualize on the scale of a vast landscape.

**3** ► Seeing an enlarged drawing of a familiar object can have a disconcerting effect, and artists sometimes "play with" scale in their paintings and drawings for this reason.

**KAY GALLWEY**

**1** ▼ The straight lines and clean edges of a man-made object like this are very much part of its character, and must be drawn accurately, so the artist uses a ruler.

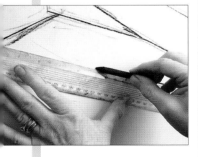

**2** ▼ Care has been taken with perspective – a mistake would be very noticeable on this scale.

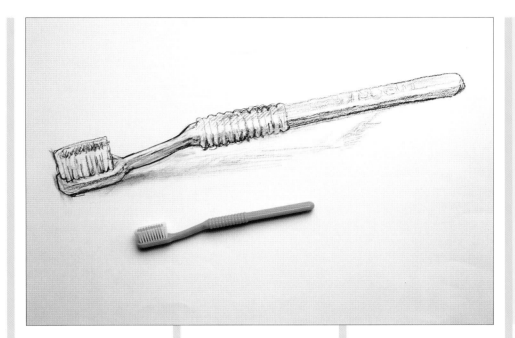

**SELF CRITIQUE**
● Have your enlargements made you get the proportions of the objects wrong?

● Did you find any of the objects easier to enlarge than the others?

● Were the forms of the soft object easier to enlarge than the more precise forms?

● In making your enlargements, did you try any measuring?

**3** ◄ With the shading completed, the giant stapler looks entirely convincing. An object like this is ideal, as its architectural qualities become more apparent in enlargement.

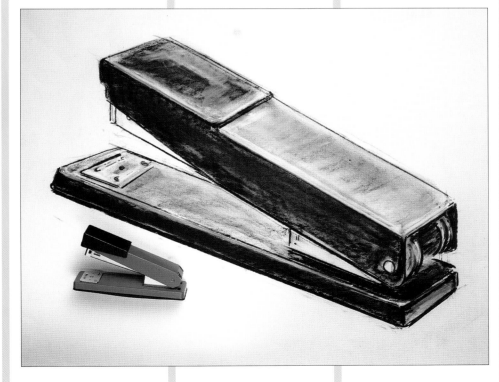

Also, sight size can be surprisingly small, often too small to make an exciting drawing, for instance when you are drawing the figure in a life class. You can easily check the sight size by holding up your drawing board, closing one eye and marking off horizontal measurements, such as the head and shoulders. You will find that the figures fits onto quite a small piece of paper. The same applies to a still life, such as a group of bottles, which will be very small if you draw them sight size, and may look more interesting if you draw them the actual size they are (life size).

### ENLARGING AND REDUCING

Because drawing sight size doesn't work well for every subject, you will have to learn to enlarge and reduce so that you can draw any size you choose. There are two semi-mechanical methods of enlarging or reducing the scale of objects, one being the method known as squaring up and the other being a drawing aid called a pantograph.

For squaring up, a grid of squares is drawn over your sight-size drawing, and a similar grid of larger or smaller squares on another sheet of paper. The drawing is then transferred, line by line, to the second grid. A pantograph is a simple adjustable copying instrument. It looks like several rulers joined together at the ends so that they pivot, and it has a point at one extremity and a lead for drawing at the other. By tracing your drawing with the point, the lead will automatically draw an enlarged or reduced version of it. The scale depends on how the "arms" of the pantograph are adjusted.

Squaring-up and the pantograph have their uses, but they are essentially devices for copying or tracing, and they remove any vitality and spontaneity from a drawing. It is essential to be able to reduce and enlarge by eye if many of the qualities which are most important in drawing are to be preserved.

### PROJECT 2
### Reducing

This project also requires you to make three drawings, each taking about an hour. For your first drawing, choose a large piece of furniture such as a kitchen dresser with objects on it, a dressing table, or a closet with the doors open revealing the contents inside. Decide where you are going to position yourself to draw, but before you begin your drawing make a sight-size measurement of the width of the piece. I want you to make your drawing not larger than half this size. Mark on your paper the width you intend the object to be, and then draw the overall shape of the furniture within this dimension. Continue your drawing, adding details such as drawers, shelves and handles. Pay particular attention to the proportions of the furniture and the scale of its details in relation to the whole piece.

When you have finished this drawing, find two quite different subjects for making drawings which are much less than sight size. You could draw the corner of a room or another building seen through a window. You need subjects which compel you to fit a great deal of detail into large overall shapes. This will enable you to see, once the general size of an object has been decided, whether you can continue to draw to the same scale. Try to see how small you can draw without losing any important detail.

**JOHN TOWNEND**
**1** ▼ It is surprisingly difficult to draw smaller than you see, particularly when you are using a relatively large sheet of paper. The artist found it essential to begin by setting a definite margin for the drawing. It is also helpful to use a medium that encourages small, detailed work, such as this fine-tipped pen.

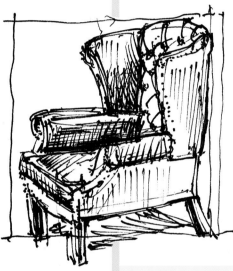

**2** ▲ Although both drawings have expanded slightly beyond their boundaries, they are very successful; the proportions of the chairs are correct, and the artist has managed to include quite a lot of detail.

**SELF CRITIQUE**

● Did you manage to get detailed information into your drawings?

● Did you find that there didn't seem to be enough space to fit everything in?

● Are your small-scale drawings better than the enlargements in the previous project?

**ELIZABETH MOORE**
▲ These three drawings, also in pen and ink, are small sketchbook studies of the artist's studio, done specifically to practice reducing the scale. You will need to make a good many drawings before you can do this with confidence, but it will become easier in the course of time.

| **further information** | |
|---|---|
| **148** | Drawing detail |
| **202** | Ink drawing techniques |

# THEMES AND TREATMENTS

# Drawing on location

**W**hen you are first learning to draw, it is convenient to work indoors in comfort, drawing objects which are carefully chosen and thoughtfully placed. But now it is time to try out your drawing skill in a more adventurous way by working outside. The subjects in this lesson won't have objects which have been specially arranged, and much more is going to be left to chance when you draw.

The thought of drawing in public may initially make you feel apprehensive – perhaps you dislike the idea of dealing with inquisitive people who come and look over your shoulder – but these problems can be overcome, and I would like you to try it, if at all possible. If you really do find that for some reason you can't draw outside, you will be able to do the projects in this lesson from indoors, looking out from a doorway or a window.

If you can find a sheltered spot, you can draw outdoors for most if not all of the year in most countries. Rain is a greater obstacle than cold, and although nosy people can be a nuisance, most drawings can be made in a sketchbook, which is a relatively private way of working. In any case once you start to draw, you will be so engrossed in what you are doing that you will be unaware of passers-by, and they probably won't notice you – you are never as conspicious as you imagine.

The point of asking you to draw outside is not, however, to set an endurance test. It is an exciting experience without which any course in drawing would be incomplete. In particular, drawing on the spot puts great pressure on you to work at speed. Even on days when the weather is reliable, the light changes constantly, and if you are including people in your drawing, they are bound to move before long. But because you have to work quickly, all kinds of things can happen in your drawings that you may not be aware of until you get home. These may be accidents, but chance happenings often produce better drawings than a highly controlled approach.

**THE AIMS OF THE PROJECTS**
Producing spontaneous drawings from outdoor subjects

―――

Working quickly and exploiting chance effects

―――

Choosing good subjects and including their most important features

―――

Making a composition
●
**WHAT YOU WILL NEED**
All the drawings can be made in sketchbooks. An A2 size sketchbook is needed for the larger drawings but if you have an A3 sketchbook bound along the longer side (not spiral-bound) you can draw across two pages. Alternatively, the larger drawings can be made using your board and A2 paper. You will need all your drawing materials, and you can use color if you wish
●
**TIME**
About 3 hours for each project

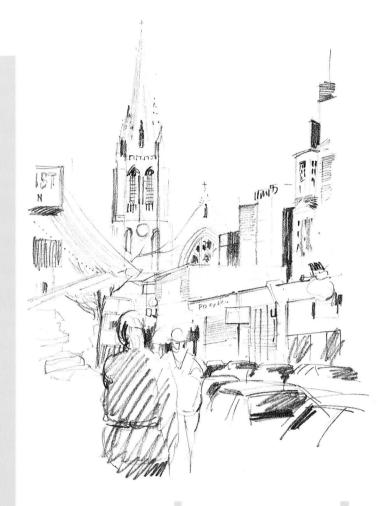

**PROJECT 1**
**Townscapes**
Once you have reached your chosen location, I want you to make at least three quick studies (taking about twenty minutes for each) and a larger A2-size drawing on which you should work for at least two hours. If you can't do all the drawings in one session, make two trips, saving the larger drawing for the second. You will need an unbroken period of at least two hours for this, and if you stop and plan to continue later, you will probably discover after the break that things look so different that you won't know where to begin again.

**Selecting**
Once you have decided where to draw, you will find the first problem is what to draw. The subjects you have drawn so far have been very specific, but now you will be confronted with a

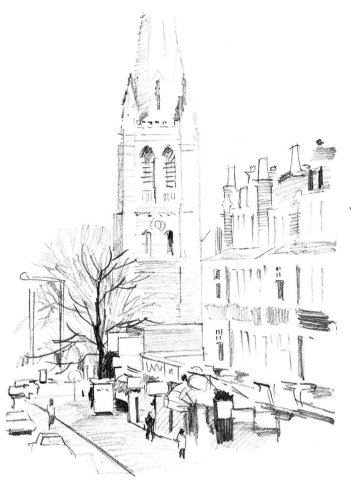

**PHILIP WILDMAN**

1 ◄ ▼ These three rapid pencil sketches have been made from different viewpoints to explore the compositional possibilities of the subject. The one in the center was chosen as the basis of the larger drawing shown overleaf. ▷

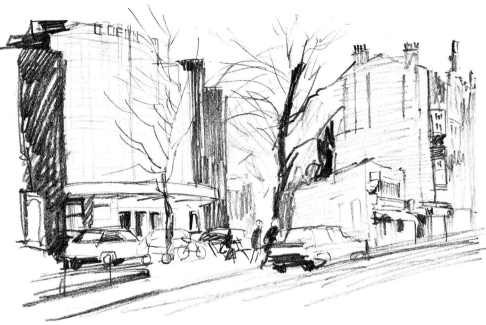

wide choice of views and objects. This is the purpose of the preliminary studies, which will help you to decide what will make the best subject for your larger drawing. All the studies may be variations of the same view, perhaps adding more foreground in one and trying more on the right-hand side in another. Or each could be a different view drawn from the same place. By merely turning your head it is amazing how different the view can be. You will find a "viewfinder," a piece of card with a rectangular hole in it, a good aid to get you started, as it will help you to select a small part from a complex subject.

**The large drawing**
When you have completed the studies, look at them carefully, and decide which one will be best to develop as a larger drawing. If possible, make this drawing A2 size, but if not, make it as large as you can. It should be in both line and tone, and you may wish to use color. Make as complete a drawing as you can on location; don't try to do something quickly and finish it when you get home, as this won't work. However, you can make minor alterations later. If you put the drawing away for a couple of days and then look at it again, together with the studies, you may see some fault that you can put right, such as a feature in the foreground which could be slightly strengthened. There may, however, be nothing you feel you want to change. Change as little as possible, though, because altering a drawing once you are away from the subject seldom improves it.

**2** ► For the finished drawing, the artist has turned to a different medium, pen and wash, which he uses frequently and finds ideal for urban subjects. The suggestion of cloud on either side of the church steeple was made by the wax resist method (see page 210).

**SELF CRITIQUE**

● What do you feel about your studies and your drawing?

● Did you include things which surprise you?

● Do you now feel that you chose the most interesting study to develop?

● Do you think that the larger drawing does justice to the subject?

● Have you learned anything which you know you can put into practice in your next drawing?

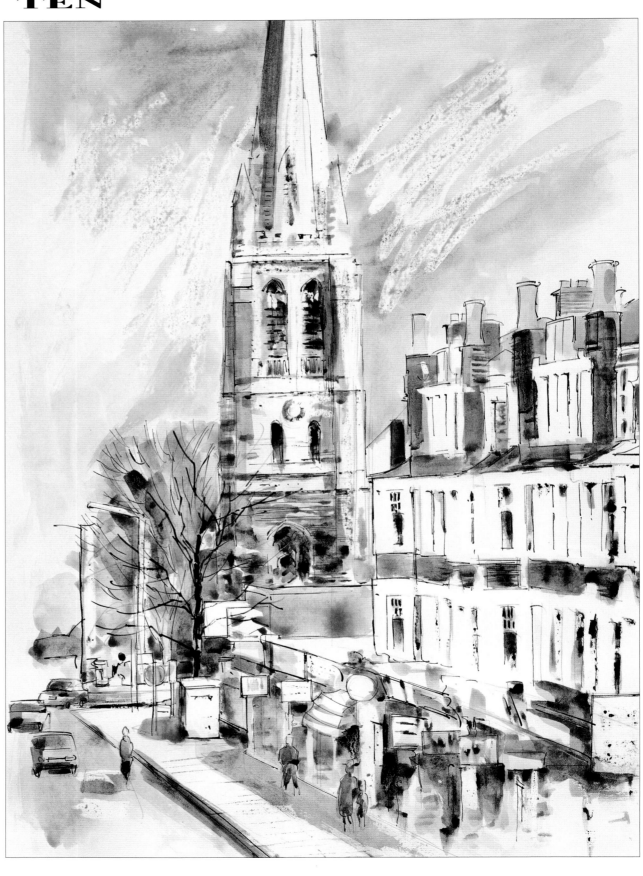

## PROJECT 2
### Landscape

Urban and village scenes offer a wide range of locations and different subjects, but for many it is the desire to make contact with nature that encouraged them to draw in the first place. Drawing the landscape can be very rewarding. It was what the French painter Eugène Boudin (1824–98) advised the Impressionists to do. "Study, learn to see and to paint, draw, paint landscapes. The sea and the sky are so beautiful – animals, people, trees just as nature has made them with their personalities, their real way of being in the air, in the light just as they are."

The word landscape is not intended just as a generic term for hills, mountains, fields and trees; parks and gardens are also landscapes. A greenhouse can provide a kind of "interior landscape," and even a windowbox can be a landscape in miniature. You could make your landscape drawing from a window, but if possible take Boudin's advice and draw in the open air. Parks are particularly good places, and they even provide seats.

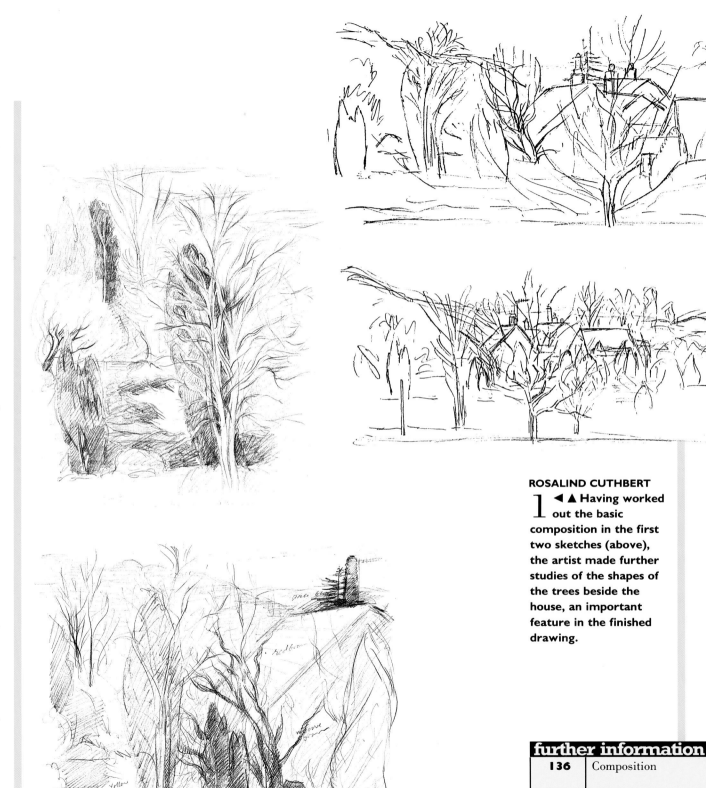

**ROSALIND CUTHBERT**
1 ◀▲ Having worked out the basic composition in the first two sketches (above), the artist made further studies of the shapes of the trees beside the house, an important feature in the finished drawing.

THEMES AND TREATMENTS

83

**2** ▼ **The final drawing has been made in pastel, using the sketches and color notes as reference. The drawing's center of interest is the house with the line of trees in front, so the artist has treated the central foreground tree very lightly and delicately so that it does not form a "block" for the eye.**

**Studies and a drawing**
I want you to plan your work in the same way as the last project, making three preliminary studies and then a large drawing. The latter should take you at least two hours, and you should try to finish a single session without a break. Work in line and tone or in color, but consider using a different medium from those you used in the last project. When you have completed this project, pin up your work, and also the drawings from the last project, and compare them.

**SELF CRITIQUE**
● Did you find that the experience you gained from the townscape project helped you to draw landscape?

● Which of the drawings or studies do you feel best captures the subject?

● Have you discovered anything new about the medium you used?

● Did you find the trees and plants more difficult to translate than the more clearly defined forms of buildings?

▲ Stephen Crowther
*Charcoal and conté crayon*
Crowther works on location a good deal, and although many of his drawings are studies for paintings, this one, **Supreme Endeavour**, was seen as an end in itself. The composition has been planned with care; notice the balance of light and dark tones and the way the triangle made by the quay and pier echo and reinforce the irregular triangle of the boat's bows.

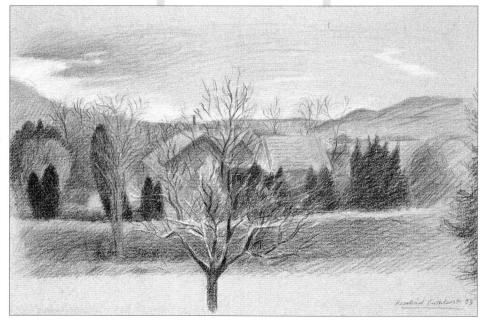

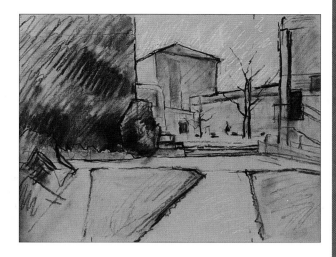

▶ Joan Elliott Bates
*Charcoal and white chalk*
Time is often limited when you are working out of doors, and decisions have to be made about how much to include. In this simple but beautifully balanced drawing, the artist has limited herself to exploring the balance of shapes and tones.

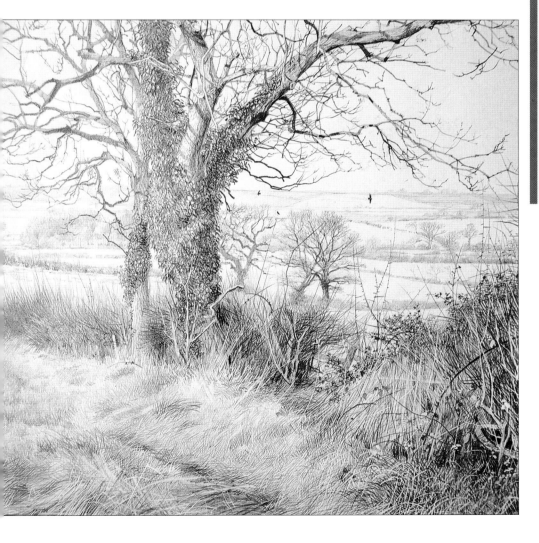

**tip**

### SPECIAL EQUIPMENT

Depending on the medium you choose, you may need a few extra items for working outside, for instance, a bottle to carry water for thinning ink or paint. This can be carried in a plastic mineral-water bottle or something similar. You will also need a plastic carton to pour some of the water in for use. A bag of some kind will be needed to carry your drawing materials, and depending on where you decide to go, a folding stool may be useful. And take warm clothes; even on warm days it can be cold drawing outside because you are not moving about.

This might also be the point at which to consider buying a sketching easel. These are light and reasonably portable, and are perfectly suitable for indoor use as well. If you have a friend who draws or paints, try to borrow their easel to try, or if you go straight to a store, set up the easel in the store to make sure that it suits you, is a size and weight that you can carry easily and will hold your drawing board satisfactorily.

It's a good idea to make a checklist of all the things you'll need before setting out for a drawing session. It is most annoying to have plucked up the courage to start, only to find that you have left something vital, such as a pencil sharpener, at home.

◀ Martin Taylor
*Pencil*
It is hard to believe that a drawing containing so much intricate detail could have been done on the spot, but Taylor always works on location, whether he is painting or drawing, sometimes returning to a subject over a period of days. In poor weather he uses his automobile as a mobile studio.

# THEMES AND TREATMENTS

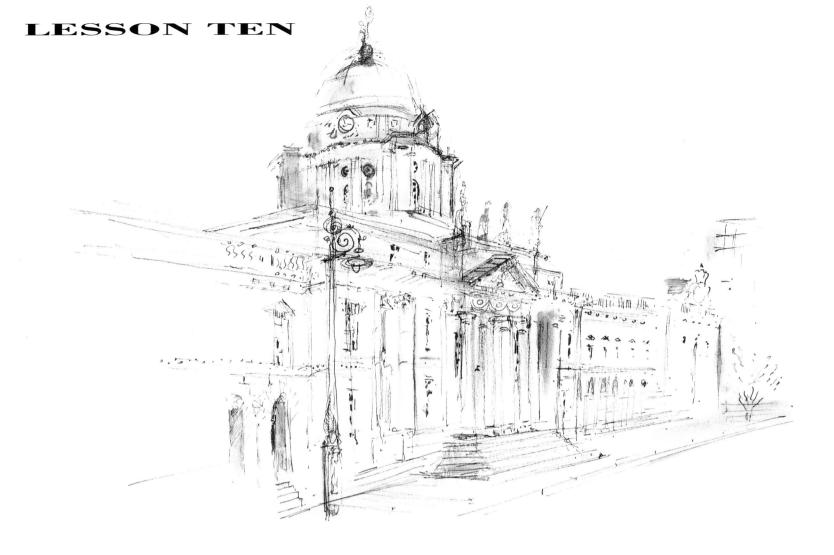

▲ Audrey Macleod
*Pen and ink*
The ink used for this sketchbook study of the **Customs House, Dublin** is water-soluble, enabling areas of tone to be produced by applying clean water. You can see this smudged wash effect most clearly on the dome of the building, where it contrasts nicely with the fine pen lines.

▶ John Townend
*Colored pencil*
Townend finds colored pencil an ideal medium for location work, versatile and quick to use. In **Copped Hall** he has used the pencils freely and boldly, contrasting the slanting strokes that build up the colors and tones with firm contour lines establishing the shapes.

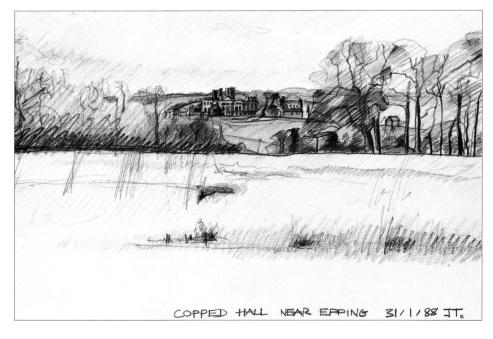

COPPED HALL NEAR EPPING 31/1/88 JT.

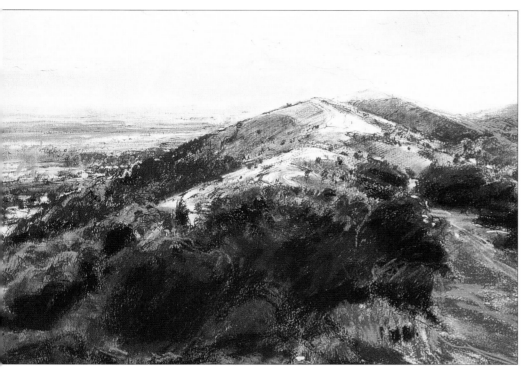

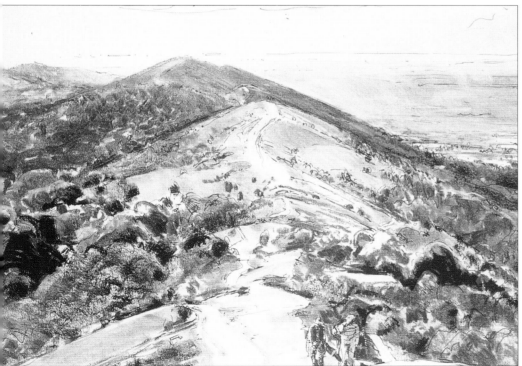

◄ David Prentice
*Ink and chalk*
These two drawings,
**Malvern Perseverance**
(top) and **Climbing the
Beacon**, **Malvern**
(bottom) were done as
studies for paintings, and
the mixture of media has
allowed the artist to record
a great deal of visual
information. He has
returned to this particular
landscape subject
repeatedly, and drawn and
painted it in several
different media and in all
seasons of the year.

▲ David Ferry
*Charcoal pencil*
Charcoal and charcoal
pencil are not best suited
to small sketchbook
drawings, but can be used
to advantage on larger-scale
location drawings; this
study of buildings is A1
size. The strong dark lines
and decisive diagonal
hatching suit the rather
somber, unromantic subject
very well.

| further information | |
|---|---|
| 180 | Pencil and colored pencil |
| 202 | Ink drawing techniques |
| 210 | Mixed media techniques |

THEMES AND TREATMENTS

# Natural forms

. . . . . . . . . . . . . . .

This lesson takes you back indoors to deal with some of the problems you will almost certainly have encountered when drawing on location. Whatever kind of landscape you decided to draw in the last project, you will almost certainly have experienced the difficulties of drawing trees, shrubs or plants, so in this lesson I want you to consider some of the special problems involved in drawing these and other natural forms.

With the townscape project, you were in the more familiar territory of objects based on geometric forms, man-made objects with clearly defined shapes, but a landscape confronts you with shapes that may seem irregular and unpredictable. However, geometry underlies nature also, and in this lesson I want you to discover the parallels between the natural world and the manufactured world. In addition, I want you to consider another feature which drawing outdoors makes you very aware of − texture.

## PERSPECTIVE

Even if you are drawing a small plant in a pot, all that you have learned about foreshortening and the diminishing size of objects as they recede is still relevant. The nearest leaves of the plant, if they grow in a near horizontal position and are facing towards you, will be foreshortened in just the same way as the postcards you drew earlier. And if a flower has a shape which is basically circular, it will become an ellipse when seen from an angle. As you will have realized, perspective is as relevant to natural forms as to man-made objects.

## DETAIL AND TEXTURE

One of the difficulties in drawing natural forms is that you will find yourself faced with a lot of detail, and in attempting to describe this, it is easy to lose both the character and the form of the object. The perfect example of this is a tree, either in full leaf or bare in winter; there is a tendency to focus on the shapes of leaves and branches, or the texture of

91 ▷

**THE AIMS OF THE PROJECTS**
**Using the experience gained through drawing geometric objects to draw natural forms**

─────

**Using texture to describe and enhance the forms**

─────

**Experimenting with different media**
●
**WHAT YOU WILL NEED**
**All your drawing materials. A selection of different papers**
●
**TIME**
**Each project will take about 4 hours**

## PROJECT I
### Plants and flowers

For this project you need at least two main items: some cut flowers with large, simple shapes (or a flowering pot plant), and a large plant which consists of closely packed leaves making a solid, rounded, three-dimensional form. The plant could have flowers, but the mass of leaves should be the deciding factor in choosing it; you want a plant that presents the same problems as drawing trees or shrubs.

Don't forget that one of the aims of this project is to experiment with different media, so think about which you want to start with and plan to change it when you are part-way through the drawing. This is also a time to experiment with different kinds of drawing paper. Make your drawing as large as possible. As you draw the flowers I want you to be concerned mainly with their foreshortening and with the plant, making it look as though it is a solid three-

dimensional form.

Try to see the underlying geometry in these natural forms. Start with a very simple statement and then gradually introduce the details of petals and leaf shapes. Make certain that the flowers are constructed properly in your drawing, with the flower heads correctly aligned with their stalks, and try to see in your mind the parts of the flowers and plants which are hidden, for example, when a leaf covers a stalk, or petals obscure a point where stalks join. As you draw, bear in mind these hidden parts of the plant, and think about the actual construction of the plant. If you decide to draw leaf veins, draw what you actually see. Don't just draw the veins in black lines. With many plants the veins are actually lighter than the leaves. Pay particular attention to where stems join. Look for growth characteristics, and notice how the joints of plants and flowers often give important information about the cross-section of the stem and help to explain its particular three-dimensional form.

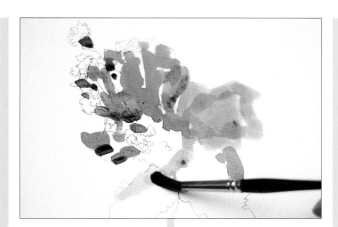

**ELIZABETH MOORE**

**1** ▲ The artist has chosen pen and wash for this drawing. Having sketched in the basic shapes with pen, she now builds up the forms with diluted ink and a brush.

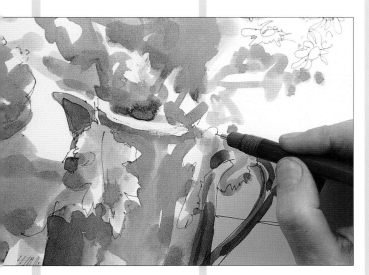

**2** ▲ Line drawing in ink alternates with wash drawing as the precise positions of the jug and the leaves are gradually decided.

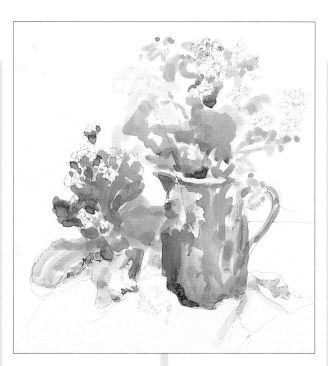

**3** ▲ Now that the flowers and plant pot have been developed, the artist is able to take stock and decide whether anything else should be included.

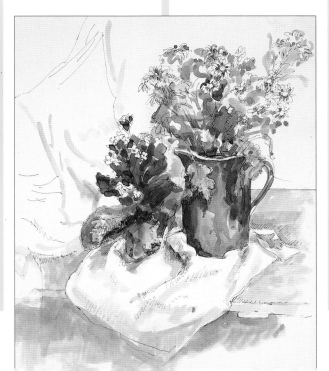

**4** ◄ In the previous stage the drawing had a rather dull, flat bottom edge because the plant pot and jug were in line with each other. The artist thus decided to include the pointed shape of the cloth, which leads the eye into the drawing.

**SELF CRITIQUE**

● Did you manage to make the flowers and plant look three-dimensional?

● Did you find you became too involved with detail at too early a stage?

● Have you avoided drawing superficial detail?

● Has your drawing a feeling of solidity and an underlying sense of construction?

● Have you discovered anything new about your drawing media?

**PROJECT 2**
**Contrasting textures**

For this project assemble a group of objects which presents as many different textures as possible. This can include plants and flowers, but see if you can also lay hands on some unusual objects, for example, an animal skull or a stuffed bird. Fruit and vegetables will make ideal objects, as they offer a wide range of textures: smooth, shiny tomatoes and eggplants will contrast sharply with the heavily grained leaves of some types of cabbage, or the rough, dull surfaces of many root vegetables. Rough stones and smooth pebbles will provide similar texture contrasts. Try cutting some fruit and vegetables in half. Pomegranates, bell peppers or cauliflowers, for instance, can reveal very interesting cross-sections to draw.

You could add a textured background to the group, perhaps a piece of sacking or a coarsely woven fabric. The emphasis in the drawing should be on textures, but these must enhance the solidity of the particular object and help to give the drawing a feeling of three-dimensional space.

Remember that you must experiment with different drawing media and with textured and colored drawing paper. Make your drawing as large as possible.

**KAY GALLWEY**

**1** ▶ The artist is working in pastel on toned paper, and has begun with a light application of black to indicate the positions of the fruit and vegetables in the basket.

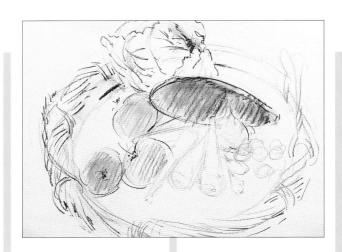

**2** ▶ More black is used, and some white and off-white introduced to build up the textures and tonal contrasts.

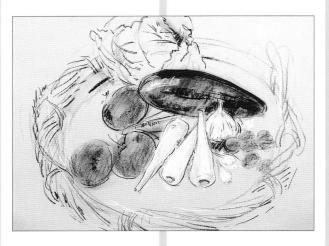

**3** ◀ The shiny surfaces of the eggplants have been described by rubbing the black pastel with a finger (blending), and then applying highlights on top. The shapes are now drawn more firmly.

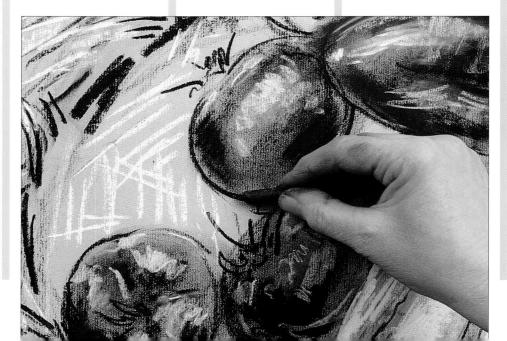

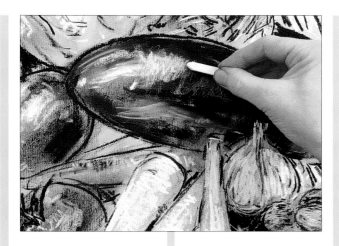

**4** ▲ **Further highlights are applied to the** shiny surfaces of the eggplants which contrast nicely with the rougher textures of the garlic and parsnips. Here the pastel has not been blended.

**5** ▼ **Excellent use has been made of the** mid-tone of the paper, and the medium has been freely used to describe the contrasting textures of fruit and vegetables, and the hard, stiff basket that contains them.

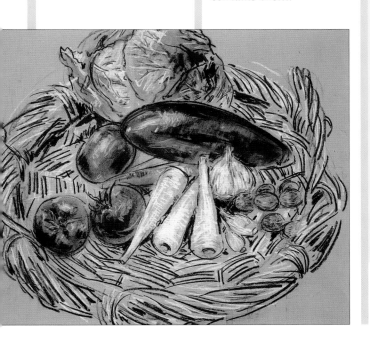

**SELF CRITIQUE**

● Does your drawing hang together as a whole, or does it look like a series of separate studies of individual objects?

● Did you choose the most appropriate media for describing the various textures?

● Did you discover any medium which automatically suggested a particular texture you wanted to describe?

Do you think textures will now play a more important role in your drawings?

Did you find that drawing textures on a small scale gave you ideas that you might apply to larger objects such as trees and shrubs?

● Have you now a greater awareness of the capabilities of the various drawing media?

bark, and lose sight of the fact that the tree is a three-dimensional form. This can make the drawing look flat and unconvincing.

Texture is important, however, and you will need to find ways of describing surface qualities and contrasting one with another. Texture can also be important as a useful means of revealing form and creating a sense of depth. For example, the way the texture of an animal's fur changes over the undulations of its body gives a perfect description of the underlying form, while the lumpy, receding furrows of a roughly plowed field can give an excellent illusion of three-dimensional space.

Many things can be implied in drawings without their actually being stated. The silhouettes of objects can suggest their texture. A firm, precise shape might be used to suggest, perhaps, the smooth surface of a tomato, and a blurred edge to give a feeling of the soft fur of an animal. These devices have to be used sensitively and, equally important, experimentally. There are no formulas for creating the texture of feathers, stone or grass; you have to look with great concentration and distill from what you see the things that seem important to you.

Just as the objects you draw have textures, your drawings contain their own textures produced by the intrinsic qualities of the materials you use. A scribbled area of pencil lines, for instance, has a quality which is different from the effect created by shading with conté crayon, or the smoothly blended tones that can be achieved by using wash. Lines

92 ▷

also have textural possibilities which can suggest the particular qualities of objects. A pencil can produce a hesitant, soft, gray line which contrasts with the sharp definite line of a pen.

**EXPERIMENTING WITH DRAWING MEDIA**
You should experiment with the textural qualities of different drawing media in these projects, and also with different kinds of paper, both colored and textured. Sometimes you'll find that a particular medium will describe a texture quite naturally. Charcoal used on its side on a roughly textured paper may automatically create a texture which will describe stone perfectly. The sharp, spiky texture of a field of corn stubble may best be described with the stabs and spatters of a pen used very quickly on smooth paper. You need not use the same medium throughout; your experimentation should extend to making multi-media drawings. Some media are much better than others at describing particular textural effects, and it is important to choose the most effective for the job.

▲ Audrey Macleod
*Charcoal*
The ability of charcoal to create a wide range of textures is clearly illustrated in this attractive drawing. A firm line has been used for the apples; the texture of the paper has been allowed to show through charcoal shading on some of the trees, and the charcoal has been rubbed smoothly for the foreground field. The artist has made excellent use of the contrast between the downward sweeping branches of the apple tree and the more upright trees.

◀ Pip Carpenter
*Oil pastel*
In **White Daffodils** oil pastel has been used freely to describe the upward thrust of the stems, and rubbed with a finger in the direction of the growth of the petals to create a feeling of life and movement. The contrasting texture of the background has been created by scraping into the oil pastel with a palette knife, a technique called sgraffito (see pages 191–2).

► Elizabeth Moore
*Pen and watercolor*
Line and color have been skillfully combined in this sketchbook study to describe the different textures in the group. Firm lines and scribbled shading with the pen have been aided by lovely touches of color, and slightly more elaborate painting of the foreground fruit.

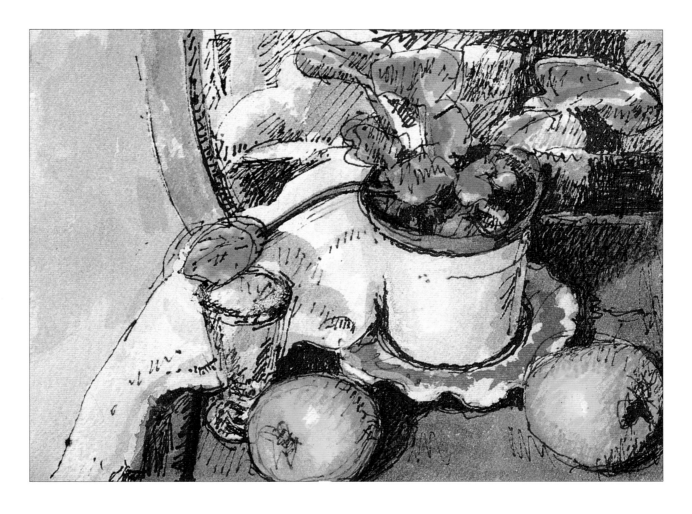

◄ James Morrison
*Pencil*
In this sketchbook drawing the artist's first concern has been with the strong, almost architectural shape of the main tree, but he has also given a general impression of the contrasting textures.

# Human proportions

Perhaps more than with any other subject, when we draw the human figure, we tend to ignore what we see and draw from our imagination. Some students seem to base their drawings on other figure drawings they have seen, while others produce an idealized figure with quite different proportions from those of the model posing for them. This is because the figure is the most familiar of all subjects, which makes it difficult to approach it without preconceptions, and look at it in the way that we would a plant or tree.

## PROPORTIONS OF THE BODY

There is, of course, no standard human being; everyone is different. But since the similarities are greater than the differences, it is useful to remember some general points about the figure, and in particular about its proportions and measurements.

The head, measured from the crown to the chin, is used as the "yardstick" for measuring the height of a standing figure. Many artists have devised systems of proportion, and opinions have varied as to the precise number of heads which will measure the height of a figure. However, since the 19th-century anthropometrist Professor Paul Richer, who spent a lifetime measuring figures of different ages, decided that the length of the body of both the adult male and female comprised seven and a half heads, this proportion has been widely accepted. Proportions of seven or

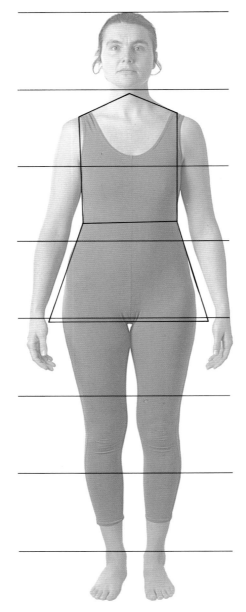

## STANDARD MEASUREMENTS
◄ Few of the people you draw are likely to conform absolutely to a norm, but you will find the rule that the body is seven and a half heads high useful as a check.

## FEMALE/MALE
◄ ► As a general rule, the man's shoulders are broader and squarer than the woman's, and the hips are narrower in relation to the waist. The proportion of the head to body is more or less the same.

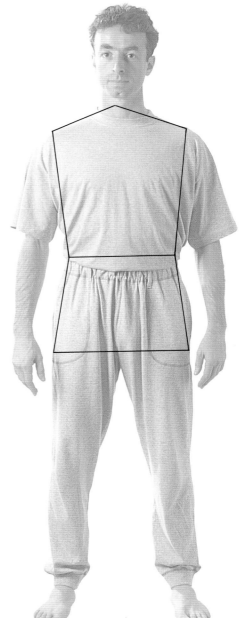

eight heads are sometimes quoted, perhaps as much for easier measuring as for any other reason.

The other key proportion is that of legs to torso. The groin is the approximate halfway point in the height of a standing figure, not the waist, as people sometimes assume. There are, of course, differences between male and female, and although these basic proportions are similar, the male is generally much broader across the shoulders and narrower at the hips than the female.

## PROPORTIONS OF THE HEAD

Not surprisingly, drawing the head presents similar problems to drawing the figure. The proportions tend to be ignored as you try to draw those features which you feel will make the person identifiable. The surprising thing about the head is that the features occupy a much smaller part of it than most people at first think. If you have a front view of the head and measure the position of the eyes, you will find that they are on a line approximately halfway between the crown and the chin. A line drawn through the bottom of the nose is halfway between the eyes and the chin, with the mouth approximately halfway

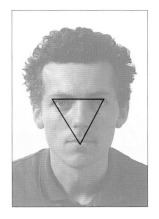

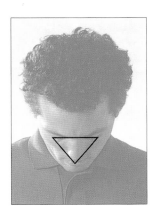

**ANGLES OF THE HEAD**
**When the head is angled upwards, downwards or to one side, it is seen in perspective, and the features occupy less space than in a straight-on view.**

between nose and chin. The depth of the head is also deceptive. Seen in profile, the distance from back to front is the same as from the crown to the chin.

## CHECKING AGAINST THE "NORM"

The drawings that result from a rather casual look at the figure often have two major mistakes: overlarge heads and legs which are too short. It is always wise to check your drawing to see that the head and legs are about right according to "average" proportions. You will obviously find that some people have shorter legs than average, or smaller heads, and you should recognize and record these characteristics.

It is not too difficult to check proportions when you are drawing a standing figure, but it is harder when the subject

is seated. In this case, particularly if the view is from the front, you must take account of foreshortening when you check the proportions, so to judge whether the proportions would be reasonable, you have to imagine the seated figure in your drawing actually standing.

The most common error in portrait drawings is making the features much too large. Also, if the head is seen in profile or from a three-quarter view, its depth is often underestimated.

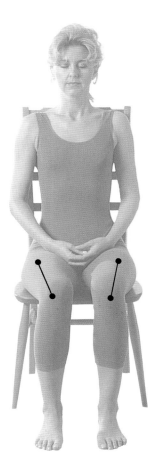

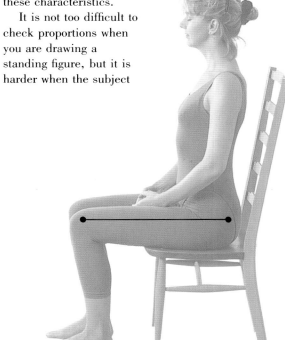

**FORESHORTENING**
**▲ ◀ The rules of proportions are not much use when it comes to foreshortening – here you must trust your eyes. Compare the relative lengths of the thighs in the photographs left and above.**

THEMES AND TREATMENTS

# Drawing a head

**S**o far, most of the objects you have drawn could be categorized as still life or natural forms. These provided convenient subjects for starting the course, not least because they were readily available and could be easily arranged to provide particular drawing problems. I now want you to transfer the skill and experience you have gained from drawing objects to a more ambitious subject – the human figure. This may seem totally different, but remember that different subjects don't require different ways of drawing. No matter whether you're drawing a still life, a landscape, a building, a figure or a portrait, the basic problems of seeing, selecting and translating remain the same.

**SIMILARITIES AND DIFFERENCES**
I have already said that natural forms are based on geometric ones, and the same applies to the human figure. In this lesson you will be drawing heads, first your own and then a portrait of someone else. You will find that you are presented with similar problems to those you had in the earlier lessons. A three-quarter view of a head is not very different from a similar view of a box, and the roundness of cheeks and chin, and the hollows in which the eyes sit, are similar to the convex and concave forms you drew earlier. The perspective of a head is also the same: lines drawn through the eyes and the mouth, for example, would when extended converge at a vanishing point on your eye level. An awareness of the position of your eye level, and the points on the head which are above and below it, are just as important as if you were drawing a building.

The forms of the head, however, are more subtle than those of boxes and cylinders. Perhaps the main difference between drawing the figure and other natural forms is that the figure demands a standard of accuracy which is generally far greater than that required for drawing a tree or plant. Inaccuracies in a flower drawing may not be

101 ▷

## THE AIMS OF THE PROJECTS
**Making drawings which look solid and three-dimensional**
___
**Understanding the structure of the head**
___
**Relating perspective to the features**
●
## WHAT YOU WILL NEED
**Your choice of drawing medium; you can use more than one. You will also need a mirror for the first project and someone to pose for you for the second. You will need your portrait model for about 4 hours, but they can pose in two or more sessions**
●
## TIME
**About 4 hours for each project**

**PROJECT I**
**Drawing a self-portrait**
Choose a drawing medium which allows you to build up good solid masses of form. Position yourself in relation to a mirror so that you have a three-quarter view of your head, not a full-front view, and sit so that you are comfortable and can move your eyes from your drawing to the mirror without moving your head. This is important. It will help you to draw accurately, and save you having to reposition your head each time you turn back to the mirror after drawing. If possible, position the mirror so that light falls on your head from one direction.

Drawing a self-portrait will reveal a number of things about your appearance you may not have been aware of before. You may be surprised at how asymmetrical your features are. Slight differences between the shapes of your eyes or a twist in your nose are examples of things to look for and record. These are the features which give your face character and will make your drawing look authentic and convincing.

**Shape and proportions**
Before you begin to consider the details of features, however, make certain that the main proportions of your head are correct. Check the overall shape of your head. Is it long and narrow? Is it rather square? Then, remembering your drawings of natural forms, try to make your basic head shape look three-dimensional. As you draw, think about what you see. For example, your eyes are in hollows and your lips are two rounded surfaces, one probably turned up towards the light and the other in shadow. Don't worry about getting a likeness. Your first priority is to make the drawing look three-dimensional, with the features fitting convincingly. The nose is a feature which often causes problems in drawing. It is a form projecting from the front of your face, and you must draw it indicating planes at either side and underneath. Often the three-dimensional form of the nose is ignored, and two dark holes for nostrils are drawn, but nostrils are usually of secondary importance; what matters is the nose itself.

3 ◄ Further touches of lightly applied colored pencil introduce hints of color, and build up the forms.

**KAY GALLWEY**

1 ▲ Conté crayon has been used lightly on toned paper to establish the shape of the head, the position of the features and the main areas of shading which will make the head appear solid and three-dimensional.

2 ▼ Having added light areas, the artist is now drawing with a colored pencil to build up the darks and define detail. The paper itself is used as a mid-tone.

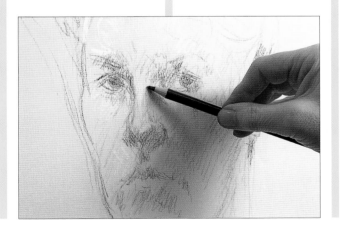

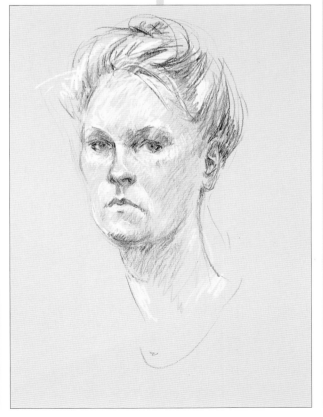

4 ◄ Although the artist has concentrated solely on the head, the drawing has not been allowed to become tight and over-detailed. The features are well described, but the shading and touches of color have been applied in a free and spontaneous way so that the drawing remains full of life. Another approach to self-portraiture is shown overleaf.

THEMES AND TREATMENTS

**KAREN RANEY**

1 ◀ The drawing has been started by blocking in the main forms of the head freely in charcoal. Notice how at this stage the artist has concentrated on the overall shape of the head.

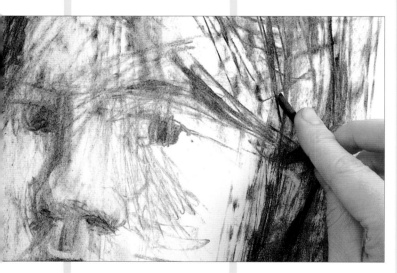

2 ▲ She now begins to describe the features, still broadly, and draws in "checking lines" across the head to make sure that they are accurately positioned. Although heads and features vary, it is worth remembering that the brows almost always line up with the tops of the ears.

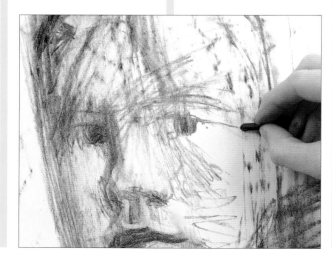

3 ▼ The direction of the hair is now indicated, and the artist continues to check and re-check various points.

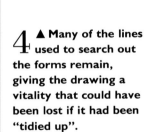

4 ▲ Many of the lines used to search out the forms remain, giving the drawing a vitality that could have been lost if it had been "tidied up".

**SELF CRITIQUE**

● Does the head look solid and realistic?

● Did you spot the irregularities in your features and draw them?

● Has the drawing a feeling of life or is it like a mask?

● What have been your main problems?

**PROJECT 2**
**Drawing a portrait**
Make sure your model is comfortable, and doesn't look stiff and uneasy. He or she can read or knit, providing the head and body are kept in more or less the same position. If it is an appropriate time of the year, you can pose your model outside, or in a greenhouse or conservatory – forget the conventional portrait with its dark, vague interior background.

Position yourself so that you have a three-quarter view, and use a different medium from the one you chose for the self-portrait; you may like to use color, but it is not essential. Don't try to draw the whole figure, but concentrate on the head and shoulders.

Drawing someone other than yourself may seem a little daunting at first. You may be anxious about how they will react to seeing your

impression of them. Don't be too concerned with drawing a likeness though. Approach this drawing as you did the self-portrait, giving consideration to form, color and tone. If you look hard for the underlying structure of the head and face, and what you judge to be the most important aspects of the sitter, you will probably end up with a likeness.

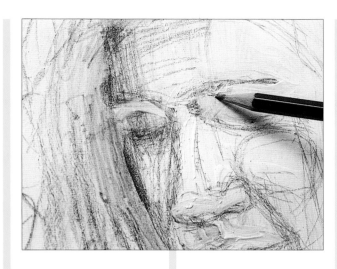

**4** ▲ **As the drawing nears completion, the lips are given greater definition.**

**3** ▲ **All the features are being developed at the same time, and seen in relation to one another.**

**5** ▼ **The finished drawing is a very direct statement of what the artist has considered important.**

**KAREN RANEY**

**1** ◀ **Here the artist is using a technique of her own, which involves applying a layer of acrylic gesso (a thick substance mainly used as a primer for painting), and then drawing over it with conté pencil. Here the gesso is painted over a drawn line to correct it.**

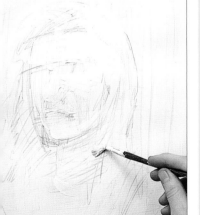

**2** ◀ **The features are now more clearly defined, but the emphasis is still on the broad shapes and the planes of the face.**

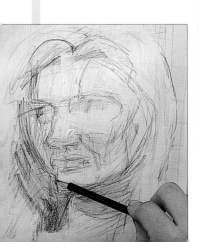

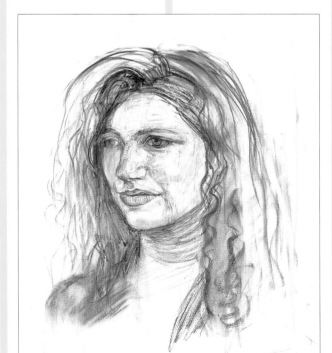

**SELF CRITIQUE**
● Does the portrait head look solid?

● Did you find that you became too involved with detail?

● Did you find this drawing easier or harder than the self-portrait?

● Does the drawing look like the sitter?

● If not, can you analyse the faults?

► John Houser
*Carbon pencil*
With profile views it is difficult to stop the head from looking flat, but in this drawing of a Seri Indian the artist has modeled the cheeks, forehead and chin with great skill and delicacy. All the attention is on the features, with the sitter's headgear (a plastic rainhood) merely indicated.

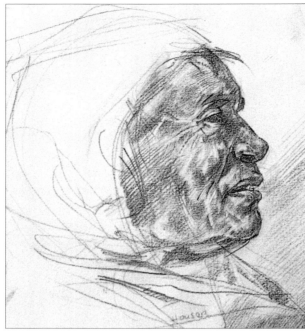

▼ John Lidzey
*Pencil*
This sketchbook self portrait is amazingly convincing – it almost seems to jump out from the page. Notice that there is no conventional line around the head; the artist has concentrated on the play of light on the features, suggesting the top and sides of the head with a few lines standing for hair and ears.

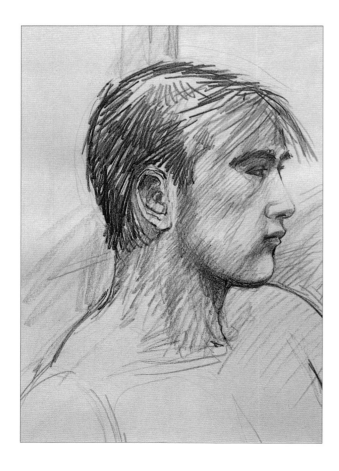

◄ Ray Mutimer
*Colored pencil*
The modeling of forms is equally fine in this profile view, and the glimpse of the far eyebrow and eyelash, and the shoulder seen overlapped by the chin also help to create depth and volume. The spiky hair provides a lively contrast to the more smoothly drawn features, and the touches of color are very effective.

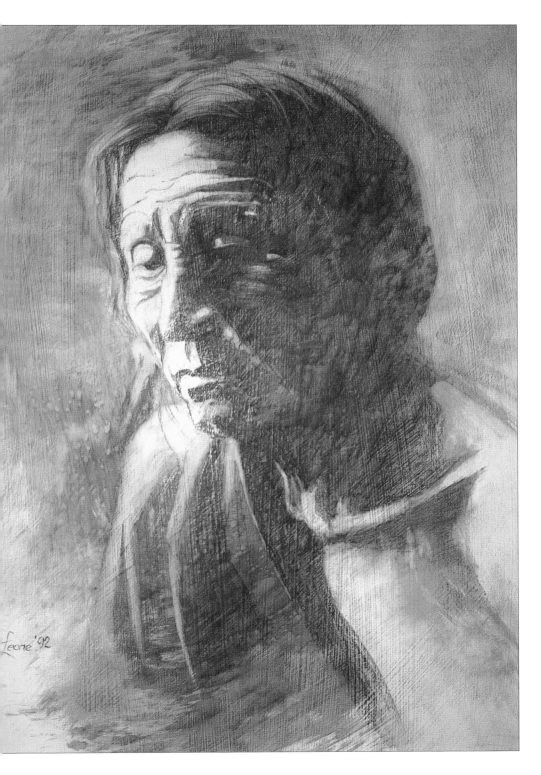

noticed by anyone other than a botanist, but we are all experts on the human figure and can readily identify unlikely forms or proportions.

## THE IMPORTANCE OF LIGHTING

Generally, the forms of the face and head can be explained by selectively describing the light falling on them, and thus the way it is illuminated is very important. For each project in this lesson you will probably need more than one drawing session, and you will have to have the same lighting for each session. If you are working from natural light, that means you must plan your sessions to be at roughly the same time of day. In the first project you are asked to draw your own head, lit from one side so that the shadows will help you to create the impression of solidity. In the second project you can experiment with the lighting.

In the history of portraiture there have been different preferences for the way the sitter should be lit. Some artists, of whom Rembrandt (1606–69) was one, liked strong contrasts of light and dark. Others worked in what became known as the "Italian manner," without extremes of tone. If you light your model from the front, you will be able to try the rather flat lighting which characterizes the Italian manner. Whether you use natural or artificial light, experiment with lighting your model from different angles and directions.

◀ Leonard J Leone
*Conté crayon*
**In Tough Times** was drawn on a primed panel rather than paper, giving a rich painterly quality. The shadowed side of the figure has been beautifully drawn in a single tone, and the light side of the head separated from the soft background with a sensitive line which at some points completely disappears.

# Drawing the clothed figure

From drawing heads you are now going to move on to what is arguably the most challenging of all subjects, the human figure. To make successful figure drawings, you have to learn how to look for the essentials and ignore any preconceptions. In the case of a standing figure, it is vital to be able to analyze the characteristics of a particular pose. The best way to understand what this means is to get someone to stand for a few seconds first in one position and then in another, and try to see what effect this change of position has on the body. Notice, for example, that if the weight is mostly on one leg, the hip above this leg is raised and the opposite hip drops. If you then look at the shoulders, you will find they compensate for the tilt of the hips by sloping in the opposite direction. In order to avoid falling over, an unsupported figure has to maintain its balance around a center of gravity. You will find that a figure standing with its weight on one leg has its head on a vertical line directly above this leg. Check this for yourself, and check also how the center of gravity changes with the pose.

## DRAWING FROM THE RIGHT PLACE

The distance from which you draw the figure is very important. You already know that most people draw objects the actual size they see them, and so if a figure is to be drawn reasonably large on an A2 size sheet of paper, it's no use drawing it from a distance. There is, however, a danger in being too close. Unless you draw a figure from six to eight yards away, you may produce a very distorted drawing because you won't be able to see the complete figure at one glance. You will have to look up at the head and down at the feet, producing what is in effect drawings of two different views joined together.

## USING THE BACKGROUND

In the first project you will be making a series of three-minute drawings, which won't give you time

109 ▷

---

**THE AIMS OF THE PROJECTS**

**Identifying the essential features of a pose**

---

**Making rapid drawings**

---

**Making convincing drawings of clothed figures**

•

**WHAT YOU WILL NEED**

Your choice of drawing materials and a model. The drawings in Project I could be made in your sketchbook. You will need large-size paper for Projects 2 and 3

•

**TIME**

Project I: about $1\frac{1}{2}$ hours. Projects 2 and 3: about $2\frac{1}{2}$ hours each

---

**PROJECT I**
**Short poses**

In order to grasp the importance of analyzing a particular pose and drawing its essential features, this project requires you to make several quite rapid drawings. If possible these drawings should all be from standing poses because when the figure is standing, the balance and center of gravity are most obvious. Start by making ten drawings of different poses with your model posing for not more than three minutes each time. You will find that three minutes is long

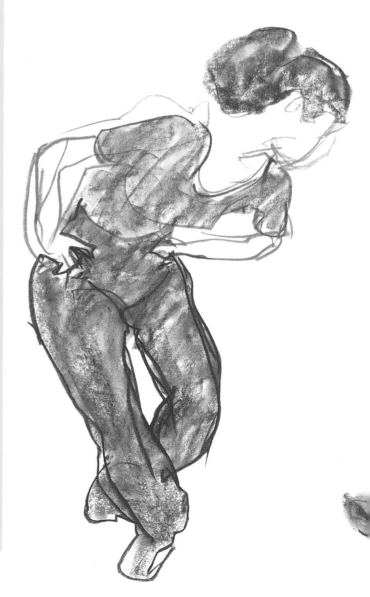

enough to allow you to record the essentials of each pose. The drawings can be almost like stick figures, but they must show the angle of the shoulders and hips, and the position of the head and legs. Ask your model to bend forward in one pose, and backward in another. Have the weight on one leg and then on the other, and so on, trying as wide a range of poses as possible. The position of the hands is important. They should be above the head for some poses and reaching sideways in others.

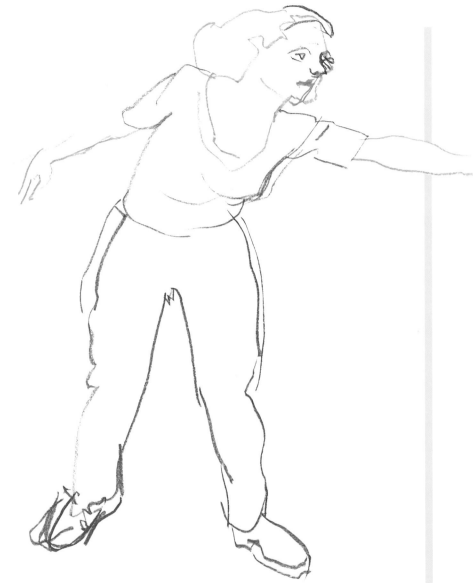

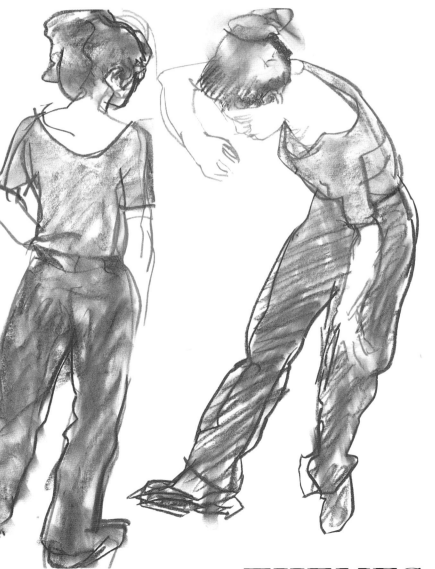

**ELIZABETH MOORE**
◀▲ These drawings have each been made in no more than three minutes, drawn rapidly in line with pastel. Pastel is an excellent medium for quick studies, as you can block in areas of color and tone very speedily.

## THEMES AND TREATMENTS

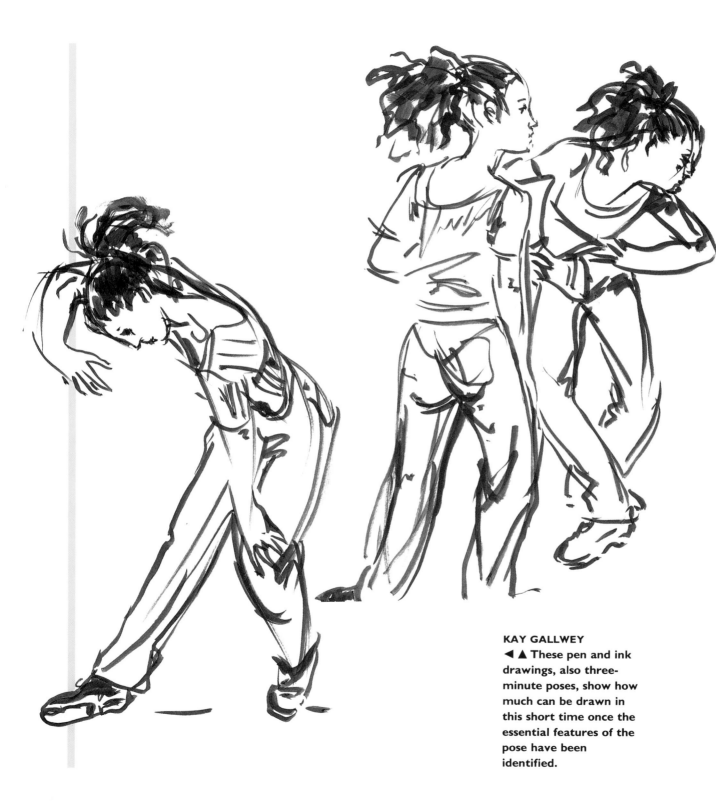

When you have completed these drawings make four further ones, this time asking your model to pose for fifteen minutes each time. These should also be standing poses. With these four drawings you should still be looking for the essential features of the pose, but trying to develop the drawings much further, and including some suggestion of background. They won't be finished drawings, but the complete figure should be indicated — even the hands and feet. Draw the main features of the head, but don't bother about much detail; what is important is to get the main characteristics of each pose so that the figures stand properly balanced.

**KAY GALLWEY**
◄ ▲ These pen and ink drawings, also three-minute poses, show how much can be drawn in this short time once the essential features of the pose have been identified.

**SELF CRITIQUE**

● Do the figures describe the essentials of the poses?

● Which drawing is best and why?

● Do the drawings have life?

● Have you managed to keep them simple and direct?

**ELIZABETH MOORE**
▼ In this brush and wash drawing the artist has used shapes and directions in the background to assist her in getting the balance of the figure correct. She has clearly identified and drawn the tension in the left side of the figure, with the weight firmly placed on the left leg, and the right side of the figure more relaxed.

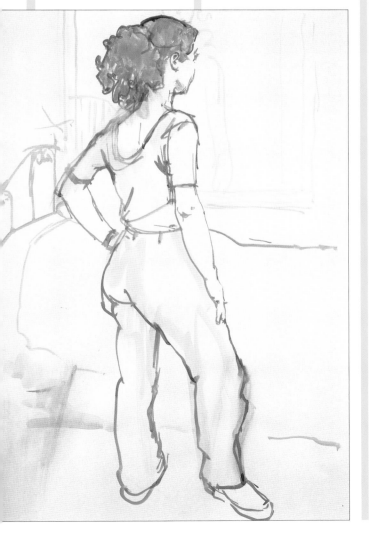

**tip**

**USING A PLUMB LINE**
Drawing a standing figure is always easier to draw if you have a vertical to use as a reference. If there isn't one in the background, you may find that a plumb line is a helpful alternative. For hundreds of years artists have drawn figures with the aid of a plumbline, which is simply a weight on the end of a length of cord. If you are a carpentry enthusiast you may already have a plumb line, but if not, one can be made in seconds. All you need is a piece of thin cord about a yard and a half long and something small and comparatively heavy with a convenient hole in it through which to thread the cord.

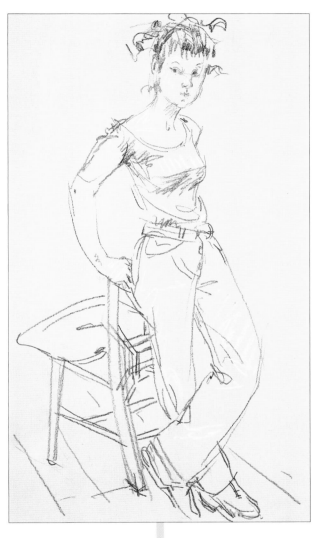

**KAY GALLWEY**
▲ Using black conté crayon, the artist has in fifteen minutes produced a lovely figure study which provides a surprising amount of visual information about the model's clothes, features and hairstyle.

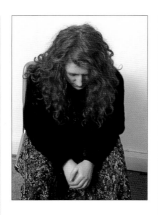

**PROJECT 2**
**A seated figure**
In this project you will be drawing a figure with the head tilted downward. When someone is looking down, their features are foreshortened, and you see more than usual of the top of their head. When you have a front or three-quarter view of the head in an upright position, the nose is slightly foreshortened, but with the head tilted

down the nose appears to be longer. When the head is held upright, the features occupy half of it, but when the head is looking down, they may occupy a third or less.

Have your model sitting comfortably on a chair looking down at his or her knees, with hands resting on thighs or holding a book. You have more time for this drawing than the previous ones, but start in the same way, spending fifteen minutes or so just getting the proportions of the figure and the characteristics of the pose right. Try to draw with as much freedom and vitality as you did with the short poses.

**KAREN RANEY**

**1** ► **Working in charcoal, the artist has started by drawing the distinctive shape of the hair framing the head and below it the triangle made by the figure's arms and clasped hands.**

**2** ▲ **The foreshortened features of the head have been identified, with the full length of the nose drawn and the lower part of the face reduced almost to nothing.**

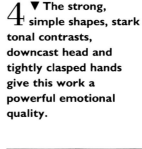

**3** ▲ **The strong vertical lines used to shade the sweater add to the downwards thrust of the pose.**

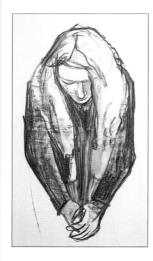

**4** ▼ **The strong, simple shapes, stark tonal contrasts, downcast head and tightly clasped hands give this work a powerful emotional quality.**

**SELF CRITIQUE**
● Have you managed to capture the essential features of the pose?

● Have you used the background effectively?

● Did you have difficulties with the foreshortening?

● Has the drawing suffered through having a longer time to develop it?

● Would you try another medium next time?

## PROJECT 3
### More foreshortening

For this project pose your model sitting or lying down with legs drawn up or crossed, and the arms in any comfortable position. If you choose a reclining figure, look for anything which will describe cross-sections of the figure; it will be helpful if your model can wear a T-shirt or similar garment with horizontal stripes. Unless you draw a side view, the main challenge in drawing a reclining figure is again foreshortening, and if the body is severely foreshortened, as it will be if you draw from in front of the model's feet, or behind his or her head, it is difficult to indicate the true size and solidity of the figure. Posing your model in stripes will make you more aware of its three-dimensional form. If you choose a seated figure, look carefully at the foreshortening of the legs. And don't ignore the other aspects of perspective; if your model is sitting or lying on a bed or a couch, you will have to assess the angles of its receding sides very carefully.

You need not draw from directly in front, but you do want some degree of foreshortening, so start by making some quick sketches so that you can decide on the best view to take. Once you start your main drawing, work as you did in the last project, but be sure to relate the figure to whatever it is lying on. This will also help you to get the foreshortening right – it is almost always underestimated. Think about how the width of the figure, or an individual limb, compares to its length, and remember that often the best way to get a difficult shape right is to draw the negative shapes around it.

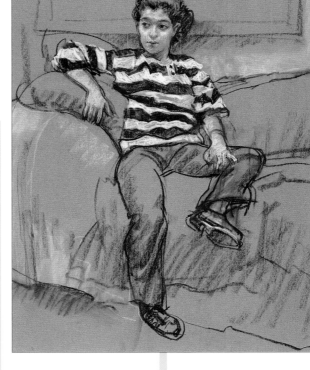

**ELIZABETH MOORE**
▲ In this pastel drawing the artist has used the shapes around the figure to help her to assess the slight foreshortening of the left arm, the lower torso and the legs.

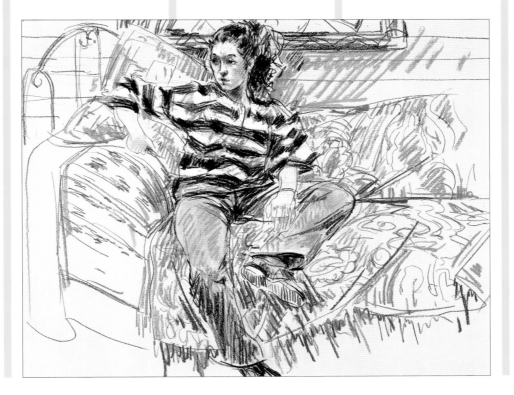

## SELF CRITIQUE
● Does the figure in your drawing look as if it's lying down?

● Is the foreshortening convincing?

● Have you seen cross-sections and used them in your drawing to explain the forms?

● Is the perspective of the couch or bed correct?

**KAY GALLWEY**
◄ The figure in this conté drawing of the same pose is more closely integrated with its background. As in the drawing above, the striped shirt has been used to explain the three-dimensional form of the figure, but it has also been drawn to contrast with the floral patterned rug on which the model is sitting.

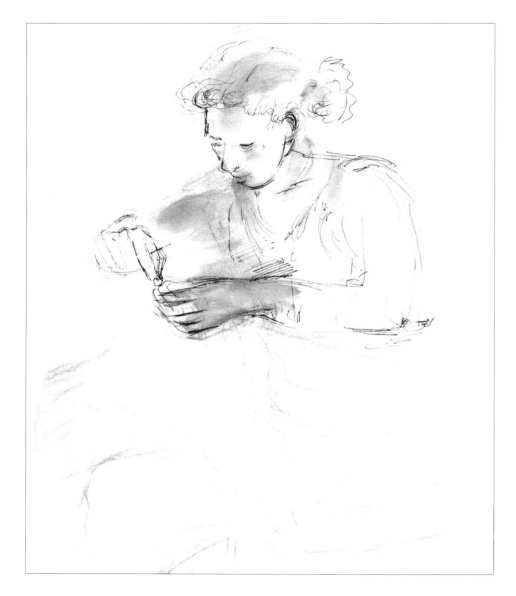

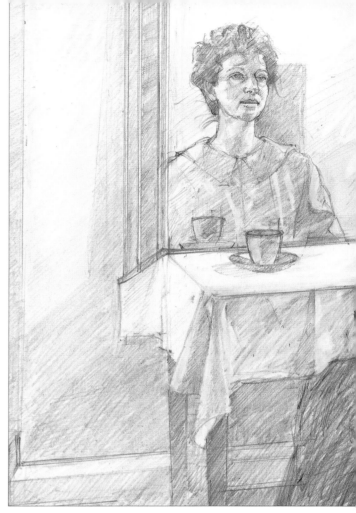

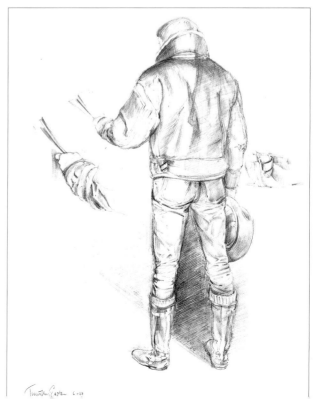

▲ Audrey Macleod
*Fiber-tipped pen and chalk*
Chalk has been smudged to provide misty areas of tone, blending perfectly with the loose, sketchy but sensitive pen lines which emphasize the head and hands.

▶ Timothy Easton
*Pencil*
In this drawing, although the balance of the figure and the proportions are beautifully observed, the emphasis is on the clothes. The artist has described the seams on the jacket, the pockets on the trousers, and the buckles on the boots in great detail. However, he has also used every opportunity to describe the underlying forms, and the figure is completely convincing.

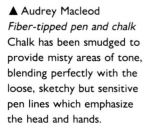

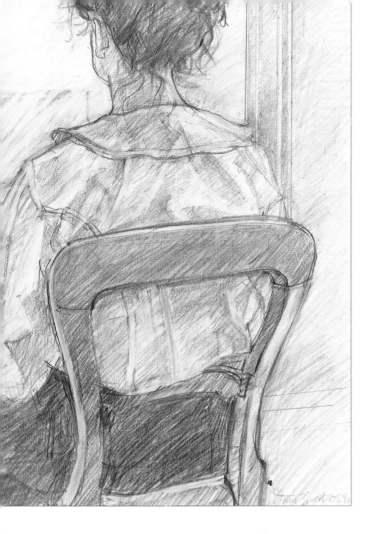

◄ John Sprakes
*Pencil*

This unusual drawing gives a back and a front view of the figure simultaneously by using a mirror – the sides of which have provided useful verticals against which to relate the figure. The drawing has a strong narrative element, and every part of it has been carefully considered; note, for example, the inclusion of the cup and saucer. There is variety and vigor in the way line and tone are used, and the drawing has life and vitality as well as a high degree of control.

to draw any background, but normally you should not draw the figure in isolation. You have already discovered how useful the background is as a check for getting directions and shapes correct, but there is another important reason for drawing the background. Unless there is an indication of three-dimensional space behind the figure in your drawing, it will be almost impossible to make it look real and solid. Even a few lines describing perhaps the corner of a room or the shape of a window frame can be sufficient to create a feeling of depth.

## THE FIGURE BENEATH THE CLOTHES

You will be drawing clothed figures in this lesson, so you will have to cope with an additional difficulty. Although garments simplify the forms of the figure, they can also disguise them, so it is necessary to consider the body underneath if the drawing is to look convincing. This doesn't mean that you have to be able to imagine the concealed figure in great anatomical detail, but it is important to visualize the way the neck, appearing from a shirt, joins the shoulders, or the legs, visible below a skirt, join the hips.

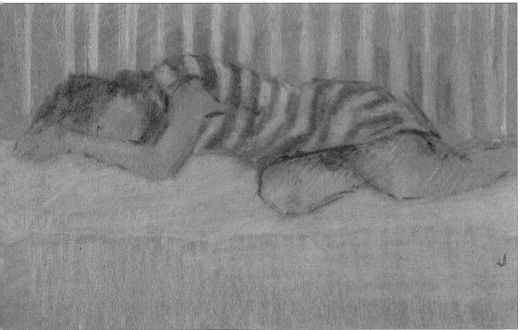

◄ John Denahy
*Pastel*

In **The Striped Dress** the artist has cleverly used the two sets of stripes to contrast the three-dimensional form of the figure with its flat background. The simplified treatment of figure and foreground ensure that nothing detracts from the stripes which form the theme of this very effective drawing.

# THEMES AND TREATMENTS

# Drawing the nude

. . . . . . . . . . . . . . . . . .

In the past, the life room was seen as the place where real drawing was learned, and the nude figure was regarded as the subject which, once conquered, would enable the student to draw anything. And not only was the nude figure the artist's essential training ground; it also had to be drawn in a particular way. I personally do not believe that there is a kind of hierarchy of drawing subjects with the nude at the highest pinnacle, nor that learning to draw should be concerned with acquiring a particular drawing style. I share the view expressed by the French painter Camille Pissarro (1831–1903). In a letter to his son he advised him: "When you have trained yourself to look at a tree, you know how to look at a figure." However, there is no doubt that drawing the nude is an exciting challenge, and it is interesting that after decades of eclipse in art schools, life drawing is now beginning to come back into favor.

In the earlier lessons you have been training yourself to look at a variety of objects which I am sure will have given you the experience and the confidence now to draw the nude. Don't be overawed, draw it like the other objects you have drawn by selecting what you think is important, and translating from what you see.

## YOUR MODEL

The most important requirement for this lesson, of course, is a model. You may have difficulty in finding someone who is prepared to pose, and even if you can, your work program may have to be determined entirely by their availability. If you can't find a model, there are two alternatives. You can draw yourself in a large mirror, although you will obviously be limited in the poses you can draw, or you can join a life class and share the model with a group of other artists. In the latter case you may not get the exact pose you want, but by carefully choosing your drawing position, you will be able to set yourself problems similar to the ones in the projects.

---

**THE AIMS OF THE PROJECTS**
**Analyzing the characteristics of a pose**

—

**Conveying a feeling of movement**

—

**Gaining further drawing experience**
•
**WHAT YOU WILL NEED**
**You will need all your drawing materials and a model. Read quickly through the projects to see the periods of time for which a model is required. You can use a clothed model for the second project**
•
**TIME**
**Each project will take about 3 hours**

---

## PROJECT I
### A short and a long pose

This project consists of two poses, one lasting about fifteen minutes and the other about one to two hours not including breaks. For the first pose I want you to draw quickly and spontaneously, going for the essential features of the pose. Get your model to stand for this pose if possible. He or she can rest against a table or chair so that they do not have the difficult and tiring task of standing unsupported.

Try to include everything you can in the time available, but if you see that your drawing is basically incorrect, don't add detail. Getting the balance and proportions right matters much more than whether the features or fingers have been drawn.

For the long pose your model should be seated or reclining.

Begin in the same way as you did before, working quickly so that your drawing retains the liveliness of the earlier drawing. You can work in line, or line and tone, using any medium you like. Don't be tempted to begin with small details just because you have more time. Use a plumb line (see page 105) for checking which points fall directly beneath others, and for getting the balance of the figure right.

Every quarter of an hour or so, leave your drawing for a few minutes, and look at the pose from different places in the room. This will help you to understand the way the figure is positioned.

### Drawing without the model

When the model has a break, it doesn't mean that you have to stop drawing. The break gives you an opportunity to assess your drawing, and decide which things need special attention when your model returns to pose. It is also the moment to draw parts of the background which are obscured when the model is posing. This will enable you to see whether everything is fitting together satisfactorily in your drawing. When you are drawing a seated figure, the model's break gives you the opportunity to draw the chair. This is most important. Often you will be much more aware of foreshortening when you are looking at the chair on its own than when the model is sitting on it. Making certain

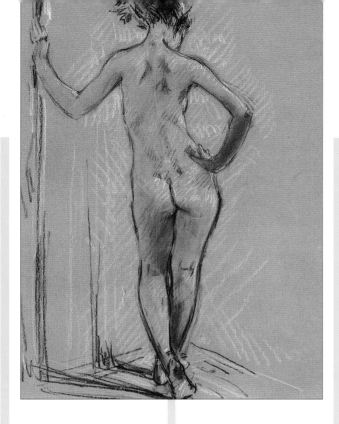

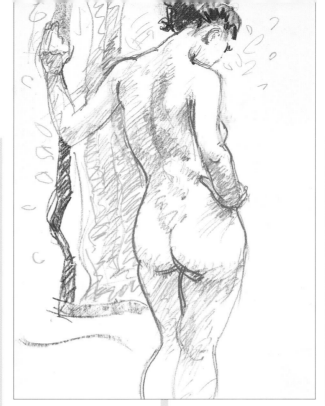

that the chair is correctly drawn and that it rests properly on the floor will help to insure that the figure is accurately drawn as well.

**KAY GALLWEY**
▲ ▼ The fifteen-minute drawing (above) is in charcoal and white chalk, and for the longer pose the artist has used a small range of pastel colors.

**ELIZABETH MOORE**
▲ ▼ Both the fifteen-minute drawing (above) and the drawing of the longer pose are in oil pastel, used as a linear medium (see page 191).

**SELF CRITIQUE**
● Did you find it easier to draw the figure nude than clothed?

● Has the second drawing as much vitality as the first?

● In the second drawing, did you use the extra time to good effect?

● Or did you find yourself "fiddling about?"

● Did you make a good choice of medium for both drawings?

● Did you draw the background in both drawings?

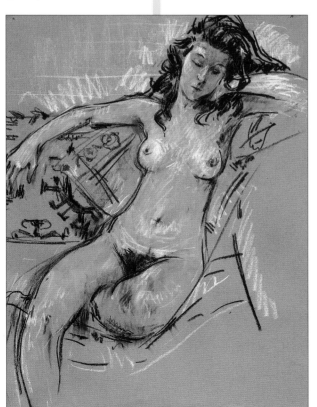

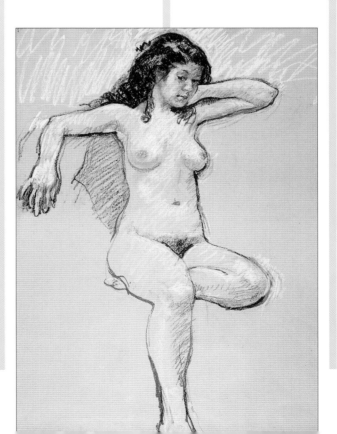

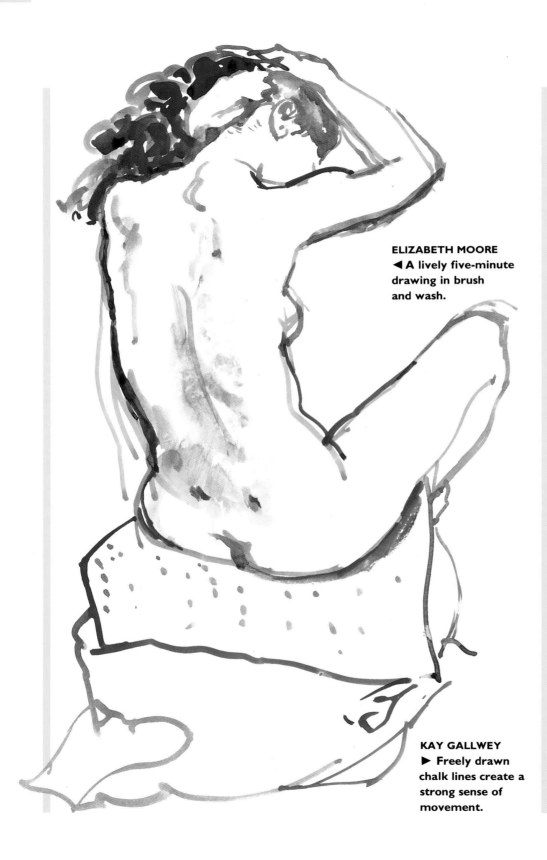

**ELIZABETH MOORE**
◄ **A lively five-minute drawing in brush and wash.**

**KAY GALLWEY**
► **Freely drawn chalk lines create a strong sense of movement.**

### PROJECT 2
### A moving figure

A posed figure provides a fascinating subject, but one which is in a sense contrived. People don't normally remain still for long, and a more natural way to draw them would be as they move.

Movement in a drawing can have two meanings. It can be what I referred to as "inner forces" in Lesson Two, or can mean the description of actual movement, which is the subject of this project. It has three parts, and you should spend at least an hour on each. You can use any medium. The drawings can all be made from a clothed model, but for the last movement sequence a nude will be particularly helpful as it will give you a clearer idea of the changes that take place in the balance of the figure as it moves.

First, make a drawing of a figure standing more or less in one position, carrying out a series of repeated movements. It could be someone ironing, preparing food, or brushing their hair, or it could be a musician practicing or a dancer ▷

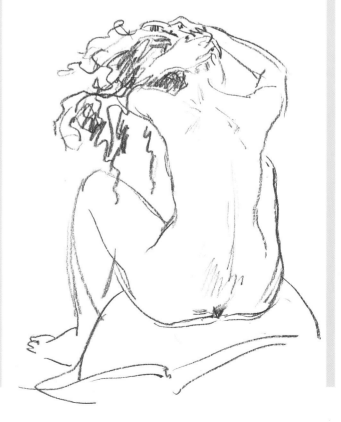

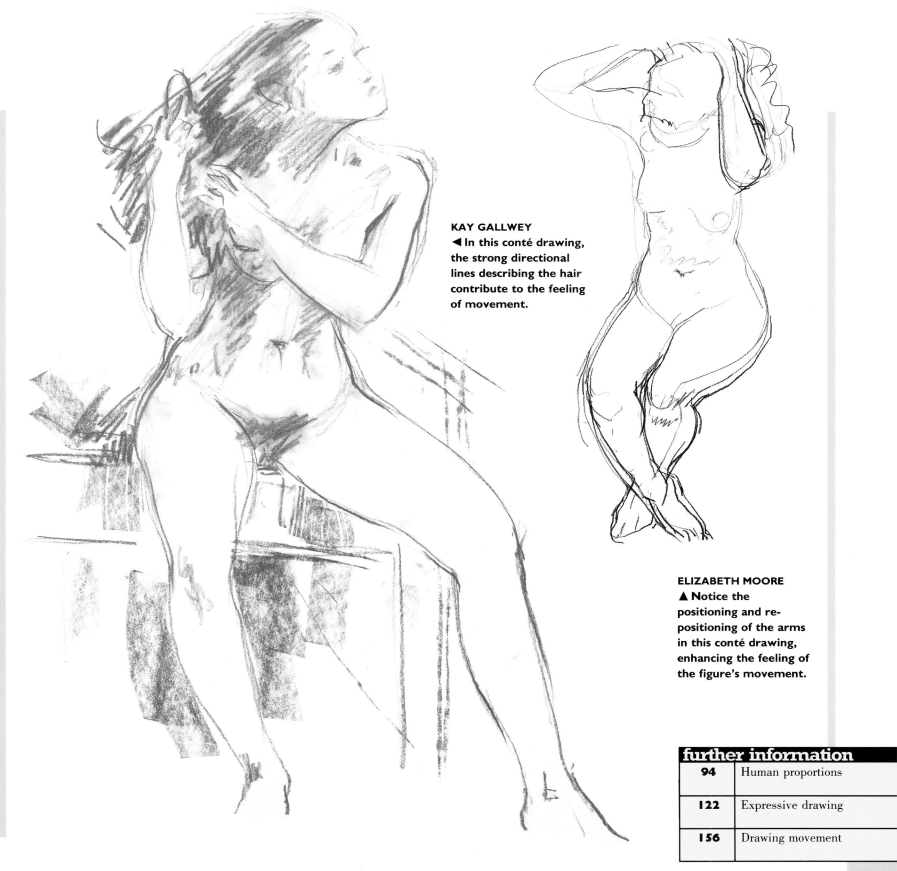

**KAY GALLWEY**
◄ In this conté drawing, the strong directional lines describing the hair contribute to the feeling of movement.

**ELIZABETH MOORE**
▲ Notice the positioning and re-positioning of the arms in this conté drawing, enhancing the feeling of the figure's movement.

THEMES AND TREATMENTS

rehearsing steps. Make a few rapid drawings to decide which particular moment in the movement best captures the activity.

Next, I want you to draw someone rising from a chair. Get your model to sit in a chair, and then get up and move before returning to the original position. Each time he or she begins to rise you will have to look keenly, and memorize the movement. Then draw it from memory as quickly as you can so that when your model returns and the movement is repeated, you can check the action again.

For your third drawing your model should again be moving from one place in the room to another. This time try to follow the whole sequence of movements, making five or more

drawings across your paper showing the figure at five key positions. Your model could start from a standing position, walk very slowly across the room and then slowly sit down. You should move from one drawing to the next in your

sequence of drawings, spending a few seconds at a time on each. Individual figures in your drawing may not turn out to be very detailed, but that doesn't matter – it is the overall effect of movement which is important.

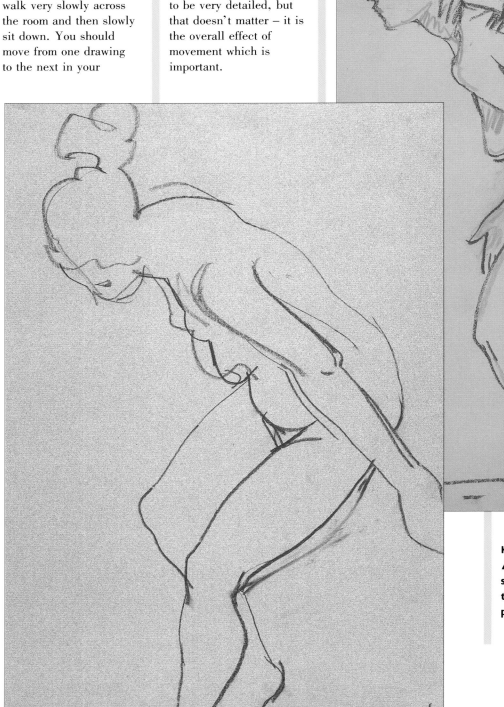

**ELIZABETH MOORE**
▶ **This conté drawing records the precise point at which the model is pushing herself from the chair.**

**KAY GALLWEY**
▲ **The artist has selected a later point in the movement for her pastel drawing.**

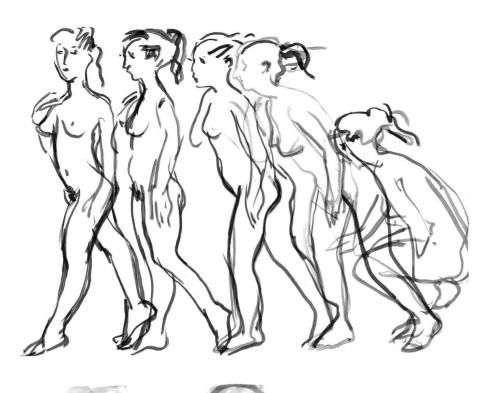

**KAY GALLWEY**
◀ A sequence of five brush and ink drawings shows the model at different moments as she moves across a room. There is a strong element of memory in drawings like this, as you could never draw as rapidly as the model moves.

**ELIZABETH MOORE**
◀ This artist has also chosen to draw with a brush, but with watercolor rather than ink.

**SELF CRITIQUE**
● Even though you have "frozen" a moment in time, do the drawings give a feeling of movement?

● Which drawing gives the best sense of movement and why?

● Did you find that the projects compelled you to draw freely and that this helped to suggest movement?

● Have the figure's proportions tended to become inaccurate as you tried to capture movement?

● Have background features been included in your drawings and did these help you to draw the figure?

● Did you find that any particular drawing medium seemed most appropriate for drawing movement?

# THEMES AND TREATMENTS

▼ Robert Wraith
*Red conté crayon*
This sensitive, delicate drawing is reminiscent of the figure studies of an earlier age by such artists as Ingres (1755–1814), both in the classic pose and the use of the medium.

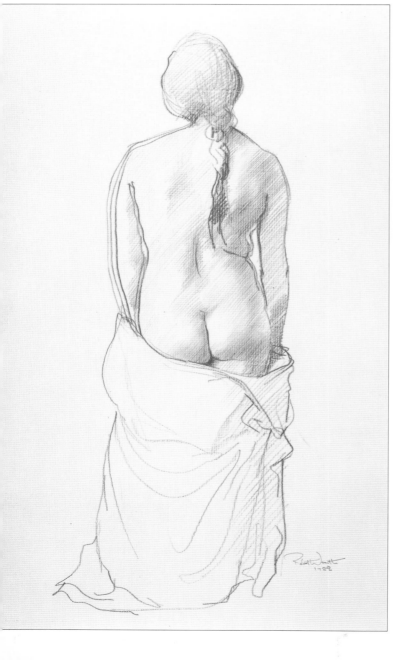

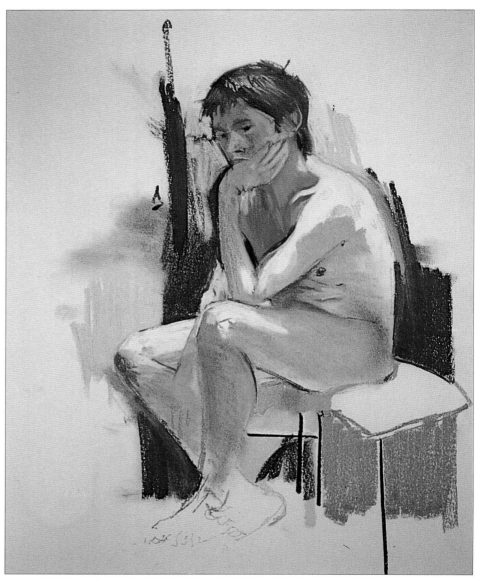

▲ Peter Graham
*Pastel*
Patches of bright color and a strong sense of light on the figure give **The Thinker** a feeling of life and vitality even though the pose is static, and movement is not a part of the subject. It is interesting to compare this use of pastel with some of the drawings on the previous pages, as in this case almost no line has been used.

▼ Paul Millichip
*Colored pencil*
This drawing shows an interesting and highly individual use of colored pencil, with light overlaid lines building up the figure's solidity without appearing to do so in any obvious way. The broken lines, sharp accents and scribble shading give a feeling that the drawing was made at speed before the model had a chance to change position.

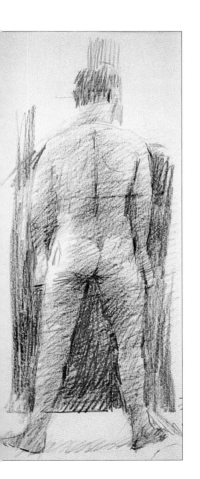

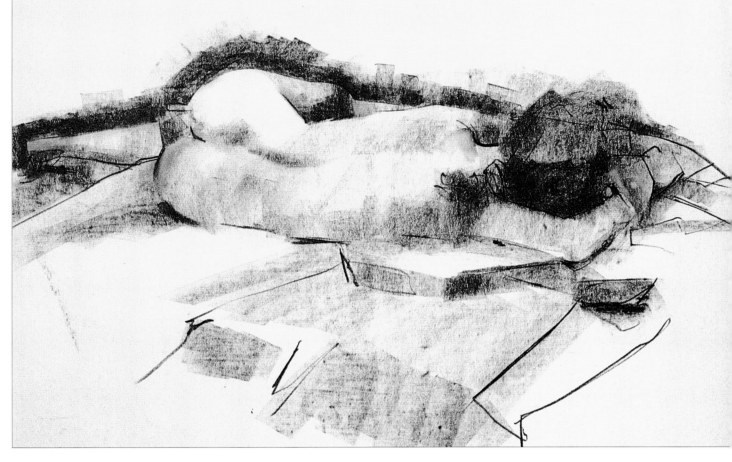

▲ Peter Willock
*Charcoal*
Here the artist's interest has been in the lovely series of shapes made by the figure in repose, and he has worked mainly in tone, with only a few sharp accents in line. The way the charcoal has been applied, however, in broad slabs, radiating out from the figure, gives a sense of the figure's inner dynamism.

# THEMES AND TREATMENTS

# Drawing for painting

A drawing can be an end in itself – a finished work of art – or it can be a means to an end. Drawing is often used by artists in the latter way, as a means of exploration and discovery, and it is widely used by painters for trying out ideas and collecting information. A painter may, for example, draw a landscape from direct observation, and later make a painting of the same subject in the studio, quite removed from the original subject, relying entirely on drawings for information and inspiration.

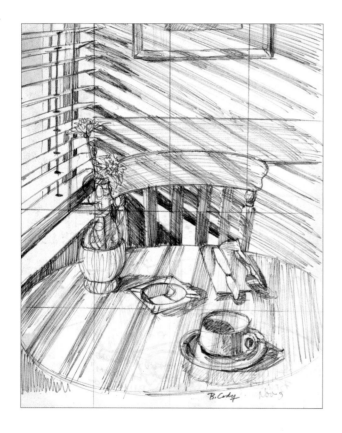

have all the information on shapes, tones, and colors that your painting will require. In order for such drawings to be really useful, it is necessary always to bear in mind the eventual painting. You must concern yourself not with making what you consider to be a beautiful drawing, but with recording the kind of information from which you can later paint.

## WORKING DRAWINGS

Drawings which are made as a step toward a work in another medium are often called working

drawings. Drawing is particularly useful for this purpose, and there are not many artists who do not use it in this way. Drawing is very important in relation to painting because it is the quickest way to respond to a visual idea. A few lines, drawn in as many seconds, can effectively conjure up the first idea of a painting. Drawing is quicker even than taking a polaroid photograph, and much more use, because in order to make any drawing you have already had to decide which aspects of the subject are significant,

## VISUAL NOTES

▼ Gordon Bennett is primarily a landscape artist, but although he draws on location, he paints in the studio, constructing his paintings from sketches like this. The drawing, although rapidly executed, includes a series of color notes, and contains all the information he needs.

## SQUARING UP

▲ This working drawing by Bruce Cody has been squared up for transfer. This method enables you to enlarge a sketch: a small grid of squares is made on the drawing, and a larger one on the painting surface. The information is then copied from one to the other.

A drawing from which a painting is to be made is different from one made for its own sake, as it must not only be effective in itself, but it must also have all the information you will need when you begin to paint. It must usually be capable of being enlarged, and it must

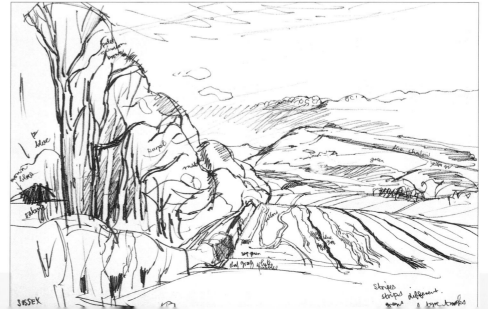

and commit them to paper. Working drawings may not always have any great merit in themselves, sometimes acting simply as an aide-memoire to jog the memory into recalling a particular visual incident rather than actually describing it.

Some artists find it difficult to make drawings from which they can later paint, and the problem is usually lines. We are so familiar with using lines to describe the visual world that we forget that there are virtually no lines in nature. We draw a line to show where one object ends and another comes into view, but it can be extremely difficult to translate this interpretation of a visual experience into two areas of color which will meet to produce the same effect.

A drawing from which you intend to develop a painting should first be an investigation of the subject, testing its potential for painting. It is a kind of rehearsal, with the marks in your drawing anticipating the marks you believe you will later make with your brush. You must restrict yourself to recording only information from which you can paint.

**VISUAL INVESTIGATION**
▶ ▼ Joyce Zavorskas's graphite drawing, **Wrapped Urn and Trees**, is one of a series of study sketches exploring the possibilities of the subject for the monotype print below. Some artists will make just one drawing, while others will spend several working sessions making preparatory investigations this kind.

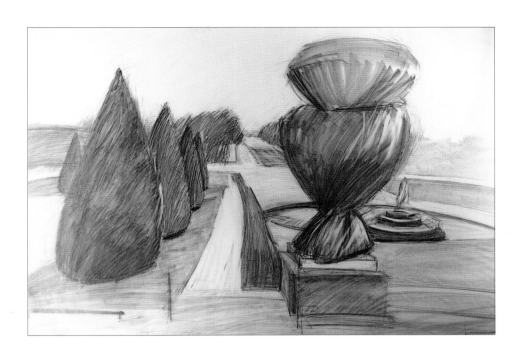

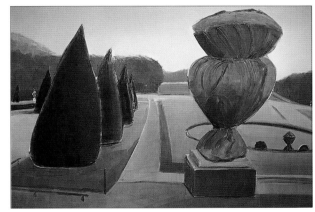

Sometimes you may create an effect which looks perfect in the drawing, but if it will be impossible to reproduce it in paint later, you must reject it. On other occasions you may be tempted to leave something out if the drawing looks alright without it, thinking it won't be needed in the painting. If in the slightest doubt, however, be prepared to ruin the drawing in order to have sufficient information from which to paint.

It is possible to make a painting from a single drawing, recording in it information about shapes, tones, and colors, including written notes. Sometimes, however, it is better to make separate studies of shapes, tones, and colors, and use all three as references for the painting.

**DRAWING SHAPES**
Once you have decided on your subject, your first priority should be to visualize the main shapes in your painting. If after your first attempts at recording these, you think that your drawing is too small to include everything, extend it by joining on additional pieces of paper as necessary, or if you are working in your sketchbook, by drawing onto the next page. Don't let the dimensions of the original sheet of paper dictate the outcome of the drawing, even if this means that you end up with a drawing larger than your board. You don't need to decide where the edges of your picture will be until you start work on the painting. Pencil, charcoal or a pen are ideal for this kind of drawing.

## TONES AND BRUSH MARKS

Any medium could be used for making a tonal drawing, but pencils (except for very soft ones or charcoal pencils) are limited in their tonal range. Charcoal or conté crayon are both effective for making tonal drawings. You can draw freely and broadly with them to recreate the pattern of tones you can see, and you can use them in much the same way as you will use your brushes when you paint.

A finished tonal drawing may include information that you didn't put into the original drawing of shapes because by this time you might have seen possibilities in the subject which you hadn't noticed before. A good way of starting a tonal drawing is to draw the main shapes, then decide the tonal limits of the subject – which are the lightest and which the darkest areas. Decide next how many tones to have between these limits. There may in fact be a great many slightly different tones to be seen in the subject, but usually it is necessary to reduce these to two or three so that there is an adequate balance between contrast and

harmony. Once the tonal framework has been decided, draw the tones within it and change them if they don't look right.

## COLOR INFORMATION

Some artists write notes about color on their drawings. This is very useful, but only when you have learned how to describe colors. Merely writing "blue," for example, is not going to be much use when you begin to paint. "Warm blue" or "purple blue" would be better, and "prominent warm blue" or "receding purple

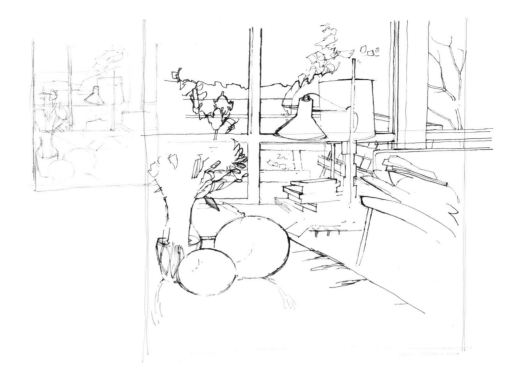

## SHAPES AND TONES

◄ ▼ The kind of drawings you make for paintings depends very much on your personal style and visual interests. In Ronald Jesty's paintings both shapes and the pattern of light and dark play an important part, so he has made two separate studies, one in line and the other in tone.

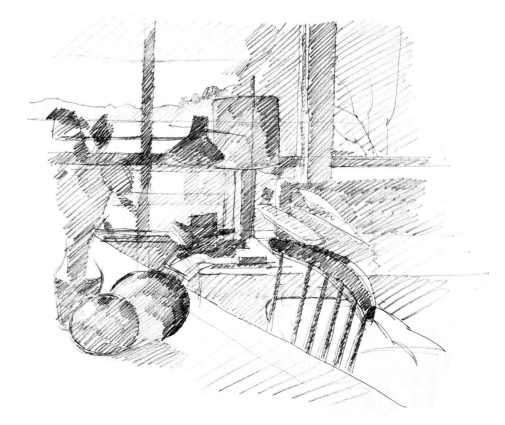

### COLOR AND LINE
◀ In John Denahy's sketch for **Thames Barges**, a combination of pastel and ink has allowed him to record small details as well as color.

### SKETCHING
◀ James Morrison's pastel and pencil drawing was done in a large-format sketchbook, of which the artist has several.

### DEVELOPING A SHORTHAND
Because drawings for paintings are made only as a step in a process, they need only mean something to the artist concerned. Through experience, artists learn which information they can retain in their memory and which they need to record, and they often develop a kind of shorthand.

A quick method of making visual notes is extremely valuable, first because it enables you to record something which might soon change, like a particular atmospheric effect, and second because it enables you also to draw in inconvenient places, where speed is of the essence, perhaps on the steep bank of a river or near a busy highway.

It is only through experience that you will develop this kind of expertise, but there are some well-tried methods for recording information on tone and color. I have already mentioned making written color notes, and many artists also have their own system for numbering tones. Tones can be numbered from lightest to darkest or in the reverse way. If necessary, write notes on the drawing about the tone plan as well, perhaps describing the overall effect or identifying particularly dark and light areas.

### SHORTHAND NOTES
▲ Looking at this drawing it is hard to believe that a painting could be made from it, but Arthur Maderson has developed a highly effective personal "code," numbering the colors and tones, and sometimes also writing more elaborate notes on his sketches.

blue'' even more informative. To be effective, a color note has to tell you, perhaps months after making it, what you need to know to recreate the intended color. Color notes can be written on the appropriate places in your drawing or round the edges with lines pointing to their positions if necessary.

You can also make colored drawings, but these also have

limitations unless the same medium is used for both drawing and painting. It is very difficult to translate the distinctive effects created by, say, felt-tips or pastels into a medium such as oil or watercolor. If the end product is to be a painting in oils, you could use oil pastels, which behave in a similar way to oil paints, or make color studies in acrylics, or oils on paper.

| further information | |
|---|---|
| **80** | Drawing on location |
| **180** | Pencil and colored pencil |
| **188** | Pastel and oil pastel |

# Expressive drawing

In Lesson Six you experimented with using color to emotional effect, but monochrome media can also be used to express feelings, and create a sense of mood and atmosphere. These qualities can be the most personal and important feature of a drawing, and can convey a feeling for a person, a place or a particular kind of day in a way that is impossible in words.

Some artists are less interested in faithfully depicting objects or scenes than in expressing the feelings that these subjects invoke. The Norwegian painter Edvard Munch (1863–1944) described the overpowering feeling of a particular scene. ''I was walking along a road one evening – on one side lay the city, and below me was the fjord. The sun went down – the clouds were stained red, as if with blood. I felt as though the whole of nature was screaming – it seemed as though I could hear a scream.'' From this emotional experience Munch produced his famous painting *The Scream*, with its clouds painted like blood, but his emotions are equally well expressed in the black and white print he made of the same subject, where – as in the painting – the screams of a distorted head are echoed by black curving lines.

You don't have to be in Munch's disturbed emotional state to make expressive drawings, and it is not always necessary to exaggerate or distort shapes and forms to give emotive content to a subject. The French Impressionist painter Alfred Sisley (1839–99) wrote to a friend that ''Every picture shows a spot with which the artist has fallen in love,'' and you can express this love for a subject, as Sisley did, without departing significantly from what you actually see.

## MOOD AND ATMOSPHERE

Just as your own mood influences the way in which you see a subject, some subjects, particularly outdoor scenes, constantly change their mood and character. Landscapes, seascapes and townscapes

125 ▷

125 ▷

---

**THE AIMS OF THE PROJECTS**
Drawing with an emphasis on expression

Using different media expressively

Responding to different kinds of mood and atmosphere
●
**WHAT YOU WILL NEED**
You will need all your drawing materials, and you should be prepared possibly to work outdoors
●
**TIME**
Each project will take about 3 hours

---

**PROJECT I**
**Sky studies**
Make at least three drawings of skies. You can either work outside or from a window. You will have to look out for particular days and times of day which will be best for drawing – those when you will be able to see the most dramatic effects. Rain or an approaching storm, sunset or sunrise can offer very different moods which may require quite different drawing approaches.

As well as recreating the mood of the weather in your drawing, your main problem is going to be drawing movement. Clouds move quickly, light changes constantly, nothing in nature stays still. Just as you will need to look intently, memorize what you see and record it quickly, just as you did when you drew the moving figure in Lesson Fourteen. Before you start, give some thought to which drawing medium or media you are going to use. You will probably find that a tonal or color medium such as ink wash, charcoal or pastel will give you the most scope, and that pencils and pens are less useful.

**ROSALIND CUTHBERT**
1 ▲ This drawing gives a good impression of both depth and movement, with the black conté crayon used in gentle criss-crossing curves.

**SELF CRITIQUE**
● Do any of your drawings have a particular feeling of mood and atmosphere?

● Do you feel that the drawings show a personal "handwriting?"

● Did you find your experience of drawing moving figures helpful?

● Did you find that your chosen medium or media influenced the way you expressed your visual experience?

● Do you feel that this approach to drawing will lead to more personal work?

2 ▼ Wind clouds can make dramatic swirling patterns, which can be exaggerated for effect, as in this pastel drawing.

3 ▲ Notice the depth in this conté drawing. Skies are not flat; they are subject to the laws of perspective, and clouds become smaller as they approach the horizon.

4 ▼ The emphasis in this pastel drawing is on the pattern in the sky, but the way the white pastel has been applied suggests movement.

THEMES AND TREATMENTS

**JOHN LIDZEY**

**1** ▶ Natural light through a window has provided the artist with interesting effects for this conté crayon drawing, and the silhouette of the bed makes an excellent foreground. The loose, vigorous drawing technique provides additional excitement.

**PROJECT 2**
**Interior light**
Effects of light in interiors, at least to some extent, can be controlled. However, it is often the accidental effect of daylight entering a room which creates a particular atmosphere. Your drawing could be of a chance effect like this, say, stripes of light coming through a louvered shade, or it could be of the atmosphere created in a room by artificial light, or even dim, gloomy light.

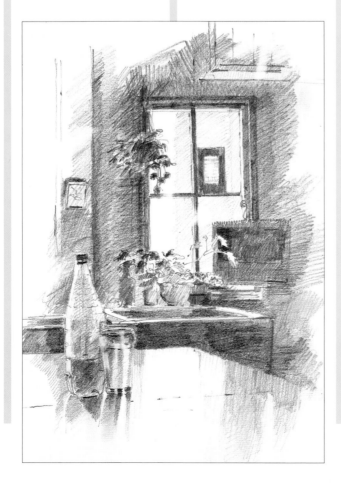

**2** ◀ In this case the straight-on view of the window has provided some bold silhouettes and a strong foreground, with exciting reflections on the shiny tabletop. The drawing is in soft pencil.

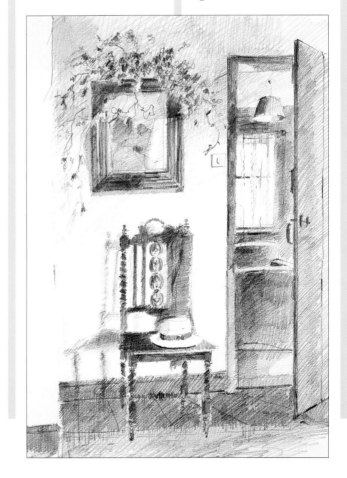

**3** ▶ Again working in soft pencil, the artist has brilliantly caught the contrast and change of atmosphere between the light hallway and the shadowy room, viewed through the open door.

Before you decide on your subject, look around your home at different times of day. Make some quick drawings in your sketchbook of interior views which you think would be interesting subjects for drawing. If you decide to draw a daylight effect, you will probably have to make a quick study of the patterns of light so that you can refer back to it as you develop a larger, more detailed drawing; the light will change as you work.

If you are working by artificial light, it won't, of course, change, and you won't be under the same pressure to work quickly. This is both an advantage and a disadvantage: you won't have to rush, but having time to dwell on the subject could stifle the expressive quality of your drawing. The drawings in this lesson should emphasize the mood of the subject, your feelings about it and the qualities of the medium. Work quickly and spontaneously, and allow your hand to respond directly to your eye.

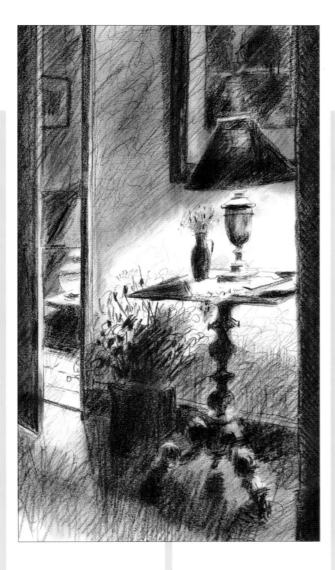

4 ▲ Here the lamp creates a pool of light and strong contrasts of tone. The inherent drama of the subject is enhanced by the artist's technique: using smudged, hatched and scribbled conté shading, he has created a lively and expressive drawing.

**SELF CRITIQUE**
● Have the straight lines of the interior reduced the expressive quality of your drawing?

● Did you find it harder to draw freely when you had more time?

● Do you feel that you captured the mood?

● Do you think you chose the most suitable medium?

change from minute to minute. The season of the year, the time of day and the weather all create a mood and a particular atmosphere which can provoke a powerful response in you. The way you react to a subject bathed in the even light of a gray day can be very different from the way you see it under the setting sun or on a wet day.

**USING THE MEDIA EXPRESSIVELY**
Drawing is the quickest means of responding to a visual sensation; a few lines can evoke a particular person or place, and the way these lines are drawn – their softness, sharpness, or the speed of their execution – can describe the artist's response to the subject. When you draw expressively, the marks made by your pencil or pen are as revealing as your handwriting, and the gestures made by your hand as you draw will clearly reveal your excitement and involvement with the subject. Allowing your hand and eye to respond directly to a subject is one of the main ways in which your drawing will shift from descriptive to expressive.

The other means by which drawings can be expressive is by the use of tone. Tone is particularly useful in creating a particular mood or atmosphere. Sharp contrasts of black and white will, for example, help to evoke the brilliant sunlight of a summer's day. A drawing which is almost entirely black will have a feeling of doom and despondency.

▶ David Carpanini
*Charcoal*
**Village End**, with its dark buildings silhouetted against a sky full of movement, is a marvelously atmospheric drawing, and the artist has played up the tonal contrasts with a bold, vigorous use of charcoal. Depth has been subtly and cleverly suggested by slight tonal changes in the foreground and touches of light on the left and on the fence in front of the house.

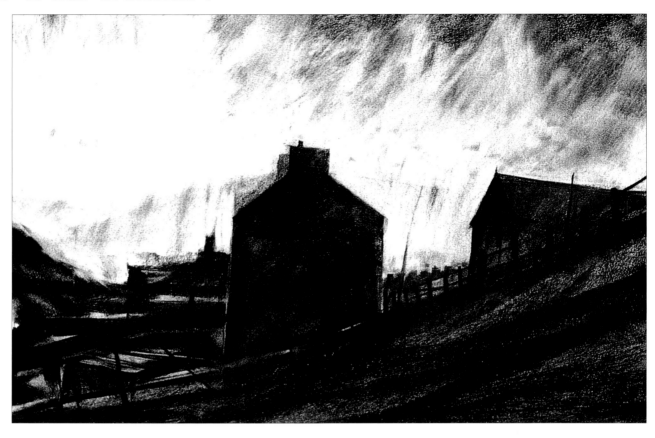

◀ Brian Yale
*Pastel*
In this deceptively simple-looking drawing the artist has distilled the essential visual elements, recreating the dramatic moment when the sun disappears into a cloud.

▶ Barbara Walton
*Charcoal and pastel*
Sharp contrasts always create an impact, and here have been used to good effect to create a powerful portrait. The forms of the face are built up with a combination of incisive black lines and softer smudged charcoal shading, while the dark sweater is drawn as a flat black shape.

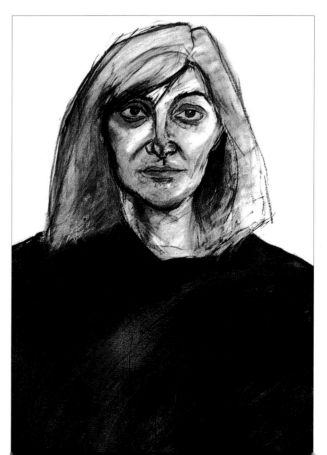

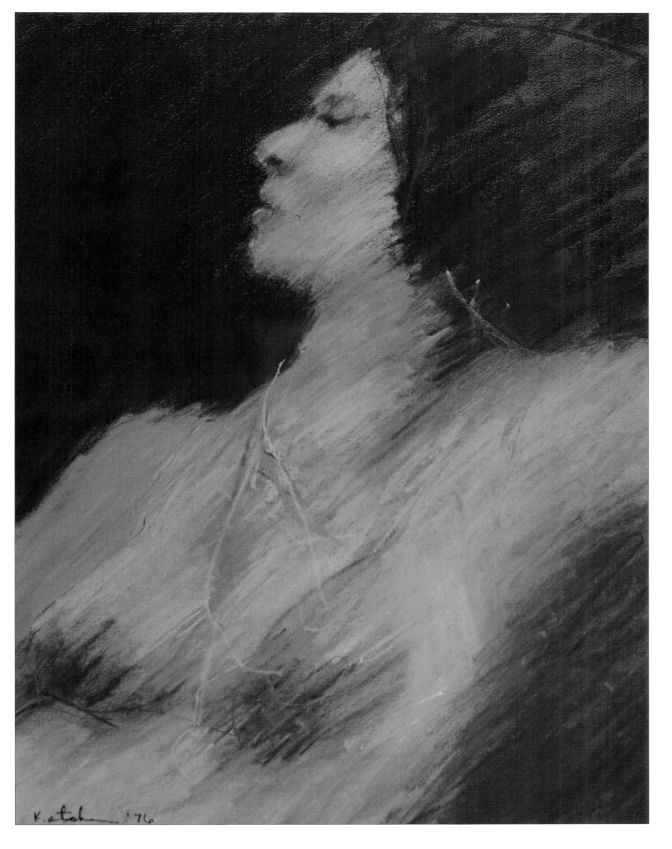

Katchen '76

◄ Carole Katchen
*Pastel*
This vigorous drawing,
**Belly Dancer**, gives a
powerful feeling of action;
we could sense the
movement even without
knowing the title. The
diagonal strokes, the
striking profile, and the way
the artist has cut off the
arms and body at the edges
of the drawing are all
contributing factors. This
kind of composition, where
the subject is "cropped"
(see page 143) is difficult to
do well, but when
successful, as in this
drawing, it can brilliantly
express both atmosphere
and movement.

# Extending the view

When you look at any scene, you naturally "pan around" moving your eyes and head so that you can take in everything. If you decided to draw the scene in the normal way, you would focus your attention on a particular part of the subject, and look directly at that area, with one fixed viewpoint. But it is possible to draw in the way that you naturally see.

Particularly in the 20th century, artists have experimented with different forms of realism. Some don't draw with a single fixed viewpoint. In this lesson I want you to make drawings of this kind, allowing your head and eyes to move around to provide you with a wide angle of vision.

## WIDE-ANGLE VIEWS

It is customary to draw with a narrow angle of vision because otherwise objects at the edges of your drawing tend to become distorted. Widening your angle of vision to include what you see from more than one viewpoint sometimes produces strange drawings. I explained in Lesson Thirteen what would happen if you positioned yourself so close to your model that you had to move your head to see the complete figure. Widening your angle of vision in this way would result in joining together two different views of the figure. With figure drawing this kind of distortion is usually obvious, but in other subjects, such as landscapes or interiors, the distortions are less apparent; indeed you might not notice them unless you were familiar with the subject. And distortion is not necessarily wrong; used intentionally, it can be an important feature in your drawing.

## SCANNING

If you allow your eyes to scan a subject – an interior, for example – turning your head from left to right and looking from your feet up to above your head, you might have as many as fifteen or more viewpoints. If you draw in this way, joining together what you see from each viewpoint, it will

133 ▷

**THE AIMS OF THE PROJECTS**
Experimenting with multi-viewpoint drawings
———
Producing unusual effects
———
Experiencing different kinds of reality
•
**WHAT YOU WILL NEED**
You will need all your drawing materials. You may decide to have a model for the second project, but it is not essential
•
**TIME**
Project 1: at least 4 hours. Project 2: 3 hours

**PROJECT 1**
**A panoramic view**
The subject should preferably be a landscape or townscape from a high position, drawn outdoors or from a window. If this is not possible, however, you can draw a view of an interior, perhaps looking from one room into another or across a room and out through a window. I want you to work on two sheets of paper, each A2 size. Each should be worked on separately, but when finished they should join together to make one drawing.

Before you start on the large drawing, or drawings, make a very quick small-scale sketch of what you expect it will include. This is so that you will know roughly where to start on your first sheet. You can use any medium and work in color if you wish. When you have completed the first sheet, you will need to transfer some of the main lines from it to the second sheet so that objects crossing the

sheets will join together. It won't matter if they don't join very accurately. Work on the two sheets independently. If you are using color don't be concerned if you see the color differently in the second. Although the two sheets are going to be joined together they don't have to look as if they were drawn at the same time. You might in fact deliberately draw them on different days, so that each has a different atmosphere. When the second sheet is completed, join it to the first using masking tape or gummed strip on the back.

**KAY GALLWEY**

1 ▲ The artist has started her drawing with the left-hand side of the room. Having first indicated the positions of the objects, she is now beginning to draw some of them more firmly, using a felt-tipped pen.

2 ▼ Chunky water-soluble colored pencils are now brought in to add areas of color to the drawing.

3 ▲ This photograph shows the whole of the first drawing. In order to include more of the room looking from left to right, the artist has worked on a horizontal format, so that the two drawings will form a long strip.

4 ▲ Moving her viewpoint to the right, she now begins the second drawing, using the same media as before.

6 ▼ As she is drawing her own studio, the artist takes trouble to include all the pictures on the wall. Here she produces a wash of color by brushing over the water-soluble pencil with clean water.

5 ▲ This photograph shows the whole area of the second drawing, which will be developed with further areas of color.

7 ▼ The two drawings are now joined together to give a panoramic view of the room. Drawings of this kind, with different viewpoints, can cause perspective to look odd and objects to appear distorted, though in this case it is not noticeable because the artist has not attempted to convey a feeling of depth and has treated the subject more as pattern.

**SELF CRITIQUE**
● Does your drawing look odd, or are the different viewpoints not apparent?

● Do you feel that your drawing has lost anything by not concentrating on a single view?

● Has drawing in this way opened up new possibilities?

## PROJECT 2
### A close-up

I now want you to make a drawing of an object from a close position, say two yards away, so that as you look at the top, you can't see the bottom without moving your eyes. You need to draw something quite large; it could be a stepladder, a small tree or a large plant. It could also be a figure. If you can get someone to sit for you it will be helpful, but you could draw yourself if you have a long mirror. Pose your model (or yourself) on a high stool so that you have as tall a subject as possible.

The drawing should be made on a single sheet of paper, so start by assessing approximately how large it will need to be. You may be able to manage with an A2 sheet, but if not you can extend one by joining on another piece. Work in any medium, and this time try to keep the whole drawing developing at the same speed. Don't complete the top half of the subject and then join the bottom half on. Draw what you see, and don't on this occasion stop and stand back from your work to see how it is developing. Try to continue joining the different views of the object and background together without concerning yourself too much about the outcome.

**ELIZABETH MOORE**

**1 ▼ In this self-portrait** in colored pencils, the artist has indicated the whole figure, but is concentrating for the moment on the head.

**2 ▼ When she drew her head, the artist looked straight into the mirror, but for the hands and drawing board she had to look down.**

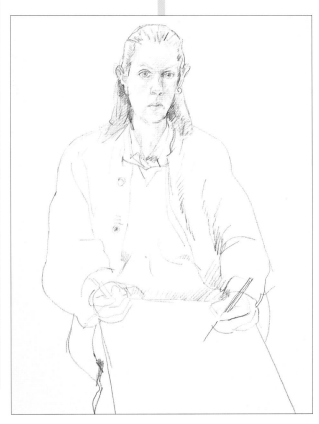

**IAN SIMPSON**

**1 ▲ This is also a self-portrait, in conté crayon.** At an early stage of the drawing the distortion is already noticeable.

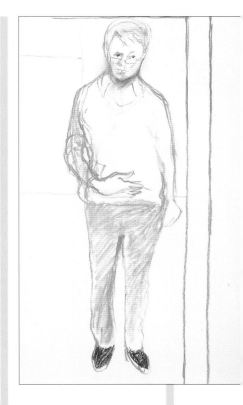

### SELF CRITIQUE

● Has the result surprised you and do you feel that your drawing is unusual?

● Has this project made you more aware of the importance of the viewpoint?

● In concentrating on making a multi-viewpoint drawing, have you neglected other aspects of drawing?

● Do you think this drawing is successful, and if so why?

**2 ▲ Although the artist was able to** check the proportions by using the negative shape between the figure and the mirror, the drawing is out of scale. The necessity of moving his view down to draw his feet has made the lower half of the body appear as though it were sloping backward.

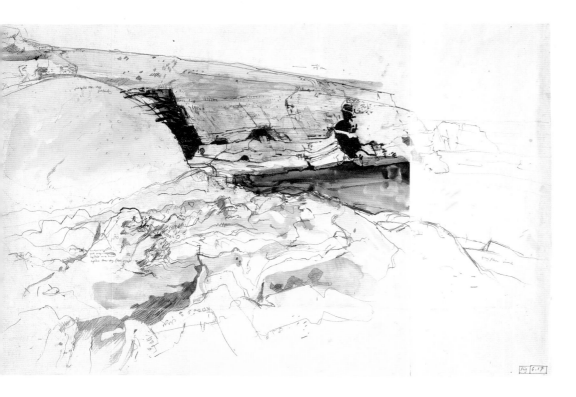

◀ Ian Simpson
*Pencil, charcoal pencil
and acrylic*
This drawing, made on
location as a study for a
painting, contains many
different viewpoints. The
artist began by scanning the
landscape from the sky
down across the rocks to
his feet. At a later stage he
also decided to extend the
view to the right, making it
necessary to add a sheet of
paper to the right side of
the drawing. Washes of
acrylic color were used to
describe the main tones and
colors, and there are also
some written tone and
color notes.

◀ Samantha Toft
*Pencil*
The artist has produced an interesting and unusual long, horizontal drawing as she has looked along a line of people waiting for a bus. Without losing the unity of the complete group, she has made delightful individual studies of the people in the line, describing the way they pass the time or their attitudes of annoyance or boredom as they wait.

▲ Richard Wills
*Charcoal*
In **Coldra Roundabout, M4** the wide view taken by the artist, and the sharply angled perspective, create a dramatic drawing. The width of the drawing enables the strong vertical direction of the road to be counterbalanced by the oval of the roundabout below it, and the glimpse of the landscape over the hill to the left.

have the effect of stretching and flattening the objects. You may draw what you see accurately, but the drawing will not give the same illusion of depth as one from a single viewpoint, and some objects will turn out to be oddly proportioned. To understand what I mean, make a very quick drawing from where you're sitting now. I'm assuming it's indoors, so quickly draw the view from your feet to the ceiling above your head. This might involve you in making four or five movements of your head and will, in effect, be four or five views joined together. The result might be a drawing which surprises you. Perhaps it will demonstrate that when you draw, providing you understand what you are doing, you don't have to restrict your view. You can draw what you see naturally and produce unusual effects and images.

# THEMES AND TREATMENTS

# PART THREE

# Different Approaches

· · · · · · · · · · · · · · · ·

**T**his section of the book provides insights into some of the different ways drawing can be approached. You will discover that a drawing can be a pure "voyage of exploration," with no predetermined idea on the part of the artist and a completely open mind about the result. But this is only one way to draw: you may start a drawing with a clear aim, perhaps to make a detailed, close-up study of an object, or to work out compositional ideas.

The section begins with a feature on composition, which is just as important in drawing as in painting, particularly if a drawing is done as an end in itself. Each of the lessons that follow takes as its theme a "key" drawing by an old master or important contemporary artist, demonstrating a particular approach to drawing.

# Composition

As I said earlier, drawings can be the first stage in developing a work in another medium, or they can be works of art in their own right. A drawing that is to be an end in itself must be composed as carefully as a painting. When a drawing is an exploration of a subject, it may be done partly to investigate the compositional potential of the subject.

Composition is the art of combining the various elements of a drawing (or painting) into a satisfactory visual whole. In a good composition the various shapes, forms and colors (if color is used) are arranged so that the work continues to hold the viewer's interest after it has made its initial impact. The drawing must be contained in a rectangle of appropriate proportions and size, and the various dynamic forces created within this rectangle must be held in equilibrium. When you look at a well-composed drawing, you should feel that its composition is not weighted in one direction or the other, but that everything is held in balance.

### THE DYNAMICS OF THE RECTANGLE

You begin to tackle the all-important problem of composition as soon as you put the first mark on a piece of paper. On its own, a rectangle is static, but anything introduced into it, even the merest mark, disturbs its equilibrium and has an effect on how the rectangle is perceived. A relationship is created between it and the mark. For example, a mark put in the top right-hand corner will lead your eye immediately to this point. If you make the composition more elaborate by adding large and small squares, and converging lines, new directional forces will

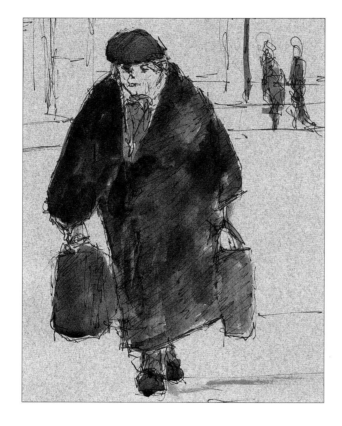

### TRIANGULAR COMPOSITION

◀ In John Denahy's pen and wash drawing **The Shopper**, the overall shape is a triangle, placed in the rectangle with its apex left of center. This is balanced by the background figures set within an inverted L-shape.

### SYMMETRICAL COMPOSITION

▼ Christopher Chamberlain's pen and wash drawing has an almost symmetrical balance, but the strong verticals and diagonals in the left foreground prevent the composition from becoming too predictable.

come into play. The inclusion of tone, by adding dark areas, will make further changes in the balance of the rectangle, and the introduction of curved shapes will change the balance yet again.

### THE FLEXIBILITY OF DRAWING

One of the features of drawing is its flexibility. Just as you can very easily change the marks in your drawing, so you can change the shape of the drawing rectangle. If the piece of paper proves to be too large for the subject, you can cut it down, and if your drawing begins to expand beyond its boundaries,

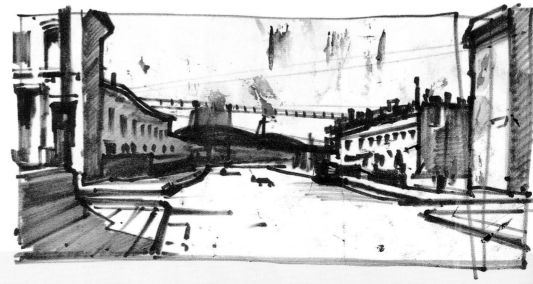

you can easily add pieces on. It is usual to overlap the paper you are joining onto a drawing, and attach it at the back with an adhesive which will not cause the paper to buckle. You can also make joins which are virtually invisible by butting together the two pieces of paper you wish to join, and taping them at the back.

## SIZE AND SHAPE

There is no reason why a drawing should not be planned within a circle or oval, but the majority of drawings are rectangular. These shapes, depending on whether they are horizontal or vertical, are usually known as ''landscape'' or ''portrait'' format respectively. Traditionally, these subjects have been drawn and painted in these particular shapes, but they do not have to be; an upright landscape can be very effective when you want a composition with a vertical emphasis. What is important is that the shape suits the subject.

## DIFFERENT APPROACHES

There are two main ways in which you can approach composition in

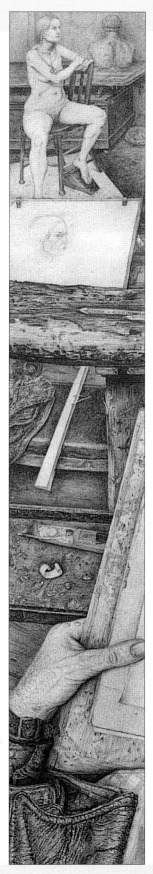

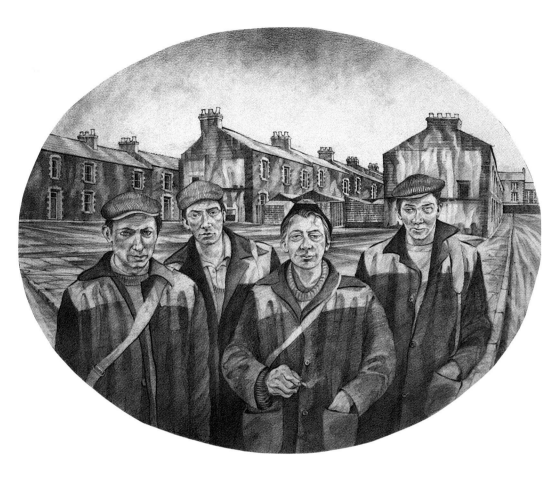

## VERTICAL COMPOSITION

◀ Paul Bartlett's unusual pencil drawing **First Term in the Life Drawing Room** gives an excellent impression of the narrow view you often have as you look between the other students in a life studio. The foreground hand and the side of the drawing board direct you toward the model, but these directional forces are balanced by the many near-horizontal lines.

## OVAL FORMAT

▲ The shape of David Carpanini's pencil drawing **The Brothers** echoes those of the heads of the standing men. The horizontal provided by the terraced houses, together with the lines of the roofs and angular shapes of chimneys, counterpoint to the curves and repeated ovals.

## EXPLORING POSSIBILITIES

▶ In these two pencil sketches, compositional studies for a still-life painting, Ronald Jesty has tried out two variations on a theme – the contrast between oval and angular shapes. For the right-hand example, the mushrooms have been cut in half, producing two further shapes, which he has placed on a light stripe between darkly shaded areas.

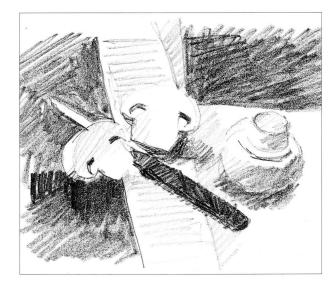

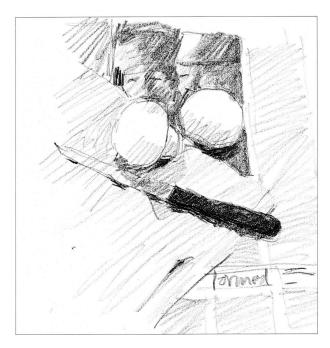

drawing. The first is to draw without being concerned about the shape the drawing will finally take, and only as it nears completion, decide on the best-proportioned rectangle to contain it. This can be done by masking off your drawing with strips of paper, or two L-shaped corners cut from card or paper, until you are satisfied that you have the best shape. Photographers do this to help them decide on the best area of a negative to print up.

The second approach is to treat the rectangle itself as the starting point, and compose your drawing within it. If you are making a drawing for a painting, you may have a particular size in mind for the picture, and so the drawing needs to have the same proportions.

In the history of art many drawings and paintings have been based on simple geometric designs. The drawing rectangle was divided in particular ways, and the main features of the composition made to conform to this predetermined design. Many compositions, for example, are based on a triangle, with the base at the bottom of the paper and the point at the top. However, it is more usual today to draw by trial and error, composing the drawing as you work, and using your judgment to decide what looks right.

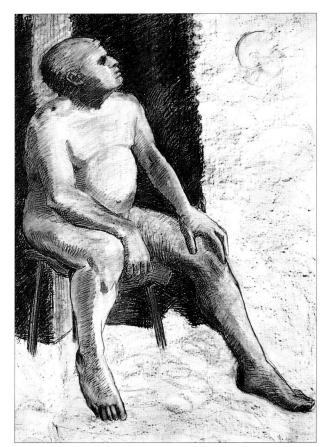

## ON THE DIAGONAL

◀ In Olwen Tarrant's charcoal drawing, **Daniel**, the figure fits into less than half of the rectangle, but the diagonal of the leg and the way the sitter is looking to the left provide a balancing directional force.

## THE GOLDEN SECTION

Formal geometric compositions have often been based on a proportion called the golden section, in which a line or rectangle is divided into two parts so that the ratio of the smaller to the larger is equal to the ratio of the larger to the whole line. This ratio (approximately 8:13) has been known since antiquity, and was

believed to possess inherent aesthetic virtues, bringing art and nature into harmony. The golden section proportion was used extensively by Renaissance artists. Although it is considered less important today, it is interesting to note that many drawings and paintings, when analyzed, reveal the use of this proportion even though the artists concerned did not use it consciously. It appears that we tend naturally to divide the drawing rectangle in this way.

## BASIC RULES

The fundamental rule of composition is that the picture surface should not be divided symmetrically. Although you could produce a balanced composition by echoing a line on the left side of a drawing with an identical line on the right the same distance from the edge of the drawing, this would only achieve the kind of balance you would find on a repeating pattern. Pictures require a form of equilibrium which is much more complex and subtle than this, and the balance must not be too apparent. A well-composed drawing is one

## THE GOLDEN SECTION

▲ Ian Simpson's pen and wash drawing of **Hungerford Bridge** was done on the spot. No definite shape was chosen in advance, but the rectangle the artist eventually decided on shows that the far bank of the river and one of the bridge's strong verticals divide the drawing into Golden Section proportions.

| **further information** | |
| --- | --- |
| **80** | Drawing for painting |
| **118** | Drawing on location |

that remains satisfying after you have looked at it for some time – it is rather like peeling the skin from an onion, where each layer reveals something new.

The basic rule of asymmetry in composition can be extended to provide further rules. For example, it is courting disaster to place a standing figure in the center of your paper, or position a fence so that it runs horizontally across your drawing, equally dividing the distance from the bottom edge of your drawing to the horizon line. There are, however, no rules that can't be broken, and artists do sometimes make symmetrical compositions work well. Composition is something to be aware of and to

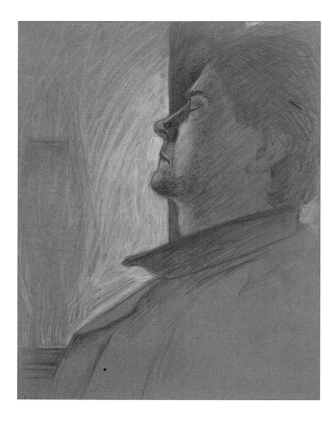

**VERTICAL EMPHASIS**
► Peter Graham's pastel drawing **Gare du Nord, Paris** has several verticals, giving an upward direction to the drawing. They are balanced by the arched windows in the background, and the strong horizontal interest created by the figures on the track.

**VERTICAL DIVISION**
◄ In her pastel drawing **Sleeping Passenger, Morning** Rosalind Cuthbert has achieved a cleverly balanced composition in which the symmetry of the emphatic central vertical is broken by the overlapping profile.

respect, but just as following a set of rules does not guarantee success, breaking them does not always mean failure.

**THREE-DIMENSIONAL COMPOSITION**
So far I have put the emphasis on two-dimensional design, but it is equally important that a drawing is balanced in depth, with the intervals of space between foreground, middle distance, and background as varied as the surface pattern. In creating an illusion of space, the depth of the drawing has to be composed as carefully as the balance of the main shapes and the divisions of the rectangle.

This is easier for some subjects than for others. A typical example of a difficult composition is a close-up view of the facade of a building – a subject which seems to

have a fatal attraction for many drawing students. An experienced artist may be able to use the small intervals of depth in door and window recesses to offset the flat face of the building, but, for many artists, drawing this kind of subject will almost certainly lead to failure. It will be virtually impossible to create an interesting

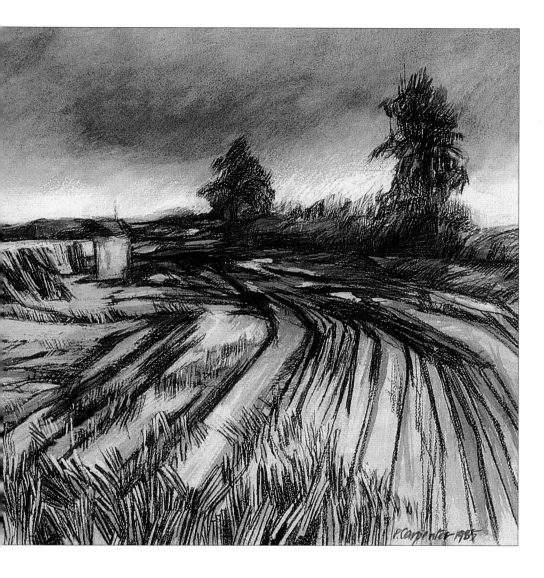

## COMPOSITION IN DEPTH

▲ In Pip Carpenter's mixed media drawing, the curving lines of the field take the eye rapidly to the background, but it is then led back and around the drawing by areas of interest in the intervening three-dimensional space.

composition in depth, even if a satisfactory arrangement of two-dimensional shapes can be selected. A subject where the main interest is in the middle distance can be equally difficult, as you will have to find means of organizing the foreground so that the eye is led through interesting intervals of space into the picture.

Most subjects, however, approached carefully, can be used to provide an interesting composition, but you need to be on your guard for problems such as those described above.

## SELECTION

It could be said that you begin to compose even before you put the first line or mark down, that

## SHAPES BETWEEN FIGURES

▲ Timothy Easton's pencil drawing **The Hoeing Team** takes the eye through a fascinating series of intervals of three-dimensional space between the working figures to the archway in the middle distance. This route is

balanced by the road on the left which passes between verticals to the landscape in the background. Notice how the artist has made use of the hoes to link the figures together, and create a variety of interesting angles.

**KEY ELEMENTS**

▼ The hairstyle and clothing were obviously the key elements here, so Rosalind Cuthbert has wisely left the background of her pastel drawing plain in order to emphasize both these and the delicate drawing of the face.

is, when you decide on the position from which to draw your subject, or even earlier still, with the idea of what to draw. Another problem you will face in this pre-planning stage is how much of your subject to include. No drawing, however detailed, includes everything the artist can see. Selecting the key elements, and discarding

those which are unimportant for the purposes of your drawing, is an essential part of the process of composing. This could mean leaving out complete objects, a tree or a building perhaps.

The kind of composition you decide on can also determine the amount of detail you include in your drawing. For example, if you are drawing the middle distance of a landscape as broad, simple shapes, don't be lured into trying to depict the texture of the grass in these areas. If you have decided that the foreground of your drawing has to be kept simple so that your eye can move through this area into an interesting incident in the middle distance, don't be tempted to add unnecessary details.

As you are deciding what to include and what to leave out of your drawing, bear in mind that particular objects which are incidental to the subject might add something to the composition. A radio antenna, for example, may look out of context in a view of a village, but it may provide a very useful vertical emphasis. Always consider both your drawing and the

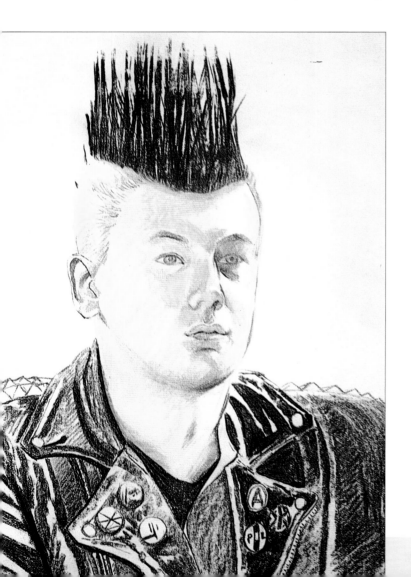

subject, and think about how each element can contribute to the composition.

If you find it difficult to make these decisions – and it can be – break the subject down into simple shapes. Once you see how these work two-dimensionally, you can progress to selecting more detail and building up gradually.

**RHYTHM AND BALANCE**

▲ Ray Mutimer has rejected anything that would detract from the composition of his pencil drawing. The figures, placed one above the other, create an interesting verticality, balanced by the swirling curves and horizontals of the water, and the diagonals of the striped pattern on the middle figure's dress.

## CROPPING

Until the mid-19th century, the conventions of composition required that the main interest in a picture was entirely contained within the picture rectangle. No vital element was cut off at the edges of a drawing or painting. The advent of photography brought about important changes in how composition was seen. "Snapshot" photographs sometimes cut off people and objects in strange ways, and artists began to experiment with similar effects. Dramatic effects could be obtained by "cropping" a figure or object, and artists also found that other photographic effects could be useful, for example, having part of a picture indistinct and out of focus, which could add to its sense of depth and drama.

Cutting off objects at the edges of drawings can have the effect of bringing the viewer into the scene, and sometimes can create an illusion of events existing outside the limits of the drawing. Pictorial devices like these, first used by the Impressionists, have been widely exploited by 20th-century artists. Part of the process of

selection is to decide where the outer edges of your drawing should be, and how they should contain the subject. If you are cropping an object or figure, consider the way the edges of the drawing rectangle cuts across them; if the cropping is awkward, the composition can look casual and unplanned.

**HEAD IN CLOSE-UP**
▲ The form of dramatic composition seen in Robert Geoghegan's pastel **Head Study** is more often associated with photography than with drawing.

**FIGURE IN CLOSE-UP**
◄ In this pastel drawing by Diana Constance the artist has chosen a close view to make an interesting composition. The joined arms and the upward-thrusting knee make the composition complete even though much of the figure has been omitted.

## DIFFERENT APPROACHES

# Drawing as discovery

**A** quotation from the British writer and critic John Berger summarizes the importance of drawing in a few words. "The basis of all painting and sculpture is drawing. For the artist, drawing is discovery."

By continually investigating the visual world, the artist constantly finds new things to say, so that the process of discovery continues. The Japanese artist Hokusai (1760-1849) wrote about this never-ending search, claiming that all he had produced by the time he was seventy was not worth taking into account. "At seventy-three I have learned a little about the real structure of nature," he wrote. "In consequence when I am eighty I shall have made more progress; at ninety, I shall penetrate the mystery of things; at a hundred I shall have reached a marvellous stage; and when I am a hundred and ten, everything I do, be it but a dot or line, will be alive."

### OPEN-ENDED DRAWING

A drawing can be begun with no preconceived notion about either what it is to include or what its ultimate purpose will be. This open-ended approach to drawing is seen in its most obvious form in doodles and similar kinds of spontaneous drawings where the drawing is given a life of its own, and allowed to develop as it will. Chance effects created in this kind of drawing may be exploited only to be discarded later if another accidental effect is preferred. Drawing from a particular subject can be just as much concerned with discovery. The subject can be used only as a starting point, and the drawing then allowed to develop its own momentum without being constantly compared to the subject.

There are, however, many other open-ended ways in which drawings can be made from the visual world. If a subject excites you, you will be trying to identify the elusive features which create this excitement when you draw it. Or you may start to draw something which doesn't particularly appeal to you, searching for some arrangement of

### VINCENT VAN GOGH (1853-90)

**Landscape Near Montmajour**
*Reed pen and sepia ink, with touches of black chalk*
Van Gogh frequently made drawings of the subjects he painted, but these were seldom if ever used as preliminary studies for paintings. The drawings, although they are clearly investigations of the possibilities of subjects, appear to have been seen as ends in themselves. He developed a style of painting which featured brush strokes of thick paint, and in this drawing you can see that he has used short pen strokes, he is rehearsing the stabs with the brush he will make when he paints.

Notice how the pen strokes are much larger in the foreground than in the distance, which helps to create a feeling of depth. This sense of depth is also increased by the way he has carefully drawn the shapes and textures of the fields. Although small in scale, the little train and the horse and cart, going in opposite

directions, and the two small figures in the middle distance are very important. Perhaps Van Gogh intended to draw only the fields and trees at first, but discovered that the incidents in the middle distance added an important feature.

shapes and forms which will suddenly intrigue you.

Even if you haven't started to draw with the idea of inquiry at the forefront of your consciousness, you will often make discoveries when drawing. You may begin a drawing feeling sure of what is important about the subject and how you will translate it, but less certain of the best possible composition. In trying to decide the best composition, you may discover aspects of the subject which are much more significant than those you had identified at first.

### DRAWING THE PARTICULAR

There are many drawings which give perfectly accurate descriptions of a scene or person but which tell you nothing more. A good drawing, however, should provide you with more than information about the subject; you should be able to see what it was that intrigued the artist, and what they felt about it. Every human being is different, each with their own view of the world, and one of the purposes of drawing is to allow this personal view to become apparent.

When you draw, you should avoid merely making a generalized statement and concentrate on the particular aspects of the subject which are important to you. These will often be things that you can't describe in words, and may even be something that you only recognize when you see it in your drawing. This search for the particular rather than the general is what will give your drawings the individuality which will make your work easily recognizable.

### DISCOVERING A PERSONAL LANGUAGE

Usually the work of great artists is instantly recognizable. As well as having found important new things to say, they have also found new ways to say them. As you draw more and more, you will find that a particular style of drawing begins to develop. That is not to say that your drawings will become strikingly different, but that your work will

▷ 146

▷ 146

## other artists to study

### PAUL KLEE (1879-1940)

Klee produced some 5,000 drawings, probably the largest graphic output of any 20th-century artist, which he filed away in portfolios. One of the most imaginative and individual artists of the century, he believed that art does not reproduce visible things but that the artist makes things analogous to nature. "Now it is looking at me," he would say of a work in progress, and the titles of many of his drawings have been suggested by the works themselves. "My hand is wholly the instrument of some remote power," he wrote.

### PABLO PICASSO (1881-1973)

Picasso is an essential study for anyone interested in drawing. It has been said of him that "No man has changed more radically the nature of art." Throughout his long career his drawings constantly searched for new subjects and new means of expression. There are several series of drawings where a subject such as the bullfight or the artist and model are investigated in many different ways. Even when he was experimenting with extreme forms of non-representational painting he frequently returned to making realistic drawings.

### ARTISTS' SKETCHBOOKS

One of the best places to see drawing as a process of investigation and discovery is in sketchbooks. There have been exhibitions of Picasso's sketchbooks, and many museums have artists' sketchbooks on display. A number of publications have also been devoted to sketchbook drawings because this private and personal work best illustrates the artist's character, working methods and reactions to the world.

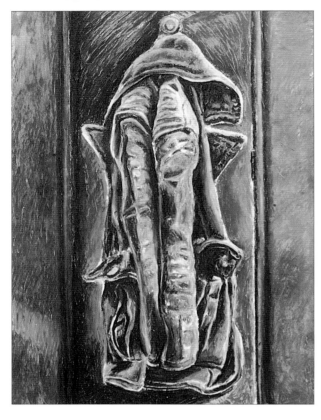

◀ Paul Bartlett
*Oil pastel*
A very ordinary subject has inspired a most dramatic drawing. The sleeves of the jacket, looking almost like elephants' trunks, have been simplified into a contrasting pattern of light and dark which gives an excellent feeling of the tough, thick material. Notice how the artist has used the pastel stick to follow the folds and creases around the sleeves, collar and the pockets to create a feeling of three-dimensional form.

acquire a distinctive personality. As the actual "handwriting" of your drawing develops, the way you use it to describe things will become more personal. To a large extent this will come from greater fluency, which will develop your ability to co-ordinate eye, brain and hand quickly.

As your work becomes more accomplished, however, there are some dangers to look out for. One is that your work becomes mannered, that is, the same shapes, forms and effects appear frequently in your work without being related to the particular visual experience. Another danger is developing a superficial slickness which produces what at first glance look like reasonable drawings, but where all the shapes and forms look similar and generalized. The way to develop a personal language while guarding against mannerism and slickness is to search for the elements of the

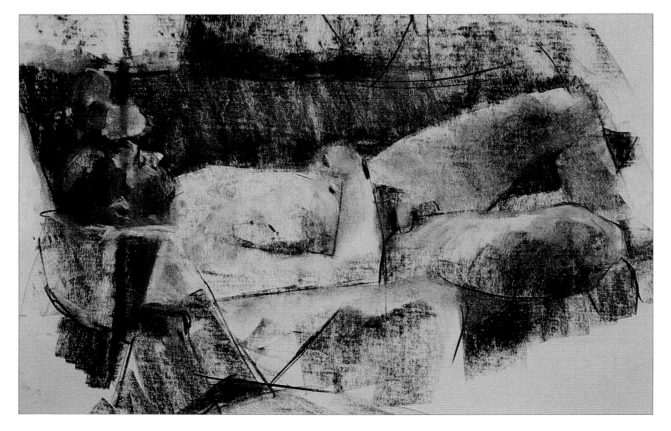

◀ Peter Willock
*Charcoal*
While the play of light on the figure is an important part of this drawing, it is not a conventional figure drawing. The artist's primary concern has been to explore the human figure as a series of planes and semi-geometric shapes linked to the surrounding objects. These relationships have been closely observed; the head has become linked to the dark background, while in the foreground angular shapes in front of the figure echo the figure's sharply angled arm.

subject which seem to you to make it unique. This could be described as discovering something not seen at a first glance – finding the extraordinary in the ordinary.

To anyone learning to draw, Van Gogh should be an inspiration. He virtually taught himself, and there are around 1,600 cataloged drawings that demonstrate his progress, and the development of his language of drawing. Even before he decided to commit himself fully to becoming an artist he drew avidly, and drawing sustained him through many of the emotionally difficult periods of his life. "In spite of everything," he wrote in 1880, "I shall rise again: I will take up my pencil, which I had discarded in great discouragement and go on with my drawing."

Because drawing is the most direct way of recording visual information, artists' drawings are often more revealing than their paintings, giving special insights into their thinking and approaches to the visual world. And the most revealing drawings are frequently those which have been produced quickly and spontaneously. When you draw outdoors, for example, you have to work at speed, and sometimes when you look at the drawings later you see things in them which you don't remember and can't imagine having drawn. Drawing is not only a medium for making discoveries about the external visual world; it is also good at giving us insight into ourselves.

### DRAWING AS INSPIRATION

Although it may seem a contradiction, drawing can be a means of discovering things to draw. If you are ever stuck for a drawing subject, the best advice is just to start drawing – anywhere and anything. The French painter Pierre Bonnard (1867-1947) was a compulsive draughtsman. He took a pencil and a scrap of paper everywhere he went, but he was particularly adept at discovering new subjects (or new things to say about old subjects) in his immediate surroundings. A catalog of the pictures he produced while living at one

▲ John Sprakes
*Pencil, charcoal and chalk*
The contrast between the areas of freely drawn tone and the ruled, precise lines in this drawing – a study for a large acrylic painting – give it an interesting tension. Depth is created mainly by the use of perspective. The darkest lines and tones have been reserved for the cabinet topped by the cat in the glass case, which will be the central feature of the painting.

particular house records that he made seventy-four paintings of the dining room and twenty-one paintings of the bathroom. Many of these were developed from ideas which he had quickly drawn in his diary.

Drawing can reveal imaginative and creative powers you didn't realize you possessed. It can make you aware of the marvelous richness of pattern and three-dimensional form which is everywhere – even in what may seem at first the most drab of surroundings. It also gives you a greater awareness of other artists' work and an appreciation of their achievement.

## the projects

### PROJECT I
### Seeing through the medium
To some extent the medium determines how you draw the subject; if you only had a fine pen, you would be compelled to look for linear features. Choose a detailed subject, such as a bush with small leaves or a similar plant, and make some drawings using only ink and a brush not smaller than a No.4. The medium will not describe the objects easily, so you will have to find a way of translating what you see to suit its characteristics.

### PROJECT 2
### An object hanging
In earlier lessons you have spent some time making things – and figures – stand properly in your drawings. Now see if you can discover how you can make objects hang so that they look heavy. The subject can be anything heavy which you can hang up, such as a full shopping bag.

## DIFFERENT APPROACHES

# Drawing detail

### ALBRECHT DÜRER (1471-1528)

**A Study of Rocks**
*Brush drawing in watercolor*
It is difficult to think of anyone in the history of art who was able to cram more information into such a small pictorial area. Dürer's wood engravings and engravings on copper are often no larger than about 6×4in, yet they contain an incredible amount of detail – the cracked mortar of a wall, for instance, and birds nesting in the rotting timbers of a roof, are all keenly observed. The patience which must have gone into the production of these is also evident in the beautiful drawings Dürer made directly from nature, some of which, like his drawing of a hare, have become world famous. This keenly observed landscape drawing, made on a trip to Italy, is full of detail. But although the rock surfaces, the trees and plants growing from them and the play of the light on their angular forms are recorded with meticulous care, these details are only seen at a second glance. The initial impact is made by the dramatic and unusual shape of the rock formation, and it is this powerful abstract shape that engages your attention first.

There is no rule about how much detail a drawing should contain; it depends on the type of drawing and the artist's interests. Drawings which are not intended to be works in themselves but are done as a means of gathering information may be concerned only with a single aspect of the subject, such as tone or texture. But even when a drawing is the artist's complete statement, it may not go into elaborate detail. A drawing of a figure seen against the light, for example, may contain little detail of the figure's features because they would detract from the main point of the drawing – a dark shape silhouetted against a light background. Deciding how much

detail to include in a drawing is part of the important process of deciding what to include and what to ignore.

Many people, however, find it hard to make these decisions as they see more and more that could be included. Often, having tried to draw everything they can see and discovered that this led to a fussy, overworked drawing, they retreat into stopping their drawings as soon as they become interesting in case they are spoiled.

### CREATIVE USE OF DETAIL
Detail isn't something with which to decorate drawings. If your drawing is to be highly detailed,

the detail must serve a purpose. Sometimes, particularly in the 17th century, the amount of detail in a drawing or painting was an indication of the artist's virtuosity. The Dutch still-life and flower painters, for instance, used their subjects as vehicles to demonstrate their technical skill – though even then, detail was secondary to the overall composition of the paintings, which was carefully planned. Detail in drawings, however, can be used for other purposes. It can bring the attention of the viewer to particular parts of a drawing, and provide a contrast with other areas of the drawing which are more simply treated. In a landscape, detail can also be used to increase the illusion of space by describing the foreground more minutely than objects in the background.

### DETAIL AND ILLUSTRATION

There has often been a tendency for the most detailed drawings to be concerned with social commentary or satire. This more illustrative use of drawing can be seen particularly well in the works of two artists working in the 18th and early 19th centuries, William Hogarth (1697-1764) and Thomas Rowlandson (1756-1827). Their drawings, which were often intended to be translated into engravings and sold as prints, communicated a strong ideological message. In a sense, they were intended to be ''read'' as much as appreciated for their visual appeal, and the artists filled them with detail to reinforce their message. It is no coincidence that these drawings were usually made with a pen and reproduced with the sharp line of the engraving – incisive lines are often the best means of making highly descriptive drawings.

### STATED OR IMPLIED DETAIL

But detail does not have to be drawn in this way; many drawings of the highest quality which at first glance look to be broad statements, turn out on closer examination to be quite detailed. Edgar Degas (1834-1917) is an excellent example of an artist who is a master of this kind of understatement. His figure drawings in charcoal

## other artists to study

**WILLIAM HOGARTH (1697-1764)**

Hogarth was an excellent painter, particularly of portraits, but his fame, both in his lifetime and now, rests mainly on his masterly satirical engravings. "I have endeavoured to treat my subjects as a dramatic writer," he wrote. "My picture is my stage, and men and women my players, who by means of certain actions and gestures, are to exhibit a dumb show." His subjects – the first three were *Harlot's Progress, Rake's Progress* and *Marriage à la Mode* – are full of information which is superbly organized. Each moral story is told in a series of pictures and as well as appreciating each picture as a whole, it is necessary to read them detail by detail. They contain fascinating and shrewd observations of people, places and attitudes.

**EDGAR DEGAS (1834-1917)**

Degas had a traditional training in drawing, and was a great admirer of the classical draughtsman Ingres (1755-1814). He also embraced the ideas of Impressionism, and by taking the best from both worlds, he produced some of the most original and compelling drawings in the history of art. From around 1873 onwards he became interested in drawing and painting women at work, women dressing and bathing, dancers and cabaret artists. There are some monumental drawings, often in charcoal, of figures in repose with simple contours containing beautifully drawn details. The heads, hands and feet, and the muscle and bone structures in these drawings are keenly observed and very subtly suggested.

and pastel often give an impression of being a brilliant translation of the main features of a particular pose, and it is only when you have looked at them for some time that you realize how detailed they actually are. The bone structure, for example, at the wrists, knees and ankles – important points of articulation which are often disregarded in drawings – are beautifully suggested, but Degas doesn't allow detail to interfere with what he considers the most important features of the pose.

### SCALE AND DETAIL

In drawing detail, one of the things you have to be constantly aware of is that it is easy to get it completely out of scale. This is sometimes due to a common problem which I have already mentioned: when we focus our attention on one aspect of a drawing, we tend to lose sight of the whole. The bricks or stones in a wall or building are often drawn much too large, particularly if they are in the foreground, which immediately destroys the

151 ▷

# DIFFERENT APPROACHES

► Jean Canter
*Pencil and white chalk on colored paper*
The paper has been used as a mid-tone, with pencil as the dark tone and white for the light areas. This has given the artist more scope for a detailed description of the leaves, each vein of which has been drawn with complete accuracy. Notice the skillful use of the shadows to describe the curvature of the leaves and explain their positions in three-dimensional space.

◄ Martin Taylor
*Pencil*
This drawing contains an amazing amount of detail, identifying and describing individual plants and grasses as well as the various textures. Depth has not been sacrificed to detail, however, and care has been taken to get the scale of the detail right and to reserve the strongest tonal contrasts for the foreground.

credibility of the structure. And if an object is some distance from you, say, a tree in the middle distance, and you draw individual leaves too large you will also lose the sense of space.

### BUILDING UP DETAIL

Making a detailed drawing requires, above all, patience. You must be sure that the basic shapes and the main features of your drawing are right before you focus in on details. Generally, this kind of drawing is an additive process, with visual information being added until you have created the statement you require. You will also need to give careful consideration to the most suitable medium to use. I have already mentioned the precision of pen drawings, and both pencils and colored pencils are also well suited to detailed approaches.

## the projects

### PROJECT 1
**A single object**
For this drawing, which should contain as much information as possible, you need an object which has texture, shape and complexity. You might choose something out of the ordinary, such as a coil of thick rope, either lying on the ground or hanging, a piece of coarsely woven fabric draped or crumpled in a heap, or you could draw a more conventional subject such as a single bloom with leaves.

### PROJECT 2
**Architectural detail**
Architectural subjects often pose problems about how much detail to include. The subject for this drawing could be an interior or exterior. A church would provide a wide range of architectural detail. Draw everything you can see — stonework, brickwork and architectural features — but make certain that they are added to a basic drawing which is well constructed.

### PROJECT 3
**A figure in a room**
With figure drawing, there is often a tendency to concentrate on drawing the figure and only to give an indication of the background. For this drawing you need a clothed figure (this could be a self-portrait), and you should try to draw everything you can see in both the figure and its surroundings. The background should be in just as sharp a focus as the figure.

◀ Rosalind Cuthbert
*Pencil*
A very different use of pencil is seen in this portrait drawing, **Lynne Feeling Poorly**. The medium is used not only to give the figure solidity but also to describe color in terms of dark and light tones. Here again, the amount of detail in no way detracts from the impact of the drawing, which comes partly from the strong darks and partly from the sitter's intense gaze.

| **further information** | |
| --- | --- |
| **88** | Natural forms |
| **160** | Drawing a likeness |
| **180** | Pencil and colored pencil |

## DIFFERENT APPROACHES

# Drawing from memory

To some extent all drawing is memory drawing because it is impossible to look at the subject and the drawing at the same time. When you are drawing from objects, the visual information only has to be carried in your memory for a second or two, but it is surprising what a difference it makes if this time is a fraction of a second longer than necessary.

Many people feel they couldn't draw anything without having it in front of them, but visual memory can be improved by training yourself to memorize shapes, tones and colors. This is useful, as drawing from memory is sometimes the only means by which a subject can be recreated. When you draw a moving figure or animal, you can only do so by remembering them in one particular position. If your memory is good enough, you can also add things to a drawing that are not actually there. You might, for example, decide after making a drawing of a park or garden that a figure working in the foreground was needed.

## ANALYSIS

Setting out to memorize something so that you can draw from it demands a degree of conscious analysis which will almost certainly be greater than when you draw from direct observation. You can't work by trial and error in the same way that you can with the subject in front of you.

If you spend five minutes looking at an object which you intend to draw later, you will not only have to retain a number of images in your mind but also to organize them into categories of relative importance. When you start to draw, you will find that although the absence of the objects has the advantage of preventing you from copying irrelevant details, it can also make it very difficult to recapture the precise forms or tonal relationships.

## A 19TH-CENTURY DEBATE

The importance of the visual memory to artists was much debated in the middle of the last century. In Paris, which was then the center of the art world, a

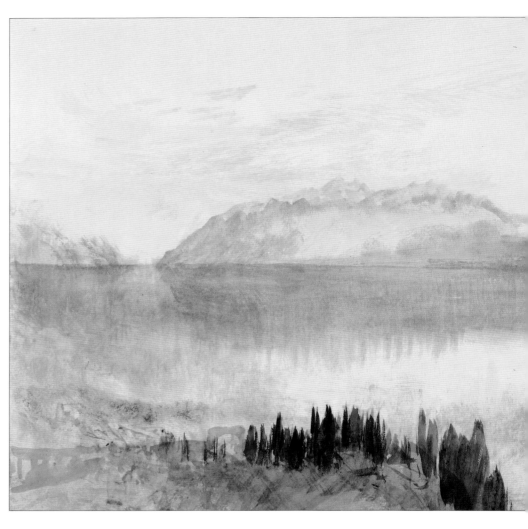

**JOSEPH MALLORD WILLIAM TURNER (1775-1851)**

**The Lake of Geneva With the Dent d'Oche**
*Watercolor*
Turner was a prolific artist who on his death left to the nation almost 20,000 drawings and watercolors. His visual memory was exceptional; he claimed to be able to remember the exact look of the sky during a storm in the Alps long after he had seen it. An eye-witness account from a train passenger in England records how Turner thrust his head out of the open window of a stationary train and kept it there for several minutes in a howling gale. This was to fix in his memory a scene which he later recreated in his famous painting *Rain,* *Steam and Speed.*

Throughout his life he made rapid pencil jottings and small colored sketches to serve as reminders. This is a page from his Lausanne sketchbook. John Ruskin, fellow artist and writer, described Turner's working method on this visit to Switzerland. "Turner used to walk around the town with a roll of thin paper in his pocket, and make a few

tradition of academic drawing had developed, embodying a system of learning and a conventional visual language. Most drawing was from the figure, but first, students had to learn a technique of finely gradated shading by making drawings of plaster casts of Classical statuary. The Classical proportions and simplifications learned from this process was then in effect superimposed on the living models drawn in the studios. When a drawing master corrected students' drawings, the corrections were as much adjustments toward ideals of beauty as towards accurate observation.

The rigid conservatism of the bastion of academicism, the Ecole des Beaux-Arts in Paris, was challenged by the appointment of Horace Lecoq de Boisbaudran as Director of the Ecole Royale et Speciale de Dessin. Lecoq described drawing as "looking at the object with eyes, and retaining its image in the memory whilst drawing it with the hand." He set out to train the memory, since he believed that left to itself it was inclined to store irrelevant information. His memory-training exercises progressed from simple objects to moving figures, working outdoors as well as in the studio, and he stressed that the flexibility of his teaching encouraged invention.

Henri Fantin-Latour (1836-1904), best known now for his exquisite still-life paintings, was a student of Lecoq, and because Fantin-Latour was friendly with most of the progressive artists of his day, Lecoq's ideas on the importance of the memory filtered into Impressionist circles. Camille Pissarro (1830-1903), for example, advised his son to draw from memory in the evenings what he had drawn in the life room during the day. The underlying belief which began to gain currency was that nature itself provided unedited information which it was necessary to filter through the memory before you began to draw. To quote Pissarro, "The observations you make from memory will have far more power and originality than those you owe to direct contact with nature. The drawing will have art – it will be your own."

155 ▷

scratches on a sheet or two of it, which were so much shorthand indication of all he wished to remember. When he got to his inn in the evening, he completed the pencilling rapidly, and added as much colour as was needed to record his plan of the picture."

### PAUL GAUGUIN (1848-1903)

Gauguin was another advocate of working from memory. He wrote, "It's good for young artists to have a model, but they should draw a curtain across it while painting. It is better to work from memory, and then the work will be your own." The filtering of the visual world through memory was very important to him, and he advised against copying nature. "Art is an abstraction: draw it out of nature while dreaming before it and think more of the creation."

### JAMES ABBOTT McNEILL WHISTLER (1834-1903)

Whistler, an American who studied painting in Paris and lived mainly in England, is renowned for his masterly etchings as well as his paintings. As a friend of Lecoq's student Fantin-Latour, he had imbibed the idea of working from memory, and described his famous *Nocturne* series of paintings as "painted from my mind and thought." He stressed that what mattered in drawing (and painting) was not the subject but the way in which it was translated. His most famous – and enormously popular – painting is a portrait of his mother entitled *Arrangement in Grey and Black.*

### WALTER RICHARD SICKERT (1860-1942)

Sickert was influenced by Whistler and worked in a similar way, omitting unnecessary detail. Many of his subjects were scenes at the theatre and incidents (usually with figures) in the shabbier parts of London, Dieppe and Venice. He never painted on the spot, relying on memory, drawings and sometimes newspaper photographs and picture postcards. He made many drawings, sometimes several slightly different versions of the same subject. Many of these can be seen in the form of etchings.

# DIFFERENT APPROACHES

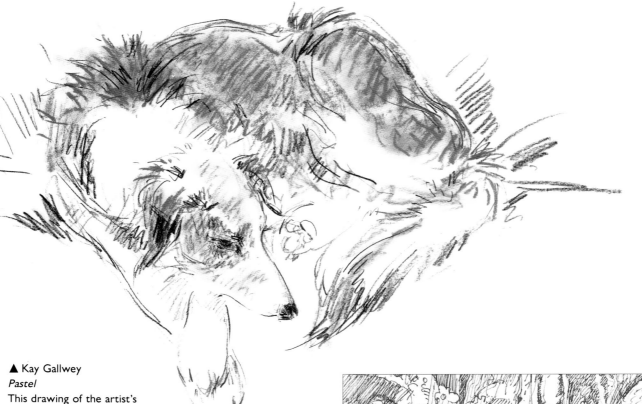

▶ Stephen Crowther
*Pen and gouache*
This powerful and expressive drawing, **Durham Miner**, is a detail of a sketchbook study done from memory as the basis for a lithograph. The original drawing, of the miner in a railroad car, showed more of the man's body and the surroundings, but the artist later decided to isolate the head only and exhibit the drawing in this form.

▲ Kay Gallwey
*Pastel*
This drawing of the artist's dog Clarence was made several years after the dog's death, when he and his feline companion Mr Bill became the subject of a children's book. The drawing shows a remarkable degree of accurate recall; the proportions, coloring and characteristic pose of the dog are beautifully conveyed.

▶ Ian Simpson
*Pen and ink*
This fantasy drawing was based on the interior of a theater, and although not a strictly accurate representation, it conveys a strong sense of atmosphere. Drawing from memory, although initially a daunting prospect, can also be liberating, as it frees you from the constraints imposed by minute faithfulness to perspective and scale.

### PROJECT 1
### Drawing by touch

This is not strictly memory drawing but it is an interesting variant, and will serve as a useful introduction. Take several objects which are small and hard, perhaps some pebbles, a shoehorn and a pair of scissors, place them on a table and look at them for about three minutes. Try to fix in your mind their positions on the table and their relationship to each other. Then put the objects in a bag made of some kind of thin non-transparent material. Make a drawing of the group of objects as you remember them but feeling them through the bag from time to time, so that you can remind yourself of their appearance without actually looking at them.

### PROJECT 2
### A head from memory

Get someone to pose for you for not more than five minutes, and try to fix their features and characteristics in your mind – the shape of their head, the form of their nose, their particular kind of chin and lips. Then make the most detailed drawing you can from memory. Try to avoid it looking like a police identikit picture, where each feature looks as if it has been remembered separately. Close your eyes from time to time and see the head you are drawing in your mind's eye.

## AIDS TO MEMORY

Theoretically Pissarro's advice may be sound, but it probably needs the thorough training in memory drawing which Lecoq provided to make it bear fruit. In practise, when most people draw from memory the drawings are not so much original as vague and generalized. They find it difficult to remember precisely how something was and so a rather unspecific statement has to make do.

However, memory will help you if you combine it with rapid note-making. On occasions when it is impossible to make a considered drawing of a place, person or event, a few quick notes can be made to act as a reminder of what was important about the subject. These may be scribbles on the back of an envelope, or the main shapes of the subject quickly drawn in a sketchbook with some accompanying written notes. Many artists develop their own kind of ''drawing shorthand,'' producing visual notes which might mean little or nothing to anyone else, but to the originator contain vital information which combined with the memory can recreate the scene as a drawing. Also, the simple act of drawing, however rapidly or roughly, helps to commit a scene to memory in a way that simply looking does not.

◀ Karen Raney
*Charcoal*
A self-portrait makes a good starting point for an exercise in memory drawing. But try to make your drawing convincing in terms of form rather than concentrating on the features. In this self-portrait the artist has begun by establishing the forms and planes of the face, and the drawing works as a three-dimensional structure as well as being a reasonable likeness.

## DIFFERENT APPROACHES

# Drawing movement

O ne of the most significant features of the visual world is that virtually nothing in it is static. We ourselves are hardly ever still, and everywhere there are natural and man-made objects that are permanently on the move. Even something which doesn't actually move, such as a building or mountain range, gives the impression of movement because of changing light and the play of sun and shadow. You have already tackled some of the problems of drawing movement when you made studies of the

sky in Lesson Fifteen and drew a moving figure in Lesson Fourteen. From this experience you will already be aware of some of the difficulties of both seeing and recording movement.

There have always been drawings made from moving objects; in fact the earliest drawings we know, made some 15,000 years ago, are cave drawings of moving animals. The aim in most drawings of moving objects, however, has been to make a static record of them, that is, ''freezing'' the movement at one moment in time rather than

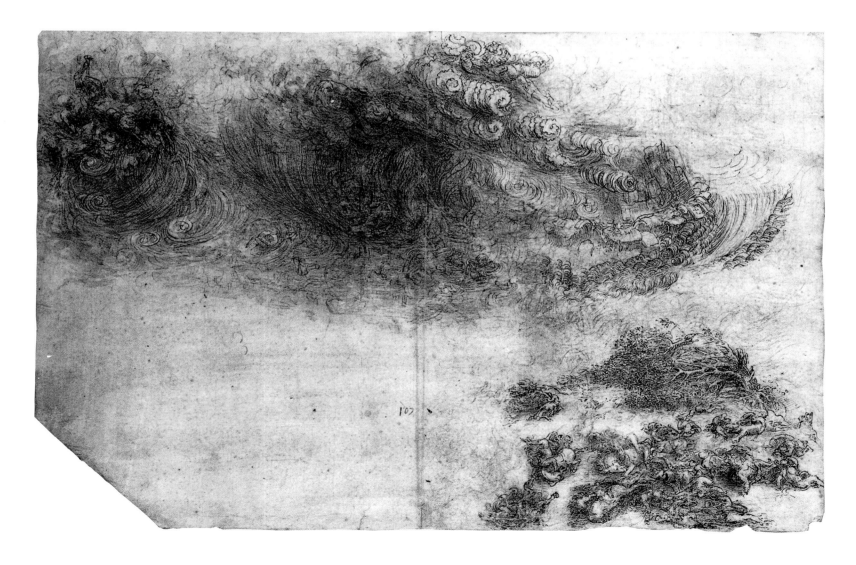

showing them in motion. Often even this has proved extremely difficult as our eyes find it impossible to seize and preserve a single point in a complex movement, particularly if it is a rapid one. The way the legs of a galloping horse move was not identified until the development of photography; previously artists had drawn horses in movement with their legs in completely inaccurate positions.

Sequences of photographs like those made by Eadweard Muybridge in the 1870s not only showed how a horse's legs moved as it trotted, cantered or

## other artists to study

### AUGUSTE RODIN (1840-1917)
Rodin, the most celebrated sculptor of the 19th century, opposed the academic tradition in sculpture in much the same way as the Impressionists did in painting. Both he and painters like Delacroix and Degas became increasingly interested in drawing a moving figure, and his freely drawn, multiple-contour drawings of nudes, often made in line and wash, give a marvellous sense of movement and energy.

### HONORE DAUMIER (1808-79)
The interest of the Impressionists in drawing moving figures had been prefigured by Daumier, painter and cartoonist, who made over 4,000 drawings for journals, many of them bitter political and social satires. He developed a keen visual memory and this, coupled with his free use of line, gives his drawings great verve and vitality. His free handling of line and tone made one critic of his time write that he "transformed muscles into rags hanging from a framework of bones." He was, however, adept at describing movement; in his drawings of horsemen, the array of lines come together to create a vivid impression of speed.

### LEONARDO DA VINCI (1452-1519)

**The Deluge, with Neptune and the Gods of the Winds**
*Black chalk reinforced with pen and ink*
Leonardo was one of the greatest and most versatile artists of the Renaissance. Not only did he anticipate many later developments in art but also many later discoveries in other fields, such as aeronautics and military engineering.

Few of his paintings survive, but fortunately he has left us thousands of drawings, which continue to be an inspiration to artists. His drawing of *The Deluge*, one of a series exploring the earth's terrifying forces, anticipates the approaches of many later artists. His use of the spiral in particular is an artistic device which was to be used many times later to create dramatic effects by artists as varied as Turner, Van Gogh and Victor Pasmore (see page 170). The drawing has almost certainly been made from imagination, but it is no doubt based on Leonardo's personal experience. It is as if he realized that effects of movement could best be described in an abstract form and so he used abstract images to make us feel the powerful swirling of the wind and the violence of the elements. In this drawing (in black chalk and touches of pen and ink on gray paper), he has not relied on line alone to create his dramatic effects; his use of tone helps to give the drawing a sense of atmosphere and foreboding, foreshadowing similar effects in the work of Expressionist artists.

galloped, they also demonstrated how a sequence of pictures showing an object gradually moving from one place to another could give an impression of movement. Some artists began to experiment with using this effect in pictures.

### LINE AND MOVEMENT
There are a variety of ways in which movement is depicted in drawing. Some of these can be seen most clearly in the graphic conventions used in strip cartoons. A rapidly moving figure is often shown followed by "movement lines" indicating that his body isn't static. Our eyes readily follow strong linear directions, and this can give a line the attribute of movement.

Movement in drawing is thus mainly created by use of line, and in part by the gestures made by the artist's hand as he or she works at speed to try to describe the moving image. Many of Leonardo's rapid sketchbook drawings of men and horses show this very clearly — they are some of the finest studies of movement ever made.

The way the line is used is of the utmost importance. One kind of movement may be best described with bold, vigorous pen strokes, or fluid brush drawing, while another can be most effectively recreated with swirling lines made with

158 ▷

▼ Aubrey Phillips
*Pastel*
In **Sutherland Peaks**, the movement of the wind and the sea are simply but effectively described with broad, rapid strokes made with the side of a short length of pastel. The shapes of clouds and the light line of a wave on the shore give a good sense of a breezy day and rolling sea.

a pencil using free sweeps of the hand. Generally some realism has to be sacrificed to create an illusion of movement in drawing. The energy which comes from the sweeping strokes with pen, pencil or some other drawing medium is much more important in generating a feeling of movement than the realistic description of detail.

### FREEZING THE ACTION
In making a drawing of a moving subject, you can also describe the object in different positions as it moves, as an animator does, or "freeze" the action. If you do the latter, it is important that you consider which precise point in the action you will portray. Often it is more effective to show the instant before the most dramatic point of a particular movement rather than the height of the

◀ Elsie Dinsmore Popkin
*Charcoal*
In **The Mostly Mozart Festival** the artist has drawn a portrait of each musician, but the freedom with which the bodies and musical instruments have been drawn makes these portraits very informal. The strong rhythms in the drawing created by the sweeping lines and the small areas of dark tone scattered around give a good impression of music and movement.

## the projects

### PROJECT I
### Water patterns
Water movement can be translated in many different ways. Your drawings might be linear and gestural, emphasizing the swirling movement of water flowing over rocks, or they could be concerned with the interplay of shapes, perhaps describing the patterns of gently disturbed water in a quiet river. Draw as many kinds of water movement as possible, from the water dripping from a faucet into a bucket to waves breaking on the shore or over a pier. Try to draw dramatic water effects like waterfalls, where describing the force of the water will almost certainly require strong straight lines. Draw also pattern effects, like those you see when you throw a pebble in a pond.

### PROJECT 2
### People in action
Make drawings of people working, either indoors or out. Preferably you need several people to draw, but if this isn't possible, you could draw the same figure several times. You could choose men working on a building site, swimmers, tennis players, dancers practicing or athletes training or in action. Before you start to draw, spend some time observing what the figures do and try to analyze the aspect of their activity which will give the best sense of the action.

action itself. For example, if you were drawing a man striking a piece of metal on an anvil, the moment at which the hammer is raised to its highest point will give a much better idea of dramatic movement than the instant when the hammer hits the metal.

Bear in mind also that the slightest movement, whether of a human figure or an animal, affects the whole body. Merely moving one foot in front of the other changes the complete position of the torso. Sometimes it is best to try out for yourself the movement you are intending to draw so that you can feel the most dynamic point in the action, and the way other parts of the body move to compensate for changes in balance.

### CHANGING THE VIEWPOINT
So far I have assumed the artist would be in a fixed position and the object moving. A sense of movement of a different kind can be created when the artist moves, drawing a sequence of different views of the subject. If these drawings are drawn (or later arranged) side by side, they will give an idea of the passage of time, and can provide an accumulative experience of an object. As in some Cubist drawings, which I referred to earlier in the article on perspective (page 64), drawings from different viewpoints can be superimposed so that you have two or more views in the same drawing.

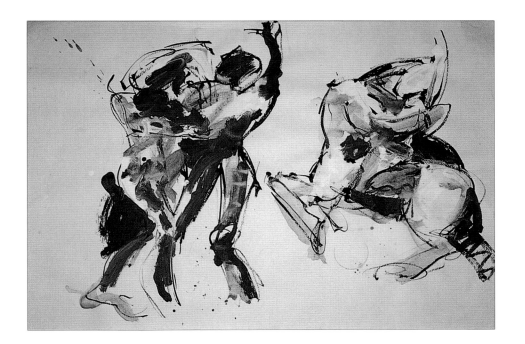

▲ Paul Powis
*Ink and gouache*
Movement is often conveyed in drawing by a swiftly executed, vigorously drawn line. In this drawing, however, the strongly contrasting light and dark tones are equally important in contributing to the feeling of movement and excitement, as they cause the eye to dart around the drawing.

## DIFFERENT APPROACHES

# Drawing a likeness

**W**e instantly associate the word "likeness" with portraiture, but a likeness, in the sense of an instantly recognizable representation, can be painted of anything. While portraiture is the central theme of this lesson, it will also consider how recognizable images are created from other subjects.

Perhaps what characterizes all good works of art is that they are utterly convincing. It is the same with a good play or book. As the story unfolds, both the plot and the characters are entirely believable because the writer has created a world into which you enter, and while you are there, its logic goes unquestioned. In the same way an artist can produce a picture which is completely convincing. One of my favorite examples is a painting by Anthony van Dyck (1599-1641), *Cornelius van der Geest*, in the National Gallery, London. The sitter looks out at us from the painting, his eyes slightly tearful and his lips moist, and there is no doubt in my mind that this portrait is exactly how he looked. On the face of it, this might seem an odd thing to say, because I can't possibly know what this long-dead person was really like, yet I remain totally convinced that I know Cornelius van der Geest and would recognize him if I saw him in the street.

In most cartoons a particularly characteristic feature – a distinctive nose, bushy eyebrows or large ears – is identified and exaggerated, becoming the main feature in the drawing, with most other aspects of the person's appearance ignored. Selecting and exploiting a telling feature of a person – although in a less exaggerated way – plays a significant part in obtaining a likeness, and you will need to look out for what is most obvious in terms of features, the shape of the head and so on. Students often imagine that filling their drawing with detail – drawing in eyebrows and eyelashes or the creases at the corner of a mouth – is the secret to creating a likeness, but this is seldom the case, indeed drawing unnecessary detail can detract from the likeness rather than enhancing it.

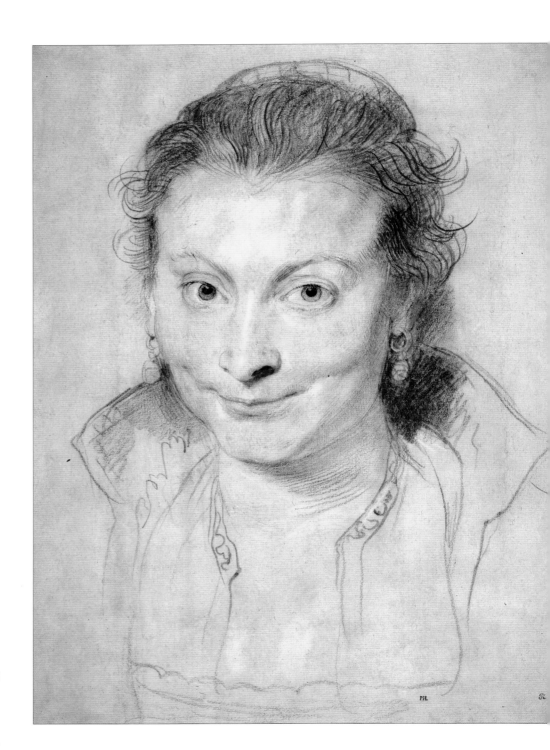

### SIR PETER PAUL RUBENS
### (1577-1640)

**Portrait of Isabella Brandt**

*Black, red and white chalk and pale brown wash with touches of pen*

Rubens, court painter and diplomat, knighted by Charles I, was probably the most successful artist in the entire history of painting. The young van Dyck worked in Rubens's studio in Antwerp, a highly organized workshop where assistants helped him deal with the flood of commissions which his fame attracted. Many of his drawings are freely executed in a flamboyant style, but this portait of his first wife is drawn lovingly with delicate modeling and great attention to detail. But it is nevertheless quite freely drawn, with the eyes, hair and clothing indicated with great economy. Notice how Rubens has positioned the sitter with the light from above on the left so that the structure of her head is revealed.

## other artists to study

### MARY CASSATT
### (1844-1926)

Cassatt, an American who settled in Paris and became a friend of Manet and Degas, exhibited at the Impressionist Exhibitions between 1879 and 1886. She made some beautiful drawings and paintings of domestic scenes which are often informal portraits. Children, like animals, are subjects which often produce very sentimental drawings, but Cassatt's drawings of mothers with babies are tender without ever descending to trite sentimentality.

### SIR STANLEY SPENCER
### (1891-1959)

Many of Spencer's drawings and paintings could be called informal portraits; he incorporated recognizable people into his religious paintings. He also produced formal portraits which are carefully observed and skillfully simplified, and he made many "portraits" of landscapes and houses around Cookham in Berkshire, England, where he lived for most of his life. His drawings, which combine a strong sense of pattern with a stylized representation of three-dimensional form, show an eye for unusual detail and great technical certainty.

### DAVID HOCKNEY
### (b1937)

In the 1970s, at a time when abstract painting and conceptual art were regarded by the art establishment as the only forms worth pursuing, Hockney was one of a small number of artists who swam against this powerful current and promoted figurative art. He is an excellent draughtsman, and many of his most brilliant works are spontaneous informal portraits of his friends. There are also more formal portraits, including drawings of his parents and portraits of people and buildings, which are produced by ingenious use of photography.

▲ The subtle and delicate modelling around the mouth, nose and eyes creates a completely convincing impression of the forms and planes.

**A SENSE OF PLACE**

When we draw a landscape or urban scene, we seldom worry as much about creating a ''likeness'' as we do when drawing a person. Yet all the things which should be considered in drawing a portrait are equally important when tackling other subjects such as landscape and still life.

Not all depictions of figures aim to make the persons recognizable; it may be what they are doing is more important than who they are. In the same way not all landscapes are intended to be portraits of a particular place. Perhaps one of the advantages of landscape painting is that a number of different experiences of a landscape can be brought together to convey a feeling for a place rather than a literal description of an actual view. If you are drawing a particular view, you can treat it very much as you would a portrait, exaggerating some features and ignoring others, but the drawing

162 ▷

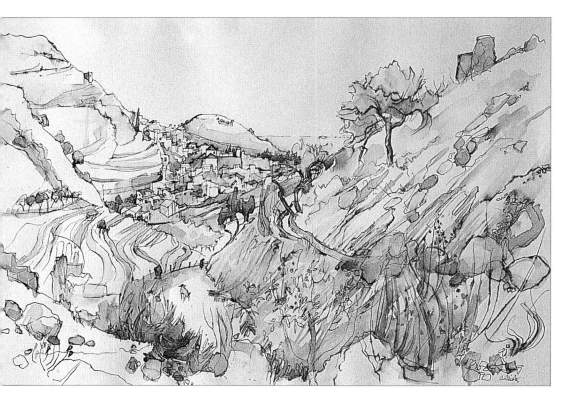

will only be convincing if it has a "sense of place," which is in many ways the equivalent of the "likeness" in a portrait.

### DIFFERENT KINDS OF PORTRAITS

There are many other possible kinds of portraits, for example, there is no reason why portraits should not be drawn of pets — which, being members of the household, we often think of almost as people. They are difficult, however, partly because they won't remain still for long and partly because their shapes and forms are so much obscured by hair or fur. And unfortunately, although fine animal drawings have been produced throughout the history of art, the majority of the animal portraits we see — and perhaps subconsciously try to emulate — are characterized by cloying sentimentality. But if you can avoid this pitfall, by all means try a pet portrait. Just as you would when drawing a person, look for the important characteristics, which in the case of

▲ Joan Elliott Bates
*Pen and wash*
In **Frigiliana**, the artist has produced a convincing likeness of a small town nestling between hills. Although simplified, all the features of the town and its surroundings are included, and there is a distinct "sense of place." Individual buildings, although a long way off, are clearly recognizable, as are features of the rock-lined path and the animals in the fields.

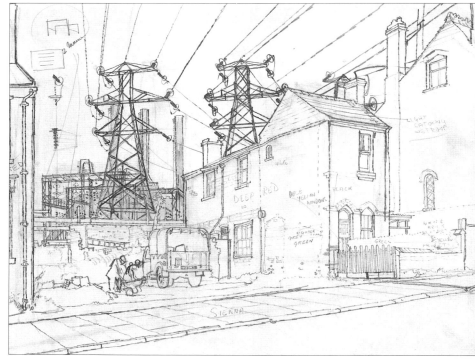

◀ Christopher Chamberlain
*Pen and ink*
In **Near Stoke on Trent** different qualities of line have been skillfully used to convey the textures of paving stones and walls and the hard, dark structures of the pylons. Unerringly the artist has seized on the significant features of what to some would seem a mundane subject and showed us how interesting they are. This drawing was made as a reference for a painting and incorporates some notes on color.

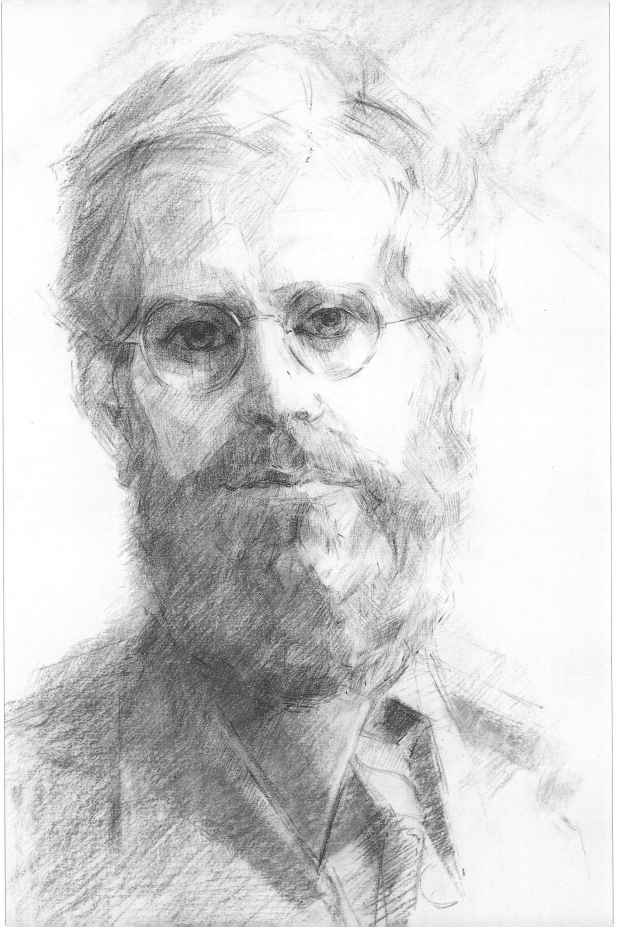

◄ Richard Wills
*Charcoal*
This keenly observed drawing of a head is completely convincing even though we do not know the sitter. The penetrating eyes behind the glasses, the asymmetrical mouth and the slightly dishevelled collar and tie show how the artist has looked for the particular features which would reveal his sitter's personality and individuality. Shading has been built up by means of sensitive hatching lines (and crosshatching in places), which give the drawing a quiet vitality.

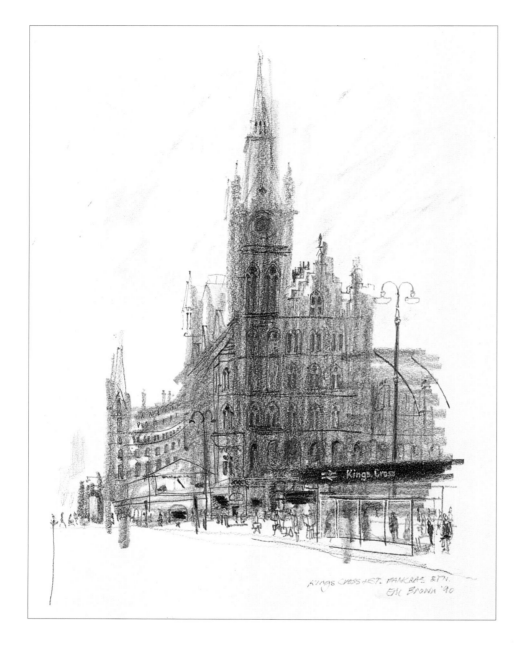

animals, is more likely to be coloring, texture and typical postures rather than specific facial features.

Apart from people and animals, the other major portrait subject has traditionally been houses. At least since the 16th century, rich landowners have had pictures made of their homes, and in recent times this idea has been extended to portraits of commercial buildings. It is not unusual for architects to commission drawings and paintings of their buildings, not to be produced as bland architectural representations but in the selective way that a portrait would be made.

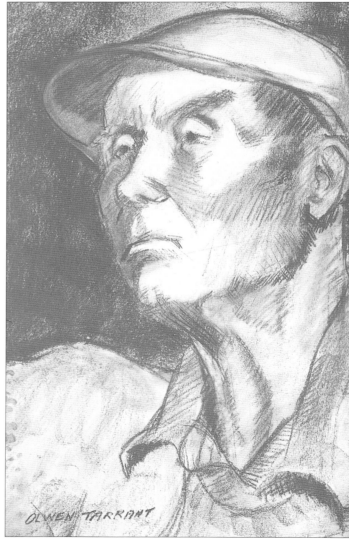

▲ Eric Brown
*Charcoal*
The distinctive, dark silhouette and towering size of this famous London landmark, St Pancras station, make it instantly recognizable. Although **St Pancras Station** is not a detailed architectural drawing it works perfectly as a "portrait" because all the important features of the Victorian Gothic building are included, and the proportions are completely accurate.

▶ Olwen Tarrant
*Conté crayon*
In this lively drawing, which conveys atmosphere as well as describing the features, the head has been simplified into two main tones with a third and darker tone for the background.

## PHOTOGRAPHY VERSUS PAINTING

We usually relate likeness, however, not to someone in the distant past but to someone we know now and whose appearance is familiar to us. They may be people we know personally or famous personalities from film or television pictures, and the likenesses will usually take the form of photographs. These, although they portray a person objectively and in a sense accurately, don't always satisfy us as being a true likeness. There are, of course, many good photographic portraits, often where the lighting has been carefully arranged to emphasize a particular feature of the sitter, but the tradition of the drawn or painted portrait has persisted in spite of photography, because it is capable of characterizing a person in a way that photography seldom can.

## IDENTIFYING CHARACTERISTICS

Cartoons have something to teach us about obtaining a likeness. The word cartoon (from an Italian one meaning a large sheet of paper) originally referred to a full-size drawing for a painting or tapestry, complete and ready for transfer to the working surface. The word is still used in this sense, but to most people cartoons are the humorous or satirical drawings which are featured in almost every newspaper or magazine. They are usually concerned with public figures whose appearance is well known, and it is interesting that although they are instantly recognizable, they really look nothing like the actual person. They aren't convincing in the way that a great portrait painting or drawing is, and will mean nothing unless you are familiar with the person's real appearance. Nevertheless they provide a kind of likeness, often with great economy of means.

## the projects

### PROJECT 1
### A portrait in a setting

Although a likeness depends primarily on selecting those particular features which seem to be unique to the sitter, a good portrait should also say something about their character. You can often give an extra dimension to a portrait by hinting at the person's occupation or interests, and placing the sitter in an appropriate setting. A gardener might be drawn with a garden or greenhouse as a background, for instance, or a writer drawn in a book-lined study. Make a drawing which is a likeness and describes as much as possible about the sitter's personality.

### PROJECT 2
### A particular place

Choose as your subject a building or some scene which you feel you can draw like a portrait – it could be your own house, or a single tree in a park.

Remember that the success of the "portrait" will depend on selection, not on merely trying to draw as much detail as possible. As you draw, try to discover its most telling features and be prepared to emphasize or even exaggerate them so that the subject is recognizable as one particular house or tree.

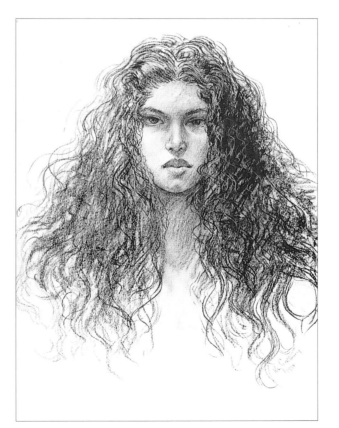

◀ Kay Gallwey
*Black pastel*
The dominant feature of this drawing is the flowing hair, drawn in long, curling lines, but careful attention has been given to the features also. The eyes and mouth have been drawn in considerable detail, and shadows and reflected light used to model the distinctive forms of nose and chin.

# DIFFERENT APPROACHES

# Drawing from imagination

**D**rawing is the most direct means of communication available to the artist, and it is possible through it to release the imagination and to make drawings of an inner world. The popular concept of the artist is that he or she works entirely from imagination, but in reality the great majority of artists, even those whose work is abstract, usually work from direct experience of the external visual world. For some, however, the inner landscape provides a fascinating vista, and it is one worth serious exploration.

During the period from the middle of the 18th century to the middle of the 19th, often called the Romantic era, many artists used imagination as a source of inspiration. To some extent this was a reaction to the scientific discoveries of the time, which were gradually attempting to explain what had previously been magical and mysterious. In the 20th century also there have been periods when artists have turned away from reason and logic, arguing that although science may be able to explain some things, it can't rationalize everything. Why, for instance, do people dream? How can the supernatural be explained?

### INNER VISION

There are interesting stories told of the visionary powers of the artist William Blake. Like many artists of the 18th century, Blake became interested in the occult and attended seances with a fellow artist, John Varley. At these seances, characters from history and myth were seen and drawn by Blake; these drawings are called *Visionary Heads*. Varley said that he saw nothing himself, but was totally convinced that Blake did see visions. Blake described imagination as "the world of Eternity; it is the divine bosom into which we shall all go after the death of the vegetable body." He thus equated the imagination with the soul, and believed that the mind needed to be receptive if a person were to see through the window to the soul.

The artist's view through this window is not

## SAMUEL PALMER
### (1805-81)

**Imaginary Animal**
*Pen and ink and watercolor*
In Palmer's sketchbooks, along with the visionary landscapes, are drawings of saints and angels, mysterious woods, strange gnarled trees and threatening figures. There are also peculiar creatures like this one, from a sketchbook of 1824. This slightly comical creature is drawn with great assurance in Palmer's typical style – a firm pen contour with the three-dimensional form suggested by skillful use of texture and careful drawing of overlapping forms. The animal, however convincing its appearance, is entirely from the imagination. It looks as if it might be part-mule and possibly part-camel.

The sketchbook from which this drawing comes is one of only two which have survived. Palmer left twenty, but the rest were burned by his son before he emigrated to Canada. Although Palmer himself had valued them highly, his son thought they contained only "slight sketches, blots and designs."

## other artists to study

### WILLIAM BLAKE
### (1757-1827)
A poet as well as one of the most original artists of his time, Blake's drawings and prints are truly sensational. Although his work was only known to a small group of admirers in his lifetime, his genius began to be recognized in the second half of the 19th century, and many people's ideas of what heaven and hell are like come from the representations of them in Blake's drawings. The reality of the visions which gave rise to the *Visionary Heads* drawings has been questioned ever since Blake drew them. Did he really see the people he drew? Are they from his imagination? Could he have been fooling Varley? Was he mad? Whatever the truth, these drawings are among Blake's most unusual and imaginative work.

### FRANCISCO DE GOYA
### (1741-1825)
At the end of the 18th century Goya was the most fashionable portrait painter in Spain and First Painter to the King, in spite of the fact that he depicted the royal family as coarse, stupid and arrogant. While following his career as a portrait painter he was also engaged in making imaginative drawings and prints. Tormented by demons, which he began to think were real, Goya's many drawings, paintings and prints show horrific imaginary creatures and terrifying scenes. He became more and more dominated by his imagination. A serious illness left him deaf and even more introspective. In his old age he produced his most disturbing work, a series of murals in his own house (the *Black Paintings*) in which his imagination inspired violent images.

necessarily romantic, and can be decidedly unpleasant, just as dreams sometimes are. The great Spanish painter Francisco de Goya drew the horrifying creatures which plagued his mind, and the drawings made by the Swiss-born artist Henry Fuseli (1741–1825) from the late 1700s and early 1800s are capable of disturbing us still. Typical examples are drawings of malevolent-looking, threatening women, which clearly reveal his fascination with the murkier areas of the psyche.

### THE IDEAL WORLD
Imagination in art has often been used to take the artist from the mundane concerns of the present day to the idealized world of the past. Subjects were taken from history, particularly the medieval period, but this celebration of the past had little to do with the historical reality; artists tried to recreate a past which they wished they could inhabit in the present.

Samuel Palmer also recreated an ideal world, but not one of the past. A painter of pastoral landscapes, he met Blake in 1824 and became a follower. In his early twenties he drew the landscape around Shoreham in Kent, England, where he lived, seeing it full of Christian symbolism. Palmer's most typical work featured nature, God and worship fused together. His early drawings were based on nature, but nature transformed by the imagination into dreamlike, idealized English scenery. The drawings reflected a world which Palmer wished was reality. Sheep graze on perfectly rounded hills; there are rainbows, shining stars and blazing suns, sometimes painted in gold. Sadly, his "primitive and infantile" feeling for the landscape faded and his work became more conventional.

### MEMORY AND THE SUBCONSCIOUS
Until the early part of this century the subject of a drawing or painting was all-important. The Impressionists shocked the public by painting scenes thought too mundane and thus unsuitable

168 ▷

# DIFFERENT APPROACHES

▼ Paul Powis
*Graphite on board*
This drawing is not in fact an imaginary subject; it is a detail of the sculptures on the Albert Memorial, London. But because the masks and figures are taken out of context the first thing you notice is the bizarre differences of scale, which create a dream-like, almost menacing effect.

for art, and artists like Paul Klee (1879-1940) took this a stage further by drawing with no subject at all. Klee described drawing as "taking a line for a walk," and his art of free fantasy allowed him to draw lines on the paper which eventually suggested a real or fantastic subject from his imagination. He was convinced that these found images were more real and true to nature than any drawing made from an object.

Surrealist artists, greatly impressed by the writings of Sigmund Freud, tried in the 1920s to create something more real than reality itself. Freud had revealed that when our wakened thoughts are numbed, then the child or the savage takes control. This made the Surrealists believe that art could never come from wide-awake reason. Writers of the Romantic period had experimented with drugs to suppress reason and allow the imagination to be released, and the Surrealists looked for ways of allowing what was deep in their minds to come to the surface. Like Klee, they believed that artists shouldn't plan their work but should allow it to grow, and they drew and painted pictures where objects merged and exchanged places, as they do in dreams.

## IMAGINATION AND A SUBJECT

It does not follow, however, that drawings from subjects must by definition be unimaginative. If someone who knows nothing at all about drawing and painting were to see two or three artists drawing the same subject, they might wonder why each one is making quite different marks in response to it. Some part of the difference between artists' drawings of the same subject must come not from the subject itself but from what the artist brings to it. This might include knowledge and experience, but it also includes imagination. When we admire a realistic drawing and wonder why we hadn't thought of drawing that particular subject or seeing it in that way, what we are admiring is the artist's imagination.

Artists are by nature inquisitive people, and they can discover strange features and unexpected associations by closely studying the character of things. Just as you can see pictures in the fire, so you can place things from one context into another, working on the "what if?" principle. "What if Christ came to Cookham?," Stanley Spencer (see page 161) may have asked himself before he began his series of religious paintings which were located in his own village. The most ordinary object or location needs very little manipulation to turn it into something from another world.

## the projects

It is impossible to set a number of projects asking you to "be imaginative" since your inner self by definition is private, and you have to find your own ways of drawing inspiration from it. It is possible, however, to suggest some ideas, or starting points, which may stir your imagination. These are listed below. It is suggested that you try all of them but you may find one or two particularly fruitful and decide to develop several drawings from these.

● An incident as a vision – like the Géricault horse.
● The "what if?" principle for instance, what if an ecological disaster struck?
● An ideal world, past or present.
● Dreams and fantasies.
● Things out of context.
● A poem or piece of music.

▲ David Cuthbert
*Colored pencil*
In **Flaming Tea Strainer** the artist makes excellent use of the qualities of colored pencils to give a dazzling account of this imagined event, with the intense blue background providing a brilliant contrast for the orange flames. Because the drawing is not primarily representational, the artist has felt free to change the relative sizes of the strainer and teapot and to distort the shapes.

◄ Linda Anne Landers
*Charcoal*
The woman, the lion and the tree have been drawn in a simplified, stylized manner inviting us to see them as symbols. Is the tree symbolizing life? Are the woman and the lion a comment on male and female relationships? The title, **Woman on Lion**, gives little away. Drawings like this might be made from dreams, or the drawing style and the subject can be from a more conscious ordering of the imagination.

## DIFFERENT APPROACHES

# Abstraction through drawing

**A**bstract art is based on the belief that shapes, forms and colors have intrinsic aesthetic values and thus don't necessarily have to relate to a real subject. Some 20th-century artists have found drawing and painting what they see too restricting. They have looked to music and seen that it can exist as an art form capable of communicating in all kinds of ways without imitating natural sounds. Why then, they have asked, should art not also be able to exist in a similar way, independent of representation?

This idea is not new. As long ago as the 4th century BC the Greek philosopher Plato had seen the artistic potential of abstract shapes and forms. He wrote, "I do not now intend with beauty of shapes what most people would expect, such as that of living creatures ... but straight lines and curves and the surfaces of solid forms produced out of these by lathes and rulers and squares. ... These things are not beautiful relatively like other things, but naturally and absolutely."

## A BRIEF HISTORY OF ABSTRACT ART

The terms "abstract art" and "modern art" are sometimes thought to be synonymous, but this popular notion is completely misleading. In a sense, abstract art has always existed, often as decorative pattern. In Muslim culture, for example, where representations of the human figure are forbidden, abstract art has been developed to a level of great beauty and expressiveness. Even in Western art, where the emphasis has been on depicting what is seen, there is often an element of abstraction, which is more pronounced in some artists than in others. Piero della Francesca, the 15th-century Italian painter, is a good example of an artist who showed as great an interest in the interplay of positive and negative shapes in his paintings as he did in their descriptive qualities.

It was in the 19th century, however, that a more urgent exploration of non-representational art developed. There were two main reasons for this

**VICTOR PASMORE (b1908)**
**Beach in Cornwall**
*Pencil*
Pasmore has been an influential teacher. He developed a Basic Design course based on abstract principles of design and influenced by the Bauhaus, the famous school of architecture and design which operated in Germany between 1919 and 1933. In his transitional stage from realism to abstraction, Pasmore made many drawings like *Beach in Cornwall*. This drawing uses only line, and the clouds and rocks are translated into interlocking shapes with the sea wedged between. A spiral motif began to be introduced into Pasmore's drawings as a translation of movement,

and it appears in a rudimentary form in the sea in this drawing. It is interesting to note that Leonardo had used a spiral in his deluge drawings (see page 156) and Turner in his sea pictures.

experimentation. First, invention of photography seemed for a time to make representational art redundant, and second, artists began to realize that the main aim of Western art – depicting what we see – was one which was impossible to achieve. The real difficulty, they discovered, was that no matter how they tried to do otherwise, they drew what they had learned to believe things looked like rather than their actual appearance. The Impressionists thought they had achieved a major breakthrough in painting when they discovered how to paint what they saw with what they thought to be ''scientific'' accuracy, but it was soon known that they weren't accurate in this sense, although their ''impressions'' are possibly more like what we actually see than other forms of painting. We know now that we can't be a completely objective eye and separate what we see from what we know. We recognize that there are different ways of seeing, and we don't regard this as a disadvantage.

The experimental art of this century has taken two main routes. One has been that of communicating the artist's feelings, while the other takes the formal arrangements of shapes, forms and colors as the artist's actual subject. On the formal route, the way divided again into two different directions, one of which I will call ''pure'' abstract art, which has no external visual starting point in nature. The other direction, which I will call ''abstraction,'' took from the visual world those things which would create interesting and unusual effects in an art work, regardless of whether they helped to give a sense of reality. This lesson is concerned with the latter direction – abstracting from nature.

### FROM REALISM TO ABSTRACTION

Many artists in this century have moved from representational drawing and painting to abstraction. Some have moved back again to representation and some have alternated between the two, as did Picasso (although he regarded all

## other artists to study

### LYONEL FEININGER (1871-1956)

Though an American, Feininger only returned to New York in 1937, having trained and lived in Germany and become interested in Cubism in Paris. His drawings and paintings show how he developed from Cubism a form of abstraction for which he then selected particularly appropriate subjects. His ingenious device of building up his pictures with overlapping transparent triangles made it possible for him to convey an illusion of depth and allowed him to simplify the objects in his pictures without them looking flat. The ends of gabled buildings and the sails of boats gave particular scope for his compositions based on triangles, and most of his work is concerned with these subjects.

### BEN NICHOLSON (1894-1982)

Nicholson came from a family of painters and began by painting in a naturalistic style reminiscent of his father's work. In his early days he spent some time

trying to shake off the good taste he felt he had inherited, and "bust up the sophistication all around" him. He was adept at assimilating into his own work the ideas of other artists. He met Picasso, Braque and many of the leading artists of the 1930s in Paris. He was particularly impressed by the Dutch abstract painter Piet Mondrian (1872-1944), and began to make semi-abstract paintings, some with incised lines which sometimes described objects and sometimes had a life of their own. He then moved to making geometrically inspired abstract reliefs (some white and some colored) which are regarded as a high point of abstract art in Britain. His later work alternated between the completely abstract and drawings and paintings which, though abstractions, clearly revealed the subject. There are many particularly interesting drawings in the latter style.

## DIFFERENT APPROACHES

his work as being representational).

Victor Pasmore began as a painter of subtle landscapes and interiors, but his paintings became increasingly simplified, with a sense of tone and pattern reminiscent of Oriental pictures. In the 1950s he began to make abstract relief constructions based mostly on horizontals and verticals, and he has since continued to work as an abstract artist.

He described his move into abstraction as the logical result of his professional evolution. "I had no interest in rebellion, I never tried to do anything new. ... I explored all the possibilities, I'm not interested in my style. I'm not even against subject but it's not for me. I believe that abstraction is the logical culmination of painting since the Renaissance." He later explained that he had reached the conclusion that, "The solid and spatial world of traditional naturalism, once it was flattened ... and disintegrated by the Cubists, could no longer serve as an objective foundation ... the painter confronted an abyss from which he had to retreat or leap over and start on a new plane. The new plane is abstract art."

Not all abstract artists go through these

◄ Ray Mutimer
*Black wax crayon and gouache*
The artist has taken a high viewpoint to enable him to investigate the patterns of the stones and water without the distraction of a landscape context or the necessity to describe three-dimensional space. The stream and rocks are instantly recognizable, but the drawing has a strong abstract quality.

▲ Pip Carpenter
*Carbon pencil and wash*
The close-up view of these rock formations accentuates their abstract qualities, and the rugged character of the subject has been translated by drawing line over line almost as if the artist was carving the drawing. The carbon pencil, which is denser and blacker than graphite pencil, has been overlaid with patches of color to give an almost stained-glass effect.

transitional stages. Some famous abstract artists of recent times have had no experience of representational drawing, and similarly many art students of the last thirty years or so have been abstract artists from the very beginning.

### ABSTRACTION

Abstraction takes from a subject those shapes, forms and colors which have the greatest pictorial significance. When you are abstracting from nature, you don't have to worry about whether your drawing looks realistic; indeed you can select and exaggerate shapes, forms and colors until the subject is completely unrecognizable. Most people find it difficult to draw anything without it creating an illusion of reality, so you may find it easier to work from a drawing you have made previously. Make another drawing from the first one, extracting the important shapes, forms, textures and tones.

▶ David Ferry
*Pencil*
In **Skull Form**, as the name implies, a bird skull has been the inspiration for a bold drawing which contrasts clearly defined shapes and light and dark tones. The artist has also compared the foreground organic forms with forms in the background which have been given an architectural quality. Areas of dark shading and sharp lines give the shapes and forms clear definition.

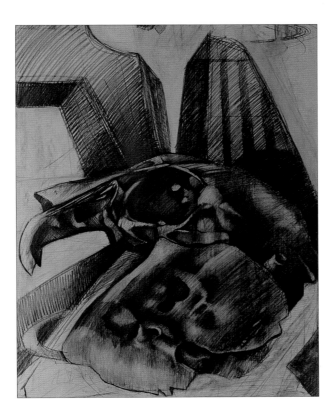

## the projects

### PROJECT 1
### Abstraction from still life
A good place to start making abstract drawings is with still-life subjects, as the Cubists generally did. You may like (as they did) to use bottles, musical instruments and other objects with clearly defined shapes.

### PROJECT 2
### A flat expanse
The aim in this abstraction is to make a drawing which is concerned with pattern and has very shallow depth. Find a flat vertical area, such as an old wall, with stains, perhaps moss, cracks and general signs of wear and make as exciting a drawing as you can, treating it as an intricate abstract design.

### PROJECT 3
### A tree or a hedge
In this project the idea is to make an abstraction from a single natural form. There are some fascinating drawings and paintings of thorn hedges and other natural forms by Graham Sutherland (1903-80) that you might like to look at before you start. The silhouettes, the textures, the intertwining shapes of branches and leaves are all possibilities for abstraction.

One way to do this is to lay tracing paper over the first drawing and trace on it the shapes and forms you think are important. Then transfer these to a sheet of drawing paper to develop the work.

If you work directly from a subject, start by blocking in the main shapes with tone or color and develop your drawing by selecting and exaggerating the shapes, forms and colors (if you are using color) which you see as significant. You may need to turn away from the subject periodically and develop the drawing independently of it, as otherwise you may find it impossible to prevent yourself from describing it realistically.

## DIFFERENT APPROACHES

# Drawing through painting

There is a widely held belief that in order to paint you must first learn to draw. This view has its origins in the academies of the 19th century where students only graduated to painting after completing a rigorous course in academic drawing.

Even at that time, however, there were those who questioned the validity of this approach. Some of the Impressionists rebelled against the academic dogma, and Paul Gauguin (1848-1903), one of the few major artists of the period who had no first-hand academic teaching, derided the academies' "cookery school approach" and prided himself on being "untouched by the putrid kiss" of academic education. Offering his view on it he said, "One learns to draw and afterwards to paint, which amounts to saying that one begins to paint by coloring in a ready made contour, rather like painting a statue."

John Ruskin (1819-1900), the most influential British art critic of the 19th century as well as an artist and meticulous draftsman, pointed out more than a century ago that "while we moderns have always learned, or tried to learn, to paint by drawing, the ancients learned to draw by painting." By "ancients" Ruskin meant the artists of the Renaissance. He went on to observe that you never saw a childish or feeble drawing by any of the "ancients" because they had only turned to drawing when they were already accomplished painters. Their drawings, Ruskin said, were "for rapid notation of thought or for study of models but never as a practice helping them to paint."

## DRAWING AS A SEPARATE ART

Herbert Read, another distinguished writer and critic, suggested in his book *The Meaning of Art*, published in 1933, that the drawings of the Old Masters "constituted a separate art, distinct from painting, ancillary to it in that they provide a means of rapidly noting moments of vision or of thought which can later be translated into painting, but having no immediate relationship with the

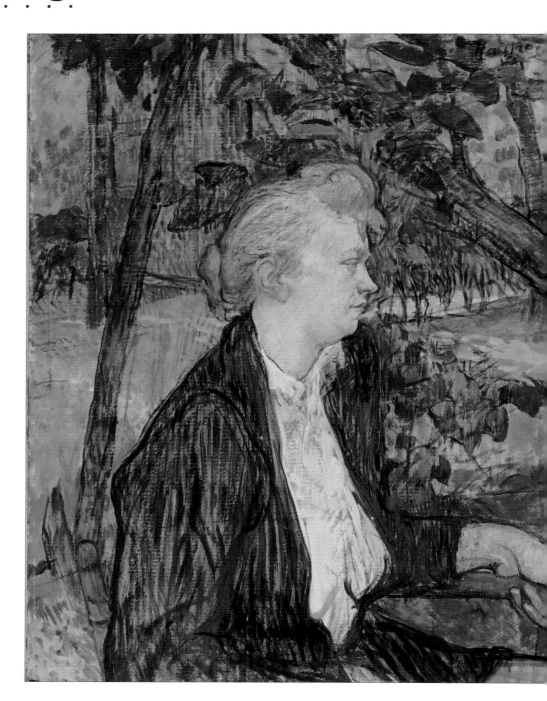

## HENRI DE TOULOUSE-LAUTREC (1864-1901)

### Woman Seated in a Garden

*Oil on board*
Lautrec was deeply influenced by both Degas' technique and his choice of subject, and his works, like Degas', are a record of his personal life. He drew and painted scenes from the Paris dance halls, cafés and brothels, the cabarets and the circus; actresses, clowns, circus performers, and many prostitutes, nude or partially dressed. He depicted them while washing or dressing, just as Degas painted them, or waiting for clients. He hated posed models, and prostitutes provided him with the informal poses he needed.

He painted many portraits, also informal, and often in outdoor settings. This one is typical, and it also shows very clearly his technique of building up the forms with a succession of colored lines drawn with a brush. Like many of his paintings, it is done on unprimed board with the oil paint heavily thinned with turpentine, a technique Degas had pioneered. The profile view of the head and the leaves behind the figure give the painting a sense of pattern, as in the Japanese prints which Lautrec and his contemporaries so admired. The brush lines, with the warm gray color of the board showing through, give the painting a feeling of vitality.

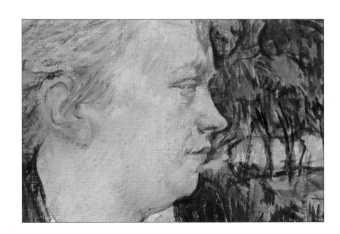

▲ The flesh tints have been built up more thickly than the darker colors, but Lautrec's distinctive linear brushstrokes can still be seen.

## other artists to study

### ALBERTO GIACOMETTI (1901-66)

Sculptor, painter and poet, Giacometti trained in Italy and France and is best known for his sculptures of extremely tall, thin, single standing figures. As a painter, his subjects were usually interiors, sometimes empty and sometimes with a single figure. The color range he used was deliberately limited almost to monochrome and the paintings, carried out in thin lines made with a brush, look very much like drawings, but with a peculiar atmosphere and intensity. Working with great concentration, Giacometti found that the more he stared at his subject the less it seemed to remain static, and it was this that accounted for the almost frenzied attempts to fix the positions of the objects by stating and restating lines. He was often in despair as he found it impossible to record his visual sensations.

### CLAUDE MONET (1840-1926)

Monet's early works include some most accomplished drawings and brilliant caricatures – he had a facility for obtaining a likeness. It is interesting that many of his later drawings were made from paintings rather than for them (these were for publication in journals). Most of his paintings were made without elaborate preliminary drawings, and in his mature years his drawings were usually rapid sketchbook studies of possible subjects to paint, where he often tried out different viewpoints. These give an impression of impatience, as if he couldn't wait to start the painting itself. From the 1880s the paintings became the drawings, and there was little if any preliminary drawing on the canvas. His paintings, particularly the last large *Nympheas* (waterlilies) pictures were really drawings on a grand scale, arrangements of intertwining colored lines drawn with a brush.

process of painting." Read saw these drawings as a form of shorthand, and made the observation that "we do not regard shorthand as a useful preparation for the art of writing."

### DRAWING AND PAINTING

Often the relationship between an artist's paintings and his or her drawings is easy to see, but sometimes the two appear to have little connection. Some drawings by the painter Ivon Hitchens (1893-1979), for example, look as if they are by a different artist from the one familiar through his paintings. The drawings are crisp, clear statements with sharp black and white contrasts, while the paintings are indistinct and atmospheric, painted with free sweeps of color.

Herbert Read appears to have found little relationship between Picasso's drawings and his paintings. The constantly changing styles of the

177 ▷

# DIFFERENT APPROACHES

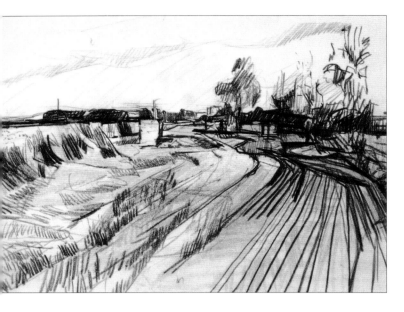

◀ Pip Carpenter
*Pencil and colored pencil*
In this rapidly made sketchbook drawing the artist is responding directly to the subject, but also perhaps unconsciously testing it for its painting potential. The lines in the drawing which describe foliage, grasses and the sweep of the track leading into the picture could as easily be brush strokes as pencil lines.

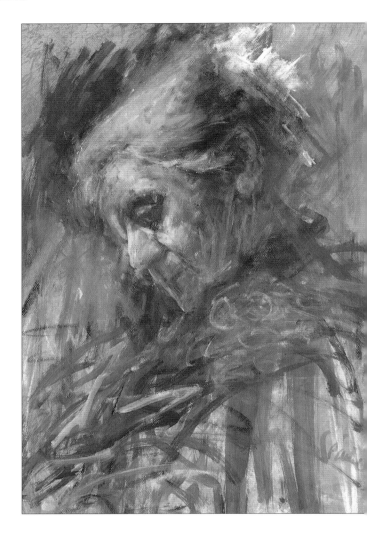

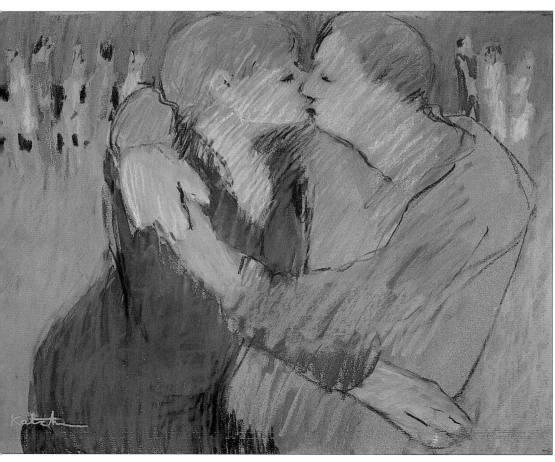

◀ Carole Katchen
*Pastel*
There is some similarity between the way Katchen uses pastel in this drawing, **Turquoise Kiss**, and the way Lautrec has used oil paint in **Woman Seated in a Garden** (page 174). The background figures have been blocked in simply in slabs of color, while those in the foreground are built up with freely applied colored lines, with a dark line used to separate the male figure from the background.

▲ Ken Paine
*Watercolor and gouache*
Paine's watercolor technique is unusual, perhaps because he works predominantly in pastel. **Amelia** has been painted by building up the image with a series of linear brush strokes, so that the result is more drawing than painting. The color of the paper has been allowed to show in places to become part of the finished picture.

paintings worried Read, but he was convinced by the drawings that Picasso was an artist of the highest order. The drawings, Read thought, were consistent, and "with a minimum of effort express a vastness of three-dimensional form."

Some see drawing as an integral part of painting or any other art activity. Every mark made by a painter's brush, for example, can be regarded as a form of drawing with color. In an interview, the contemporary sculptor Michael Kenny described drawing as "a conceptual thing" which could be carried out in any medium. He pointed out that in making abstract stone carvings, the decisions about the shapes and forms of the various elements in these sculptures was to him as much like drawing as making a study of a figure from life.

Kenny thinks the term "drawing" is a misnomer when used to describe work in a particular medium, such as pencil or ink. He regards drawing as a "process of ordering," concerned with selection and deciding what is significant and what can be dispensed with – a process which he feels has been used by all great artists. He believes that every kind of art activity is a form of drawing.

### A CONCEPTUAL THING

Because line drawing is so familiar to us and using lines seems such a natural way to draw, it comes perhaps as a surprise to realize how conceptual line drawing is. There are no lines in nature. The line is used as a means of describing where one object stops and another starts. Blake regarded line as an instrument of the imagination. "Nature has no outline, but imagination has," he wrote. He saw "bounding outline and its infinite inflections and movements" as the most significant quality of great art. "The ... golden rule of art, as well as life ... is ... the more distinct and wiry the bounding line, the more perfect the work of art."

### DRAWING WITH PAINT

The main difference between drawing and painting might then seem to be lines. We automatically

think of drawing as lines and of painting as areas of paint. But although it is generally advisable to keep line to a minimum when you paint, not all artists work in this way. For some, their paintings are drawings, and they use the paint very much as they would a drawing medium. An excellent example of this kind of painter is the Swiss artist Alberto Giacometti. He was convinced that everything had to be discovered through drawing, and drawing on a canvas, with paint, provided him with the most sympathetic surface on which to draw and redraw what he saw.

Many of the paintings of Toulouse-Lautrec also have a linear, drawn quality; indeed the essence of his painting style was his drawing. A superb draftsman who excelled at capturing movement, he could convey a sense of his subject in a few lines or brush strokes, which makes a comment made by his early tutor Léon Bonnat particularly interesting. "Your painting isn't bad – it's clever, but it still isn't bad," Bonnat said, "but your drawing is simply atrocious." Today this seems almost unbelievable, so fluent and powerful are Lautrec's drawings and lithographs, but Bonnat was an academician, and Lautrec's drawings were simply not in the style he was accustomed to.

## the projects

**PROJECT 1**
**No preliminaries**
Using all your marker colors this time (or, alternatively, paints if you have them) make a drawing directly from either a landscape, a figure or a still life, with no preparatory drawing and no guidelines drawn on the picture surface before you start to paint. Start describing the subject directly in color, and move everything around on the picture surface until you are satisfied that you have a good composition.

**PROJECT 2**
**A colored ground**
Lautrec used a warm gray colored board to unify his "drawings in paint." There is less contrast between the paint lines and the painting surface than with a white ground, and the color of the board can become an intrinsic part of the painting. You can use paints if you have them, with thin brushes, or pastels again, but don't blend the colors. Build up with a series of lines in the way that Lautrec did in *Woman Seated in a Garden*. The subject could be a figure outdoors, a landscape or perhaps a still life with flowers.

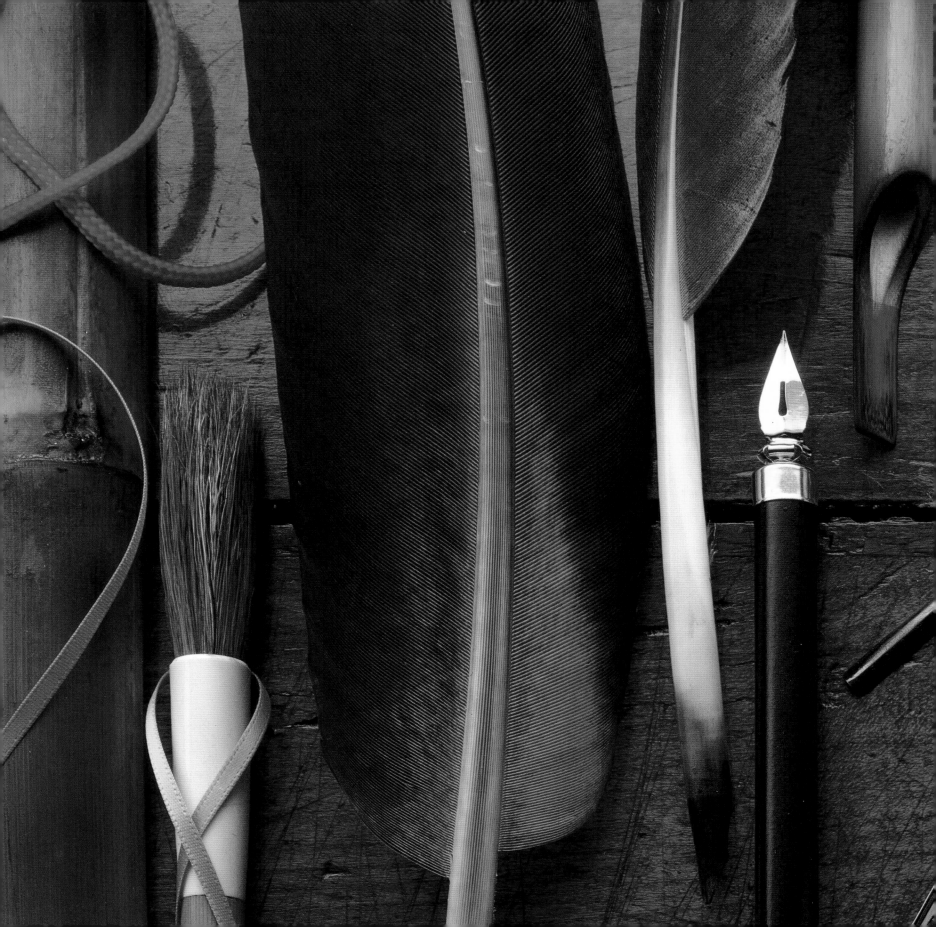

## PART FOUR

# Media and methods

· · · · · · · · · · · · · · · · · ·

**M**any people believe that the best way to learn to draw is to study drawing techniques – they expect to be shown a particular way of drawing eyes or hair in a portrait, or foliage in a landscape. But as I have reiterated throughout this book, learning to draw is first and foremost about learning to see, and too much concern with technique in the early stages can actually inhibit you and prevent you from seeing clearly.

By the time you have reached this stage in the Drawing Course, however, you will have acquired the good habit of concentrating on your subject, analyzing it and deciding what is important about it. And you will also have developed technical skills and found your own ways of using the drawing media to translate what you see.

This is the point when technique can be re-examined. There is always a danger that artists may get into a rut, having found a particular subject, medium or technique at which they excel, and thus repeat over and over again. But drawing is about discovery, and you should constantly be finding new subjects or new things to say about familiar ones. Experimenting with media and techniques can help you to do so, and this section may point you in different directions by offering new insights into how you treat your own visual experiences.

# Pencil and colored pencil

During the course of carrying out the projects in the earlier sections of the book you will certainly have discovered some of the capabilities of pencils – both ordinary graphite ones and colored pencils. The techniques described here will help you to experiment with some new ways of expressing your visual experiences.

### THE VERSATILE PENCIL

Although the first pencil was made in 1662, following the discovery of a deposit of pure graphite in Borrowdale, Cumbria, Britain, pencils, as we know them, were not manufactured until the 18th century. Since then the pencil has been the most widely used of all the drawing implements. Few if any artists are without a selection of pencils, and in spite of the ever-increasing range of drawing materials now available, many still prefer them to any other medium.

It is not hard to see why. The pencil is a convenient and versatile tool, capable of achieving many effects from fine, delicate lines through hatching, crosshatching and scribbling to dense areas of shading. The effects you can obtain depend on several factors: the grade of the pencil (its hardness or softness); the pressure you exert; the speed of the line; the surface of the paper, and last but not least the way the pencil is held.

Because we write with pencils, there is a tendency to hold a pencil for drawing as we do for writing. This gives maximum control and is fine for detailed areas of shading and line, but it can lead to rather stiff, unexpressive drawings. Holding the pencil in different ways, even if they seem unfamiliar at first, can enable you to make freer sweeps of the arm. Often standing at an easel and drawing from the shoulder rather than the fingers and wrist can transform the way you draw. Try different ways of using pencils, perhaps drawing with a sharp point in one part of a drawing, and a blunt end in others. As a general rule the point should be kept sharp, but there are always

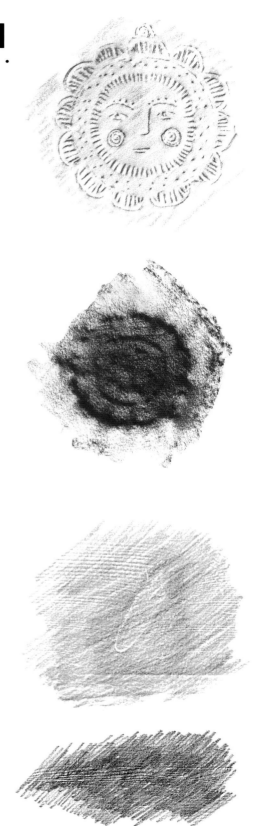

**FROTTAGE**

**1** ◀ The effects you achieve with this technique vary widely, as they are affected by both the thickness of the paper and the implement used for making the rubbing. Both these examples were made from the same object, a patterned tinfoil ornament. First colored pencil was used, on thin typing paper, and then conté crayon on heavy drawing paper.

**2** ◀ Wood grain is a popular subject for frottage; patterns and textures such as those shown here can easily be incorporated into a drawing. Both were made by placing paper on a pine kitchen table – a rougher surface would produce a more pronounced pattern. Hard pastel was used for the first rubbing, and soft (6B) pencil for the other.

exceptions to rules. Don't restrict yourself to one grade of pencil in a drawing, either; you can use two or three different ones, thus extending the possible tonal range.

Because the pencil is so versatile, there are few special techniques, or "tricks of the trade," associated with pencil drawing; each artist develops his or her own "handwriting." However, there is one interesting technique that, although not restricted to pencil, is worth mentioning here.

### FROTTAGE

This is a method often used for building up areas of texture. The drawing paper is placed over some rough surface, such as heavily grained wood or coarse fabric and rubbed with a soft pencil, colored pencil, conté crayon or pastel stick so that it takes on the texture and pattern of the material below.

The technique has for long been used for brass rubbings, but its use in the context of art was pioneered by the German Surrealist artist Max Ernst (1891–1976). He is said to have conceived the idea when looking at some scrubbed floorboards, whose prominent grain stood out like the lines in a drawing. Areas of frottage in a drawing can be used either suggestively or realistically. For example, you might simply want some irregular tone to enliven an area of your drawing, but if you were drawing a group of objects on a grainy wood table or against a textured wall, you could take rubbings of the actual texture.

### COLORED PENCIL

Colored pencils are a much newer invention than graphite pencils, and because of their popularity with illustrators, the range is becoming more and more varied. Some manufacturers produce larger color ranges than others, and the pencils vary in character – from soft, chalky and opaque, or soft and waxy, to hard and translucent. These variations are caused by the different proportions of binder used – the substance which holds the

### HATCHING AND CROSSHATCHING

**1** ▶ **This traditional method of building up areas of tone in the monochrome media is also used to overlay colors. There is no rule about the direction of the crisscrossing lines; here the artist has begun with roughly diagonal hatching lines which she then overlays with crosshatching.**

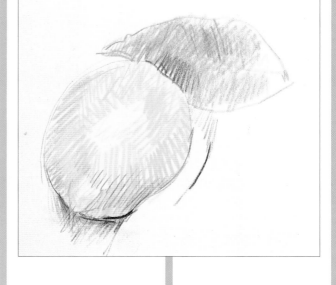

**2** ▶ **Further crosshatching builds up the forms and colors, and the artist increases the pressure of the pencil where she wants dense areas of color.**

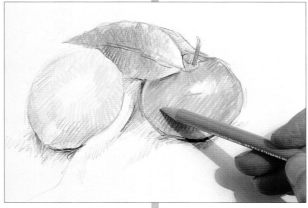

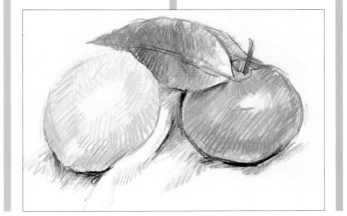

**3** ◀ **The colors are rich, and the vigorous use of the pencils gives the drawing an attractive feeling of liveliness.**

| further information | | |
| --- | --- | --- |
| 12 | Basic drawing materials | |
| 40 | Color drawing media | |

## MEDIA AND METHODS

colored pigment together and makes the pencils easy to handle. This is usually a white filler such as kaolin, and various waxes. As with graphite pencils, you can mix different types in the same drawing, and you may need to build up a selection of different brands to provide a comprehensive color range – the pencils are sold singly as well as in sets. You can also mix colored pencils with graphite pencils; the two are natural partners.

### BUILDING UP COLORS AND TONES

Colored pencils, being easy to handle as well as light and portable, are an excellent medium for rapid drawings and outdoor sketches. They can also achieve intricate, highly detailed effects and rich blends of color. In most colored pencil drawings, tones and colors are built up by various methods of overlaying, such as hatching, crosshatching and shading.

Hatching and crosshatching have traditionally been used to build up areas of tone in monochrome drawings, such as pen and ink (see page 202), but they are equally effective with colored pencils for mixing colors. Shading can also be used for mixing and modifying colors. One layer of shading can be laid over another to achieve a softer effect than is attained by hatching.

### BURNISHING

This is a technique sometimes used to increase the brilliance of colors. After the color has been mixed on the paper, the surface is rubbed with a finger or a rag to produce a slight sheen. Metals, or surfaces covered with gold leaf, are often burnished to increase their luster, and the same principle is used in colored pencil drawing. The rubbing action sometimes smooths the grain of the paper and it grinds down the colors and presses the particles of pigment into the paper, so that they blend together in a way that can't be achieved by any other method of overlaying colors.

**3** ▶ As in hatching and crosshatching, shading lines can take any direction you choose. Here the pencils follow the forms of the vegetable.

**SHADING**

**1** ▲ The artist begins by laying in the colors lightly, leaving certain areas of the paper white for the highlights.

**2** ▼ The dark shadow is now added. With this in place, the artist will be better able to judge how much further shading is needed to build up the colors of the vegetables.

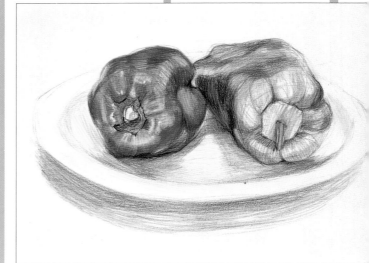

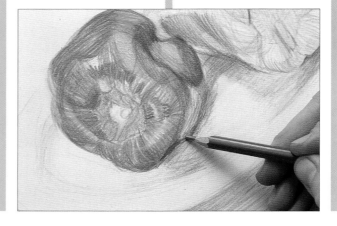

**4** ▲ In the final stages, the reds and greens were built up more densely by further shading. In the highlight areas the paper has been left uncovered or only very lightly covered, while in the areas of deepest color the paper is no longer visible.

**2** ► The artist continues to lay colors, using a combination of the shading and hatching techniques. Notice that on the body of the green vase he has used curving lines that follow the contours.

**BURNISHING**

**1** ◄ Burnishing is always a final stage in a drawing; first all the colors must be established and built up as thickly as desired.

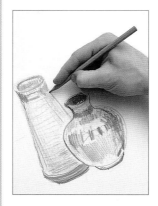

**3** ◄ A very dark blue pencil is now used to press the color into the paper, creating a small area of dark reflection. On reflective surfaces, tonal changes are often very abrupt, with a distinct, hard-edged boundary between one tone and color and another.

**5** ► The bottom lip of the small vase is now darkened; it is in shadow because it curves away and under the body of the pot. The shiny, reflective surfaces of the objects have allowed the artist to introduce a wide range of colors.

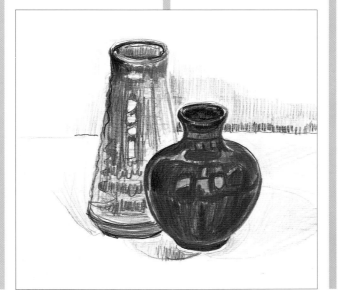

**4** ◄ In this area of the pot's surface, the colors merge more gently, so the artist "pushes" the colors into one another and into the paper by rubbing with a torchon.

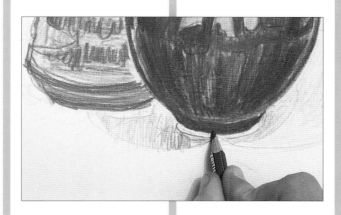

**6** ◄ The contrast between the rich burnished colors and the sparkling highlights creates a convincing impression of the pot's shiny surface.

| further information | |
|---|---|
| **40** | Color drawing media |
| **44** | Drawing with color |

You can use a torchon (a rolled-paper stomp), a plastic eraser, or one of the pencils themselves for burnishing. Torchons and erasers are most suitable for soft, waxy pencils. Drawings in hard colored pencils are sometimes burnished with a white or pale gray pencil, using close shading with a firm pressure. This fuses the colors in the same way as a torchon or eraser, but the underlying colors will be modified by this form of burnishing. White-pencil burnishing is a method well-suited to drawing highlights on highly reflective surfaces. Burnishing is a slow process, and is often restricted to one area of a drawing, perhaps to describe a single metal or glass object.

### IMPRESSING

If the surface of the paper is indented, the pencil will glide over the impressed lines when you apply color on top, so that they show through. It is best to use a fairly tough paper such as good-quality smooth watercolor paper, and to put another sheet of paper below to provide a yielding surface. You can either draw "blind" directly onto the paper with an implement such as a paintbrush handle or knitting needle, or use a tracing method. For an intricate design, draw it first on tracing paper, lay this on top of the working surface, fixed with pieces of masking tape so that it does not slip, and then work over it with a hard pencil or ballpoint pen. Do not use a paintbrush handle in this case, as you will be unable to see which lines you have drawn over. If your paper is white, the indentations will produce what is sometimes called a "white line drawing," but the lines need not be white; you can also impress a design with the sharpened tip of a colored pencil, or a graphite pencil, and work another color on top. Or you can lay one layer of solid color before impressing, and work further layers on top. There are many different possibilities, and the impressed design can be as simple or as complex as you like.

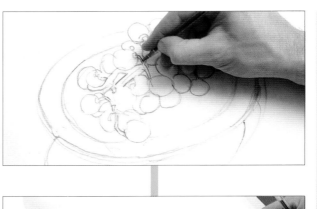

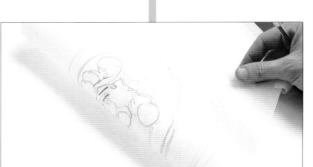

**IMPRESSING**

**1** ◀ The artist has begun by making a drawing, which he has then traced. He now goes over the traced lines firmly with a ballpoint pen.

**2** ◀ Having made sure he has drawn firmly over all the lines, he removes the tracing paper. The impressed lines will appear when colored pencil is laid on top.

**3** ◀ The colored pencil glides over the impressed lines, which emerge more strongly the more color is laid on.

**4** ◀ A second color has now been added, and the rim of the plate has become visible. The drawing could be built up further, with subsequent stages of impressing.

▼ John Townend
*Colored pencil*
The artist's personal "handwriting" is very apparent in this lively and rapidly made location drawing. Notice the variations in the direction of the lines, with diagonal marks used for the sky, vertical ones for the foreground field, and multi-directional ones suggesting the different growth patterns of the trees.

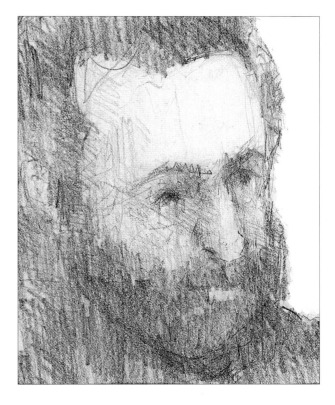

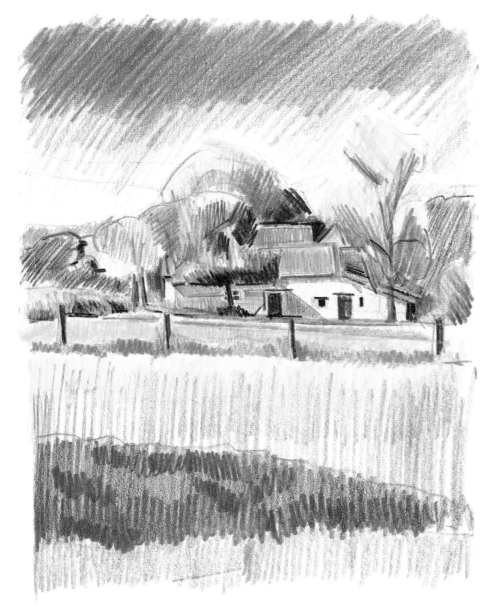

▲ John Denahy
*Pencil*
No two pencil or colored pencil drawings are alike – compare this drawing with John Houser's overleaf and you will see two very distinct styles. For **The Model**, Denahy has used a highly controlled scribbling technique, lightly smudging the pencil in places. Although there is an overall "soft-focus" effect, the forms and features are described with considerable precision.

◀ Paul T Bartlett
*Colored pencil*
A comparison of this drawing with those below and opposite shows something of the range and versatility of colored pencil. Bartlett's amazingly detailed and intricate work, **Some Sort of Bloom of Hope in the Thicket of Despair**, is in water-soluble pencil, which allows colors to be built up by overlaid washes as well as by line.

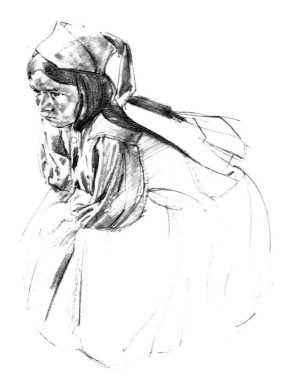

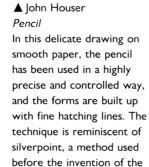

▲ John Houser
*Pencil*
In this delicate drawing on smooth paper, the pencil has been used in a highly precise and controlled way, and the forms are built up with fine hatching lines. The technique is reminiscent of silverpoint, a method used before the invention of the pencil, in which a fine metal point was used to draw on specially coated paper (see Glossary).

▶ Philip Wildman
*Colored pencil*
In this lively drawing, the artist has used the impressing technique to reinforce his energetic drawn lines. You can see this particularly clearly in the left-hand tree and the area of sky behind it. The white lines made with a stylus have been drawn over in the opposite direction, creating a powerful impression of wind and movement.

**COMBINED TECHNIQUES**

Normally you would probably only use one or two of the techniques described earlier in any one drawing. For this project, however, try to find a subject that will enable you to employ all of them. You will be using graphite and colored pencils and the techniques of hatching and cross-hatching to build up colors, and frottage, impressing and burnishing for other visual effects.

You could assemble a still life, for example, where the texture of a bare wood table could be created by frottage, an incised pattern on a jug by impressing, and the shine on a metal bowl by burnishing. If you prefer to work outdoors, you might choose a view of a park, with frottage used for a foreground tree, the lines of bamboo stems impressed in the paper, and burnishing describing the shining windows of a greenhouse. Give careful consideration to the subject, but don't become too obsessed with the techniques. You will almost certainly not use them all to the same extent. They have to take their right place in your drawing, and they shouldn't become features in themselves. The most difficult of these techniques to handle is possibly frottage. It is very easy to create a texture using this technique, but it must be the correct scale for your drawing. Usually frottage can only be used for surfaces close to you, or the texture is too large in scale.

◄ David Cuthbert
*Colored pencil*
This drawing, **Wired**, shows an interesting and unusual use of the medium. In colored pencil drawing, a light color cannot cover a dark one below, so the light-colored drawing was done first, with pale gray and orange. The shapes between the lines were then filled in with white lines, created by leaving areas of the paper uncovered.

# Pastel and oil pastel

**P**astel can be either a drawing or a painting medium, depending on how it is used, which illustrates that there is no real dividing line between the two activities. A work in pastel can be entirely composed of lines, or the colors and tones can be built up by hatching and crosshatching as in a colored pencil drawing. When colors are layered and blended, the result can look almost like an oil painting.

### PASTEL STROKES

With a linear medium such as colored pencil, the variety of different marks you can make is limited. The beauty of pastel sticks, whether you are using the soft (also known as chalk pastels) or the hard variety (see pages 40–41), is that you can draw with the side of the stick as well as the tip, which allows you to range from broad, sweeping lines to fine, precise ones. And these can be further varied by increasing or decreasing the pressure.

If you have not used pastel much, it is worth experimenting with both linear strokes and side strokes to get the feel of the medium and begin to develop your own "handwriting." Side strokes are best done with a fairly short length of pastel, so snap a stick in half. You will be able to draw lines with the resulting sharp edge. You can achieve very fine lines in this way, particularly if you are using hard pastels.

### SURFACES FOR PASTEL WORK

The texture of the paper will also affect the appearance of your pastel strokes. Pastels are almost pure pigment, with just a little gum tragacanth used to hold the colored powder together (hard pastels have a higher proportion of this binder). If pastels are used on smooth paper, such as drawing, the pigment will tend to fall off, so the papers made for pastel work have a slight "tooth," or texture, which "bites" the particles of pigment and holds them in place.

The two best-known papers sold for pastel work

190 ▷

**SIDE STROKES**
◀ To lay in broad areas of color, the quickest method is to use the side of a short length of pastel. Pressure can be as light or as heavy as you like, the strokes can follow any direction, and you can mix colors on the paper surface by laying one color over another.

**LINEAR STROKES**
◀ These can be more or less infinitely varied according to the relative softness of the pastel, the sharpness of the tip or edge, and the way you hold the pastel stick. The more variety of line you can introduce into a drawing, the more expressive it will be.

**WATERCOLOR PAPER**
◀ Some pastellists love this; others hate it. As you can see, it breaks up the pastel colors, giving a speckled effect, and it is virtually impossible to push the color right into the grain.

### CHARCOAL PAPER
◄ This paper is made especially for charcoal work, and is also popular for pastel and conté drawing (see page 198). It is not suitable for a very heavy build-up of overlaid colors.

### MI-TEINTES PAPER
◄ This is the other "standard" pastel paper. Some find the heavy grain over-obtrusive, and prefer to use the "wrong" side, which is smoother but still has sufficient texture to hold the pigment. Both this and charcoal paper are made in a wide range of colors. .

### VELOUR PAPER
◄ This is expensive, and only available from specialist suppliers. It gives an attractive soft line, with no paper showing through, and is ideal for those who like to build up thick layers of color.

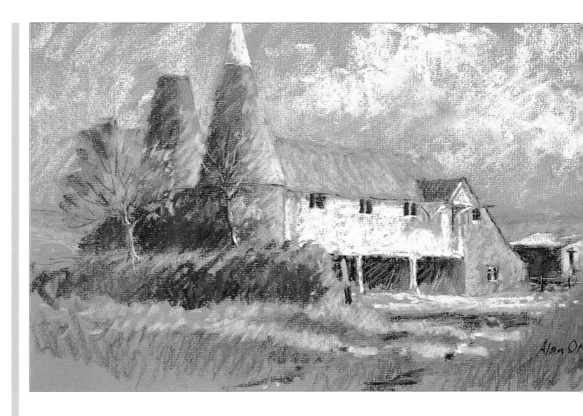

▲ Alan Oliver
*Soft pastel*
In pastel work, the color of the paper is as important as the texture, and here you can see how well the light brown – clearly visible in the foreground and parts of the sky – blends in with the overall warm color scheme of the picture. Before you begin a pastel drawing, try to visualize the general scheme and any dominant color, and choose the paper accordingly.

are charcoal, which has a laid pattern of small, regular lines, and Mi-Teintes, which has a pattern resembling very fine wire mesh. But there are many other suitable surfaces, including watercolor paper, which breaks up the strokes and gives a slightly speckled look. Artists who paint rather than draw in pastel, building up colors thickly, also use velour paper, which has an attractive velvety quality, and a type of fine sandpaper made especially for the purpose.

Unless very heavily applied, pastel marks don't cover the paper as thoroughly as paints or inks. For this reason pastels are usually done on colored paper, otherwise little flecks of white jump out and spoil the effect of the colors. This is not to say that you can never work on white paper; if your approach is mainly linear you may find it quite satisfactory, but for a more "painterly" drawing you will find colored paper helpful. Not only will it blend in with the pastel colors if the color is chosen wisely; it will also save you having to cover the whole of the surface. For example, if you draw a still life against a blue background you could choose a blue paper of suitable hue and leave areas of it uncovered.

**BUILDING UP COLORS**

If you are using a fairly small range of colors and want to achieve subtle effects or rich, dark hues, you will have to "mix" colors on the paper by overlaying. The hatching and crosshatching methods used in colored pencil drawing are also suitable for the whole range of pastels. For broad effects made with side strokes you can overlay colors more directly, simply by putting one stroke over another. If you are working on heavily textured paper, you can make a good many such overlays, but lighter paper will become clogged with pigment more quickly, and you may need to spray with fixative between layers.

The color-mixing technique particularly associated with pastel work is blending, in which two or more colors are laid over one another and

**BUILDING UP WITH LINE**

**1** ► This artist works mainly in colored pencil, and he uses pastel in a similar way, laying a series of firm hatched lines.

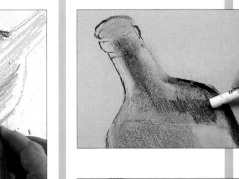

**2** ► He now introduces darker colors, using the same method.

**3** ▼ Notice how the direction of the lines has been varied to express the forms of the bottle and the two separate horizontal planes.

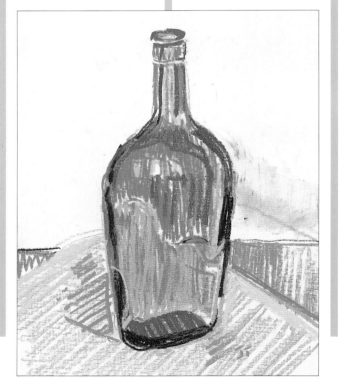

**BLENDING**

**1** ▼ This artist works in a completely different way, rubbing the colors into the paper to create a soft effect. Here she modifies the green with a touch of white.

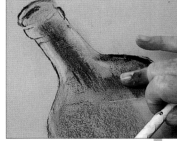

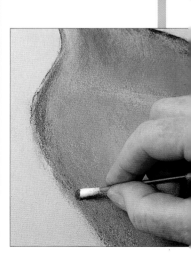

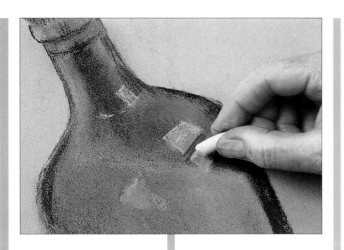

**4** ► Because pastels are opaque, light colors can be laid over dark ones provided there is not too much build-up of color on the paper surface. The highlights are thus left until last.

**2** ◄ Rubbing with a finger blends one color into another. A gray paper (the "wrong" side of Mi-Teintes) has been chosen, as this makes it easier to judge both the darks and lights.

**3** ◄ A finger would be too clumsy an implement for the blending on the side of the bottle, so a cotton bud is used. The artist prefers these to torchons, as they are softer and have a gentler action.

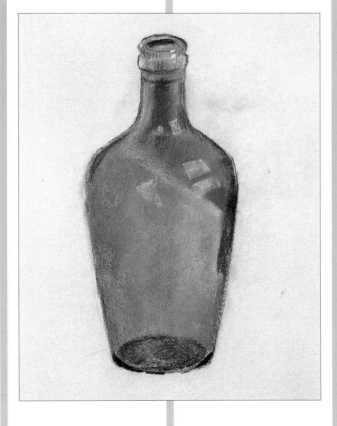

**5** ▲ This makes an interesting contrast with the demonstration opposite; here there are no visible lines. The two methods can be combined in one drawing.

then rubbed with a cotton ball, your fingers or a torchon (good for small areas) so that they fuse together. This method allows you to achieve almost any color or tone, but it is not wise to overdo blending, as it can make your drawing look bland and insipid. You will often need to blend colors in some areas of a drawing, but try to combine the technique with vigorous lines, or fix the blended color and draw over it.

### OIL PASTELS

These come in two different versions, oil pastels and wax-oil pastels. Both in fact are bound with a mixture of waxes, but in the wax-oil type the wax content is much more apparent in use. These are extremely useful for the wax resist technique (see pages 210–11), but some find them less suitable for general drawing than the non-wax type, which is softer and more malleable.

Just like ordinary pastels, oil pastels can be mixed on the paper by overlaying. They can't be blended by rubbing, but the color can be melted with turpentine or white spirit, so that you can mix them on the paper very much as you would mix paints on a palette.

The other great virtue of oil pastels is they don't need fixing, and you can build up layers of color without worrying about the top layer falling off. A disadvantage is that in hot weather they tend to melt even without the aid of turpentine, becoming both messy to use and difficult to handle.

### SGRAFFITO

Oil pastel is a much newer medium than chalk pastel, and without the same history of traditional techniques. Consequently, artists have approached it without preconceptions, and enjoyed

193 ▷

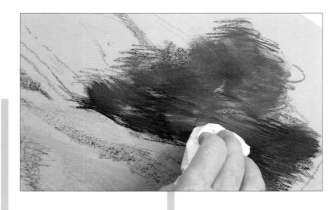

**OIL PASTEL AND WHITE SPIRIT**

**1** ► The dark color is spread with a rag dipped in white spirit.

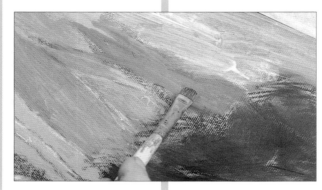

**2** ► A brush, similarly dipped in white spirit, is now used to spread the color in the sky areas.

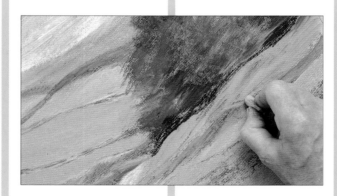

**3** ► The artist now draws over the spread color with the tip of the pastel stick, introducing a more linear element into the foreground of the landscape.

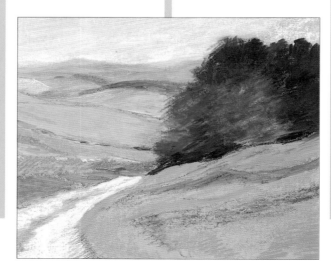

**4** ► This method, which combines drawing and painting, is a very quick and effective way of building up areas of color, ideal for location work when time is often limited.

**SCRATCHING BACK**

**1** ► The effect of this technique varies according to the paper you use and the implement used for the scraping. Here the artist is working on watercolor paper, and uses a penknife to scrape off the top layer of color.

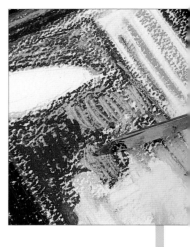

**2** ► The penknife is used in this case very much as a drawing tool, to manipulate the colors into shapes suggestive of trees.

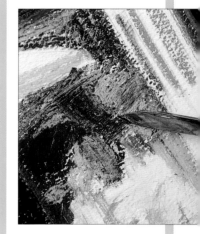

**3** ► The effect of the sgraffito is not over-obtrusive, but adds a touch of movement and excitement to the focal point of the picture – the group of people relaxing in the sun. Notice how cleverly the artist has set up echoes by using similar colors in the foreground, applied in diagonal strokes that lead the eye into the drawing.

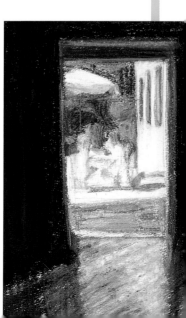

experimenting with it to discover its capabilities. One of the techniques becoming increasingly associated with the medium is sgraffito, in which one layer of color is scratched away to reveal another one below. This can also be done with chalk pastel provided the first layer of color is sprayed with fixative, but it is more difficult, and the effects are less dramatic.

You will need to work on a reasonably tough paper for this technique – watercolor paper would be a better choice than the standard pastel papers. Start by laying down a layer of solid color; oil pastel covers the paper thoroughly if heavily applied. Then put another color on top and use a sharp implement such as a craft or X-acto knife to scrape parts of it away. You can make a variety of different effects: try using the point of the blade for fine lines and scraping lightly with the side of it to create areas of broken color by only partially removing the top color. You can build up several layers of sgraffito, or vary the color combinations from one part of a drawing to another.

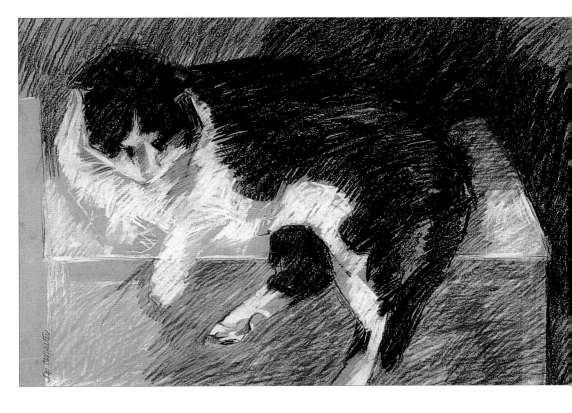

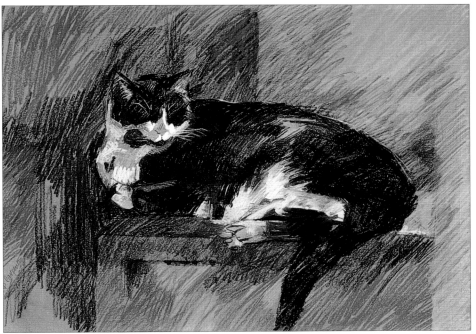

▲ ◄ Pip Carpenter
*Hard pastel*
These delightful studies were done one after the other on the same day. Pastel, whether hard or soft, is the perfect medium for rapid drawings. The artist has caught the cat's relaxed poses beautifully, and has managed to suggest the texture of the fur simply by varying the direction of the pastel strokes. In both cases she has worked on a warm, mid-toned paper, which provides a touch of contrast to the cool grays and blues in the drawings.

## MEDIA AND METHODS

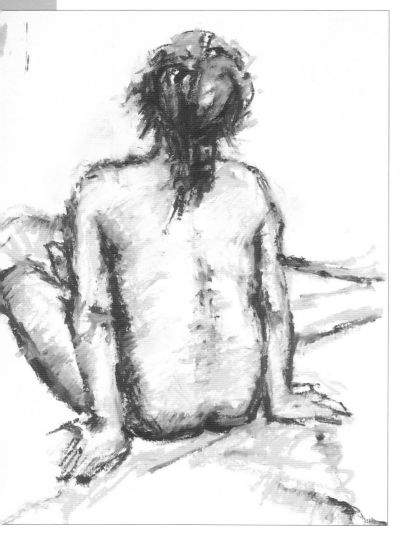

◄ Joan Elliott Bates
*Oil bar*
This artist enjoys experimenting with new media, and has used an oil bar for this bold drawing. Although not strictly speaking oil pastels, these chunky bars of condensed oil paint can achieve similar effects and be used in much the same way. They are considerably thicker than pastels, however, and are more often used for painting than for drawing.

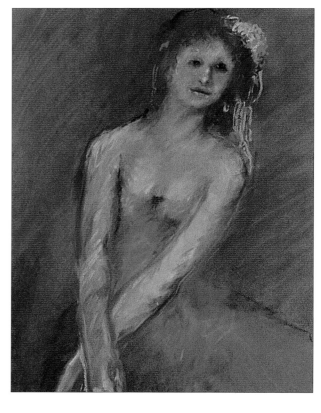

► Aubrey Phillips
*Soft pastel*
This lovely drawing, **Welsh Farm**, was done on location, with a combination of rapidly applied side strokes and linear strokes building up the impression of the scene with great economy. Notice the clever choice of a paper color which blends with the overall color scheme, allowing large areas to be left uncovered.

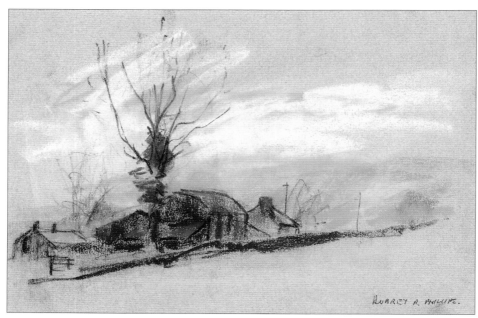

▲ Carole Katchen
*Soft pastel*
In **A Bridesmaid Again** the artist has used a highly effective combination of blending and diagonal strokes made with both the side and tip of the pastel sticks. The overall effect is soft, yet the application of the pastel is clearly visible, even in the background, giving energy and vigour to the drawing.

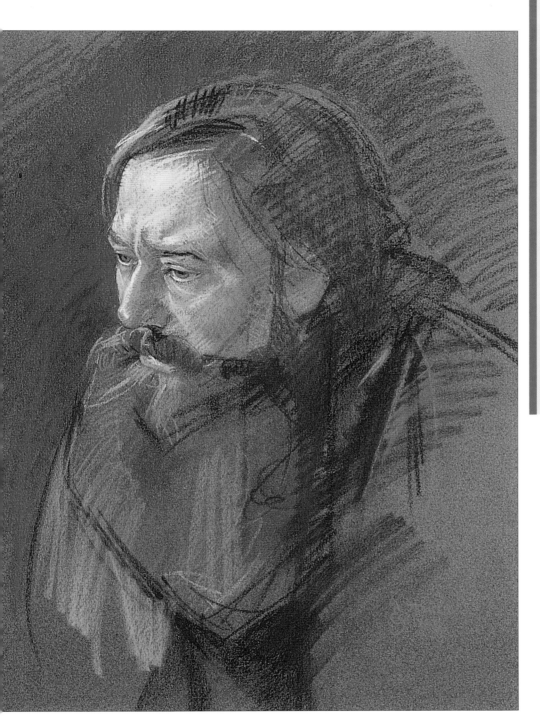

### PROJECT 1
### Soft pastel landscape

It is not impossible to combine pastels and oil pastels, but the two media are not very compatible, and I suggest that at this stage you explore their possibilities separately.

This project should exploit different kinds of strokes to build up colors and the technique of blending. Use a type of paper you haven't used previously, perhaps one where the color of the paper itself can be featured in the drawing. Use a limited range of colors so that you will be compelled to build up colors in your drawing.

I suggest a landscape without too many small details which will enable you to treat each area broadly.

### PROJECT 2
### Oil pastel waterscape

For this project you could choose a seascape, a view of a river, a lake or a pond. As with soft pastels, build up color, this time using the techniques of spreading the pastels with white spirit in some areas. Try also to exploit the sgraffito technique. This could be used to describe grass or reeds beside a river, or the lines of ripples, or the patterns made by water receding down the sand.

◄ John Houser
*Hard pastel*
Here too the way the pastels have been used play a major role in the drawing, with diagonal and near-vertical lines both describing the forms and providing visual excitement. The colors have been built up solidly only on the face; over the rest of the drawing much of the paper has been left bare to become a color in its own right.

## MEDIA AND METHODS

# Charcoal and conté crayon

Charcoal, one of the oldest of all the drawing media, is made by firing twigs of wood such as willow at high temperatures in airtight containers, which carbonizes the wood while leaving the twigs whole. It is a wonderfully versatile medium, and is often recommended by art teachers because it is less inhibiting than pencil or pen, encouraging a broad, free approach.

**LINES AND TONES**

Charcoal is very responsive to the slightest change in pressure, so you can produce a line that varies from the faintest possible tone to a deep, positive black. The marks you make are also affected by the way you apply the charcoal, and as with brush drawing (see page 206), it is worth experimenting with different methods. Note, for instance, the difference between pulling the charcoal down the paper and then pushing it up. Pushing it gives a stronger line. Try pulling the stick across the paper horizontally. Then break off a short piece and use the side to make broad, chunky strokes.

It is easy – and very quick – to create areas of tone simply by using the side of the stick. If you want a flat, even mid-tone you can rub the charcoal into the paper with your fingers. It can be darkened later with a further application. If you are working with willow charcoal, you may wish to fix the drawing from time to time if you want areas of very dark tone, or you could combine willow and compressed charcoal.

**FROM DARK TO LIGHT**

Normally, darks are gradually built up in drawings, but with charcoal it is also possible to work the other way round, beginning with the dark tones and "subtracting" the light ones, using a kneaded eraser. This is an exercise often given to art students, as it has a liberating effect, particularly on those who become over-dependent on using line. You can draw any subject in this way, but it should be something that has strong tonal

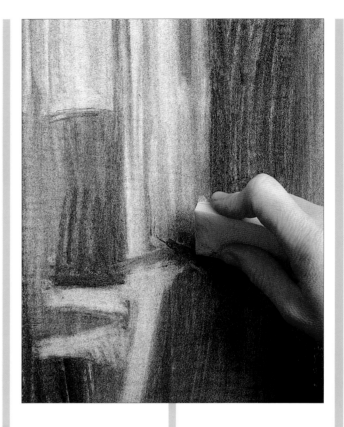

**DARK TO LIGHT**

**1** ▲ Having spread charcoal evenly all over the paper, the artist's next step was to lift out the larger areas of lighter tone with a kneaded eraser.

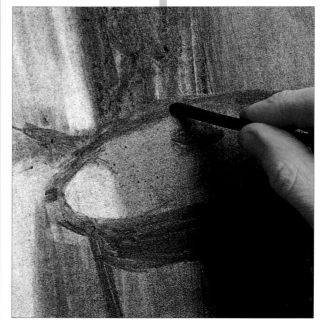

**2** ▲ She now uses the corner of the kneaded eraser to remove more of the charcoal, thus beginning to "draw" the light front edge of the door. A kneaded eraser can be used almost as precisely as the charcoal itself.

**3** ◀ The marble-topped table in the foreground is now beginning to take shape, and more charcoal is applied to darken and define the rim.

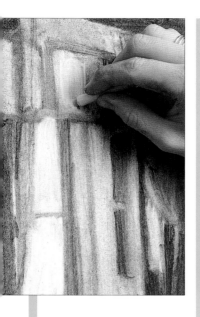

4 ◀ It is not always possible to remove all the charcoal, and this area needs to be pure white, so a little white pastel is used.

5 ▼ The finished drawing has a pleasing atmospheric quality. If necessary, the charcoal can be fixed after all the light areas have been lifted out and darkened in places with further applications of charcoal.

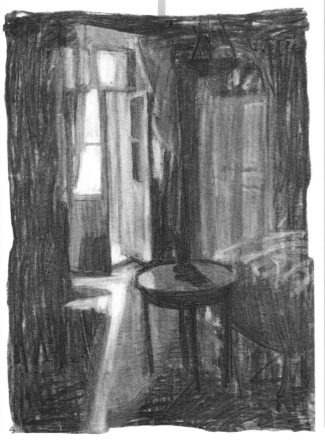

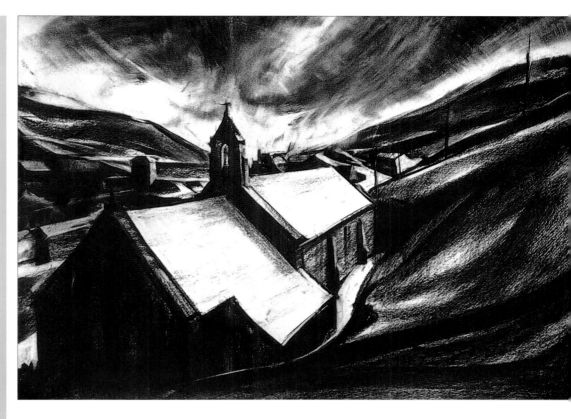

contrasts. An interior lit from a window, with some areas in shadow, or a portrait strongly illuminated from one side, would be suitable subjects.

The method is simple. You begin by covering the whole of the paper with charcoal – compressed or scene-painter's charcoal are best. Rub the charcoal well into the paper so that it becomes dark gray, then draw the subject on this gray ground. Don't put in too much detail, and don't erase if you make a mistake; just rub the lines into the background and redraw them. When you have finished the drawing, lightly rub over the lines so that they are still visible, but merge into the background gray. (If you are confident about your subject, you can omit this drawing stage).

The strongest highlights should be picked out first, so look at the subject carefully and decide

198 ▷

▲ David Carpanini
*Charcoal*
Here too a powerful sense of atmosphere, but what is most impressive about **St Gabriel's** is its drama and movement. The swirling clouds are echoed by the wave-like shapes of the fields and hills, with the small church the stable center of a landscape in flux.

MEDIA AND METHODS

**PAPER TEXTURE**

**1** ▶ In charcoal, pastel and conté crayon drawings, the texture of the paper is an important factor. This photograph shows conté crayon on drawing paper, which is relatively smooth and does not break up the strokes to any great extent.

**2** ▶ Charcoal paper (called Ingres paper in Britain) is made with a laid pattern of even lines which will show through unless the conté is very heavily applied. This can be used to advantage in a drawing, but it makes it difficult to achieve dense blacks.

**3** ▶ Watercolor paper has a very pronounced texture, and because the conté will adhere only to the raised grain, creates a distinct speckling. This can be effective for a drawing in mainly light and mid-tones, but not for one where you want solid blacks.

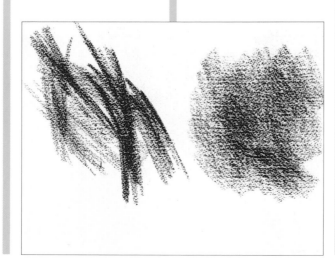

where they are, and then use the eraser to "lift" them out. It is easier than it sounds, as you can pull the eraser to a point or use the flat edge, so that you can virtually draw with it. When the main highlights are in place, begin to work on the mid-tones, and strengthen the darker areas if necessary.

**CONTE CRAYON METHODS**

Like charcoal and pastels, the tip or edge of a conté crayon can produce a fine line, or they can be used on their sides to create broad areas of tone. You can also exploit different textures of paper. Heavy pressure on smooth paper such as drawing will achieve solid blacks, while a rougher surface such as watercolor or pastel paper will break up the tone to create a lively speckled effect. Some artists prefer conté crayons and pencils to either charcoal or graphite pencils, because they produce such strong, positive effects. Their main disadvantage is that they are more or less impossible to erase, but they smudge less easily than charcoal, and don't need to be fixed.

As mentioned earlier, conté crayons are made from natural pigments, and are available in four colors – two browns, black and white – and in both stick and pencil form. The reddish color, often called red chalk, or sanguine, has a particularly pleasing quality, and has been widely used for figure drawings, portrait and landscape studies throughout the history of art. A warm cream or buff paper is often chosen to enhance the quality of the red ocher pigment.

Another traditional method, known as drawing "*à trois couleurs*" (three colors) uses black and white conté on gray or light brown paper, which allows tones to be translated very rapidly. The paper represents the mid-tones; the darks are built up with black, and white is used for the highlights. Also, all five colors can be combined in one drawing to build up an effect which has almost the quality of a painting.

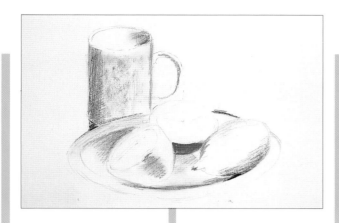

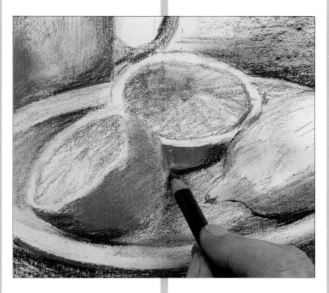

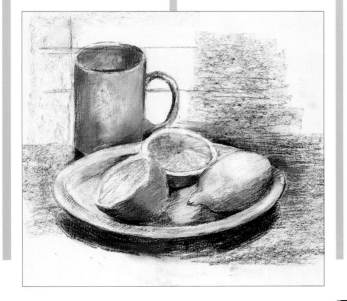

## CONTE IN THREE COLORS

**1** ◄ Because the conté colors do not match the still-life group, the artist chooses tonal equivalents, using light brown conté for the lemons and mug.

**2** ◄ The darker brown and then the black are brought in for the shadow areas. A conté pencil rather than a crayon is used here, as it allows for finer drawing and more definition.

**3** ◄ Unless you choose a subject with a predominance of browns, it is not possible to achieve naturalistic color, but you can produce an interesting drawing. The method will also teach you a lot about tonal relationships, like the colored paper "drawing" in Lesson Five.

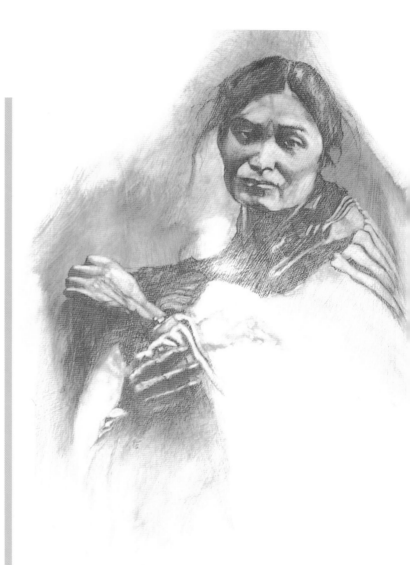

▲ Leonard Leone
*Conté crayon*
This artist likes a smooth surface for his conté work, and in this drawing of a Navajo Indian he has used a primed wood panel. This would not be suitable for charcoal because it would not provide enough texture to hold the charcoal, but conté has a higher degree of adherence.

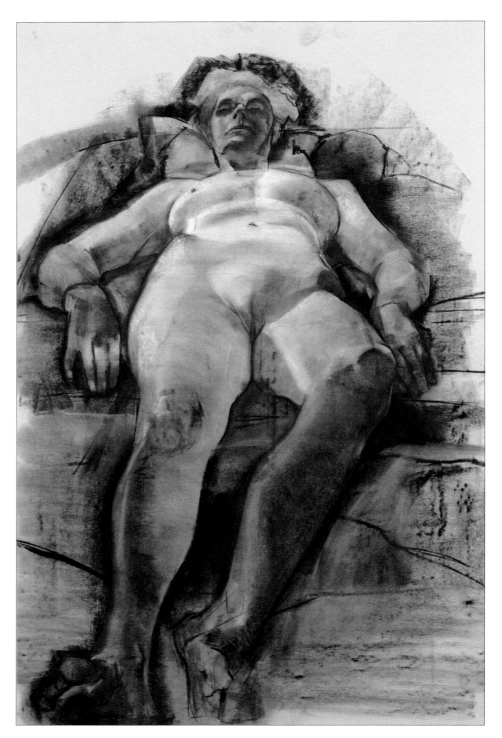

▲ Stephen Crowther
*Charcoal*
The three charcoal
drawings on these pages all
show very different uses of
the medium. In **The First
Baby** thin willow charcoal
has been used lightly to
create a delicate effect in
keeping with the
tenderness of the subject.

▶ Peter Willock
*Charcoal and white pastel*
A quite different approach
has been taken in this life
study, where there is
almost no line. The artist
has used the side of a
charcoal stick to build up
the shadows that define the
main planes of the body.
White pastel has been
employed in a similar way
for the light-struck areas,
while the color of the
paper stands for the mid-
tone, giving the drawing an
overall warmth.

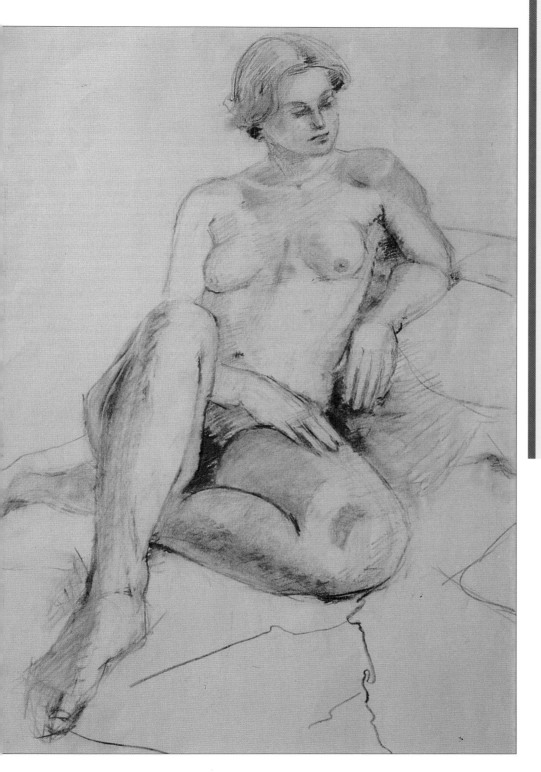

the projects

**PROJECT 1**
**Subtractive drawing**
For this project I suggest
an interior with a single
source of artificial light.
The light should be weak
and perhaps positioned
low down in the room so
that there are shadows
and pools of darkness. A
table lamp, or a candle,
on a table will be ideal.
Prepare a sheet of paper
by covering it with
charcoal until you have a
dense gray/black. Then
draw into this, lifting out
the lightest areas with a
kneaded eraser as shown
on pages 196–7. This
drawing won't be highly
detailed. It should be a
description of the play of
light over the objects in
the room. You won't be
able to fix the drawing
until you reach the final
stages, so you have to try
to avoid too much
unintentional smudging.

**PROJECT 2**
**"A trois couleurs"**
I suggest that you choose
a figure or head for this
drawing. It could be a
nude, a clothed figure, a
portrait or a self-portrait.
Use only black and white
conté, but work on tinted
paper, medium-tone gray
or light brown. It is
difficult to remove conté,
but don't let this inhibit
you. If you get something
in the wrong place, the
black and white mixed
together on the paper can
be used to obliterate it.
Use the three distinct
tones of black, paper-
tone and white to make a
crisp representation of
three-dimensional form.

◄ Olwen Tarrant
*Charcoal and pencil*
Charcoal and pencil is an
unusual mixture, but one
that has been used very
successfully in **Rachel
Posing**. The charcoal has
been used lightly, and a
soft, delicate effect
produced by smudging
in places.

MEDIA AND METHODS 201

# Ink drawing

Ink is the oldest of all the drawing media. In Ancient Egypt, reed pens were used with some form of ink for both writing and drawing, and in China, inks were being made as early as 2500 BC, usually from black or red ocher pigment made into solid stick or block form with a solution of glue. They were then mixed with water for use. These inks, later imported into the West in their solid form, became known as Chinese inks or Indian inks. Chinese block ink is still widely used for brush drawing.

### PEN AND INK

From late Roman times until the 19th century the standard pen was the quill, made from the feathers of a goose, a turkey, or sometimes a crow or gull. The reed pen, however, continued to be used and still is. Both Rembrandt and Van Gogh exploited its sensitive line with consummate skill. A rather similar kind of pen, made from the bamboo, has been used for centuries in the East. This is thicker than the reed or quill pen, and gives a very attractive rather dry line. Bamboo pens can be bought in some specialist art stores, or you can make your own. Quill pens can also be made quite easily, and some artists still do this, finding quills more sympathetic than metal-nibbed pens.

If pen and ink is a medium you find you enjoy, it is worth experimenting with homemade pens. However, there are a great many different drawing pens on the market today, from the old-fashioned (but still much used) dip pen, with wooden handle and interchangeable nibs, to reservoir pens and various ballpoints, felt-tips and fiber-tips. Only by experimenting can you discover which suits you best, and you may need to have several different types, to suit the particular job in hand. For example, ballpoints and felt-tips don't offer much variety in the kind of lines they make, but they are convenient for outdoor sketching. Dip pens and bamboo pens are more versatile as drawing implements, but less practical for location work, as they require you to carry a bottle of ink.

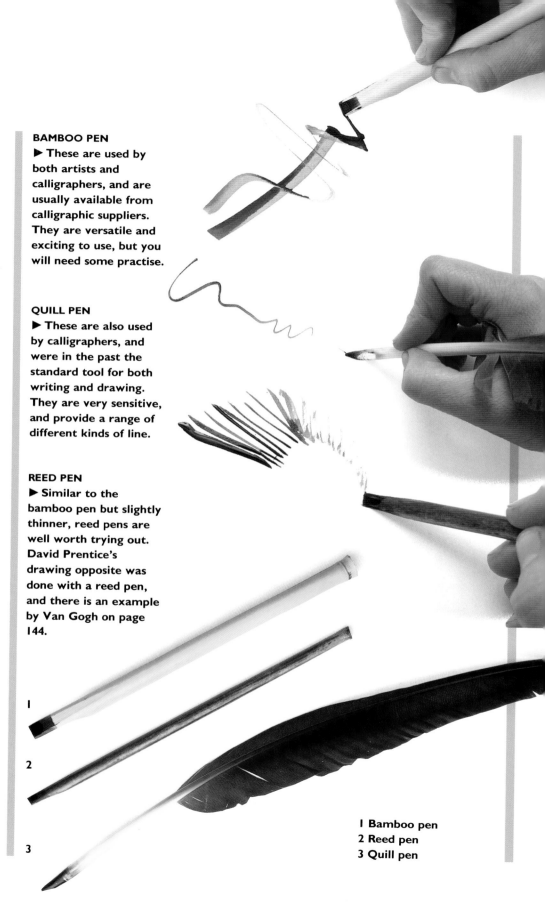

**BAMBOO PEN**
▶ These are used by both artists and calligraphers, and are usually available from calligraphic suppliers. They are versatile and exciting to use, but you will need some practise.

**QUILL PEN**
▶ These are also used by calligraphers, and were in the past the standard tool for both writing and drawing. They are very sensitive, and provide a range of different kinds of line.

**REED PEN**
▶ Similar to the bamboo pen but slightly thinner, reed pens are well worth trying out. David Prentice's drawing opposite was done with a reed pen, and there is an example by Van Gogh on page 144.

1

2

3

1 Bamboo pen
2 Reed pen
3 Quill pen

## BUILDING UP TONE

When you are drawing with pencil or charcoal, tonal variations can be easily achieved by shading, but the same technique is not possible in pen and ink. The traditional method of building up a tonal drawing with a pen is by hatching and crosshatching. This has been mentioned already in the context of colored pencils (see pages 181–2), but it is even more relevant to pen and ink.

Remember that although hatching and crosshatching lines should be roughly parallel, they don't have to be straight and completely even. Although a very controlled, regular network of lines could be suitable for a subject such as a building, in general you should aim to create as much variety as possible in a drawing, or it may become dull and mechanical. If you are drawing a solid form like the trunk of a tree, or a figure, try

204 ▷

▼ David Prentice
*Reed pen and ink*
**Under Black Hill**
provides an excellent

demonstration of the sensitive and varied line you can achieve with a reed pen.

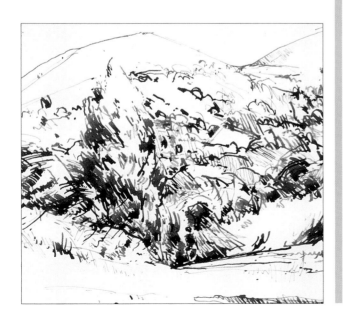

## BUILDING UP TONES

1 ◀ Using a fine fiber-tipped drawing pen, the artist lays in a set of hatching lines.

2 ◀ He is now ready to begin building up the darker tones. Erasures are not possible with pen and ink, so until you are experienced, it might be wise to begin with a light pencil drawing.

3 ◀ The hatching and crosshatching method is used to produce areas of dark tone. Here the lines are diagonal, in contrast to those above, which describe the flat plane of the windshield.

4 ◀ Notice how the artist has varied the hatched and crosshatched lines, both to give the drawing more interest and to suggest the different shapes and planes.

**SCRIBBLE LINE**

**1** ◀ The artist begins with a series of loosely drawn lines roughly following the main forms of the head and face.

**2** ◀ As the network of lines becomes more intricate, a definite impression of the head begins to emerge, though there is as yet no attempt to define the features in detail.

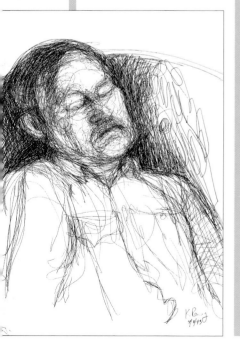

**3** ◀ In the final stages, further scribbling has built up the forms of the head and body, and the drawing gives an excellent impression of the slumped posture of the sleeping man. The effect is softer and less precise than that produced by hatching and crosshatching.

letting the hatching lines follow the contours of the form. This is called bracelet shading, and was pioneered by the great German artist Albrecht Dürer (1471–1528).

An equally effective but harder-to-handle method for defining tone is scribble-line, which was used by Picasso (1881–1973). The pen is moved freely and randomly backward and forward until the right density of tone is built up. This method requires practise, but is well worth trying, as it creates a wonderfully free and energetic effect. The energy can, however, be at the expense of control, as you cannot achieve very precise effects.

**LINE AND WASH**

Another method of achieving depth of tone is to combine ink drawing with a wash, either a monochrome wash of diluted ink, or colored washes of watercolor or colored ink. Line and wash is a traditional technique with a long history, and is still deservedly popular for its expressive and suggestive qualities. Because you do not have to rely on the pen line to provide tone, it can be a freer and more rapid drawing method than when hatching with pen and ink. Forms and impressions of light and shadow can be suggested with a few brush strokes, strengthened with touches of line where necessary.

It is important to develop both tone and line together rather than drawing an outline, and then filling it in with washes. If you are new to this technique, you might begin with a light pencil drawing which will act as a guide for the first areas of tone. You can then add line and further tone as the drawing demands, or you can work with a pen with water-soluble ink, which you can spread by washing areas of the drawing with clean water. There are many different ways of exploiting this attractive technique.

206 ▷

**LINE AND WASH**

**1** ▶ To create the effect of the soft petal, the artist is working on damped paper, which causes the ink to spread and diffuse. She now uses a Chinese brush to drop undiluted ink lightly into a paler, dilute wash.

**2** ▶ The first washes are allowed to dry before a dip pen is used to add definition to the stems and petals.

**3** ▶ Further areas of wash were added after the pen lines to pull the drawing together. Care must be taken to prevent the drawn lines from dominating, but in this case the drawing is well-integrated.

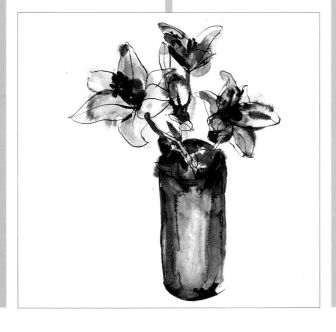

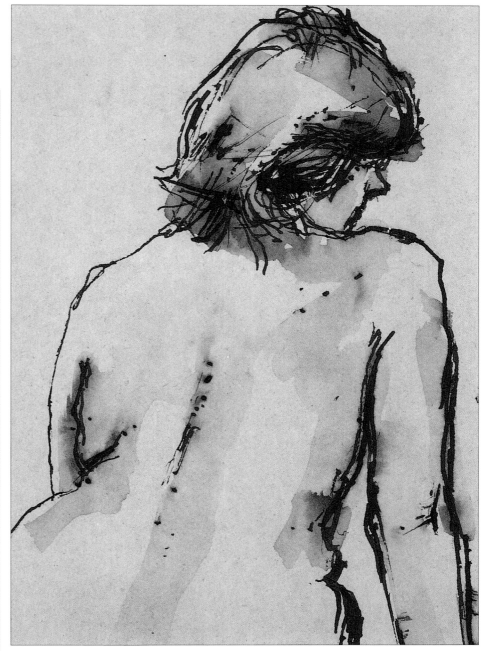

▲ Joan Elliott Bates
*Line and wash*
For this bold but sensitive drawing, the artist has used an experimental technique. Instead of the conventional pen, she has drawn with the stopper inside the lid of the ink bottle, which has produced an interesting and varied quality of line. The wash has been kept to a minimum, with just a few deft touches of pale gray suggesting the planes of the body and head.

## INK AND BRUSH

1 ◄ **Drawing directly with a brush is very satisfying, as well as being an excellent method for quick studies. Because he wants to create a soft effect, the artist has first damped the paper.**

2 ◄ **Undiluted ink is now laid over a still-wet paler wash.**

3 ◄ **The Chinese brush is a sensitive drawing tool. Here it is used to make both bold lines and small pointed shapes suggestive of trees.**

4 ◄ **Although unfinished, the drawing gives a good impression of the fields and trees, and the effect of the spreading ink in the foreground is attractive in itself.**

## BRUSH DRAWING

Brush and wash is a similar technique where lines are made with the point of the brush alone. Rembrandt produced some wonderfully expressive figure drawings in which both figures and their surroundings were economically suggested with a few strokes of brush and ink, used at different strengths. This is an excellent method for making quick tonal landscape studies which could be developed into a painting or finished drawing, and was used by John Constable (1776–1837) among others.

The linear qualities of the brush can be used with a variety of colored inks. It is a very sensitive drawing implement, capable of producing an almost endless variety of different marks. For centuries, Chinese and Japanese artists have exploited its potential and produced beautiful brush and ink drawings.

The marks you make are dictated by the type and size of brush you use, the direction and pressure of the stroke, and the way the brush is held. You can use any good-quality brushes, preferably sable, as these are firm and springy, and hold the ink well. Or you might like to try Chinese brushes, which are now readily available and relatively inexpensive. Try different ways of holding the brush. Oriental artists and calligraphers have developed a series of different hand positions, and often work with the brush held vertically and the working surface horizontal.

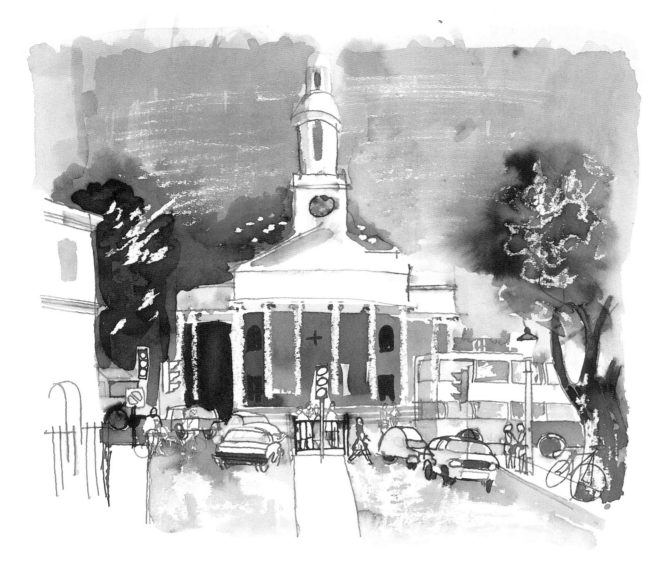

◄ Eric Brown
*Line and wash*
Here line is restricted to defining the people, automobiles and other objects in the foreground. The drawing is mainly in tone, done with dilute washes of shellac-based ink. The effect of water on this type of ink sometimes has odd results – in the sky area you can see how it has turned yellowish in places, and has an opaque blue-white "bloom" in others. Always be on the lookout for accidental effects like these which you can use to advantage. The white scribbled lines on the trees and in the sky were produced by the wax resist technique, which is explained and demonstrated on pages 210–11.

▶ Stephen Crowther
*Pen with a touch of wash*
A fine pen has been used for this drawing, **My Mother and Father**. Much of the tone has been built up by hatching and crosshatching, but on the collar and back of the woman's coat, the water-soluble ink has been spread with a wet brush to produce a gentler, more even tone.

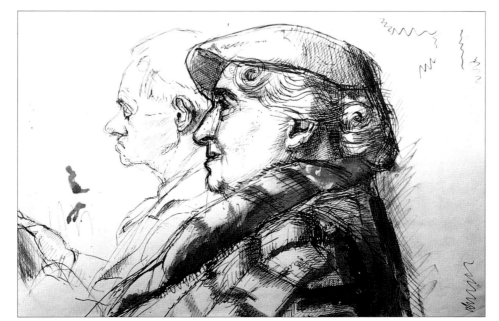

MEDIA AND METHODS

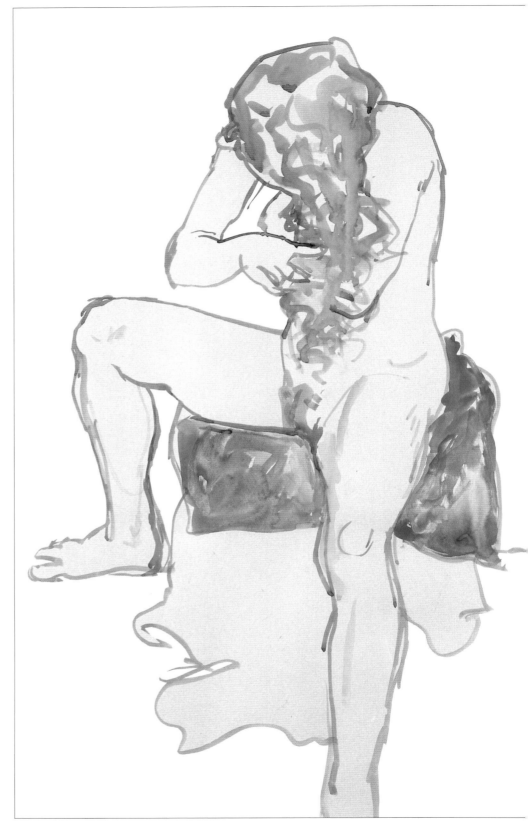

▲ John Denahy
*Pen and brown ink*
In this expressive drawing
of **The Old Man**, the
artist has used a similar
scribble-line technique to
that demonstrated on page
204. Although the lines
look random and free, the
features are delineated with
great skill, and the face is
full of character.

► Elizabeth Moore
*Brush and watercolor*
This lovely figure study well
illustrates the virtues of the
brush as a drawing
implement, and shows the
exciting variations of line
that can be achieved. The
brush lines describe the
figure and hair with great
accuracy as well as
conveying a strong sense
of movement.

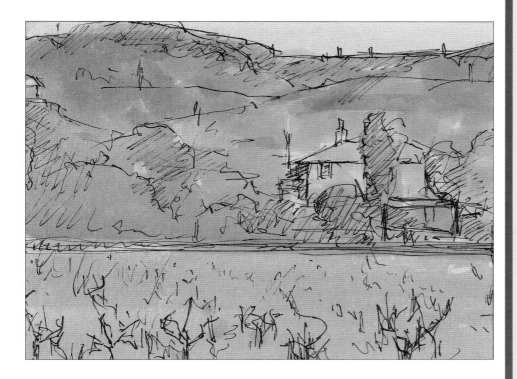

**PEN AND BRUSH**
It will be difficult to include in a single project all the possible kinds of pens there are available, but you should try to use two or three. Perhaps you could combine a quill or reed pen with a dip pen and one of the more modern fiber- or felt-tipped pens. You should also use a brush in this project, both for drawing lines and for creating areas of tone with wash. The techniques you will be exploiting will be cross-hatching, scribble tone, bracelet shading, and wash tone.

I suggest you choose a subject such as a figure in an interior. The background should be an important part of this drawing. The bracelet shading can be used selectively to describe folds and creases in garments, which help to create a sense of the three-dimensional form of the figure. Wash could be used to describe the way the figure is illuminated, and the particular atmosphere of the subject. Pen and brush lines should be used to make a detailed description of the figure – the head and hands in particular. This should be a portrait with special attention given to describing the personality of the sitter.

▲ John Denahy
*Pen and wash*
In this study of a French landscape, done as references for a painting, the artist has used line and wash to provide all the visual information he needs about both shapes and tones. The pen drawing in this case was done first, and the two washes of diluted brown ink laid on top.

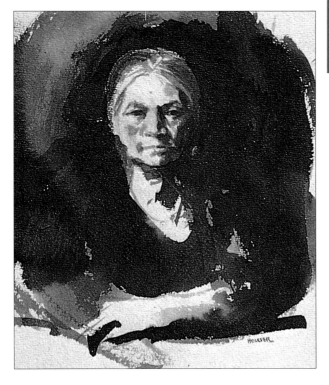

◄ John Houser
*Brush and ink*
Rembrandt was perhaps the greatest-ever exponent of brush and ink drawing, and this powerful portrait of a Cherokee Indian has a distinctly Rembrandtesque quality. The dark clothing and background have been allowed to merge together, so that the face, which is treated in some detail, becomes the undisputed center of attention.

# Mixed media

$S$ome of the projects in Parts One and Two of the book will have already introduced you to mixed-media drawing, and you will have discovered that some of the drawing media combine more naturally and effectively than others. In mixed-media work you need to consider the physical characteristics of the media as much as the subject you are drawing, and decide whether the effects they create are compatible.

For example, charcoal and pastel are natural partners, as they both have the same soft, smudgy quality. Charcoal is sometimes used to make a tonal underdrawing, then fixed, and the pastel color applied on top. Alternatively, charcoal can be used at the same time as the pastel, to build up dark areas. As already mentioned, colored pencil and graphite pencil go well together, and the classic example of compatible media – which have been used together for so long that they are hardly now considered as mixed media – is line and wash (see page 204).

On the other hand, pencils (or colored pencils) and markers could be difficult to combine in one drawing, because unless the pencil marks are very heavy and solid, they will be swamped by the brilliant ink colors. In the same way, fine pen lines would be unlikely to marry well with black conté crayon, though you might use conté and a broad black felt-tip, or conté and ink. Only by experimenting will you discover which combinations work best for your style of drawing, and the ideas you want to express, and you may find that you can create exciting effects by mixing media that seem quite incompatible.

### WAX RESIST

One of the mixtures of incompatible materials that has now become very well known, and is used both in drawing and painting, is that of oil and water. If you draw with a wax crayon, and then put down a wash of diluted black ink or colored ink – or draw

213 ▷

► An ordinary household candle can be used very effectively for wax resist, but in this case the resist areas will be white unless subsequently covered with another color. For the demonstration, the artist has used oil wax crayons.

**WAX CRAYON AND INK**

1 ◄ She has begun by scribbling lightly over the trees with wax crayon. It takes some trial and error to discover how much pressure to apply, but in general, the denser the application the more successful the resist.

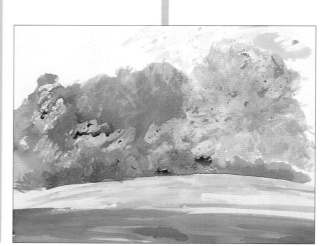

2 ◄ The first application covered the crayon too thoroughly, so the drawing was left to dry before more wax was added, and then more ink. You can see how the color has slid off the waxed areas.

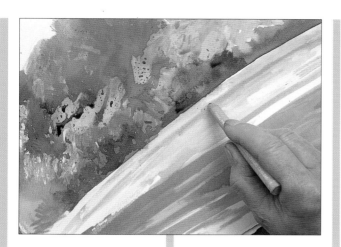

**3** ◀ In this area the wax resist is not intended to be very obvious, so she uses a color close to that of the ink which will be used on top.

**4** ◀ This photograph, taken with the ink still wet, shows the effect very clearly, with the ink forming irregular blobs and pools. The technique has an exciting element of chance – you can never be quite sure what will happen.

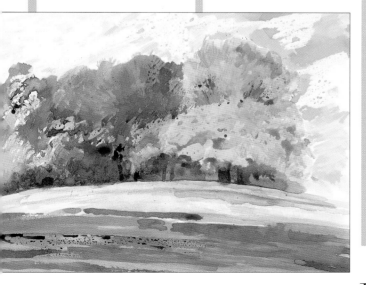

**5** ◀ As she worked, the artist discovered that the lighter oil pastel colors resist the ink more effectively than the darker ones. Notice how the white used for the clouds has completely blocked the ink.

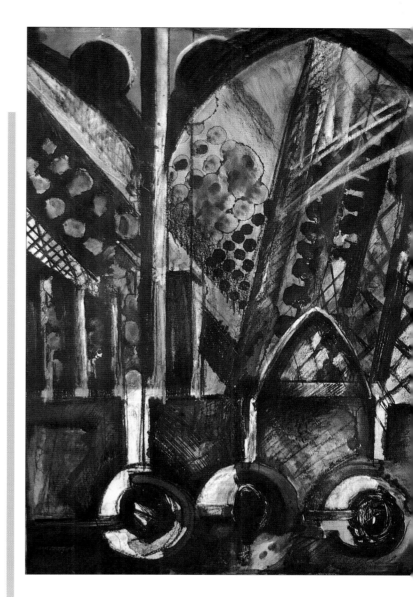

▲ David Ferry
*Monoprint and drawing*
To achieve the rich effects seen in **Cathedral**, the artist began with a monoprint – a "one-off" print made by placing the drawing paper on top of an inked-up sheet of metal or piece of glass. He then drew over the print first with colored pencils, then with black oil pastel, and finally with colored drawing inks.

| further information | |
|---|---|
| **40** | Color drawing media |
| **188** | Pastel and oil pastel |
| **204** | Line and wash |

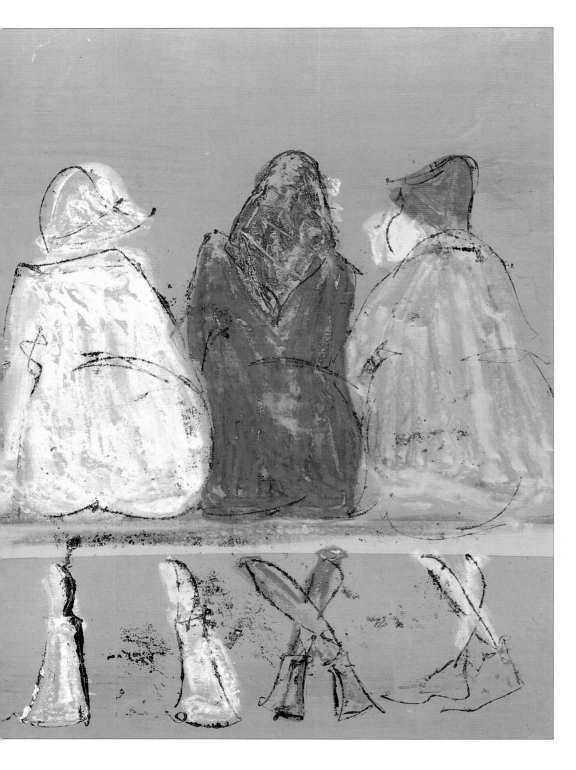

◀ Samantha Toft
*Mixed printing methods and oil pastel*
The background of **Three Portly Women** was screenprinted in order to create the soft gradations of tone, and the drawing of the figures is in oil pastel. The fine black pen-like lines were achieved by a monoprint process. The paper was placed face down on a metal plate spread with printing ink, and a pencil was used to draw on the back, thus transferring the ink onto the paper selectively.

▼ Rosalind Cuthbert
*Charcoal and pastel*
These two media can be combined in a number of different ways. Charcoal is often used in a subsidiary role, to make a preliminary underdrawing or to help build up dark areas, but in this powerful portrait drawing, **Kate**, the charcoal and pastel each retain their separate identities, with the charcoal supplying the element of taut linearity.

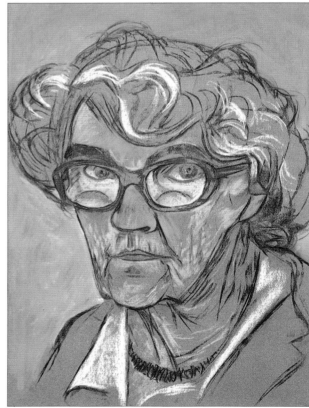

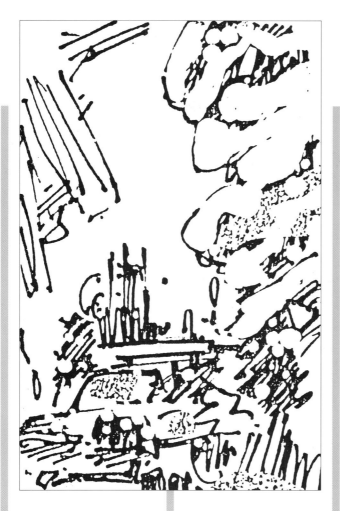

**PHOTOCOPY DRAWING**

1 ▲ This small sketch in felt-tipped pen was made from a painting by Constable which the artist particularly admired.

2 ▲ It seemed a suitable subject for a Christmas card, so the artist made a photocopy, on which he used correction fluid to paint the trees white, giving the effect of snow-laden boughs. Further copies were then made, of which this is one.

3 ◄ At a later stage the artist decided to take the photocopy a stage further, and rework it in colored pencil.

over it with a marker – the wax will repel the color so that the drawing stands out clearly.

Wax resist is an enjoyable and exciting technique because it has an element of unpredictability – you can't be sure of how the drawing will look until you have put on the color. You can simply make some broad splodges with white wax crayon, or a household candle, to create areas of texture or color in a background, but you can also build up a whole drawing by a layering method, applying colored wax crayon, then ink or marker, then more wax crayon, and so on. You can even scratch into the wax in places using the sgraffito technique mentioned in the context of oil pastels (see pages 191–2). Ordinary wax crayons (the kind sold for children) are adequate for simple effects, or you may like to try wax-oil pastels which come in a wider color range.

**USING A PHOTOCOPIER**

Artists who like to work in mixed media often use photostats as a stage in producing a work, and these machines, although primarily for copying documents, can produce fascinating effects. If you photocopy a black and white photograph or color print, you will notice that it immediately acquires a different quality – it looks rather like a charcoal drawing. If you then enlarge it on the same machine (most modern photocopiers will do this), the tone will be broken up even more, and further enlargements will continue this process.

214 ▷

## MEDIA AND METHODS

If you do the same thing with your drawings, you will find the results interesting – pencil drawings become more positive, for example, and drawings look quite different when their scale is altered. Reducing the size often produces a more condensed, crisp image. "Photocopy art" is an excellent way of recycling old drawings, or developing an idea a few steps further. You can work on top of the photostat with any medium you choose – charcoal, conté crayon, pen and ink, or markers and colored inks if you want color. Some artists then photocopy the worked-on photostat again, or make a laser print, to which further layers of drawing are added. Working in this way, you can experiment freely without worrying about

### COLLAGE

Photocopiers and laser color printers are also much used in collage techniques. Collage is basically a method of producing an image by glueing down fragments, which can be colored paper, fabrics or cut-up drawings and photographs. Exciting collages can be made from photostats of existing drawings or photographs (you won't want to cut up originals). These can be left as they are, or worked over with other media.

Even without using a photocopier, the range of media and technique that can be included in one collage is virtually unlimited. Cubist artists incorporated fragments of theatre programs, bus tickets and newspapers into their paintings, and printed paper, either color or black and white, is still much favored by collagists. Henri Matisse (1869-1954) produced some of the most wonderful collages ever seen from pieces of brightly colored paper cut and arranged in abstract patterns. These large-scale works are more related to painting than drawing, but a similar method can be used in drawings. The cut paper forms the underlying basis of the drawing, and details are developed, drawing over this collage using any suitable media.

**PAPER COLLAGE**
**1** ▲ Using the photograph as reference, the artist begins to tear pieces of paper.

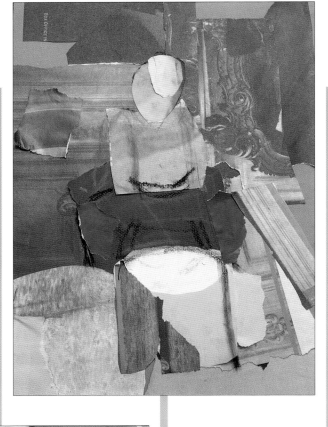

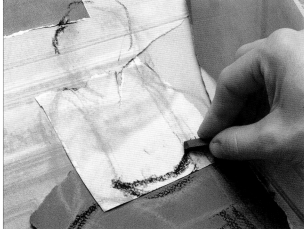

**3** ▲ The color scheme was planned in general terms before work began, and the artist decided on a range of relatively low-key colors with one or two strong darks. She is using a mixture of plain paper and pages from magazines, which provide hints of pattern and texture.

**2** ▲ Roughly torn pieces are laid on the area to be occupied by the figure, and the main shapes are defined with conté crayon.

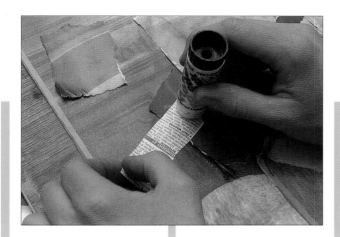

**4** ▲ The contrast between cut and torn edges is important in collage. The thick paper has mainly been torn and the thinner magazine paper cut.

**5** ▼ Notice how cleverly the artist has chosen paper to suggest texture. You can see the effect clearly on the foreground objects and the man's arms.

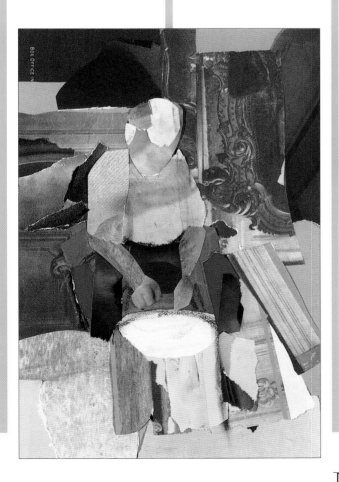

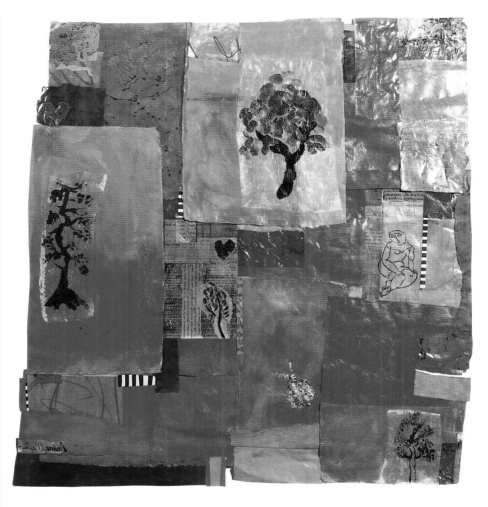

▲ Andrea Maflin
*Collage and ink*
Here a wonderfully rich effect has been achieved with colored papers and small areas of brush drawing. The artist usually paints the papers before collaging, and uses water-based glue to prevent discoloration. She has built up a wide collection of papers for her work, and experiments continually with different textures and paint effects.

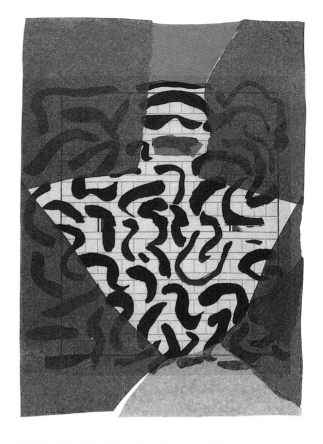

▼ Rosalind Cuthbert
*Pencil, crayon and ballpoint*
The ballpoint is an underrated drawing implement, and here a fine ballpoint has proved a useful alternative to pen and ink for defining detail and areas of pattern. **The Front Seat**, a beautifully composed drawing, shows an imaginative approach to an everyday subject.

▶ Sarah Hayward
*Collage and ink*
As in Andrea Maflin's collage on the previous page, deep, rich colors are combined with brush drawing. **Woman** owes much of its impact to simplicity – only four colors of paper have been used and textural contrast has been avoided. Notice how the area at the top is "lifted" by the white line made by the torn edge of paper.

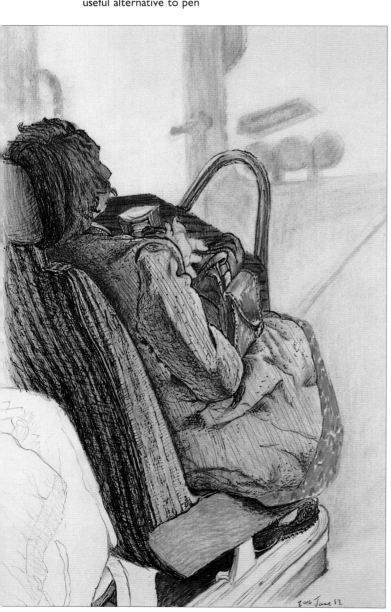

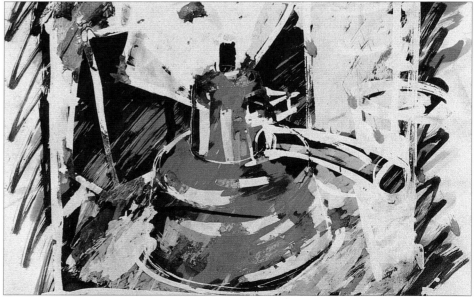

▲ Paul Powis
*Liquid frisket and watercolor*
Exciting effects can be achieved with liquid frisket, which provides a means of "painting in negative." It is a rubbery substance sold in bottles for the purpose of masking, but it has considerable creative potential. It is painted onto the paper, overlaid with ink, watercolor or markers, and then rubbed off, leaving a clear, sharp-edged "drawing" in white.

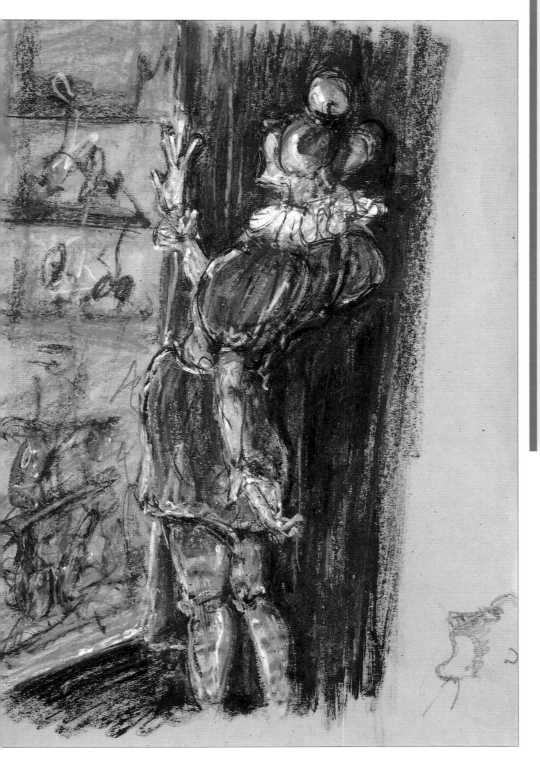

**the project**

### A MIXED-MEDIA DRAWING

I suggest you use for this project a drawing you have made earlier. An ideal subject would be a townscape with some buildings in the foreground, and perhaps some people. Start by making two or three photocopies of your original drawing, if possible enlarging it. You may have to do this section by section, depending on the size of the drawing. If you don't have access to a photocopier, you can make tracings from the original, and if necessary you can enlarge parts of your drawing (or reduce them) by eye.

Now start to work over one of the photocopies, either an enlarged one or one the same size as the original. You should try to combine as many different media as possible, and also explore the possibilities of collage and the wax resist technique. Consider whether you could use some elements of one of the other photostats to stick down on the master drawing to heighten a particular effect. Or could you introduce color or texture through collage? Could the technique of wax resist be used to create a dramatic sky or a cloud of smoke from a chimney? Allow this drawing to become more abstract than your drawings perhaps usually are, putting the emphasis on interlocking shapes and the contrasting colors and textures.

◄ Samantha Toft
*Oil pastel and ink*
For **Curtain Call** the artist has combined the wax resist and sgraffito techniques, laying ink over oil pastel, and then scraping back and reapplying the oil pastel to create texture.

# Glossary

**ADVANCING COLORS**~Colors that appear to come toward the front of the picture. These are usually the warm colors such as reds and yellows, or any particularly vivid colors.

**AERIAL PERSPECTIVE**~The effect of tones and colors becoming paler as they recede, with diminishing light/dark contrasts. Aerial perspective is important in creating a sense of space, particularly in landscape drawings.

**BINDER**~Any medium that is mixed with PIGMENT to form paints, pastels or colored pencils. Pastels are bound with gum tragacanth or other natural resins.

**BLENDING**~Achieving a gradual transition from light to dark, or merging one color into another. Pastels are often blended by rubbing two colors together with the finger, a rag or a TORCHON.

**BLOCKING IN**~This phrase, which means broadly establishing the main areas of tone and color, is most often used in connection with painting. However, it can also be relevant to the less linear types of drawing, such as PASTEL or CHARCOAL drawings.

**BRACELET SHADING**~A method related to HATCHING, but using curved lines which follow the contours of the form.

**BURNISHING**~A technique used in colored pencil drawings, in which colors are rubbed into one another and into the paper with a TORCHON, plastic eraser or white pencil. Because burnishing irons out the grain of the paper and compresses the pigment, it imparts a slight sheen to the surface and increases the brilliance of the colors.

**CHALK**~Material used for drawing since prehistoric times, and made from various soft stones or earth pigments. The term is a rather imprecise one, and is often used as another name for CONTE CRAYON or soft PASTEL. Leonardo da Vinci made many drawings in red and black chalk.

**CHARCOAL**~Charred twigs or sticks used for drawing, and particularly suited to broad, bold effects.

**CHIAROSCURO**~An Italian word meaning ''bright-dark,'' describing the exploitation of strong and dramatic light effects in drawing or painting.

**COLLAGE**~A technique of forming a picture by pasting any suitable materials (pieces of plain paper, photographic images, news clippings, fabrics, etc) onto a flat surface. The collaged pieces are often combined with passages of drawing and painting. Collage became an accepted artistic technique in the early 20th century, with the proliferation of printed matter.

**COMPLEMENTARY COLORS**~Pairs of colors that appear opposite one another on the color wheel, such as red and green, yellow and violet, and blue and orange.

**CONE OF VISION**~The field of vision in which everything can be seen clearly when the eyes are fixed in one position. This field extends for only about 40°.

**CONTÉ CRAYON**~A hard, square-sectioned crayon stick available in black, two browns and white. The crayon takes its name from Nicolas-Jacques Conté, who invented both it and the GRAPHITE pencil in the late 18th century.

**CONTOUR**~In a map, the contour is the outline of a mass of land, and the meaning of a contour line is very much the same in drawing. Contour must not be confused with outline, which only describes the two-dimensional shape of an object, while contour lines add the third dimension.

**CRAYON**~An imprecise term, but one that usually refers to sticks of color made with an oily or waxy binder. A CONTE CRAYON is not really a crayon in this sense of the word, because it is not oily.

**CROSSHATCHING**~A method of building up the tones or colors in a drawing with crisscrossing parallel lines. See also HATCHING.

**DEPTH**~The illusion of three-dimensional space in a drawing.

**EYE-LEVEL**~see **HORIZON LINE**

**FIGURATIVE**~This word simply means a drawing or painting of something actual rather than an abstract rendering; it does not imply the presence of figures. ''Representational'' is another word meaning the same thing.

**FORESHORTENING**~The optical illusion of diminishing length or size as an object recedes from you.

**FROTTAGE**~A technique akin to brass-rubbing, in which paper is placed over a textured or indented surface and rubbed with any soft drawing medium. Designs and textures created in this way are sometimes used as an ingredient in COLLAGE work.

**GOLDEN SECTION**~A system of organizing the geometrical proportions of a composition to create a harmonious effect. It has been known since Classical times, and is defined as a line (or rectangle) which is divided in such a way that the smaller part is to the larger what the larger is to the whole.

**GRAPHITE**~A form of carbon which is compressed with fine clay and used in the manufacture of pencils.

**HATCHING**~Building up tones or colors by means of closely spaced parallel lines; the closer they are, the more solid the tone or color. When a further set of lines is laid on top, going in the other direction, the technique is called CROSSHATCHING.

**HORIZON LINE**~Imaginary line which stretches across the subject at your eye level, and is where the VANISHING POINT or points are located. The horizon line in perspective should not be confused with the line where the land meets the sky, which may be considerably higher or lower than your eye level.

**IMPRESSING**~A method of making a design by indenting the surface of the paper with a pointed implement such as a paintbrush handle. Color is then laid on top, and the indented lines will show through as white (the technique is sometimes called white line drawing). It is most associated with colored pencils, but can also be used with GRAPHITE pencils or CONTE CRAYON.

**LEAD PENCIL**~This is a misnomer, but graphite pencils are still sometimes referred to in this way. The term comes from the metal points originally used for drawing (see SILVERPOINT).

**LIFTING OUT**~This method is most used in painting, particularly with watercolor, but is also a well-known CHARCOAL technique. The darks are laid first, and the highlights and mid-tones achieved by removing areas of charcoal with a kneaded eraser.

**LINEAR PERSPECTIVE**~The method of creating the effect of recession through the use of converging lines and VANISHING POINTS.

**LOCAL COLOR**~The actual color of an object, regardless of particular lighting conditions. The local color of a lemon is yellow, but the shadowed side may be dark green or brown.

**MAHLSTICK**~A stick with one padded end which is rested on the working surface while the drawing hand is supported on the other. Mahlsticks are particularly useful in PASTEL drawing, where there is a danger of smudging the soft pigment with your hand or wrist.

**MEDIUM**~1 The material used for drawing or painting, i.e. pencil, pen and ink.
2 Substance added to paint, or used in its manufacture, to bind the pigment and provide good handling qualities. To avoid confusion, the plural is usually given as "media" for the first meaning, and "mediums" for the second.

**METALPOINT**~see **SILVERPOINT**

**MODELLING**~1 Building up the impression of three-dimensional form by means of light and shade.
2 Posing for a drawing or painting.

**PASTEL**~Sticks of color, either cylindrical or square-sectioned, made by mixing pure pigment with gum tragacanth. Pastels are available in soft and hard versions, the former being alternatively known as chalk pastels. There are also oil pastels, in which the binding MEDIUM is a mixture of oils and waxes.

**PICTURE PLANE**~The plane occupied by the physical surface of the drawing. In a FIGURATIVE drawing, most of the elements appear to recede from this plane.

**PIGMENT**~Finely ground particles of color which form the basis of all paints, pastels and colored pencils. Most pigments are now synthetically made, but in the past they were derived from a wide range of plant, animal and mineral sources.

**RECEDING COLORS**~"Cool" or muted colors which appear to recede to the back of the PICTURE PLANE, while the bright, warm colors come forwards. (See also ADVANCING COLORS.)

**SGRAFFITO**~Scraping back one layer of color to reveal another one – or the color of the paper – below. The method is often used in oil and acrylic painting, but in drawing, the only really suitable MEDIUM is oil PASTEL.

**SHADING**~Graded areas of tone describing light and shade in a drawing.

**SILVERPOINT**~Before the invention of the graphite PENCIL, fine-line drawings were produced by drawing with a small, pointed metal rod on specially prepared paper. The fine gray lines oxidize in time to a light brown. There has recently been a revival of interest in silverpoint drawing, but it is only suitable for small-scale work, as little tonal variation can be achieved.

**SKETCHING**~This has taken on an outdoor connotation, though in fact a sketch can be any drawing that is done quickly and not taken to a high stage of completion.

**SQUARING UP**~The traditional method of transferring and enlarging a working drawing or sketch by ruling a grid of squares on both surfaces and transferring the visual information from one to the other.

**SPRAY FIXATIVE**~Thin varnish sprayed onto CHARCOAL or PASTEL drawings to prevent them from smudging. Spray fixative is often used at various stages in a drawing. It has a tendency to darken pastel colors.

**STIPPLING**~Building up areas of tone by means of small dots. The method is related to HATCHING and CROSSHATCHING, but is much slower and more laborious. It is used mainly by illustrators working in pen and ink.

**SUPPORT**~The term applied to any material, whether paper, canvas or board, which is used as a surface on which to draw. The word is commoner in the context of painting than drawing.

**TONE**~The lightness or darkness of any area of the subject, regardless of its color. Tone is only related to color in that some colors are naturally lighter than others. Yellow is always light in tone, and purple always dark.

**TOOTH**~The term for the grain of textured papers, which "bites" the colored pigment or pastel dust and helps to hold it in place.

**TORCHON**~A rolled paper stomp used for BLENDING in PASTEL work and sometimes also for BURNISHING. Tortillon is another name for the same implement.

**VALUE**~Another word for TONE, used particularly in the United States.

**VANISHING POINT**~In linear PERSPECTIVE, the point on the HORIZON LINE at which receding parallel lines meet.

**WASH**~Diluted ink or watercolor, applied with a brush. Washes are often used in conjunction with linear pen drawing.

**WAX RESIST**~A method based on the incompatibility of oil and water. If marks are made with a candle or waxy CRAYON, and ink washes – or undiluted ink – applied on top, the wax repels the water.

**WHITE LINE DRAWING**~see **IMPRESSING**

**WORKING DRAWING**~A drawing made specifically as the basis for a painting or finished drawing. Unlike a sketch (see SKETCHING), a working drawing establishes the whole composition, though is usually smaller than the intended finished work, and is transferred to the working surface by SQUARING UP.

# Index

# Credits

Quarto would like to thank all the artists who kindly submitted work for this book or agreed to carry out demonstrations.

We would also like to thank the following for providing photographs and transparencies, and for permission to reproduce copyright material. While every effort has been made to trace and acknowledge all copyright holders, we apologize if there have been any omissions.
The National Gallery, London 64, 174 – the Trustees of the British Museum 144, 148, 160, 166 – the Turner Collection, Tate Gallery, London 152 – Arts Council Collection, The South Bank Centre, London 170.